C000134179

PO 82 392

LANCHESTER LIBRARY — ART & DESIGN LIBRARY
Coventry Lanchester Polytechnic
Gosford Street,
Coventry CV1 5RZ

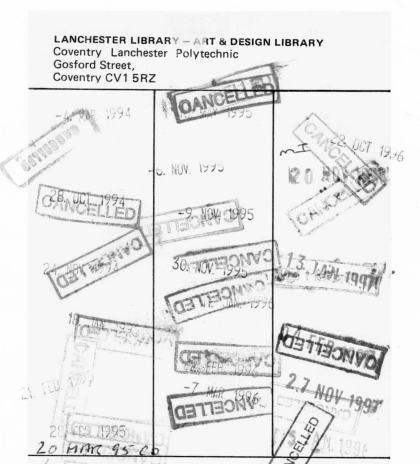

This book is due to be returned not later than the
date stamped above. Fines are charged on overdue
books.

PS57298/A

Clement Greenberg

THE COLLECTED ESSAYS AND CRITICISM

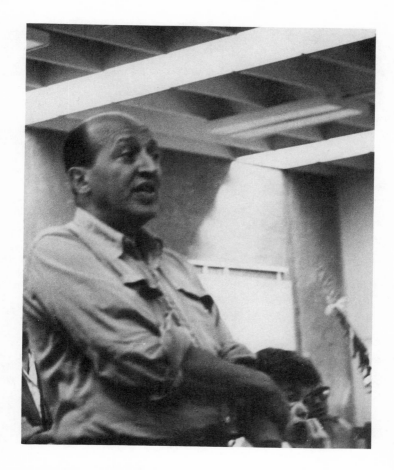

Clement Greenberg at Emma Lake, Saskatchewan, 1962. Photograph by
Toni Onley.

Notes by Clement Greenberg about possible leaders for the Emma Lake Artists' Workshop, Saskatchewan, 1963. University of Regina Archives.

Clement Greenberg

THE COLLECTED ESSAYS AND CRITICISM

Volume 4
Modernism with a Vengeance
1957–1969

Edited by John O'Brian

The University of Chicago Press CHICAGO AND LONDON

CLEMENT GREENBERG, a dominant figure in
American cultural criticism since the 1940s, has
been an editor for The Partisan Review, an art
critic for The Nation, and a book reviewer for the
New York Times. John O'Brian is an associate
professor in the Department of Fine Arts at the
University of British Columbia, Vancouver.

The University of Chicago Press, Ltd., London
© 1993 by Clement Greenberg and John O'Brian
All rights reserved. Published 1993
Printed in the United States of America

02 01 00 99 98 97 96 95 94 93 123456
ISBN (cloth): 0-226-30620-8

Library of Congress Cataloging-in-Publication Data
(Revised for volumes 3–4)

Greenberg, Clement, 1909—
 The collected essays and criticism.

 Includes bibliographies and indexes.
 Contents: v. 1. Perceptions and judgments,
1939–1944—[etc.]—v. 3. Affirmations and
refusals, 1950–1956—v. 4. Modernism with a
vengeance, 1957–1969.
 1. Art. I. O'Brian, John. II. Title.
N7445.2.G74 1986 700 85-29045

∞ The paper used in this publication meets the
minimum requirements of the American National
Standard for Information Science—Permanence of
Paper for Printed Materials, ANSI
Z39.48-1984.

Coventry University
Art and Design Library
Author ...GREENBERG...
Class ...704. 9 GRE...

Contents

1964

1965

1966

1967

1968

1969

Acknowledgments

Acknowledgments due on the present volumes are the same as for the first two volumes, with some important additions.

I must again thank T. J. Clark for first encouraging me to track down and compile the uncollected writings of Clement Greenberg; Anne M. Wagner for arming me with an excellent bibliography that greatly facilitated my work in the early stages; S. J. Freedberg, Oleg Grabar, Serge Guilbaut, Michael Kimmelman, Matthew Rohn, and Henri Zerner for offering advice on publishing matters; the staffs of the New York Public Library, the Widener and Fine Arts libraries at Harvard University, the Fine Arts Library at the University of British Columbia, Vancouver, and the Robarts Library at the University of Toronto for responding, always patiently, to inquiries; and Whitney Davis, Friedel Dzubas, Helen Kessler, Andrew Hudson, Caroline Jones, Michael Leja, and Susan Noyes Platt for bringing to my attention articles I had overlooked. I would also like to thank Robert F. Brown, at the Archives of American Art, Alan M. Wald, at the University of Michigan, and Dorothy Swanson, at the Tamiment Library, New York University, for helping me to locate stray material; and Patty Hoffman for preparing, and Victor Semerjian for reading, the manuscript.

For permission to publish exchanges between Greenberg and F. R. Leavis, Fairfield Porter, Thomas B. Hess, Max Kozloff, Robert Goldwater, and Herbert Read, I am grateful to Queen's University, Belfast, Mrs. Anne Porter, *The New York Times*, Max Kozloff, *Artforum*, and *Encounter*. In the realm of financial support, I have benefited from the Social Sciences and Humanities Research Council of Canada, and from a research grant awarded by the University of British Columbia.

Finally, I thank Clement Greenberg himself. He responded favorably to the idea of a "Collected Works," and encouraged the endeavor throughout.

John O'Brian

Editorial Note

The essays and criticism in this volume consist of published writings only, arranged chronologically in the order of their first appearance. Each article concludes with a reference stating when and in what publication it first appeared. Reprints are also indicated. The abbreviation A&C is used for the book *Art and Culture: Critical Essays,* the collection of Greenberg's writings published in 1961. Most of the articles in that book were revised or substantially changed by Greenberg for republication. This volume, however, reprints the articles as they appeared originally.

All titles are either Greenberg's own or those of the editors of the publications for which he wrote. In most cases the titles for the essays were supplied by Greenberg himself and the titles for book reviews and shorter pieces were supplied by others. In order to indicate the contents of reviews and articles for which no titles were given, I have supplied descriptive headings.

The text has been taken from articles as they appeared in print. Throughout, the titles of books, poems, periodicals, and works of art have been put in italics. Spelling and punctuation have, with some exceptions, been regularized to coincide with the usage in the essays written for *Partisan Review*. All ellipsis points in the text are Greenberg's.

Greenberg used a minimum of footnotes in his writing and for this edition I have followed his practice in my own footnoting. The text is footnoted only where there is a reference to a topic about which the reader could not be expected to find information in another source. The majority of Greenberg's articles were written as one or another kind of journalism and the edition attempts to preserve the sense of occasion for which they were written. In some cases, the published correspondence of writers with whom Greenberg engaged in a critical exchange has been included. The articles during the period

from 1950 to 1969, unlike those published during the 1940s, were in most cases accompanied by illustrations.

The Bibliography lists other writings by Greenberg, including books and translations from the German. It also provides a selected bibliography of secondary sources on Greenberg's work. The Chronology offers a brief summary of events from 1950 to 1969 to give some background to the criticism.

Foreword

In his essay "Modernist Painting," written in 1960, Clement Greenberg declared famously that "each art had to determine, through its own operations and works, the effects exclusive to itself." According to Greenberg, this required that artists pay close attention to the nature of the medium they worked in or face the consequences of their neglect; for painters, particularly, it required recognition of the limitations imposed upon them by the flat surface and shape of their painting support. Not to recognize the limitations was to risk assimilation to some other activity—at worst, in Greenberg's opinion, to entertainment and all that that connoted in the middle years of the twentieth century about Western machine-made culture

At the time, Greenberg's formulations were read as something close to an ultimatum. The rhetoric in which he couched his ideas seemed to allow little room for argument; either artists accepted the logic of his rationale or they risked producing "minor" work. Nevertheless, it would be wrong to suppose that Greenberg failed to recognize what painting stood to lose by narrowly defining its area of competence according to the properties of its medium. The purity he sought might guarantee the independence of art, but it might also render it less imaginatively fulfilled than in the past. If art was to engage constantly in an enterprise of self-criticism in order to remain uncontaminated, Greenberg understood that this amounted, as he said, to a form of "self-definition with a vengeance." The title of this fourth volume of Greenberg's collected essays and criticism, *Modernism With a Vengeance*, reflects the uncertain militancy of that phrase.

The format and organization of this volume are identical to that of the third volume, *Affirmations and Refusals*, which covers the years from 1950 to 1956. The apparatus—listing

Greenberg's published writings and selected secondary sources on his work, and providing a chronology—is also identical. The introduction, though it serves to preface the contents of both volumes, appears only in *Affirmations and Refusals*.

John O'Brian

Clement Greenberg

THE COLLECTED ESSAYS AND CRITICISM

1957

1. The Later Monet

Monet is beginning to receive his due. Recently the Museum of Modern Art and Walter Chrysler, Jr., have each bought one of the huge *Water Lilies* that were painted between 1915 and 1925, in the same series as those the French government installed in the Paris Orangerie in 1926. An avant-garde painter like André Masson and a critic like Gaston Bachelard write about him admiringly. A collector of very modern art in Pittsburgh concentrates on his later works, and the prices of these are rising again. Even more important, their influence is felt—whether directly or indirectly—in some of the most advanced painting now being done in this country.

The first impulse is to back away from a vogue—even when one's own words may have contributed to it. But the righting of a wrong is involved here, though that wrong—which was a failure in appreciation—may have been inevitable and even necessary at a certain stage in the evolution of modern painting.[1] Fifty years ago Monet seemed to have nothing to tell ambitious young artists except how to persist in blunders of conception and taste. Even Monet's own taste had not caught up with his art. In 1912 he wrote to the elder Durand-Ruel: "And today more than ever I realize how factitious the unmerited [*sic*] success is that has been accorded me. I always hope

1. Greenberg had previously been critical of Monet's later painting. For example, in May 1945, he wrote in *The Nation*: "As Debussy would often present the mere texture of sound as the form itself of music, so Monet in his last period offered the mere texture of color as adequate form in painting. Monet, logical nineteenth-century materialist, forgot that art is relations, not matter, and that it exists primarily by virtue of relations, while all that matter can do is repeat itself: thus clusters of lily pads, masses of foliage, gray mists, and watery reflections—the canvases on which Monet painted them look like segments cut from much larger pictures." [Editor's note]

to arrive at something better, but age and troubles have exhausted my strength. I know very well in advance that you will find my canvases perfect. I know that they will have great success when shown, but that's indifferent to me, since I know they are bad and am sure of it." Three years later he was to begin the Orangerie murals.

In middle and old age Monet turned out many bad pictures. But he also turned out more than a few very good ones. Neither the larger public, which admired him unreservedly, nor the avant-garde of that time, which wrote him off without qualification, seemed to be able to tell the difference. As we know, after 1918 enlightened public as well as critical esteem went decidedly to Cézanne, Renoir and Degas, and to van Gogh, Gauguin and Seurat, while the "orthodox" Impressionists, Monet, Pissarro and Sisley, fell into comparative disfavor. It was then that the "amorphousness" of Impressionism became a received idea. And it was forgotten that Cézanne had belonged to, and with, Impressionism as he had belonged to nothing else. The new righting of the balance seems to have begun during the last war with the growing appreciation of the works of Pissarro's last decade. Our eyes seemed to become less insensitive to a general greying tone that narrowed or attenuated contrasts of dark and light. But Pissarro still built a rather clearly articulated illusion in depth, which led critics hypnotized by Cézanne to exempt him from many of the charges they still brought against Monet and Sisley. The general pallor—or else general dusk—to which Monet became addicted in his last phase permitted only hints and notations of depth to come through, and that in what seemed to be— and very often was—an uncontrolled way. Atmosphere gave much in terms of color, but it took away even more in those of three-dimensional form. Nothing could have meant less to the good taste of the decades dominated by Matisse and Picasso.

Sixty and seventy years ago Monet's later manner both stimulated and met—as did Bonnard's and Vuillard's early work—the new appetite for close-valued, flat effects in pictorial art. His painting was enthusiastically admired by *fin-de-siècle* aesthetes, including Proust. But in a short time its diaphanous iridescences had gone into the creation of that new,

candy-box ideal of "beauty" which supplanted the chromo-lithographic one of Victorian times in popular favor. Never before or since the 1900s, apparently, did the precious so quickly become the banal. By 1920 popular and academic diffusion had reacted upon Monet's later art to invest it with a period flavor that made it look old-fashioned even to eyes not offended by what the avant-garde found wrong in it. Only now—when the inter-war period, with its repudiation of everything popular just before 1914, is beginning to be repudiated in its own turn—are these extrinsic associations starting to fade.

Worldly success came earlier to Monet, and in larger measure, than to any of the other master Impressionists. All of them desired it, and most of them, like Monet, needed it in order to support themselves and their families. Their attitude to the public was never intransigent. They worried about how to make an impression on the art market and were not above trying, up to a point, to satisfy the demands of prospective buyers. Cézanne, as we know, wanted all his life to make the official Salon, and few of them were ready to reject official honors. Yet the Impressionists, even after their "consecration," continued to be revolutionary artists, and their integrity established an example for all subsequent avant-gardes.

By 1880, Monet had marked himself off from his fellow Impressionists as a self-promoter, a publicity-seeker and a shrewd business man. This last he, who had been the most penurious of them all in the beginning, remained to the end; his sense of timing in raising the prices of his pictures was better than that of his dealers. This does not mean that he compromised in his work. Nor did he ever get enough satisfaction from success to feel satisfied with his art. On the contrary, after 1880, when the original momentum of Impressionism slackened even as the movement itself began to win acceptance, he became increasingly prey to self-doubt.

The Impressionists were neither worldly nor innocent, but transcended the alternative, as men of ripened individuality usually do. It is remarkable how few airs they gave themselves, and how little they wore of the *panache* of the artist. Formed by the 1860s, which was a great school in radicalism, resoluteness and mental toughness, they retained a certain hard-

ness of head that prevailed over personal eccentricities, even in Cézanne's and Degas' cases. Among them, Monet, Pissarro and Cézanne seem at this distance to form a group of their own— less by reason of their art or personal association than by their way of life and work. We see them—all three, stocky, bearded men—going out every day to work in the open, applying themselves to the "motif" and registering their "sensations" with fanatical patience and obsessive regular ity—prolific artists in the high nineteenth-century style. Though men of fundamentally sophisticated and urban culture (Monet had the least education of the three), by middle age they were all weatherbeaten and a little countrified, without social or any other kind of graces. And yet how un-naive they were.

The personalities of painters and sculptors seldom are as pointedly reported as those of writers. But Monet dead may be easier to approach than Monet alive. We get the impression of an individual as moody as Cézanne, if with more self-control; given to fits of discouragement and to brooding and fretting over details; absolutely unpretentious and without phrases, indeed without very many ideas, but with definite and firm inclinations. And though supposedly a programmatic painter and for a time held to be the leader of the Impressionists, he had even less than Sisley to put into words, much less theory, about his art. There was a kind of force in him that was also a kind of inertia: unable to stop when once at work, he found it equally difficult—so he himself says—to resume after having been idle for a length of time. Usually, it was the weather that interrupted him, upon which he was more dependent than a peasant. Sisley alone was a more confirmed landscapist.

Like most of the other Impressionists, Monet was not in the habit of waiting for the right mood in order to start working: he turned out painting as steadily and indefatigably as Balzac turned out prose. Nonetheless, each new day and each new picture meant renewed doubts and renewed struggle. His life's work contained, for him, little of the comforts of routine. It is significant that Monet undertook works that had the character of planned, pondered, definitive, master- or set-pieces only at the very beginning and the very end of his career; otherwise, it was dogged, day-in, day-out painting. Certainly he produced too much, and it belonged to his way of work

that the bad should come out not only along with the good, but in much greater quantity. And at his worst he could look more than bad—he could look inept. Yet I feel that it was to the eventual benefit of his art that he did not settle at any point into a manner that might have guaranteed him against clumsiness. The ultimate, prophetic greatness he attained in old age required much bad painting as a propaedeutic. Monet proceeded as if he had nothing to lose, and in the end proved to be as daring and "experimental" an artist as Cézanne.

That he lacked capacity for self-criticism was to his advantage in the long run. A nice taste in an artist can alienate him from his own originality, and inhibit it. Not that Monet did not try to exercise taste in his work—or at least in finishing it. He would fuss endlessly with his pictures before letting them go, and rarely complete one to his satisfaction. Contrary to what he himself gave people to understand, he did not stop painting when the motif was no longer before him, but would spend days and weeks retouching pictures at home. The excuse he gave to Durand-Ruel at first was that he had to meet the taste of collectors for "finished" pictures, but obviously it was his own taste and his own conception of what was to be considered finished that played the largest part. One can well imagine that more paintings were spoiled than improved in the process, given the tendency of self-doubts such as those that afflicted Monet to suppress the effects of spontaneity once the stimulus of the motif was no longer there. When he stopped correcting himself obsessively and became more slapdash, "realization," it seems to me, became more frequent, and greater in scope.

If Monet was the one who drew the most radical conclusions from the premises of Impressionism, it was not with truly doctrinaire intent. Impressionism was, and expressed, his personal, innermost experience, doctrine or no doctrine. The quasi-scientific aim he set himself in the 1890s—to record the effects of light on the same motif at different times of day and in different weather—may have involved a misconception of the ends of art, but it was more fundamentally part of an effort—compelled by both his own experience and his own temperament—to find a principle of consistency for pictorial art elsewhere than in the precedent of the past. Monet could not

bring himself to believe in the Old Masters as Cézanne and Renoir did—or rather, he could not profit by his belief in them. In the end he found what he was looking for, which was not so much a new principle as a more comprehensive one: and it lay not in Nature, but in the essence of art itself, in its "abstractness." That he himself could not consciously recognize or accept "abstractness"—the qualities of the medium alone—as a principle of consistency makes no difference: it is there, plain to see in the paintings of his old age.

The example of Monet's art shows how untrustworthy a mistress Nature can be for the artist who would make her his only one. He first sank into prettiness when he tried to match the extravagance of Mediterranean light while keeping his color in key according to Impressionist methods: an incandescent violet would demand an incandescent yellow; an incandescent green, an incandescent and saccharine pink; and so on. Complementaries out-bidding each other in luminosity became the ruin of many of his paintings, even where they were not handicapped to start with by the acceptance of an over-confined motif, such as a row of equidistant poplars all of the same shape and size, or one—i.e. two or three lily pads floating in a pond—that offered too little incident to design. Here a transfiguring vision was required, and Monet seemed to paint too much by method and trust himself too much to a literal honesty within his method.

But this was not always the case, and literal honesty, to his own sensations rather than to Nature, could at times save a picture for art. Monet had an adventurous spirit, rather than an active imagination, that prompted him to follow, on foot and analytically as it were, wherever his sensations led. Sometimes the literalness with which these were registered was so extreme as to become an hallucinated one, and land him not in prettiness, but on the far side of expected reality, where the visual facts turned into phantasmagoria—phantasmagoria all the more convincing and consistent as art because without a shred of fantasy. This same fidelity to his sensations permitted Monet to confirm and deepen Impressionism's most revolutionary insight, which has also been its most creative one: that values—the contrasts and gradations of dark and light—were indispensable neither to the representation of Nature nor to

the integrity of pictorial art. This discovery, made in an effort to get closer to Nature, was later to be turned against her, and by Monet first of all.

After the period of his classical Impressionism, his main difficulty was in the matter of *accentuation*. His concern with unity and "harmony" and the desire to reproduce the equity with which Nature distributed her illumination would lead him to accent a picture repetitiously in terms of color. He would be too ready to give "equivalences" of tone precedence over "dominants"—or else the last would be made altogether too dominant. The intensity of vision and its registration could become an unmodulated, monotonous one and cancel itself out, as in some of the paintings of the Rouen cathedral. At times the motif itself could decide otherwise: the sudden red of a field of poppies might explode the complementaries and equivalences into a higher, recovered, unity; but Monet seems to have become more and more afraid of such "discords."

There was good reason for his, and Pissarro's, obsession with unity. The broken, divided color of full-blown Impressionism—which became full blown only after 1880, in Monet's and Sisley's hands—tended to keep the equilibrium between the illusion in depth and the design on the surface precarious. Anything too definite—say, a jet of solid color or an abrupt contrast—would produce an imbalance that, according to the Impressionist canon, had to be resolved in terms of the general tone or "dominant" of the picture (this was analogous to traditional procedure with its insistence that every color be modeled in dark and light), or else by being made to reflect surrounding colors. Off and on Monet painted as if the chief task were to resolve discords in general, and since these would often be excluded in advance, many of his pictures ended up as resolutions of the resolved: either in a monotonously woven tissue of paint dabs or, as later on, in an all-enveloping opalescent grey distilled from atmosphere and local color. The solution of the difficulty lay outside the strict Impressionist canon; a definite choice had to be made: either the illusion in depth was to be strengthened at the expense of the surface design—which is the course Pissarro finally took—or vice versa.

In 1886, Pissarro observed that Monet was a "decorator

without being decorative." Lionello Venturi comments that decorative painting has to stay close to the surface in order to be integrated, whereas Monet's, while in effect staying there, betrayed velleities towards a fully imagined illusion of depth in which the existence of three-dimensional objects required to be more than merely noted or indicated, as they were in his practice. In short, Monet's decorative art failed because it was unfulfilled imaginatively. This is well said, but as if it were the last word on Monet's later painting. In a number of pictures, not so infrequent as to be exceptional, and not all of which came just at the end, Monet did decisively unify and restore his art in favor of the picture surface.

As it happens, Cézanne and the Cubists made painting two-dimensional and decorative in their own way: by so enhancing and emphasizing, in their concern for three-dimensionality, the means by which it had traditionally been achieved that three-dimensionality itself was lost sight of. Having become detached from their original purpose by dint of being exaggerated, the value contrasts rose to the surface like decoration. Monet, the Impressionist, started out from the other direction, by suppressing value contrasts, or rather by narrowing their gamut, and likewise ended up on the surface: only where he arrived at a shadow of the traditional picture, the Cubists arrived at a skeleton.

Neither of these ways to what ultimately became abstract art is inherently superior to the other as far as quality is concerned. If architectonic structure is an essential ingredient of great painting, then the murals in the Orangerie must possess it. What the avant-garde originally missed in the later Monet was traditional, dark-and-light, "dramatic" structure, but there is nothing in experience that says that chromatic, "symphonic" structure (if I can call it that) cannot supply its place. Sixty years of van Gogh, Gauguin, Seurat, Cézanne, Fauvism and Cubism have had to pass to enable us to realize this. And a second revolution has had to take place in modern art in order to bring to fruition, in both taste and practice, the first seed planted, the most radical of all.

Venturi, writing in 1939, called Monet the "victim and gravedigger of Impressionism." At that time Monet still seemed to have nothing to say to the avant-garde. But today those huge close-ups which are the last *Water Lilies* say—to

and with the radical Abstract Expressionists—that a lot of physical space is needed to develop adequately a strong pictorial idea that does not involve an illusion of deep space. The broad, daubed scribble in which the *Water Lilies* are executed says that the surface of a painting must breathe, but that its breath is to be made of the texture and body of canvas and paint, not of disembodied color; that pigment is to be solicited from the surface, not just applied to it. Above all, the *Water Lilies* tell us once again that all canons of excellence are provisional.

It used to be maintained that Monet had outlived himself, that by the time he died in 1926 he was an anachronism. But right now any one of the *Water Lilies* seems to belong more to our time, and its future, than do Cézanne's own attempts at summing-up statements in his large *Bathers*. Thus the twenty-five years' difference in dates of execution proves not to be meaningless—and the twenty years by which Monet outlived Cézanne turn out not to have been in vain.

Modern art, dating from Manet, is still too young to let us rest on our judgments regarding it: the rehabilitation of the later Monet has already had an unsettling effect. It may not account for, but it helps clarify an increasing dissatisfaction with van Gogh, as it helps justify impatience with an uncritical adoration of Cézanne. Van Gogh is a great artist, but Monet's example serves better even than Cézanne's to remind us that he may not have been a *master*. He lacked not only solidity and breadth of craft; he also lacked a settled largeness of view. In Monet, on the other hand, we enjoy a world of art, not just a vision, and that world has the variety and space, and even some of the ease, a world should have.

Art News Annual 26, 1957; A&C (substantially changed); *Monet: A Retrospective*, ed. Charles F. Stuckey, 1985.

2. Review of *Piet Mondrian: Life and Work* by Michel Seuphor

One still gives something of a start, recognizing Mondrian's greatness. There his pictures are, so "empty," so "mechanical,"

so "inhuman," yet communicating to those who look long and often enough a greatness that is as unmistakable in a single example as across the length and breadth of his *oeuvre*. And with time, the variety and range of that *oeuvre* (leaving aside the earlier, pre-abstract works, which have a value of their own) become increasingly evident. How can so much effect be attributed to so little cause: to a few ruled bands of black paint marking off flat rectangles or triangles of white, red, yellow, blue and gray? The answer—as with all other works of visual art—lies in the looking alone.

That it stimulates us to look is not least among the merits of the book at hand, which is as good in format, design (except for a too uniform use of sans-serif) and manufacture as it is in content and in the quality and interest of its numerous reproductions and illustrations. Mr. Seuphor writes from firsthand knowledge, having been a close friend of Mondrian's for twenty years. But I wish that he had been able to distance himself more critically from his art; that would have given his praise of it more meaning. And I also wish he had not applied the term "intellectual" to it so unconsideredly. He raises his eyebrows at the statement made by a Dutch critic forty years ago that "the art of Mondrian is 'pure feeling,' that he 'does not reason,' that he 'dreams in the abstract.' " But nowhere does Mr. Seuphor himself show clearly what role reasoning played in the creation of Mondrian's pictures. His vocabulary was limited finally to the plumb-line right angle, the primaries of red, blue and yellow, and the "non-colors" of black, white and gray: elements that Mondrian may indeed have arrived at by induction from the artistic success of Cubist and even of much pre-Cubist painting. But once this vocabulary had been found he proceeded to use it solely on an intuitive basis. Mr. Seuphor quotes Mondrian as telling Charmion von Wiegand that "he did not work with instruments nor through analysis, but by means of intuition and the eye. He tests each picture over a long period by eye: it is a physical adjustment of proportion through training, intuition, and testing." The most calculating and rule-bound of artists can proceed in no other way in the final stages of a work if he is to achieve more than accidental quality. In other words, "intellectual" art can mean only mechanical art, which Mondrian's certainly was not.

For the rest, Mr. Seuphor writes with a personal involvement, an incisiveness and a perceptive sobriety that make an edifying contrast with what we usually get in monographs about modern artists. This is most true of his approach to Mondrian's personality, which he does not assume—as people do with Picasso's—can be explained almost entirely by the fact that its possessor was a genius. At the same time Mr. Seuphor does not claim to be writing the complete or definitive book on his subject. Much research is still needed on the earlier part of Mondrian's life, before he settled in Paris, and the author hopes that his account will stimulate such research by people in a better position than himself to undertake it.

The book does offer a remarkably complete view of Mondrian's art as such. Not only are there many full-page reproductions, some in color; but a "classified" catalogue with small illustrations in black and white of 441 works, early and late, is appended, and after that a list giving size, medium and location of all known works by the master, which comprise 589 items. And aside from the copious quotations from Mondrian's writings given in the text itself, his dialogue-essay, "Natural Reality and Abstract Reality," written in 1919–20 and originally published in Doesburg's magazine, *De Stijl*, is printed for the first time in a complete English translation. (This was the only thing he had written, Mondrian told Mr. Seuphor years later, that he was still satisfied with.)

It is not altogether a shock to learn that Mondrian was deeply concerned with religion in his youth and belonged for a time, after abandoning his ancestral Calvinism, to the Theosophical Society of Holland. Only after 1916 did religion become translated into art, into neo-plasticism, which meant, to Mondrian, the "spiritualization" of painting. I think his ideas, and especially the vision to which they point of a completely humanized environment, to be of great significance. Nevertheless, I cannot help but feel that they are a misleading introduction to his art. That art is not quite the new revelation that he himself took it for, or that others have taken it for since. When we approach it through Cézanne, Matisse and Cubism (whose consequences it drew), it reveals itself as a final, quintessential statement of the basic structural principles of the Western tradition of easel painting. These principles are:

1) the integrity of the picture plane (which the old masters respected in their way as much as the Cubists and Mondrian did in theirs); 2) the decisive role in design of the enclosing shape of the picture; 3) the indispensability of value contrasts. Mondrian shows, with an explicitness beyond Cézanne's, that the representation of nature was not the element fundamental to Western tradition; naturalism as such is common to many other civilized traditions, and to several barbaric and savage ones as well. What is unique to Western pictorial art are, over and beyond the logical consequences to which it pushed naturalism, certain decorative, structural and delineatory principles. As far as these are concerned, the Impressionists remain more revolutionary than Cézanne, the Cubists or Mondrian, appearances to the contrary notwithstanding.

Unlike Mr. Seuphor, I see a falling-off in Mondrian's quality after 1936 (the multiplication of the black bands and their uniform thickening made the picture heavier and static: equivalence began to look too much like symmetry). But the narrowing of value contrasts in such works as *New York City* (1942) and *Broadway Boogie-Woogie* (1942–43), both painted after the artist had come to this country, is perhaps more truly revolutionary, however far from being successful, than anything he had done before. (In the first, the black bands are replaced by red, blue and yellow ones that crisscross instead of intersect; in the second, by little yellow, red, blue and gray squares and oblongs.) And the picture upon which he was working when death interrupted him in 1944, *Victory Boogie-Woogie*, not only reveals a more conscious sense of the effects to be gained by suppressing value contrasts in one place and emphasizing them in another; it also, even in the unfinished state in which it has been left, marks the beginning of a recovery of quality. The checkerwork of color has a life to it not seen in Mondrian's painting since the early 1930's. Thus his death at the age of seventy-two may have been premature in more than one respect. As Mr. Seuphor says, he was in sight of "new land." A capacity for renewal belonged to the essence of the artist that he was, and that capacity was being demonstrated once again in the last year of his life.

Arts Magazine, February 1957

3. Review of *Chagall's Illustrations for the Bible* by Meyer Schapiro and *Chagall* by Lionello Venturi

The only one comparable in our time with Picasso as a graphic artist is Chagall (not Rouault), and nothing even the former has done as a graphic artist quite matches in intensity or integrity these illustrations of Chagall's for the Bible. Commissioned in 1930 by the late Ambroise Vollard, the renowned art dealer and publisher, they are now presented complete in a setting that is perhaps not as magnificent as Vollard intended, but which is splendid nevertheless.

That Chagall, whose production in oil has on the whole declined over the last thirty years, has been able during that time to make such progress in his graphic work has to do, I feel, with his essential conservatism, his profound and sophisticated nostalgia for the museum. A similar nostalgia, but with different roots (in culture rather than in temperament or autobiography), has exempted Picasso's graphic work from the even more general decline his painting, too, has suffered over recent decades. The fact that the print has never been a quite appropriate vehicle for modernist art in the making is what seems precisely to enable both artists to continue to exploit it successfully now that the *élan* of their original contribution to modernist art has faded.

The print may, in such hands as Chagall's and Picasso's, still be able to register the results of innovation, but not since Goya has it lent itself to the working out of innovation. The great etchers of the 19th century, like Meryon and Bresdin, had no part in the radical changes pictorial art underwent in their time. Modernism has been almost exclusively an affair of paint and, except during its Cubist phase, has shifted the emphasis cumulatively to direct color as well as to surface design. Even Manet's preoccupation with contrasts of dark and light was something quite different from that reliance on gradations of dark and light which was intrinsic to the naturalism of pre-Impressionist art; and to the extent of that difference Manet's art fails of its characteristic effects when translated into ink on paper. Etching and engraving—if not lithography and the woodcut—lose their traditional point when it is no longer a question of the subtle transitions of shade and sha-

dow by which a "body" illusion of space and volume is articulated.

In his paintings themselves Chagall has hardly ever abandoned the indication of illusionist space, or failed to hint at modelling; but given that his style as a *painter* was formed under the aegis of Matisse and Picasso, the limits within which he could satisfy his vein for chiaroscuro in paint itself has remained relatively narrow. To give it freer play, he has had to resort to the needle and plate. It is an unexampled use of chiaroscuro that we see then, in which its traditional application is suggested, but a modernist flatness is actually realized, so that something of the best of both worlds seems preserved. In time to come Chagall's prints will possibly be rated higher than all but a comparative few of his paintings. All that is too ripe, too sauced and sweetened in his oils (significantly, the best of his "easel" pictures to be seen in this country lately were on unglazed squares of tile) is purged when his talent has only the etcher's needle or lithographer's pencil at its disposal. Nor does a virtuoso command of the etching medium seduce him into virtuoso effects. The drawing may at times go over the edge of manneredness or even of cuteness in the deliberate clumsiness of its simplifications, but in these illustrations for the Bible this does not happen often or obtrusively enough to mar the total impression of an art so genuinely inspired that it can afford to humble itself entirely to the text upon which it makes pictorial comment.

There are many things to praise in these etchings: the velvet furriness of their blacks and grays, the dramatic patterning of contrasts, the weightless density of the masses whether dark or light, the fluid, infinitely various yet incisive line, the discrete and yet masterly mixing of techniques (for drypoint and soft-ground as well as straight needle-and-acid etching seem to have been brought into play), the *mise-en-scène* by which the anecdotal meaning of each illustration is emphasized and enhanced—and so on. But I would call attention particularly to the colored lithographs that in groups of four separate the four sections ("Genesis," "Moses," "Kings," and "Prophets") into which the etchings are divided, and I would point most to the last group, "Prophets."

Lithography is the most direct and flexible of the print me-

diums, but ink cannot be handled as freely as oil pigment or even watercolor; it will not permit a similar gradualness of transition from one shade or tone to another. This very limitation purifies Chagall's color in a way much like that in which being confined to black and white purifies his design in his etchings. If in the etchings, however, we see restored some of that vigorous crudeness and abruptness by which his paintings originally won admiration, there is in the colored lithographs a new blending of brilliance and force without precedent in anything he has done before. Here, for almost the first time, the artist exploits rather than succumbs to sophistication, and the result can stand next to anything by Matisse. Never has his color been employed so convincingly as structure, never so opulently for its own sake, and never has it had more power to move than on these folio pages. (I have, however, seen wall-picture-size lithographs Chagall has done recently that achieve a like success.)

The most important factor perhaps in this triumph is Chagall's changed approach to pictorial space: the generalized background is no longer marked off so distinctly from figures or objects in the foreground by differences of color value, color intensity, or color warmth; now background and foreground are joined together in a more abstract, less determinate kind of space any point of which is interchangeable with any other as far as the illusion of distance from the eye is concerned. The effect is to enhance the role of the flat picture plane and its four sides, which in turn bestows a more emphatic and spectacular unity upon the picture itself. And all this is done, first and foremost, by bringing the different colors closer together in every sense except that of specific hue. As with almost every resounding victory in art, a paradox is involved: by way of the print, to which he was drawn in the first place by his conservative inclinations, Chagall's art has reached a point of modernity not yet attained in his easel pictures.

Meyer Schapiro's appreciative introduction covers nearly every aspect of the Bible etchings that lends itself to words (he does not touch on the lithographs) and strikes one more as a labor of love than as something done simply to provide an appropriate text for the occasion. I am not so conscious here as in other of Professor Schapiro's efforts at appreciation or criti-

cism of the strain to leave nothing unsaid; it is as if Chagall's humility toward the Biblical word had inspired in him a similar humility toward the illustrations of that word. But Jean Wahl's longish poem in free verse, *The Word is Graven*, which is offered as the main text of *Illustrations for the Bible*, is a letdown; I'm afraid its banality cannot be blamed altogether upon the transformation it has undergone in being rendered into English from French.

Lionello Venturi's book, part of Skira's small-format series called *The Taste of Our Time*, is valuable for the hitherto unfamiliar paintings to which its reproductions introduce us. The color in the plates, as usual in Skira books, and especially when the scale is much reduced, tends to be too brilliant, but we have all learned by this time, I hope, to expect information or reminders rather than aesthetic experience from reproductions of oil paintings. Professor Venturi's text is, for all unqualified admiration it lavishes upon its subject, perfunctory; Chagall is his favorite modern painter, and he has written too often upon him—but never critically enough. Nor is Professor Venturi really at ease with modern art since it stopped being Impressionist, and much of what he says, and has said, in behalf of Chagall sounds arbitrary because it lacks reference to the true context of the latter's art.

It is simply not true, for instance, that Chagall has recognized the "need for poetry in painting to a greater extent than any of his contemporaries"; and it is still inappropriate to say that "with the passing of years he has developed into a colorist comparable to the greatest in the history of painting." It is somehow significant in connection with the latter remark, that Professor Venturi nowhere mentions Matisse's truly enormous influence upon Chagall: an influence that affected his design as well as his color, and whose total role in the formation of his art is equal in importance to the influence of Cubism. Perhaps if Professor Venturi had a clearer grasp of the point of Matisse's as well as Picasso's best work, he would be able to approach Chagall's art less uncritically. That would certainly make his praise of it more cogent.

Commentary, March 1957

4. New York Painting Only Yesterday

Eighth Street between Sixth and Fourth Avenues was the center of that part of New York art life with which I became acquainted in the late 1930's. There the WPA Art Project and the Hofmann school overlapped. The big event, at least as I saw it, was the annual exhibition of the American Abstract Artists group. Yet none of the figures who dominated this scene—Arshile Gorky, John Graham, Willem de Kooning, Hans Hofmann—belonged to this group or had big jobs on the Project, and Hofmann was the only one of them connected with the school. Gorky and de Kooning I knew personally; Hofmann I admired and listened to from afar; Graham I did not even know by sight, and only met in the middle forties after he had renounced (so he said) modernism, but I was aware of him as an important presence, both as painter and connoisseur. Those I saw most of were Lee Krasner, then not yet married to Jackson Pollock, and fellow-students of hers at Hofmann's. Rather an outsider, I did not know about everything that was going on, and much of what I did know about I could not fully understand. And for over two years (1941–43), while I was an editor of *Partisan Review*, I was almost entirely out of touch with art life.[1] The reader will, I hope, bear this in mind.

Abstract art was the main issue among the artists I knew then; radical politics was on many people's minds but for them Social Realism was as dead as the American Scene.[2] Fifty-seventh Street was as far away as prosperity: you went there to see art, but with no more sense of relation to its atmosphere than a tourist would have. None of the people I knew had yet had a show in New York, and many of them had not yet had

1. Greenberg is being unduly cautious here. In March 1942 he became *The Nation*'s regular art critic, and during the period from 1941 to 1943 he wrote more than thirty essays and reviews on art. [Editor's Note]

2. In the revised version of this essay, "The Late Thirties in New York," published in *Art and Culture*, Greenberg here inserted a famous addendum in brackets. It reads: "(Though that is not all, by far, that there was to politics in art in those years; some day it will have to be told how 'anti-Stalinism,' which started out more or less as 'Trotskyism,' turned into art for art's sake, and thereby cleared the way, heroically, for what was to come.)" [Editor's Note]

even a single example of their work seen by the public. A little later I met George L. K. Morris, who was, and still is, a leading figure in the Abstract Artists group; he lived uptown and he bought art, but my impression was that his attitude toward Fifty-seventh Street was almost equally distant. The Museum of Modern Art may have bridged the gap somewhat, but it belonged more to the "establishment" than to the avant-garde. Everybody learned a lot at the Museum, especially about Matisse and Picasso, but you did not feel at home in it. Moreover Alfred Barr was at that time betting on a return to "nature," and a request of the American Abstract Artists to hold one of their annuals in the Museum was turned down with the intimation that they were following what had become a blind alley.

The artists I knew personally formed only a small part of the downtown art world, but they appeared to me to be rather indifferent to what went on in New York outside their immediate circle. Also, most of them stood apart from the art politics and the political politics in which so many American artists, as well as writers, were then immersed. Worldly success seemed so remote as to be beside the point, and one did not even envy secretly those who had it. In 1938 and 1939 I attended evening WPA life classes, and when I contemplated taking up painting as seriously as I had once half-hoped to do before going to college, the highest reward I imagined was a private reputation of the kind Gorky and de Kooning had amid their poverty.

Many of the artists I knew at that time read the New York art magazines avidly, but only out of that superstitious regard for print which they shared with most other people, for they did not really take what they read in them seriously. The art publications from Paris, and the *Cahiers d'Art* above all, were a different matter: these posted you on the latest developments abroad, and Parisian art exerted perhaps a more decisive influence for a while through reproductions in monochrome than at first hand. This may have been a blessing in disguise, since it permitted certain American painters to develop a more independent sense of color if only by virtue of ignorance or misunderstanding. In any case you could learn more about color, as long as it was only a question of learning, from Hofmann

than from Picasso, Miró or Klee; in fact, as it now looks to me, you could learn more about Matisse's color from Hofmann than from Matisse himself. Among the things most disappointing to many of us in the new French painting that came over here right after the war was precisely its color, wherein we saw even Matisse's example used to enfeeble rather than strengthen personal expression.

Picasso's arabescal manner of the early and middle thirties, with its heavy, flat cloisonnéd colors, was an obsessive influence from 1936 until after 1940, and even later. But Mondrian, Léger, Braque and Gris were also in the foreground. And almost everybody, whether aware of it or not, was learning from Klee, who provided perhaps the best key to Cubism as a flexible, general "all-purpose" canon of style. Abstract and quasi-abstract Cubism (which I see as part of what I like to call Late Cubism, although abstract Cubism had already appeared in the work of Picabia, Delaunay, MacDonald-Wright and others before 1914) reigned at the annual shows of the American Abstract Artists, which were highly important for the exchanging of lessons, and from which some abstract painters learned at least what they did *not* want to do. At the same time Hofmann, in his classes and in a series of public lectures held in 1938–39, reminded us that there was more to high painting than Cubist design. (For myself, just beginning to be able to see abstract art, these lectures were a crucial experience.) Yet no one in the country had such a thorough grasp of Cubism as Hofmann.

Looking back, I feel that the main question for many of the painters I knew was how much personal autonomy they could win within what began to look like the cramping limits of Late Cubist abstraction. And it was as if the answer had to wait upon the full assimilation of Paris. Not that Paris was expected to provide the entire answer, but that New York had to catch up with her and collaborate in delivering it. It seems to me that Miró had become a crucial factor precisely for this reason. His example and method were seen as providing the means to loosen the hold of Picasso's influence and open a way out of Late Cubism—even if Miró himself remained inside it. Matisse's influence, more pervasive and more as general grounding than as direct example, also came into play; to that

influence, artists as different as Pollock and Rothko were to owe their approach to the painted surface as something breathing and open; and the same influence is largely responsible for the specifically Abstract-Expressionist notion of the *big* picture (Matisse's huge *Bathers by a River* of 1916–17, now in the Chicago Art Institute, hung for a long time in the lobby of the Valentine Gallery on Fifty-seventh Street, where I myself saw it often enough to feel able to copy it by heart). On the other hand, Kandinsky's early abstract paintings, which could be seen at the Museum of Non-Objective Art (now the Guggenheim), did not come forward as an influence tangential to Late Cubism until the very end of the thirties. Their liberating effect on Gorky between 1942 and 1944 was analogous to that which they had on Miró some twenty years earlier.

I think that one of the principal differences between the kind of abstract or quasi-abstract art I saw downtown in New York and that being done elsewhere in the late thirties—the difference which helps explain the rise of American art in the forties—was that Matisse, Klee, Miró and the early Kandinsky were being taken more seriously on Eighth Street at that time than anywhere else. We must remember that the last three artists were not really accepted in Paris until after the war, and that all through the twenties and thirties Matisse's influence on Left Bank painting was used more as a depressant than stimulant. By 1940 Eighth Street had caught up with Paris as Paris had not yet caught up with herself, and a number of relatively obscure American artists already possessed the fullest painting culture of their time.

Whether Gorky, Graham, de Kooning, Hofmann or any one else was aware that the problem was to overcome the provincialism that had been American art's historic fate, I cannot tell. But I think the solution was felt to be hovering in the air, even if the problem itself was not fully brought to consciousness. Gorky, who was obsessed with culture conceived of as something European by definition, who constantly revisited the old as well as modern masters, and carried a little book of Ingres reproductions in his pocket—Gorky said once in my hearing that he would be happy if he could but achieve a "little bit" of Picasso's quality. Yet even in such a comparatively stumbling and derivative work as the abstract "still-life"

in the Poindexter Gallery's present show, *The 30's: New York Paintings*, Gorky's art is seen to have already had by 1936 a largeness of ambition and scope that transcends provincialism.[3] Hofmann's attitude, as gleaned from his lectures and what his students reported, seemed a more equable one: culture as such was no challenge to him. I did not see any of his painting until 1944, when Peggy Guggenheim gave him his first New York show, and it would have been hard to surmise at the time that Hofmann's art was still in process of maturing. De Kooning may have sounded as though he were in awe of Paris and culture (all the writers I knew, and I myself, sounded, and were, even more so in those days) but he was already a mature, complete and independent painter by the mid-thirties, and perhaps the strongest and most original one in the country then. His large square picture in the Poindexter show, with its characteristically clear color and large, ironed-out undulations of line and shape, strikes me as the star of the exhibition. It reveals an artist who had nothing more to learn from any one: the first on the American scene to open a really broad and major vein for himself inside Late Cubism; but it also raises the question whether de Kooning's art has gained anything in the way of quality since the thirties—whether it has not, in fact, lost something since then, and especially since it turned "expressionist."

The Poindexter show recaptures a good deal of the past for me personally, but I wish it included examples of what Gottlieb, Motherwell, Newman, Rothko and Still were doing before the 1940's—when I, for one, first became aware of them; I feel that all five of these artists are more important to the future of American art right now than any of those, except Hofmann and Pollock, who are included. For that matter, relatively little in the exhibition points toward either the adventurousness or the "expressionism" of the Abstract-Expressionism we already know. The fault in this respect, however, is not one of omission, the fact being that the best of American painting, busy as it was with learning and assimilation in the thirties, did not, except in de Kooning, show

3. This essay was prompted by the Poindexter Gallery exhibition. [Editor's note]

its enterprising hand until the mid-forties. John Graham's picture, full of Synthetic Cubism and Miró but of an original unity, sounds a note in 1932 that will prevail on Eighth Street throughout the thirties, but fade afterwards. The 1930 Stuart Davis is an admirable, sparkling canvas, but still minor, provincial art on the highest level, working with taste and personal sensibility inside an area long staked out by Paris. And the same applies to the 1938 Cavallon, which is adventurous and successful within limits set by precedent. Reinhardt's collage of 1940 anticipates the kind of brittle Late Cubism done in Paris after 1945, and says much for the sophistication of American painting in 1940, but it is the end of something, not the beginning. And this is true, too, in different ways of the pictures by Burlin (1930), Busa (1940), Kaldis (1939), Kerkam (1939), Krasner (1938), Kline (1937), McNeil (1936), Resnick (1938), Schnitzler (1935), Stella (1932) and Tworkov (1939), almost all of which exhibit great competence. (It is curious to note that every one of the artists here who later came under de Kooning's influence was still whole-heartedly representational in the thirties.)

Those who point clearly towards the forties and "expressionism" at Poindexter's are the late Arthur Carles, Avery, Hofmann and Pollock (there must be some significance in the fact that the first three are the oldest artists present). The quasi-abstract "interior with figure" done by Carles in 1934 is altogether a remarkable work of which one can say, as of the de Kooning, that its originality, despite the evident influence of Matisse, is integral. It is also a very prophetic painting, of an inspired openness of design and color, unknown to any one but Carles at the time, which vividly anticipates the manner in which abstract painting was to rid itself of the Cubist *horror vacui* in the next decade. Carles deserves to be far better known than he now is. Hofmann's large, vibrating *Atelier Table with White Vase* of 1938 is another "open painting," and offers the nearest anticipation in spirit of the "expressionism" in Abstract-Expressionism. One is struck again by the unique authority which belongs to this artist, and which still makes itself particularly felt when his work hangs next to that of others.

The Pollock of 1936, more panel than picture—if such a

distinction is permissible—shows him wrestling awkwardly to open forms that start out as closed and convoluted; but it is already filled with that personal force which became the prime mover of his greatness—and which was also the main reason why no school could form around him. Avery's dark 1938 *Brook Bathers*, despite the great difference in its approach, subject and style, seems closest to the Pollock in essential feeling. It is not, in my opinion, a successful painting, but hindsight enables me to see a good in it that renders the question of success secondary. Matisse's influence is obvious, but turned to ends that have little to do with Matisse, or any other aspect of French art. I was reminded of Arthur Dove, himself influenced, in a large but dim way, by Matisse, but I was not reminded of that in Dove which is owed to Matisse. I also thought of Marsden Hartley, who had had his own Fauve-ish moments, and I became aware of the peculiarly similar thing all three of these Americans had done with the flat shapes and colors of Fauvism, darkening the latter and making them turbid, simplifying the former and making them more abstract. In Avery's case the simplification brings clumsiness with it; the shapes become harder to compose into a unity. The original Fauves drew gracefully and in decorative, exuberant rhythms. Avery's design is stiffened and weighted by a kind of emotion in the face of nature that is not provided for by the modernism of Paris. The result conveys something particularly American, the sense of something large whose expression is thwarted by lack of appropriate rhetorical means. Avery is the special artist he is because he accepts the risk to his art involved in refusing to compromise with means already at hand. Such refusals have been essential to the liberation of American art in our time, but they would not by themselves have sufficed to liberate it from provincialism.

American art has been able to establish its full independence not by turning away from Paris, but by assimilating her. The fate of British art, with its repeated relapses into provincialism in the course of its own effort over the last half-century toward independence, forms an instructive contrast. Americans have no longer had to retreat to Ryder, as the British to Palmer or Blake, in order to get free of Cézanne and Matisse. What has made an important part of this difference is that

New York is second only to Paris as a home for artists born and brought up in other countries. And just as they become French in Paris, so they have become integrally American in New York. Thanks to Gorky, Graham, de Kooning, Hofmann and other foreign-born and foreign-raised artists, American art has been able to make itself cosmopolitan without becoming any the less American thereby. Or to put it perhaps more accurately: international art, which is coterminous with major art, is beginning today to acquire an American coloration.

Art News, Summer 1957; A&C (substantially changed).

5. Picasso at Seventy-Five

Picasso is one of the greatest artists of all time. But do his most extravagant admirers actually say that? To treat an artist as a prodigy of nature whose activity does not brook the weighing, qualifying and comparing proper to criticism is to avoid trying to place his art in relation to other art; it means exalting him as a phenomenon rather than as a master artist. And to refuse to discriminate seriously among his various works and periods is to insure that he remains a phenomenon—one whose work is received not as art, but as something that gets its value from being the product of a phenomenon or of a personality that happens to be a phenomenon.[1] By now Picasso's High Cubism lies far enough in the past for us to see, without risk of being dazzled, that it is one of the great achievements of our tradition of art. And he himself has been on the scene long enough for us to begin to realize that, though his art may be unique in quality, it is not unique in kind, and has its ups and downs like the art of any other mortal. The huge retrospective show at the Museum of Modern Art this past summer in celebration of Picasso's seventy-fifth anniversary practically made a point of showing us this.

Picasso entered art as one of a generation of great painters

1. This is precisely the attitude toward their own work that is attributed—quite wrongly, but with much indignation—to the Abstract-Expressionist painters. [Author's Note]

in or of France, following on several such generations. Some time during the 1920's his art, like that of other eminent painters in his own and even in the previous generation, was overtaken by a crisis. Braque, for whom the crisis came earliest, during the war, half-recovered from it between 1928 and 1933; Matisse came out of it only after the second war; Léger never recovered from it; nor has Picasso yet. On the contrary, Picasso's crisis, which had set in in 1927 or 1928, deepened after 1938, and the Museum of Modern Art show, by concentrating on his production since the *Guernica* mural of 1937, emphasizes the fact.

Picasso has continued to paint successful pictures, and with much greater frequency after 1938 than in the ten years before, but the paradox is explained by the lowering of the terms of his success after 1938, since when he has also painted many, many very bad pictures, many more of them, and much worse, than the well-chosen Museum show would give one to suspect. Before the war the crisis of Picasso's art was mainly one of realization. His development had continued even if it was no longer fulfilled in works of absolute quality. But then he stopped developing, and the crisis turned into one of conception, ambition and level instead of realization or execution. As far as fundamental quality was concerned, the last, and largest, section of the Museum of Modern Art's exhibition was in abrupt contrast to what went before.

Over the twenty-odd years from 1905, the beginning of his Pink Period, to 1926, when his Cubism ceased being High, Picasso turned out art of a stupendous greatness, stupendous alike in conception and execution, in the rightness and consistency of its realization. A radical, exact and invincible loyalty to certain insights into the relations between artistic and non-artistic experience, and into the nature of the fact that they are different, animates everything, no matter how slight. Even the relatively few unsuccessful works of those years at least hint at absolute quality. And the sureness of hand is like a permanent miracle. In 1927, however, the rightness of realization begins to falter for the first time. The first room on the third floor of the Museum show, where almost all the pictures from 1926, 1927 and 1928 were originally hung, reveals this fact almost dramatically. But loftiness and bold originality of conception

remain, and continue to remain in the next two rooms. Only when we arrive at the *Still Life with Black Bull's Head* of November, 1936, does aspiration itself begin to fail; then realization and execution become—if the distinction is possible—superior to conception, which happens only in derivative art. The *Black Bull's Head* "sits right," that is, it is brought off in its own pictorial terms; yet the abstractable formal structure has a blandness and correctness that, instead of enhancing the illustrative intention, negate it. The ominousness and the mystery turn into artiness, and the picture remains no more than nice. Picasso begins to derive from himself. The surprise is gone; now Picasso has begun to "make" art.

Once a master always, to some extent, a master. Every item in the remaining rooms has a certain pungency or at least piquancy. But there are no complete masterpieces, and success never transcends the relative. This relativeness, which is as omnipresent as the pungency, introduces itself into one's reaction to every work. There are losses and there are recoveries of quality after 1938, but it nowhere regains the absoluteness it once had.

The years 1950 to 1953 are a period of weakness and transition, when Picasso, as so often before, resorts to sculpture to work things out. The sculpture turns out to be lamentable, but the paintings get better again, much better in 1954, and in 1956 there is a kind of new blossoming under Matisse's influence (which Picasso seems ready to accept with pastiche-like fidelity now that Matisse is dead); yet everything continues to be the work of an artist who has stopped developing. It is not that Picasso has become perfunctory or facile; on the contrary, since the thirties he seems to distrust his facility and its promptings as never before, and consciously to avoid anything like easy or suave effects. Yet this only induces perverseness, and he too deliberately—for the sake of effect rather than of cause—makes things ugly, crabbed or clumsy. Under all its changes of theme and manner, and under all its superlative craft, Picasso's art become repetitious, and the artist, in spite of himself, a virtuoso who seeks happy contrivances rather than inspired solutions. The plenitude and exhilaration that used to come from the least thing he turned his hand to are gone. A

kind of excitement remains, and will remain, but it is not exactly the kind which animates major art.

Little in what Picasso has done since 1938 tells the professionally concerned eye anything it does not already know from his previous work. In the thirties his art still remained abreast or even ahead of advanced art in general. The contradictions and frustrations, as well as the ideas and inventions, in which it abounded then have proven more directly fruitful for younger artists with major ambitions than the more exalted and perfect works which Mondrian was producing so steadily during most of the same period. And the few things Picasso did bring off in the thirties he brought off absolutely, even though, aside from the wrought-iron sculpture of 1930 and 1931, none of them are major in format: I think of the little Henry P. McIlhenny *Bullfight* of 1934, and of the series of drawings in a kind of *Fraktur* style—for me the swan song of his greatness—that he did in the spring and summer of 1938.

No doubt the course of culture in our time has had much to do with Picasso's decline: the waning of the halcyon modernism of 1900–1925 had perhaps in the nature of things to be his too. And it would seem that no more than twenty years or so of absolute realization, whether consecutive or intermittent, have been granted even the greatest of painters since Ingres and Delacroix. Even so, whereas the Impressionists and Post-Impressionists, including Cézanne and Matisse, could in their best years realize fully only one work in several, Picasso during the twenty-odd years of his prime was able to realize almost everything he turned his hand to. And though the same can be said of Mondrian from 1914 to 1936, his production was not as varied, nor did it include sculpture. One can see the justification for treating Picasso as a prodigy. But when we recognize that he is not one we appreciate his achievement all the more, and perceive more clearly the largeness of the inspiration and talent that went into it.

Until the middle of the twenties Picasso seemed to know by instinct how to lead toward his strengths and capitalize upon his weaknesses. Then, apparently, he lost his certainty. The first picture that really bothers one in the Museum of Modern Art exhibition comes before 1927, in 1925, and is the striking *Three Dancers*, where the will to illustrative expres-

siveness emerges ambitiously for the first time since the Blue Period. It is not at all, in this Cubist painting, a question of the artist satisfying his inveterate appetite for sculptural volume as in his previous Neo-Classic works, where what is illustrated remains a relatively pure object of vision amid all the archaic allusions. Now illustration addresses itself to nature, not in order to make art say something through it, but in order to make nature itself say something—loudly and violently. This picture goes wrong, however, not because it is literary (which is what making nature speak through art means), but because the placing and rendering of the head and arms of the middle figure cause the upper third of the canvas to wobble. Literature as such has never yet spoiled a work of pictorial art; it is literary forcing which does that.

Surrealism made its first formal appearance in Paris the year before the *Three Dancers* was painted. At that time the *avant-garde* seems to have been losing its prewar confidence in the charge that lay in the impassive rightness of color and form. And there was perhaps a feeling among the artists who had come up before 1914 that it was time to declare more unmistakably their filiations with the past—as if Dada, with its claim to reject the aesthetic, now threatened to compromise all of modernism and deprive it of its rightful place in the continuity of as art (which fear, as I have already suggested, was somewhat justified). At the same time there was the contrary feeling on the part of some other, generally younger artists that the past had to be more forcefully repudiated than ever, and that the best way to do so was to parody it. Picasso, ever sensitive and receptive to the currents around him (being in this sense among the least independent of artists), began apparently to think in art-historical terms more than ever before, and to hanker for a "grand," epic, museum manner. This hankering makes itself felt in his projects for monuments and for other kinds of sculpture, in his Cubist treatment of the hitherto un-Cubist theme of artist and model, in the studies he made for a *Crucifixion* in 1929 and 1930, and in various other things he did at that time.

It could be said that it had to be either the grand style or minor art for Picasso once he had abandoned Cubism. But has he really been anything other than a Cubist since 1907? Cubist

simplifications underlie his Neo-Classicism and all the excursions into quasi-academic naturalism he has made since Neo-Classicism, and his arabesqued, "metamorphic" manner of the early thirties and his handling of *Guernica* are as fundamentally Cubist as the more obvious neo-Cubism he has embraced in the years since. What Picasso has been trying to do since 1926 is not so much find or invent a grand style as turn Cubism into one—a grand style full of *terribilità* like Michelangelo's, but developed inside the shallow space of Cubism and adapted to its rather evenly rectilinear and curvilinear cleavages. Being, however, a "grand style" in its own right, Cubism cannot be brought closer to the museum idea of one without being travestied and caricatured—and this is approximately what one sees being done in such later paintings of Picasso's as the *Night Fishing at Antibes* of 1939, the *Korean Massacres* of 1951, and the *War and Peace* of 1952. One also sees Cubism being mocked in pictures like the 1950 *Winter Landscape* and the 1951 *Chimneys of Vallauris*, both of which are just a little absurd, despite the crispness of their handling. (I have a feeling that the future will see a lot more that is funny in Picasso's later production than we do.)

Like any other real style, Cubism had its own inherent laws of development. By the late twenties these all seemed to be driving toward greater if not outright abstraction. Mondrian drew the extreme and final conclusions, but Miró, especially between 1925 and 1930, was able to produce art of a revolutionary and substantial originality by sacrificing only the integrity of nature, not nature as such. It is Picasso's double insistence on the schematic, diagrammatic, factual integrity of every image he gets from nature—and he gets every image from nature—and on a minimal illusion of three-sided space, that begins in the thirties to inhibit the abstract or decorative fulfillment of his painting. With his new will to expressiveness, he makes it almost a matter of doctrine to shun a "purely" decorative unity, even where he loads the picture with decorative space-fillers. Yet the distinction between the decorative and the pictorial had by that time been deprived of its traditional force by Matisse and by Picasso's own Cubism. Matisse, who remained to the end as dependent on the alphabet of nature as Picasso has, was able in the last years of his

life to arrange leaf motifs in huge, apparently sheerly decorative panels that are as great as *pictures* as anything done in Europe since the thirties. Picasso, in trying to turn decoration against itself, in the end succumbs to it.

His effort before *Guernica* seems to have been to make decorative flatness transcend itself by an illustrative unity. The flat-patterned curvilinear paintings of the female figure he did in the early thirties have a sort of ornamental power, but had he taken more liberties with nature they would perhaps have had more than that. The ornamental or decorative treatment of the human physiognomy generates rococo associations by now that no amount of formal rightness seems able to overcome; and in Picasso's, as in Matisse's, later painting, it is no accident that full success comes much oftener, on almost any level, where the subject tends to be more "humanly" indifferent, as with the still life, interior or landscape, and that there is usually a better chance of success when the human visage is suppressed.

Guernica was obviously the last major turning point in Picasso's development. With its bulging and buckling, it looks not a little like a battle scene from a pediment that had been flattened out under a defective steam roller—in other words, as if conceived within an illusion of space deeper than that in which it was actually executed. And the preliminary studies for *Guernica* bear out this impression, being much more illusionistic in approach than the final result: particularly the composition studies, two of which—done in pencil on gesso wood on May 1 and 2 respectively—are much more convincing in their relative academicism than the turmoil of blacks, grays and whites in the final version. It is as if Picasso took the hint, for in 1938 he overhauled the formal machinery of his art in an attempt to loosen Cubist space. Since then he has generally kept the background more clearly and academically separated from the things in front of it, and tended to compromise between the distortions motivated by expression and those compelled by the pressure of shallow Cubist space. The very fact that such a compromise has been made signifies that Picasso's art is in crisis. Where art is sure of itself, formal discipline and expression operate as one—as much in Rembrandt as in Mondrian.

Now the Cubist elements are added decoratively and do not

come with the impulse of the picture. Decoration transcends itself when the vision of the artist is decorative, but not when it is only his technique that is. Picasso's technique in so far as it remains Cubist has become largely decorative, and the decorativeness has become a cramping instead of liberating factor. One gets a sense of the picture rectangle as something into which the picture is jammed, neatly or not as the case may be, but always with an excessive application of will. This is true even of the large black and white *Kitchen* of 1948, which is the most adventurous as well as most abstract work of Picasso's that I know of since a series of untitled dot and line drawings—to which *The Kitchen* itself is not unrelated—done in 1926. It is certainly the most interesting of the post-1938 paintings in the Museum show, and perhaps the best; and not simply because it is the most abstract, but because the extreme liberties it takes with nature are imaginative liberties that make themselves felt in the originality and free strength of the design. Even so, there is a slightly disturbing heaviness and deliberateness in the line—and it is all line; and the tightness with which the frame grasps the four sides gives it a boxed-in, over-enclosed and over-controlled effect.[2] It is as if all the marks and traces of immediate creation had been edited out of the picture in order to make it a more finished *object*.

Here I believe we have another clue to what is wrong with Picasso's recent art. Modernist painting, with its more explicit decorativeness, does call attention to the physical properties of the medium, but only in order to have these transcend themselves. Like any other kind of picture, a modernist one succeeds when its identity as a picture, and as pictorial experience, shuts out the awareness of it as a physical object. But when the means of art becomes too calculable, too sure, whether in conception or execution, and too little is left to spontaneity, then that awareness re-emerges. Picasso is as conscious of this problem as anyone has ever been, but he cannot, apparently, help himself any more because he is committed to a certain notion of picture-making in which nothing remains

2. *The Kitchen* reminds me in more ways than one of the "pictographs" Adolph Gottlieb used to do, and it is reported that Picasso was much struck by reproductions of these he saw in 1947. [Author's Note]

to be explored, in which everything has been already given. Here spontaneity—or inspiration—can no longer play a real part in the unifying conception of a picture, and is confined to nuances, the trimmings of minor elaborations. The picture gets finished, in principle, the moment it is started, and the result becomes a replica of itself. With the idea of replica there comes the idea of craftmanship, and with that, the idea of *object*, and of the polish and finish of a finished object. The eye makes these associations instantaneously. Finish is always something expected, and the expected belongs more to the handicrafts, to joinery and jewelry, than to fine art.

Aside perhaps from *The Kitchen*, the best of Picasso's post-1938 paintings in the Museum: the beautifully Matissean *Woman in Rocking Chair, The Studio* and *Woman by a Window* of 1956; the almost great Lam-like version "L" and the solidly Picassoid version "N" of the 1955 *Women of Algiers, after Delacroix*; the gouache *Pastoral* of 1946—all of these items shine with a brilliance that connotes craft more than art. They are picture-objects rather than pictures. (Which is also, incidentally, what the best of Léger's and Braque's later pictures are.) And the compromising faults in other post-1938 paintings that just fail of success are faults that pertain to picture-objects and craftmanship rather than to pictures or art: thus the unfortunate reds in the *Woman in Green* of 1943, the cartoon-like obtrusiveness of the profiled head of the seated figure in the *Serenade* of 1942. Picasso's earlier works cannot be taken apart so easily . . .

Picasso has, or had, the endowment of a great sculptor, and he has produced some of the greatest as well as most revolutionary sculpture of the century. To have held on to nature with the diagrammatic fidelity he has since 1927 would perhaps have cost him less in quality had he thrown the weight of his production into a less illusionistic medium than painting. Perhaps the decision did hang in the balance for a while. Daniel-Henry Kahnweiler says (I quote from Elgar and Maillard's *Picasso*): "In 1929 he was thinking of huge monuments which could be both houses for living in and enormous sculptures of women's heads, and which would be set along the Mediterranean coast; 'I have to be content with painting them, because nobody will give me a commission for one,' he tells

me." Picasso never did become a full-time sculptor, but his hankering for the grand style had its effect on his art in that medium too. After 1931 he abandoned construction almost entirely for modeling and the monolith; and ten years and more after they first entered his painting, archaicizing tendencies likewise entered his sculpture (which perhaps has something to do with the fact that he remained a completely great sculptor longer than he did a completely great painter). During most of the thirties his work in the round was as fertile in ideas and inventions as his painting, and has had an equally lasting influence. Then, like his painting, his sculpture dropped suddenly and even further in level.

Just as Picasso has rarely been able to use color positively in his pictorial art and lacks feeling for the matter of paint, so in his sculpture he has always lacked feeling for surfaces. But just as he was able, when he wanted to, to make color serve his purpose negatively, so he was able in his sculpture to obviate his lack of tactile sensitivity by "drawing in air" and making constructions. Only when he began to aspire to sculpture on the antique model and to positive color à la Matisse did he begin to lead consistently to his weaknesses instead of strengths.

Maybe he succumbed to the myth of himself that his admirers created—the myth of the artist who could do anything, therefore was not entitled to his weaknesses, and who decided of his own accord what at any moment was modern and major. Maybe he would have become as old-fashioned as he now is no matter what he had done. Picasso, though less a prisoner of his first maturity than most people tend to be, remains one nevertheless—certainly more of one than Matisse was. *Time* reports that "He believes a work should be constructed, is distressed by the work of many abstract expressionists, once grabbed an ink-stained blotter, shoved it at a visitor and snapped 'Jackson Pollock!' " Forty years ago those who objected to Picasso's work said that it was not "disciplined," which means about the same thing as "constructed." As if anything that were not "constructed" or "disciplined" could be called even bad art.

Arts Magazine, October 1957; A&C (substantially changed).

6. Introduction to an Exhibition of Adolph Gottlieb

Hardly another among the ten or so American painters who came up during and after the war to take the lead away from Paris has continued in recent years to develop as vigorously as Adolph Gottlieb has. Until about six or seven years ago—when he triumphantly broadened, before relinquishing forever, the "pictograph" style that had become his signature—he seemed a rather narrow if tremendously competent painter. Since then he has become the most adventurous artist in the country: as much so in his readiness to look old-fashioned as in his commitment to innovation. Because being identified with a consistent, recognizable manner seems necessary to an artist's acceptance nowadays, this may have cost him some popularity. Gottlieb is far from being an overlooked artist,[1] but he has become more and more of one for whom no ready-made categories of appreciation are available. The immediacy and diversity of his art leaves the art public at a loss for a "correct" reaction; nothing augurs better for the future of his reputation.

The very abundance of Gottlieb's powers has perhaps impeded him in the quest of his particular, most personal ones; his weaknesses are not evident enough to send him straight toward his indisputable, unique strengths. So thoroughly does he possess every technical resource of his art that he could, conceivably, astonish our eyes in any of the going, accepted ways of abstract or, for that matter, representational painting. He could be a great virtuoso. But that would be something less than a great artist. Gottlieb is not interested in that kind of success; or in making pictures that enough people will like. He is out for himself. What makes him the artist I watch with special and concerned attention—and with an interest automatically reserved for major art—is the fact that, at his age, with the achievement already to his credit, and with his equipment, he continues to seek himself with such an utter humility and daring.

1. Prior to 1957 Greenberg himself had written often about Gottlieb, and in 1954 he had organized an exhibition of Gottlieb's paintings for Bennington College, Vermont. [Editor's Note]

Fate plays little tricks on those whose preoccupation with success is not instinctive. Gottlieb has thrown off ideas in passing that others have improved and built upon. When the late Bradley Walker Tomlin set out in 1948 on the all-over, "abstract expressionist" style for which he is now mainly (and too exclusively) known, its derivation from a few pictures Gottlieb had done shortly before, in which small ribbony forms were scattered over an indeterminate background, was patent to those on the spot (as I myself happened to be). Nor did Tomlin then make any bones about his admiration for Gottlieb's art. But when Gottlieb returned to his "ribbons" for a short while some two or three years ago one heard and read in many different quarters that he had been influenced by Tomlin! And no actual mention is made of Gottlieb's decisive influence upon the course of Tomlin's art—a fact of the highest importance to an understanding of its place in recent American painting—in the catalogue for Tomlin's commemorative show at the Whitney Museum this fall. I bring this up not in order to reflect on Tomlin, but to set the record right—and to illustrate. (Picasso himself, when he saw reproductions of Gottlieb's pictographs in 1947, is reported to have been much struck by them; and they do seem to have influenced his large *Kitchen* of 1948).

I think Gottlieb's later pictures to be his best. They are not the first in which he touches greatness, but they are the first in which there is the sense of a break-through on a wide front. They no longer cross the t's and dot the i's of an assimilated handwriting; they are more self-evidently products of the momentum of inspiration. There was a time when Gottlieb strove consciously against French influence; that issue has disappeared, and now New York influences Paris. Nor, in his very last pictures, does the notion of finish, of a solid completeness, preoccupy him as much as it used to. Clarity and distinctness of parts, lucidity and forthrightness of design remain among the signal virtues of Gottlieb's art, but they have become compatible with a looser, opener structuring of space. The staccato of the flat disks that rise into clear space above the ambiguous horizons of the "Imaginary Landscapes" gave our habits of seeing a jar from which many eyes have not yet recovered. The single, percussive red ball that bounces into narrower space above a disintegrating earth mass in *Burst* deals an even greater

shock. What makes such a picture difficult—difficult in the best sense—is its monumental simplicity, which seems more than the conventions of easel painting can tolerate. It is these conventions, in their present frailty, that are at stake in Gottlieb's latest art. They no longer suffice to contain major painting, and that kind of painting in which we feel this strongly has become the only kind which deserves to be called ambitious. The future will appreciate this better than we can.

In a sense, Gottlieb has only begun to show his hand. *Burst* is a masterpiece, but he will do still better. There is also his color. Who else in recent years has been able to attain such an effulgent richness without going off the deep end into confectionery? Yet it is from Gottlieb's color, and his handling of paint texture, that I still await some even less precedented, even more eye-shaking revelation, something utterly unforeseeable and explosive. The centrifugal movement that emerged in his last, large pictographs has been gathering impetus in his work of the past two years; now color, too, thrusts outwards. But his color has yet to shock us to the same extent as his syncopated design or total image. When it does Gottlieb will have discovered and realized the full measure of himself, and that full measure, the hints of which have already had an unsettling effect, will astound us.

Gottlieb has done more than enough by now to assure his place in the art of our time. If I dwell on his present and future it is because his continuing development provides, to a superior degree, that excitement of which art as an unfolding activity, not as a finished result, is alone capable. His art, as it creates itself from moment to moment, through success, and through failure, offers an experience we cannot get in museums. It is the kind of experience that the future usually envies the past for—because the present usually waits for the ratification of original art, and for the artist himself to finish developing, before it begins to interest itself in the activity that produced the art. The Jewish Museum has not waited, and I congratulate it for that.

I also dwell on Gottlieb's future because he is one of the handful of artists on whom the immediate future of painting itself depends. He is far more alone as an exploratory artist than he was ten years ago, and he is at the same time more of

an explorer than he was then. He is among the very few artists left in New York whose work I can go to in the confident expectation that my sensibility will continue to be challenged and my taste to be expanded. The very difficulty of his art, and that it increases in difficulty, attests to the fact that the heroic age of American art is not yet over.

An Exhibition of Oil Paintings by Adolph Gottlieb, Jewish Museum, New York, November–December 1957; *Adolph Gottlieb*, ICA Gallery, London, England, 1959; *Adolph Gottlieb*, Galerie de la Rive Droite, Paris, 1959 (in French).

7. Milton Avery

Milton Avery reached maturity as an artist in the days of the American Scene movement, when there was so much talk about the need for an art that would concentrate on American life and shun esoteric influences. Avery set his face against all this, yet the atmosphere such talk created may have helped confirm him in his acceptance of himself. However misguided and obscurantist the American Scene tendency was, it did urge in principle that the American artist come to terms with the ineluctable conditions of his development, and remind him that he couldn't jump out of his skin. It did prepare for the day when the American artist would cease bewailing the fact that he lived in America. Avery had, in any case, started off from American art before the American Scene movement was heard of, looking harder at Ryder and some of the American Impressionists than at any French art. And when he did go on to assimilate French influences the outcome was still some of the most unmistakably and authentically American art that I, for one, have seen. Avery's painting cannot be discussed without emphasizing its Americanness.

Avery himself would be the last to find any aesthetic merit in Americanness as such. If his art is so unmistakably American, it is because it embodies so completely and successfully the truth about himself and his condition—not because he has ever made an issue of his national identity. And it may also be because his modernism was developed to such a great extent,

relatively, within a non-European frame of reference. There are, moreover, different kinds of Americanness, and Avery's may be more readily identifiable than the others simply because it had less of a chance before the advent of Fauvism to be expressed in ambitious and sophisticated painting.

Frederick S. Wight (in his text for the catalogue of Avery's retrospective at the Baltimore Museum in December, 1952) put his finger on one of the salient traits of Avery's painting: its insistence on nature as a thing of surfaces only, not of masses or volumes, and as accessible only through eyes that refrain from making tactile associations. Avery's attitude is the opposite of what is supposed to be the common American one toward nature: he approaches it as a subject rather than object; and one does not manipulate or transform a subject: one *meets* it. A similar attitude no doubt can be found in Far Eastern art and in some phases of landscape painting in Europe. What is specifically American, I feel, in Avery's case is his employment of abstract means for ends that, however subtly naturalistic, are nevertheless intensely so. This is something I also find in four other American painters who belong to twentieth-century modernism: Dove, Arnold Friedman, Hartley and Marin. And it is significant that, with the exception of Friedman, all these Americans found the form of modernism that was most congenial to them in Fauvism.

But while the original Fauves, in France, would, where they could, sacrifice the facts of nature to an inspired decorative effect, the Americans tended to let the decorative effect go when it threatened to depart too much from the facts. For it was in the facts primarily that they found their inspiration, and when they didn't find it there they would fall into artiness. There was a certain diffidence in this: unlike Matisse, they did not proclaim themselves sovereigns of nature; but there was also a certain courage: they stood up for the truth of their own experience, no matter how intimate, modest or unenhance-able. All this applies to Avery, and to him especially— although as closely as he may skirt artiness, he has never quite fallen into it, in which respect he is more like Friedman than any of the other three. As much as he simplifies or eliminates, Avery preserves throughout something of the specific, local, namable identity of his subject, whether landscape or figure;

it is never merely the pretext for a picture, and art is never for him the excessively transcendent issue it too often was for Hartley and Marin.

There is no glamor about Avery's art; it is daring, but not emphatic or spectacular in its daring. This has to do in part with his stylistic means—the absence of pronounced value contrasts and of intense, saturated color; the thin neutral surface that displays no "paint quality" or brushwork—but it also has to do with his own temperament. Some of the diffidence with which he approaches nature is reflected in his approach to art itself. Fifteen years ago, reviewing one of Avery's shows at Paul Rosenberg's, I admired his landscapes but devoted most of my space to the derivativeness of the figure pieces which made up the bulk of the show.[1] If at the time I failed to discern how much there was in these that was not Matisse at all, it was not only because of my own unperceptiveness, but also because—as it now seems to me—the artist himself contrived not to call enough attention to that which was his and no one else's.

I still quarrel with most of Avery's figure pieces, but for different reasons now. Too often their design tends not to be total enough; the figure is not locked securely in place against the blank background; and for all the inspired distortion of contour, factual accidents of the silhouette will break through and, given the flatness with which everything is rendered, create an effect of patchwork. It is as though Avery had trouble handling displaceable objects and could best maintain the integrity of the place surface when depicting things that had grown into the places they occupied and which interlocked of their own accord into both foreground and backdrop—in short, the landscape. Not that he has not done some splendid figure paintings from time to time (among them the monumental *Poetry Reading* in his last show at Borgenicht's), but I do see him far more often at his highest and broadest and strongest in his landscapes and seascapes.

It is very difficult even to begin to account for the quality of the best of these. Many stylistic parallels could be found in

1. The review appeared in *The Nation* (13 November 1943); it is republished in vol. 1, 50. [Editor's note]

the work of other artists—Matisse, Dufy, Hartley (who was toward the end influenced himself by Avery), even Marin—but the result is always and altogether Avery's own. It is not a question of technique or even of style in the ultimate sense; nor is it one of sensibility or taste—when art is strong enough it creates taste and defines sensibility *post factum*. It is a question rather of the sublime lightness of Avery's hand and of the morality of his eyes: their invincible and exact loyalty to what they alone experienced. It has to do with *exactly* how Avery locks his flat, lambent planes together; with the *exact* dosage of light in his colors (which all seem to have some admixture of white in them even when applied as they come from the tube); with *exactly* how he manages to keep his pictures cool in key even when using the hottest pigment; with the *exact* way in which he infuses warm colors with coolness, and vice versa; with *exactly* how he inflects planes into depth without shading—and so on *ad infinitum*. Of course, all successful art brings us up against the mysterious factor of exactness, but it operates to an unusual extent in Avery's case.

Nature is flattened and aerated in Avery's landscapes, but not deprived in the end of its substantiality—which is restored to it as it were by the substantiality and solidity of the picture itself as a work of art. The painting floats, but it also coheres and stays in place, as tight as a drum and as open as light. Through the unreal means most proper to pictorial art—the flat plane parallel to the surface—Avery is able to convey the integrity of nature more vividly than the Cubists could with their own kind of emphasis of the flat parallel plane. And whereas Cubism had to eventuate in abstraction, Avery has continued to develop and expand his art without abandoning the description of nature. He is also one of the very few modernists of note in his generation to have disregarded Cubism almost entirely. It would be hazardous to say that he has not been affected by it any way, but it certainly has had no real part in the development of his art, and he has flouted the Cubist canon of the well-made picture almost as much as Clyfford Still has. This explains some of the exemplary significance Avery's work has had for the recent anti-Cubist trend of abstract painting in this country.

Like all the other modernist reactions against Impression-

ism except Cubism, Avery's Fauvism has served but to draw Impressionism's further consequences. His art is another, extremer vision of a world from which sculpture and all allusions to it have been banished, and where things exist only optically. But Avery's painting is marked off from Matisse's as well as from Monet's by its more explicit rejection of the decorative—a rejection that is given its particular, crucial point by the fact that the elements of Avery's style are so very decorative in themselves. Decoration is the specter that haunts modernist painting, and part of the latter's formal mission is to find ways of using the decorative against itself. It is as though Late Impressionism and Fauvism have come on the order of the day again precisely because, being so much more anti-sculptural and therefore inherently decorative than Cubism, they sharpen the problem by increasing the tension between decorative means and nondecorative ends.

Matisse and the later Monet overcame decoration by dint of the monumental. They established scale as an absolute aesthetic factor. Avery has never considered this solution, apparently because it would take him too far away from his conception of nature, which can be grasped only through the easel, not the wall, picture. A large picture can re-create the instantaneous unity of nature as a view—the unity of that which the eyes take in at a single glance. In my opinion, this, even more than their revulsion against the academic "machine," accounts for the size of canvas (averaging two feet by one and a half) that the classical Impressionists favored. Avery, though using much more decorative means and not painting from nature on the spot, but from penciled or watercolor sketches (always much more conventionally realistic than the pictures that result from them), is moved by a similar naturalism, and it is this that he invokes against the decorative.

The younger, abstract painters who admire Avery and have learned from him do not share his naturalism, but they see in his paintings how intensity and truth of feeling, no matter what its source, can serve to galvanize what seem the most inertly decorative elements—tenuous flatness; pure, valueless contrasts of hue; large, "empty" tracts of uniform color; rudimentary simplicity of design; absence of accents—sheer, raw visual substance—into tight, dramatic, almost anecdotal uni-

43

ties with the traditional beginnings, middles and endings of easel painting. His example shows them how relatively indifferent the artist's concrete means become once his formal training is finished, and how omnipotent is the force of feeling, which can body nature forth with the abstractest elements, and compel decoration to overcome and transcend itself by its own means.

Avery's latest landscapes, done in Provincetown this past summer, attest to a new and more magnificent flowering of his art. They were scantly and one-sidedly represented in his show at Borgenicht's. But then Avery has always been served badly by his exhibitions, which tend to reflect the inadequacies of his dealers rather than those of his art. To know his work in all its considerable range and variety, one has had to see it in his studio. This may explain, in part, the unevenness of his reputation. Painters and even collectors have paid more attention to him than critics or museum people. I feel that not only should he be shown better, but that he should be shown in larger quantity. It is time he were given a full-scale retrospective by a New York museum, not for the sake of his reputation, but for the sake of the situation of art in New York. The latest generation of abstract painters in New York has certain salutary lessons to learn from him that they cannot learn from any other artist on the scene.

Arts Magzine, December 1957; A & C (substantially changed).

8. Jackson Pollock

Jackson Pollock was born on January 28, 1912, in Cody, Wyoming, the youngest of five sons of Le Roy and Stella (née McClure) Pollock. His father, who was first a farmer and then a surveyor, had been born Le Roy McCoy, but took the name of Pollock from the family by which he was adopted as a child. (He died in 1933.) In 1915 the Pollocks moved to Arizona, and from there, in 1918, to Northern California, then back to Arizona in 1923, and finally to Southern California in 1925.[1]

1. The emphasis in this article on dates and matters of fact may reflect

44

Pollock became interested in art during adolescence, following the example of his oldest brother, Charles, a painter who now teaches at Michigan State College. He studied art at Manual Arts High School in Los Angeles (where one of his classmates was Philip Guston) with the intention of becoming a sculptor, but soon changed to painting. (Sculpture haunted him to his last days, though he made but few and desultory attempts at it in his maturity.) Leaving high school without graduating, Pollock came to New York in 1929 to study under Thomas Benton at the Art Students League, where he continued until 1931. He made several trips back to the West before 1935, but from then on lived more or less permanently in New York. From 1938 to 1942 he was employed on the Federal Art Project as an easel painter.

Pollock's work was first seen by the New York public in 1940, in a group show of French and American paintings organized by John Graham and held at the McMillan Gallery. Among the other Americans included were Willem de Kooning and Lenore (Lee) Krasner, a former student of Hans Hofmann's. She first met Pollock on this occasion, and they were married in 1944, but even before their marriage her eye and judgment had become important to his art, and continued to remain so.

In 1943 Pollock's work caught the attention of Peggy Guggenheim and her associate, the late Howard Putzel, and in November of the same year his first one-man show was held at their Art of This Century Gallery on West 57th Street. Miss Guggenheim's and Putzel's confidence in him showed itself in the form of a contract for his production that was renewed annually until the end of 1947, in which year Miss Guggenheim closed her gallery and returned to Europe. In 1946 the Pollocks were able to move out to Springs, near East Hampton on Long Island, and buy a house there.

He had a one-man show every year between 1943 and 1953: at Art of This Century until 1947; at the Betty Parsons Gallery from 1948 to 1951; and at the Janis Gallery in 1952 and 1953. His first retrospective was put on at Bennington and

Greenberg's current preoccupation with the preparation of a critical biography of Pollock—a project he subsequently abandoned. [Editor's note]

Williams colleges in 1952, his second at the Janis Gallery in 1954, and his third in 1957, after his death, at the Museum of Modern Art. A fourth retrospective, organized by the Museum of Modern Art, was presented at the 1957 Bienal in Sâo Paulo, Brazil, and is now travelling in Europe. His first one-man show in Europe was held in Paris in 1952 at the Galerie Michel Tapié, Studio Paul Facchetti, and the same works were shown in the following year at the Kunsthaus in Zurich. Although the Museum of Modern Art and the San Francisco Museum of Art acquired Pollock's work early on, his first sales in appreciable quantity came only in 1949 and 1950. Another lean period followed during which purchases by Alfonso Ossorio, a fellow-painter, helped ease an otherwise trying situation, and it is only since 1952 or 1953 that Pollocks have been in steady demand.

Pollock produced relatively little during the last three years of his life. On the night of August 11, 1956, he was killed in an automobile accident. He was buried in Springs cemetery in accordance with a wish he had expressed some time before.

Evergreen Review 1, no. 3, 1957; *Macula* 2, 1977 (titled *"Biographie"*).

1958

9. Letter to the Editor of *Evergreen Review*

To the Editor:

Miss Peggy Guggenheim and Mr. Charles Pollock (oldest, not next oldest) brother of Jackson have written to me to correct certain errors in my note on Pollock in *Evergreen Review*, vol. I, no. 3.

Miss Guggenheim writes: ". . . Pollock's first European one-man show was given. . . . by me in Venice in 1950 at the Sala Napoleonica, which is part of the Correr Museum . . . opposite San Marco . . . There were twenty-three of my paintings in it, from the end of July to the middle of August. Afterwards part of them were shown in Milan at the Gallery Naviglia in another one-man Pollock show. In 1953 a selection of [my Pollocks] . . . were lent by me to the Kunsthaus in Berne for their show."

Mr. Pollock writes: "The [Pollock] family left Cody in 1912, stopping first for some months in San Diego . . . I am sure . . . we must have been [in Arizona] earlier than 1915 . . . Jack arrived in New York for the first time in the late summer of 1930 [not 1929]. Frank and I had driven west in a 1924 Buick. Jack decided to return with us."

I would appreciate the publication of this letter. Not that I wish to magnify the importance of every detail of Jackson Pollock's life, but I would not like to see errors of fact, no matter how unessential, become current because of their appearance in a note like mine, which was designed to give nothing but facts.

Clement Greenberg
21 February 1958

Evergreen Review 2, no. 5, 1958

10. At the Building of the Great Wall of China

China acquired a special place in Kafka's imagination as the image of a vast yet isolated continuity in space and time; as a vision of swarming, anonymous generations that succeeded each other in time eddying outside history; and as the idea of a highly unified social entity whose geographical parts were nevertheless remote from one another and from their common center. Thus China became the name of Kafka's figure of speech for Diaspora Jewry.[1]

The Great Wall, being interpreted, stands on one level of meaning as the "fence" of Jewish Law, or Torah, which the rabbis themselves referred to as a fence or a wall. Their Law protects the exiled Jews not only from the profane, but from history—Gentile history, which is the only kind there has been since the destruction of the Second Temple. Gentile history, because it tends to no Jewish solution, remains meaningless vicissitude, without place or interest for the genuinely human.

Like Jewish Law, the Chinese Wall has come into being discontinuously. The Law is supposed to provide for every contingency, but contingency is infinite; hence the Wall, which can never be more than finite, must remain forever incomplete and vulnerable. For this reason there is a "legendary" uncertainty as to whether the Wall has been really finished. Though the narrator expresses skepticism about this uncertainty, it is only enhanced by the somewhat inconsistent indications of time he himself gives in his essay. The narrator passes his last examination in primary school at the age of twenty, just when the Wall is being started; the work of building it "could not reach completion even in the longest lifetime," yet at the moment of writing it appears to be long finished—why else express skepticism as to the rumors that it is still incomplete?

"Fifty years before the first stone was laid" all China is set to studying the art of building, and especially bricklaying. Similarly, all Jewry was set to the studying of the Law and the

1. This is the last of Greenberg's three essays on Kafka. The first was published in 1946, the second in 1955. During the 1940s, Greenberg also translated Kafka from the German (see bibliography). [Editor's note]

sharpening of logic years before Torah replaced Palestine as the Jewish homeland. As China had its surplus of architects and masons, so Jewry came to have its surplus of logicans; yet without an over-supply of "technicians" and the patient, circumscribed toil to which they could be made to submit, the fence of the Law could not have been raised to such an imposing height, nor could such large areas of life have been embraced within it.

The Chinese in the southeastern provinces, where the narrator lives, "almost on the borders of the Tibetan Highlands," do not really need the Wall because their remoteness suffices to protect them from the northern nomads. But this remoteness also protects them from history, or deprives them of it, because history is made in Pekin, likewise in the far North—the North being the scene of history in general: sacred history in the capital, Pekin, and profane history among the nomads along the frontier. Pekin vibrates with many meanings: the "high command" is seated there, at the feet of the Emperor, here a symbol for God, or for one who, like a high priest or prophet, is in direct communication with God. So vast is the land and the spread of time over it that the Chinese in the South, like the Jews in their exile—or like humanity itself islanded in sense experience and rationality—can have no knowledge of either the historically or absolutely contemporary. They live according to laws and decrees handed down thousands of years before. No wonder faith has become weak in the South, and at the same time very rigid. "There is perhaps no people more faithful to the Emperor than ours in the South, but the Emperor derives no advantage from our fidelity."

Israel, outside history in the Diaspora, marking time until profane history runs its haphazard course, is of little service to the God of History who is Jehovah. In the beginning, Israel was commanded to turn away from Nature, whose time is heathen because repetitious, and to seek salvation and solution in irreversible, teleological, historical time. But with the loss of Zion, the Jews lapsed from history to live solely in the Law, which became a man-made but equally repetitious substitute for Nature, reviving in even intenser form the circularity of heathen, mythical time that it was supposed originally to

overcome. This it did by perpetually celebrating and retelling the incidents of a chapter of history long over and done with. "Long-dead emperors are set on the throne in our villages, and one that only lives in song recently had a proclamation of his read out by the priest before the altar. Battles that are old history are new to us, and one's neighbor rushes in with a jubilant face to tell the news." Thus Israel, which had discovered history, became in the Diaspora the ahistorical people par excellence, more fanatical and petty in its conservatism than any earth-rooted peasantry.

Kafka constantly chides the Jews for their abandonment of history. He is aware that they did not choose to leave history, and that the "essential responsibility" might lie with the "government" for not communicating its will with sufficient directness and steadiness to the "farthest frontiers of the land." In other words, God no longer reveals himself or his wishes. Nevertheless, the Jews have in the long run become too content to stay outside history, despite the physical dangers to which this exposes them, and they have even begun to insist on staying there. ". . . a certain feebleness of faith and imaginative power on the part of the people . . . prevents them from raising the empire out of its stagnation in Pekin and clasping it in all its palpable reality to their own breasts, which yet desire nothing better than but once to feel that touch and then to die." This also alludes to the anemia of Judaism as a *felt* religion.

However, its very feebleness of imaginative power enables Israel to survive in its exile. "All the more remarkable is it that this very weakness should seem to be one of the greatest unifying influences among our people; indeed, if one may dare to use the expression, the very ground on which we live. To set about determining a fundamental defect here would mean undermining not only our conscience, but, what is far worse, our feet." Ghetto Jewry lacks religious as well as historical curiosity; its "feet" are the petty daily concerns—business, logic-chopping, and gossip—which absorb minds indifferent to public issues. However, if Jewry is not curious about religion, it is still curious about God, only not in a theological sense; and this kind of curiosity, together with its immersion in the day-to-day, serves to keep it from heretical thoughts.

Remarkably few sectarian differences have appeared among the Jews in their dispersion.

But the Great Wall should not be interpreted too consistently or closely in terms of its Jewish meaning. It alludes to the entire human condition, in the sense Kafka has of it as being walled around by ignorance reinforced by irony. His great power is to fabulize general observations, to find situations and images of behavior in which to figure forth broad conclusions of a kind that ordinarily resist the art of fiction. Conclusions about his fellow Jews in particular are extended to cover humanity in general by virtue of being so fabulized. The movement from the particularly Jewish to the universally human goes on always, and many things in "The Great Wall of China" open out into art only because they are carried by this movement, in which the allegorical meaning is kept shuttling between two or more contexts.

Thus the Wall stands for many more things than Jewish Law. Religion dissolves into culture, and culture is seen as humanity's effort to keep the formless at bay. Culture is also illusion: illusion piled on illusion. A scholar proposes that the Wall serve as the foundation for a more successful Tower of Babel to be built according to the methods of modern technology. Other intellectuals, the foremen of the work gangs, better educated than the laborers they supervise, are more aware of the possible illusoriness of the project, and need special measures of relief to keep them from despairing of its aim, of their own immediate work, and of the world. The mass of the Chinese, however, do not have such troubles; culture proceeds over their humble heads.

The art of "The Great Wall of China" consists most immediately in the interweaving of motives that enter as ideas rather than as acts or events. As is usual with Kafka, the evenness and closeness of the interweaving require that we look a second time to discern the emphasis of the pattern. This, as I see it, comes just short of halfway in the narrator's essay, and all that goes before and after circles towards it. I refer to the parable of the river with its admonition as to the point at which speculation upon the "decrees of the high command" ought to stop. Kafka has the traditionally Jewish distrust of theology, and the aversion to inquiry into the nature or ultimate purpose of

Being—"but not because it might be harmful; it is not at all certain that it would be harmful. What is harmful or not harmful has nothing to do with the question." In compensation, the positivistic intellectual—and Kafka is one in his way—has all the more curiosity about the way the world actually works. The narrator pursues his inquiry on the plea that it is purely historical. The plea is that of the post-religious, modern Jewish intellectual.

Kafka asks again and again: what is it that made me what I am? Among the things that made him what he is, the Jewish past bulks large, the Diaspora Jewish past. That past could conceive of history as only in a much remoter past and in the form of what amounted to legend. This may explain in part why Kafka cast his own history of the history-less Diaspora in legendary form. But it does not follow from this that the content of that form is legendary. In fact, it is hardly fiction.

Franz Kafka Today, ed. Angel Flores and Homer Swander, 1958

11. Introduction to an Exhibition in Tribute to Sidney Janis

American abstract painting began to receive international attention only some three or four years ago, although it had already become the vehicle of major art early in the 1940's, if not before. Our country was one of the last places from which a major new impulse in art was expected, and recognition of the fact was perhaps delayed for this reason. All the more credit belongs therefore to those few who had the perspicacity to take American "abstract expressionism" seriously before confirmation came from Paris, London, and Tokyo.

Sidney Janis started visiting the studios of artists like Arshile Gorky, Willem de Kooning, and Jackson Pollock when their names were not known beyond the circle of their friends and acquaintances. He wrote about them and reproduced examples of their work in one of the very first books that so much as noticed the "movement" which they and a few other painters in New York were beginning to constitute. *Abstract and Surrealist Art in America* appeared in 1944, a good while before

either the art magazines or the newspaper critics reached the point where they were able to discuss "abstract expressionism" with a modicum of calm. In that book Baziotes, Carles, Adolph Gottlieb, Hofmann, Motherwell, Pollock, Rothko, de Kooning, Gorky, and other Americans were discussed and illustrated—without apology or qualification—side by side with Braque, Chagall, Kandinsky, Léger, Mondrian, and Picasso.

When Sidney Janis opened his gallery in New York, in September 1948, he did not show many American artists. His "strategy," different from that of Peggy Guggenheim, Betty Parsons, Samuel Kootz, or Charles Egan, was in line with that of his book. First he made of his place a kind of museum-*cum*-seminar. The 20th century masters—from Bonnard to Miró—were exhibited in a depth and variety, as well as with an exertion of taste, that no formal museum in the country was able to match. (Janis's first Mondrian show, for instance, spread that master larger, in effect, than did the memorial exhibition he was given at the Museum of Modern Art.) I shall always be grateful to Sidney Janis for all that I have learned, and continue to learn, in his premises.

This was the context in which he began, after a while, to present American art consistently. His policy not only implied, it declared, that Pollock, de Kooning, Kline, Guston, Rothko, and Motherwell were to be judged by the same standards as Matisse and Picasso, without condescension, without making allowances. I fully believe that some of these Americans have met that test and justified Mr. Janis's faith in them. In short, he has made it that much easier for us to take them with the importance to which the quality of their achievement entitles them.

Sidney Janis's success has been a commercial as well as artistic one, and more power to him for that. Only those on the spot back in the 1940's can realize how crucial commercial success then was to artists who lived so exclusively for their art and its seriousness. Self-respect as well as material welfare was at stake. The real issue was whether ambitious artists could live in this country by what they did ambitiously. Sidney Janis helped as much as any one to see that it was decided affirmatively.

Back in 1944 Leo Lerman remarked on Sidney Janis's youth-

53

ful enthusiasm, on his capacity for remaining open, interested, and ardent.

He has not changed. There is no question of his letting success close his eyes to what is not yet successful. Painting in New York does not perhaps have the *élan* that it had ten or fifteen years ago, but it is not for lack of encouragement by dealers like Sidney Janis. Mondrian once said to him: "I like you because you are not interested in only one kind of art."

Albers, De Kooning, Gorky, Guston, Kline, Motherwell, Pollock, Rothko: An Exhibition in Tribute to Sidney Janis, Hetzel Union Gallery, Pennsylvania State University, February 1958

12. Introduction to an Exhibition of Barnett Newman

Barnett Newman is part of the splendor of American painting in the past decade and a half. In his case it is a particularly noble and candid splendor. His art is all statement, all content; and fullness of content can be attained through an execution that calls the least possible attention to itself. We are not offered the dexterity of a hand or the ingenuity of an eye. Skill and ingenuity cannot convey directly enough what has to be said. Newman is not concerned to demonstrate how well he can draw, shade, or tint; he knows (and so do several of us) how well he can. The truth of art lies for him, as for any genuinely ambitious artist, somewhat beyond what he *knows* he can do.

There is no program, no polemic, in these paintings. They do not intend to make a point, let alone shock or startle. Newman is not interested in straight lines, right angles, or empty spaces as such, or in bareness or purity. He pursues his vision. The vertical stripes enter as a result, not as part of a layout. The color comes first and does the controlling. The stained surface spreads, ascends and descends, and in certain places it pauses. The line that marks the pause does not demarcate or limit; it simply inflects a continuity, and all it needs in order to do this is to proceed as directly as possible from one point to another. This has to do with economy, not geometry.

If you are color-deaf, you will focus on the stripes. If you

54

are not color-deaf, and if you look *at* and not into pictures (and all pictures of quality ask to be looked at rather than read), you will be aware of shaped emanations of color and light. This kind of painting has far more to do with Impressionism than with anything like Cubism or Mondrian.

My first view of Newman's pictures, at his first show in New York eight years ago, left me exhilarated but also a little puzzled as to how such a minimum of means could achieve such a maximum effect. I was equally exhilarated by his second show, a year later, but no longer puzzled. Seeing the same and new pictures of his over the years since, I became increasingly aware of how complex they were in their exploration of the tensions between different light values of the same color and between different colors of the same light value. Such tensions form an almost entirely new area of interest for our tradition of painting, and it is part of Newman's originality that he should lead our sensibility toward it. Thereby he has enlarged our sense of the capacities of color and of the capacities of the art of painting in general. No wonder I consider this first retrospective exhibition of his art an historic occasion.

Barnett Newman: First Retrospective Exhibition, Bennington College, Vermont, May 1958; *Barnett Newman: A Selection, 1946–1952*, French and Co., Inc., New York, 1959.

13. Sculpture in Our Time

Art looks for its resources of conviction in the same general direction as thought. Once it was revealed religion, then it was hypostatizing reason. The nineteenth century shifted its quest to the empirical and positive. This notion has undergone much revision over the last hundred years, and generally toward a stricter conception of the positive. Aesthetic sensibility has shifted accordingly. The growing specialization of the arts is due chiefly not to the prevalence of the division of labor, but to our increasing faith in and taste for the immediate, the concrete, the irreducible. To meet this taste (and demonstrate their irreplaceability), the various modernist arts try to confine themselves to that which is most positive and immediate in

themselves, which consists in the unique attributes of their mediums. It follows that a modernist work of art must try, in principle, to avoid communication with any order of experience not inherent in the most literally and essentially construed nature of its medium. Among other things, this means renouncing illusion and explicit subject matter. The arts are to achieve concreteness, "purity," by dealing solely with their respective selves—that is, by becoming "abstract" or nonfigurative. Of course, "purity" is an unattainable ideal. Outside music, no attempt at a "pure" work of art has ever succeeded in being more than an approximation and a compromise (least of all in literature). But this does not diminish the crucial importance of "purity" or concrete "abstractness" as an orientation and aim.[1]

Modernist painting meets our desire for the literal and positive by renouncing the illusion of the third dimension. This is the decisive step, for the representational as such is renounced only in so far as it suggests the third dimension. Dubuffet has shown us that when the representational does not do that, taste continues to find it admissible; that is, to the extent that it does not detract from literal, sensational concreteness. Mondrian, on the other hand, has shown us that the pictorial can remain pictorial when every trace or suggestion of the representational has been eliminated. In other words, neither the representational nor the third-dimensional is essential to pictorial art, and their absence does not commit the painter to the "merely" decorative.

Abstract and near-abstract painting has proven fertile in major works, especially in this country. But it can be asked whether the modernist "reduction" does not threaten to narrow painting's field of possibilities. It is not necessary here to examine the developments inside abstract painting that might lead one to conclude this. I wish to suggest, however, that sculpture—that long-eclipsed art—stands to gain by the modernist "reduction" as painting does not. It is already evident that the fate of visual art in general is not equated as implicitly as it used to be with that of painting.

1. This essay has its origins in an earlier article, "The New Sculpture" (*Partisan Review*, June 1949), reprinted in vol. 2. For its publication on this occasion in *Arts Magazine*, Greenberg changed the essay substantially. [Editor's note]

After several centuries of desuetude sculpture has returned to the foreground. Having been invigorated by the modernist revival of tradition that began with Rodin, it is now undergoing a transformation, at the hands of painting itself, that seems to promise it new and much larger possibilities of expression. Until lately sculpture was handicapped by its identification with monolithic carving and modeling in the service of the representation of animate forms. Painting monopolized visual expression because it could deal with all imaginable visual entities and relations. And painting could also exploit the post-medieval taste for the greatest possible tension between that which was imitated and the medium that did the imitating. That the medium of sculpture was the one apparently least removed from the modality of existence of its subject matter counted against it. Sculpture seemed too literal, too immediate.

Rodin was the first sculptor since Bernini to try seriously to arrogate to his art some of the essential, rather than merely illustrative, qualities of painting. He sought surface- and even shape-dissolving effects of light in emulation of Impressionism. His art, for all that it contains of the problematical, was fulfilled both in itself and in the revival of monolithic sculpture that it initiated. That revival shines with names like Bourdelle, Maillol, Lehmbruck, Despiau, Kolbe, Marcks, Lachaise, Matisse, Degas, Renoir, Modigliani. But, as it now looks, it was the final flare-up of something on the way to extinction. To all intents and purposes, the Renaissance tradition of sculpture was given its quietus by Brancusi. No sculptor born since the beginning of this century (except perhaps the Austrian Wotruba) appears to have been able to produce truly major art in its terms.

Under the influence of Fauve painting and exotic carving (to which painters called his attention), Brancusi drove monolithic sculpture to an ultimate conclusion by reducing the image of the human form to geometrically simplified ovoid, tubular or cubic masses. He not only exhausted the monolith by exaggerating it but, by one of those turns in which extremes meet, rendered it pictorial, graphic. Arp and others, later on, carried the Brancusian monolith over into abstract and near-abstract sculpture, but he himself went on toward something even more radical. Once again taking his lead from

painters, he began in his wood carvings to open up the mono-
lith under the influence of Cubism. He then produced what
are in my opinion his greatest works, and he had, as it were,
a Pisgah view of a new kind of sculpture (at least for Europe)
that lay altogether outside the orbit of monolithic tradition;
but Brancusi did not actually pass over into this new kind of
sculpture. That was left to painting and painters, and the way
to it was opened by the Cubist collage.

The pieces of paper or other material that Picasso and
Braque glued to the surface of the collage acted to identify the
surface literally and to thrust, by contrast, everything else on
it back into illusionist depth. As the language of Cubism be-
came one of larger and more tightly joined flat shapes, it grew
increasingly difficult to unlock the flatness of the surface by
purely pictorial means. Picasso (before resorting to color con-
trasts and to more obviously representational shapes) solved—
or rather destroyed—the problem by raising the collage's
affixed material above the picture surface, thus going over into
bas-relief. And soon after that he subtracted the picture surface
entirely, to let what had been affixed stand free as a "construc-
tion." It is at this point that the new sculpture really began.
Its further progress can be traced through the works of the
Constructivists, Picasso's subsequent sculpture, and the sculp-
ture of Lipchitz, Gonzalez and the earlier Giacometti.

The new construction-sculpture points back, almost insis-
tently, to its origins in Cubist painting: by its linearism
and linear intricacies, by its openness and transparency and
weightlessness, and by its preoccupation with surface as skin
alone, which it expresses in blade- or sheet-like forms. Space
is there to be shaped, divided, enclosed, but not to be filled or
sealed in. The new sculpture tends to abandon stone, bronze
and clay for industrial materials like iron, steel, alloys, glass,
plastics, celluloid, etc., etc., which are worked with the
blacksmith's, the welder's and even the carpenter's tools. Unity
of material and color is no longer required, and applied color
is sanctioned. The distinction between carving and modeling
becomes irrelevant: a work or its parts can be cast, wrought,
cut or simply put together: the new sculpture is not so much
sculpted as constructed, built, assembled, arranged. From all
this the medium has acquired a new flexibility, and it is in this

58

that I see its chance now of attaining an even wider range of expression than painting.

Under the modernist "reduction" sculpture has turned out to be almost as exclusively visual in its essence as painting itself. It has been "liberated" from the monolithic as much because of the latter's excessive tactile associations, which partake of illusion, as because of the hampering conventions that cling to it. But sculpture is still permitted a greater latitude of figurative allusiveness than painting because it remains tied, inexorably, to the third dimension and is therefore inherently less illusionistic. The literalness that was once its handicap has now become its advantage. Any recognizable image is bound to be tainted with illusion, and modernist sculpture, too, has been impelled a long way toward abstractness; yet sculpture can continue to suggest recognizable images, at least schematically, if only it refrain from imitating organic substance (the illusion of organic substance or texture in sculpture being analogous to the illusion of the third dimension in pictorial art). And even should sculpture be compelled to become as abstract as painting, it would still have a larger realm of formal possibilities in its command. The human body is no longer postulated as the agent of space in either pictorial or sculptural art; now it is eyesight alone, and eyesight has more freedom of movement and invention within three dimensions than within two. It is significant, moreover, that modernist sensibility, though it rejects sculptural painting of any kind, allows sculpture to be as pictorial as it pleases. Here the prohibition against one art's entering the domain of another is suspended, thanks to the unique concreteness and literalness of sculpture's medium. Sculpture can confine itself to virtually two dimensions (as some of David Smith's pieces do) without being felt to violate the limitations of its medium, because the eye recognizes that what offers itself in two dimensions is actually (not palpably) fashioned in three.

Such then are what I consider to be the present assets of sculpture. For the most part, however, they still abide in a state of potentiality rather than of realization. Art delights in contradicting predictions made about it, and the hopes I placed in the new sculpture ten years ago, in the original version of this article, have not yet been borne out—indeed

59

they seem to have been refuted. Painting continues as the leading and most adventurous as well as most expressive of the visual arts; in point of recent achievement architecture alone seems comparable with it. Yet one fact still suggests that I may not have been altogether wrong: that the new construction-sculpture begins to make itself felt as most *representative*, even if not the most fertile, visual art of our time.

Painting, sculpture, architecture, decoration and the crafts have under modernism converged once again in a common style. Painting may have been the first to sound the knell of historical revivalism, in Impressionism; it may have also been the first, in Matisse and Cubism, to give positive definition to modernist style. But the new sculpture has revealed the unifying characteristics of that style more vividly and completely. Having the freedom of a fine art yet being, like architecture, immersed in its physical means, sculpture has had to make the fewest compromises.

The desire for "purity" works, as I have indicated, to put an even higher premium on sheer visibility and an even lower one on the tactile and its associations, which include that of weight as well as of impermeability. One of the most fundamental and unifying emphases of the new common style is on the continuity and neutrality of a space which light alone inflects, without regard to the laws of gravity. There is an attempt to overcome the distinctions between foreground and background; between formed space and space at large; between inside and outside; between up and down (many modernist buildings, like many modernist paintings, would look almost as well upside down or even stood on their sides). A related emphasis is on economy of physical substance. This manifests itself in the pictorial tendency to reduce all matter to two dimensions—to lines and surfaces that define or enclose space but hardly occupy it. Rendering substance entirely optical, and form, whether pictorial, sculptural or architectural, as an integral part of ambient space—this brings anti-illusionism full circle. Instead of the illusion of things, we are now offered the illusion of modalities: namely, that matter is incorporeal, weightless, and exists only optically like a mirage. This kind of illusionism is stated in pictures whose paint surfaces and enclosing rectangles vibrate into the space around them; and

in buildings that, apparently formed of lines alone, seem woven into the air; but better yet in Constructivist and quasi-Constructivist works of sculpture. A building and a picture, too, coinciding with its support, each require a greater amount of palpable stuff than does a piece of sculpture to convey a quantitatively equivalent spatial effect. Feats of "engineering" that aim to provide the greatest possible amount of visibility with the least possible expenditure of tactile surface belong categorically to the free and *total* medium of sculpture. The constructor-sculptor can, literally, draw in the air with a single strand of wire.

It is its physical independence, above all, that contributes to the new sculpture's status as the representative visual art of modernism. A work of sculpture, unlike a building, does not have to carry more than its own weight, nor does it have to be *on* something else, like a picture; it exists for and by itself literally as well as conceptually. And in this self-sufficiency of sculpture, wherein every conceivable as well as perceptible element belongs altogether to the work of art, the positivist aspect of the modernist "aesthetic" finds itself most fully realized. It is for a like self-sufficiency that both painting and architecture seem to strive.

Arts Magazine, June 1958; A&C (unrevised).

14. The Pasted-Paper Revolution

The collage played a pivotal role in the evolution of Cubism, and Cubism had, of course, a pivotal role in the evolution of modern painting and sculpture. As far as I know, Braque has never explained quite clearly what induced him, in 1912, to glue a piece of imitation wood-grain paper to the surface of a drawing. Nevertheless, his motive, and Picasso's in following him (assuming that Picasso did follow him in this), seems quite apparent by now—so apparent that one wonders why those who write on collage continue to find its origin in nothing more than the Cubists' need for renewed contact with "reality."

61

By the end of 1911 both masters had pretty well turned traditional illusionist paintings inside out. The fictive depths of the picture had been drained to a level very close to the actual paint surface. Shading and even perspective of a sort, in being applied to the depiction of volumetric surfaces as sequences of small facet-planes, had had the effect of tautening instead of hollowing the picture plane. It had become necessary to discriminate more explicitly between the resistant reality of the flat surface and the forms shown upon it in yielding ideated depth. Otherwise they would become too immediately one with the surface and survive solely as surface pattern. In 1910 Braque had already inserted a very graphic nail with a sharp cast shadow in a picture otherwise devoid of graphic definitions and cast shadows, *Still-life with Violin and Palette*, in order to interpose a kind of photographic space between the surface and the dimmer, fragile illusoriness of the Cubist space which the still-life itself—shown as a picture within a picture—inhabited. And something similar was obtained by the sculptural delineation of a loop of rope in the upper left margin of the Museum of Modern Art's *Man with a Guitar* of 1911. In that same year Braque introduced capital letters and numbers stencilled in *trompe-l'oeil* in paintings whose motifs offered no realistic excuse for their presence. These intrusions, by their self-evident, extraneous and abrupt flatness, stopped the eye at the literal, physical surface of the canvas in the same way that the artist's signature did; here it was no longer a question of interposing a more vivid illusion of depth between surface and Cubist space, but one of specifying the very real flatness of the picture plane so that everything else shown on it would be pushed into illusioned space by force of contrast. The surface was now *explicitly* instead of implicitly indicated as a tangible but transparent plane.

It was toward the same end that Picasso and Braque began, in 1912, to mix sand and other foreign substances with their paint; the granular surface achieved thereby called direct attention to the tactile reality of the picture. In that year too, Georges Braque "introduced bits of green or gray marbleized surfaces into some of his pictures and also rectangular strips painted in imitation of wood grain" (I quote from Henry R. Hope's catalogue for the Braque retrospective at the Museum

of Modern Art in 1949). A little later he made his first collage, *Fruit Bowl,* by passing three strips of imitation wood-grain wallpaper to a sheet of drawing paper on which he then char-coaled a rather simplified Cubist still-life and some *trompe-l'oeil* letters. Cubist space had by this time become even shallower, and the actual picture surface had to be identified more em-phatically than before if the illusion was to be detached from it. Now the corporeal presence of the wallpaper pushed the lettering itself into illusioned depth by force of contrast. But at this point the declaration of the surface became so vehement and so extensive as to endow its flatness with far greater power of attraction. The *trompe-l'oeil* lettering, simply because it was inconceivable on anything but a flat plane, continued to sug-gest and return to it. And its tendency to do so was further encouraged by the placing of the letters in terms of the illu-sion, and by the fact that the artist had inserted the wallpaper strips themselves partly inside the illusion of depth by drawing upon and shading them. The strips, the lettering, the char-coaled lines and the white paper begin to change places in depth with one another, and a process is set up in which every part of the picture takes its turn at occupying every plane, whether real or imagined, in it. The imaginary planes are all parallel to one another; their effective connection lies in their common relation to the surface; wherever a form on one plane slants or extends into another it immediately springs forward. The flatness of the surface permeates the illusion, and the illusion itself re-asserts the flatness. The effect is to fuse the illusion with the picture plane without derogation of ei-ther—in principle.

The fusion soon became even more intimate. Picasso and Braque began to use pasted paper and cloth of different hues, textures and patterns, as well as a variety of *trompe-l'oeil* ele-ments, within one and the same work. Shallow planes, half in and half out of illusioned depth, were pressed still closer to-gether, and the picture as a whole brought still closer to the physical surface. Further devices are employed to expedite the shuffling and shuttling between surface and depth. The area around one corner of a swatch of pasted paper will be shaded to make it look as though it were peeling away from the sur-face into real space, while something will be drawn or pasted

over another corner to thrust it back into depth and make the superimposed form itself seem to poke out beyond the surface. Depicted surfaces will be shown as parallel with the picture plane and at the same time cutting through it, as if to establish the assumption of an illusion of depth far greater than that actually indicated. Pictorial illusion begins to give way to what could be more properly called optical illusion.

The paper or cloth had to be cut out, or simulated, in relatively large and simple shapes, and wherever they were inserted the little facet-planes of Analytical Cubism merged perforce into larger shapes. For the sake of harmony and unity this merging process was extended to the rest of the picture. Images began to re-acquire definite and even more recognizable contours, and Synthetic Cubism was on the way. With the reappearance, however, of definite and linear contours, shading was largely suppressed. This made it even more difficult to achieve depth or volumetric form, and there seemed no direction left in which to escape from the literal flatness of the surface—except into the non-pictorial, real space in front of the picture. This, exactly, was the way Picasso chose for a moment, before he went on to solve the terms of Synthetic Cubism by contrasts of bright color and bright color patterns, and by incisive silhouettes whose recognizability and placing called up an association at least, if not a representation, of three-dimensional space.

Some time in 1912 he cut out and folded a piece of paper in the shape of a guitar and glued and fitted other pieces of paper and four taut strings to it. A sequence of flat surfaces on different planes in actual space was created to which there adhered only the hint of a pictorial surface. The originally affixed elements of a collage had, in effect, been extruded from the picture plane—the sheet of drawing paper or the canvas—to make a bas-relief. But it was a "constructed," not a sculpted, bas-relief, and it founded a new genre of sculpture. Construction-sculpture was freed long ago from its bas-relief frontality and every other suggestion of the picture plane, but has continued to this day to be marked by its pictorial origins. Not for nothing did the sculptor-constructor Gonzalez call it the new art of "drawing in space." But with equal and more descriptive justice it could be called, harking back more spe-

cifically to its birth in the collage: the new art of joining two-dimensional forms in three-dimensional space.

After classical Cubism the development of collage was largely oriented to shock value. Arp, Schwitters and Miró grasped its plastic meaning enough to make collages whose value transcends the piquant, but the genre otherwise declined into montage and stunts of illustration, or into decoration pure and simple. The traps of collage (and of Cubism in general) in this last respect are well demonstrated by Gris's case.

Cubism, in the hands of its inventors—and in those of Léger too—achieved a new, exalted and transfigured kind of decoration by reconstructing the flat picture surface with the very means of its denial. They started with the illusion and arrived at a quasi-abstract literalness. With Gris it was the reverse. As he himself explained, he started with flat and abstract shapes to which he then fitted recognizable three-dimensional images. Whereas Braque's and Picasso's images were dissected in three dimensions in the course of being transposed in two, Gris's tended, especially in the beginning, to be broken up in two-dimensional terms alone, in accordance with rhythms originating on the surface. Later on Gris became aware of the fact that Cubism was not just a question of decorative overlay and that its surface resonance derived directly from an underlying illusion which, however schematic, was fully felt; and in his collages we can see him struggling with this problem. But his collages also make it clear how unstable his solution was. Precisely because he continued to take the picture surface as given and not needing to be re-created, he became over-solicitous about the illusion. He used his pasted papers and *trompe-l'oeil* textures and lettering to assert flatness all right; but he almost always sealed the flatness inside the illusion of depth by placing images rendered with sculptural vividness on the nearest plane of the picture, and often on the rearmost plane too. At the same time he used more positive color in his collages than Picasso or Braque did, and more light and dark shading. Because their affixed material and their *trompe-l'oeil* seldom declare the surface ambiguously, Gris's collages lack the immediacy of presence of Braque's and Picasso's. They have about them something of the closed-off presence of the traditional easel picture. And yet, because their decorative

elements tend to function solely as decoration—as decoration of the illusion—they also seem more conventionally decorative. Instead of that seamless fusion of the decorative with the spatial structure of the illusion which we get in the collages of the other two masters, there is an alternation, a collocation, of the decorative and the illusioned. And if their relation ever goes beyond that, it is more liable to be one of confusion than of fusion. Gris's collages have their merits, but they have been over-praised. Certainly, they do not confirm the point of Cubism as a renovation of pictorial style.

That point, as I see it, was to restore and exalt decoration by building it, by endowing self-confessedly flat configurations with a pictorial content, an autonomy like that hitherto obtained through illusion alone. Elements essentially decorative in themselves were used not to adorn but to identify, locate, construct; and in being so used, to create works of art in which decorativeness was transcended or transfigured in a monumental unity. Monumental is, in fact, the one word I choose to describe Cubism's pre-eminent quality.

Art News, September 1958; A&C (substantially changed).

66

1959

15. Hans Hofmann: Grand Old Rebel

Hans Hofmann's art is increasingly recognized as a major foun-
tainhead of style and ideas for the "new" American painting,
but its value, independent of its influence and Hofmann's role
as a teacher, is still subject to certain reservations.[1] His omis-
sion from the *New American Painting* show that the Museum of
Modern Art has sent to Europe (1958–59) is a case in point
(an omission which did more to distort the picture than did
the number of highly questionable inclusions). A good share
of the blame rests with the public of advanced art in New
York, which has its own kind of laziness and obtuseness and
usually asks that a "difficult" artist confine himself to a single
readily identifiable manner before it will take trouble with
him. (One would think that the exhilaration and satisfaction
to be gotten from following advanced art were proportionate
to the effort of discrimination required, but most of those who
do the following, having accepted advanced art in principle,
apparently want it made easy within its own context.) But
Hofmann himself is also to blame in some part—and actually,
the more excellences I find in his art the more I incline to shift
the blame toward him.

The variety of manners and even of styles in which he works
would conspire to deprive even the most sympathetic public
of a clear idea of his achievement. At the same time, such a
diversity of manners makes one suspect an undue absorption
in problems and challenges for their own sake. Or else that
this artist follows wherever his inventive fertility leads him
instead of bending that fertility to his vision. And Hofmann's

1. This essay was published in the same month that the Kootz Gallery,
New York, mounted two exhibitions of Hofmann's work, one of which was
introduced by Greenberg (see the following item). [Editor's note]

inventiveness is truly enormous, to the point where he might be called a virtuoso of invention—such as only the Klee of the 1930s was before him. But in art one cannot scatter one's shots with impunity and Hofmann has paid a certain price for it in terms of quality as well as of acceptance. That price is certainly not as great as the one the later Klee paid, but it may be larger than that of Klee in his prime (when his "handwritten" approach and the small formats to which he restricted himself conferred a real unity of style upon all the different notational systems he used). And, unlike Picasso since 1917, Hofmann has no ostensible main manner to which all his others are kept subordinate; he can work in as many as three or four different ones in the span of a year and give them all equal emphasis.

The notion of experiment has been much abused in connection with modernist art, but Hofmann's painting would seem to justify its introduction. He is perhaps the most difficult artist alive—difficult to grasp and to appreciate. But, by the same token, he is an immensely interesting, original and rewarding one, whose troubles in clarifying his art stem in large part from the fact that he has so much to say. And though he may belong to the same moment in the evolution of easel painting as Pollock, he is even less categorizable. He has been called a "German Expressionist," yet little in what is known as Expressionism, aside from Kandinsky's swirl, predicts him. His color and color textures may be "Nordic," but one clutches at this adjective in despair at a resolute originality in which the "Mediterranean" is assimilated. I would maintain that the only way to begin placing Hofmann's art is by taking cognizance of the uniqueness of his life's course, which has cut across as many art movements as national boundaries, and put him in several different centers of art at the precise time of their most fruitful activity. And his career as an artist has, on top of that, cut across at least three artists' generations.

Born and educated in Germany, Hofmann lived in Paris on close terms with the original Fauves and the original Cubists in the decade, 1904 to 1914, during which both movements had their birth and efflorescence. He made frequent trips to France and Italy in the twenties, after having founded his

school in Munich. In 1931 he settled permanently in this country. For fifteen years he hardly picked up a brush but drew obsessively—as he says, to "sweat Cubism out." Only in 1935 or 1936, when he was in his mid-fifties, did he begin to paint again consistently—and only when he was already sixty, at a time when many of his own students had long since done so, did he commit himself to abstraction. His first one-man show in New York was held at Peggy Guggenheim's early in 1944, and since then he has shown in New York annually, as an artist with a reputation to make or break along with artists thirty to forty years younger, and asking for no special indulgence.

Hofmann himself explains the lateness of his development by the relative complacency fostered in him during his Paris years by the regular support of a patron, and by the time and energy he needed, subsequently, to perfect himself as a teacher. But I would suggest, further, that his Paris experience confronted him with too many *faits accomplis* by artists his own age or only a few years older; that he had, as it were, to wait until the art movements of those and the inter-war years were spent before making his own move; he had to "get over" Fauvism and Cubism, and Kandinsky, Mondrian, Arp, Masson and Miró as well.

His own move started with Fauvish landscapes and large still-life interiors that he began painting shortly after 1935. The interiors synthesize Matisse with Cubism in a fully personal way, but are if anything a little too brilliantly wrought. The landscapes, however, especially the darker ones, open up a vision that Nolde alone had had a previous glimpse of, and Hofmann opens it up from a different direction. Their billowing, broadly brushed surfaces declare depth and volume with a new, post-Matissean and post-Monetian intensity of color, establishing unities in which both Fauvism and Impressionism acquire new contemporary relevance. Although there are already a few Hofmanns from 1939 in which no point of departure from nature can be recognized, the effective transition to abstract art takes place in the first years of the forties. Figures, landscapes and still-lifes become more and more schematically rendered, and finally vanish. What appear to be allusions to Kandinsky's near-abstract manner of 1910–11 constitute no

real debt in my opinion; Hofmann would have arrived at the same place had Kandinsky never painted (though perhaps not if Miró, himself in debt to Kandinsky, had not). Rather than being influenced by Kandinsky, Hofmann seems to have *converged* with him at several points on the way to abstraction—a way that in his case was much broader, since it ran through the whole of Matisse and the whole of Cubism.

No one has digested Cubism more thoroughly than Hofmann, and perhaps no one has better conveyed its gist to others. Yet, though Cubism has been essential to the formation of his art, I doubt whether any important artist of this postwar era has suffered by it as much as Hofmann has. It is what I call his "Cubist trauma" that is responsible, among other things, for the distractedness of his art in its abstract phase. Without the control of a subject in nature, he will too often impose Cubist drawing upon pictorial conceptions that are already complete in themselves; it will be added to, rather than integrated with, his redoubtable manipulations of paint. It is as if he had to demonstrate to himself periodically that he could still command the language with which Braque and Picasso surprised him fifty years ago in Paris. Yet the moments of his best pictures are precisely those in which his painterly gift, which is both pre- and post-Cubist, has freest rein and in which Cubism acts, not to control, but only to inform and imply, as an awareness of style but not as style itself.

To the same painterly powers are owed most of the revelations of Hofmann's first abstract period, before 1948. In a picture like *Effervescence* of 1944 he predicted an aspect of Pollock's "drip" method and, at the same time, Still's anti-Cubist drawing and bunching of dark tones. In *Fairy Tale* of the same year he expanded and deepened a hint taken from Masson in a way that anticipated Pollock's great *Totem I* of a few months later. In the tempera-on-gesso *Homage to Howard Putzel* of 1945 still another aspect of Pollock's later "drip" manner was anticipated ("drip" is inaccurate; more correct would be "pour and spatter"). These works are the first I know of to state that dissatisfaction with the facile, "handwritten" edges left by the brush, stick or knife which animates the most radical painting of the present. The open calligraphy and "free" shapes that

rule in "Abstract-Expressionism" were foretold in many other pictures Hofmann did before 1948, and especially in numerous gouaches and watercolors, in which paint is wielded with a disregard of "construction" that represents the most inspired possession of it. Most of these pictures are more important as art than as prophecy, but it is only in the light of what they did prophesy that people like myself have learned to appreciate them; ten years ago and more, when they were first shown, they were too new.

In certain other pictures, however, Hofmann anticipated himself alone. *Summer Glory* of 1944 and *Conjurer* of 1946 declare the impastoed, non-linear manner which, in my view, has been his most consistently successful one since 1948. Here color determines form from the inside out as it were; thick splotches, welts, smears and ribbons of paint dispose themselves into intelligible shapes the instant they are placed on a surface; out of the fullness of color come drawing and design. The red and green *Flowering Desert* of 1954 is done in this manner, and so are many much smaller paintings in which bright greens predominate, as they do also in a masterpiece like *Le Gilotin* of 1953. And then there is the *Bouquet* of 1951.

Only when Hofmann tries to reinforce contrasts of color and shape with taut contour lines, and when he trues shapes into a Cubist regularity, does his art become uncertain and tend to go off in eccentric directions. Given that the originality of his color consists often in oppositions of intense hues of the same degree of warmth and even of the same value; that a cool color like blue or an ambiguous one like green will be infused with unaccustomed heat; and that such things can tax the eye the way an unresolved chord taxes the ear—given all this, design becomes a very precarious matter in which it is safer to stop too soon than too late. To insist on line or edge can be excessive or disruptive. And sometimes the energy of Hofmann's line can be more nervous, more machined, than pictorial, and force an illegitimately sculptural effect. Or, as more recently, an overloaded one is created by the compulsion to inflect every square inch of the surface both chromatically and graphically. For Hofmann's overriding weakness has nothing to do essentially with drawing, but lies in a tendency to push a picture

too far in every direction—in the endeavor to achieve, it would seem, an old-fashioned synthesis of "drawing" and "color"—a grand-manner synthesis, that is. This is an ambition that identifies him with Picasso's and his own chronological generation of artists and separates him from the generation he actually paints with. But it separates him only in so far as it distracts him, and in his bad pictures, not his good ones.

But if not all of his bad pictures are due to misplaced draftmanship, neither are all of his good ones a function of color first and foremost. There are many oils on paper, gouaches and watercolors in which Hofmann's Cubism develops a Matissean, rather than Constructivist, grace of line. There are paintings like *The Prey* of 1956 in which thick pigment is handled calligraphically. And there is the large and magnificently original *Undulating Expanse* of 1955, which, along with four or five other, and smaller, items in the same series of studies for an architectural commission, is rapidly and almost transparently brush-drawn on a white ground. These studies strike one of the freshest notes to be detected anywhere in the painting of the last five years, but it is, alas, characteristic of Hofmann not to have pursued further an idea that another artist would have built a whole career on. Pictures like these confirm, at any rate, the impression that his first impulses are usually his best ones; when he fails it is most often because he forgets what he himself has drummed into his students: that science and discipline which have not become instinct are cramping rather than enabling factors.

A good deal of what is so rashly called "Abstract-Expressionism" amounts essentially to a kind of Late Cubism (which takes nothing away from it in principle). In some of his best work Hofmann is almost as much a Late Cubist as Gorky or de Kooning. In another and even better part of it, however, he points to and enters a way that is fully post-Cubist, and when he does so he follows his deepest bent, whether he himself recognizes it or not, and fulfills his most personal vision. Klee and Soutine were perhaps the first to address the picture surface consciously as a responsive rather than inert object, and painting itself as an affair of prodding and pushing, scoring and marking, rather than simply inscribing or covering the flatness of such an object. Hofmann has taken this approach

much further than they, and made it do much more. His paint surfaces *breathe* as no others do and open up to animate the air around them; they are less closed than the surfaces of the Cubist collage. It is because of their open, pulsating textures that Hofmann's very best pictures surpass Kandinsky's, as I feel they do. And it is thanks in part to Hofmann that the "new" American painting in general is distinguished by a new liveness of surface, which is responsible in turn for the new kind of "light" that Europeans say they find in it.

But that part of the "new" American painting which is not Late Cubist distinguishes itself further by its freedom from the quasi-geometric truing and fairing of lines and edges which the Cubist frame imposes. This freedom belongs with Hofmann's open surfaces as it does not with de Kooning's or Kline's, and his hesitancy in fully availing himself of it—despite the fact that he himself had such a large hand in establishing it originally—must be attributed to his reluctance to cut himself off from Cubism as a base of operations. It is a reluctance that seems, as I have already suggested, to account more than anything else for the incoherence in the development of Hofmann's art. But, as I cannot insist enough, it detracts nothing from the mastery displayed in its masterpieces.

Art News, January 1959; A&C (slightly revised).

16. Introduction to an Exhibition of Hans Hofmann

Quietly, without creating anything like a sensation, Hofmann kept startling us with many of the abstract pictures he showed before 1948. They were so *far out* that they did not even disturb us—or they did so only enough to leave us uneasy, as if dimly suspecting that some day we would have to reckon with them again. After 1947 (that crucial year for the "new American painting") Hofmann settled down more or less to being a highly respected but problematical artist, while other painters and people like myself settled down to the task, assumed in almost total unawareness, of catching up with him. His art has continued to develop, and he has produced works that sur-

pass any he did before 1948, but the audacities and anticipations seem no longer to follow so fast on one another (and it is as if Hofmann made the break consciously, in so far as he began at that time to use oil on canvas instead of on board or plywood). [1]

The first picture I ever saw in which trickles and spatters of paint became significant form was a Hofmann done in 1943, four years before Pollock found his own way to this technique. Among the first emphatically "all-over" pictures I ever saw was another Hofmann of around the same date. This detracts in no way from Pollock's originality; nor is anything taken away from Still's by the fact that yet another Hofmann (*Effervescence* of 1944) is a pioneer example of abstract painting in close and dark color values which permit the introduction of very irregular and un-Cubist shapes.

I suggested this exhibition and chose its contents for what I felt to be the sake of the truth about contemporary art as well as about Hofmann himself. Some of the pictures here have not been shown before; of the others, only two were shown again in Hofmann's Whitney Museum retrospective; therefore most of them will be new to followers of advanced art who were not on the New York scene before 1948 (and by now these newcomers are in the majority). In their ensemble these paintings will, I hope, do something to open more eyes to the magnitude of Hofmann's achievement, as realization as well as anticipation.

Originality may not be exactly the same thing, in art, as quality; nevertheless, one is inseparable from the other. A lot of Hofmann's earlier masterpieces have not yet identified themselves, but by their originality they signify that they will eventually do so.

Hans Hofmann: Early Paintings, Kootz Gallery, New York, January 1959

1. This exhibition of the early work that Hofmann produced in America was immediately preceded at the Kootz Gallery by an exhibition of Hofmann's paintings from 1958. Greenberg had previously selected another exhibition of Hofmann, a retrospective at Bennington College, Vermont, in 1955 (see vol. 3). [Editor's note]

17. The Case for Abstract Art

Many people say that the kind of art our age produces is one of the major symptoms of what's wrong with the age. The disintegration and, finally, the disappearance of recognizable images in painting and sculpture, like the obscurity in advanced literature, are supposed to reflect a disintegration of values in society itself. Some people go further and say that abstract, nonrepresentational art is pathological art, crazy art, and that those who practice it and those who admire and buy it are either sick or silly. The kindest critics are those who say it's all a joke, a hoax, and a fad, and that modernist art in general, or abstract art in particular, will soon pass. This sort of thing is heard or read pretty constantly, but in some years more often than others.

There seems to be a certain rhythm in the advance in popularity of modernist art, and a certain rhythm in the counterattacks which try to stem it. More or less the same words or arguments are used in all the polemics, but the targets usually change. Once it was the Impressionists who were a scandal, next it was van Gogh and Cézanne, then it was Matisse, then it was Cubism and Picasso, after that Mondrian, and now it is Jackson Pollock. The fact that Pollock was an American shows, in a backhanded way, how important American art has lately become.

Some of the same people who attack modernist art in general, or abstract art in particular, happen also to complain that our age has lost those habits of disinterested contemplation, and that capacity for enjoying things as ends in themselves and for their own sake, which former ages are supposed to have cultivated. This idea has been advanced often enough to convert it into a cliché. I hate to give assent to a cliché, for it is almost always an oversimplification, but I have to make an exception in this case. While I strongly doubt that disinterested contemplation was as unalloyed or as popular in ages past as is supposed, I do tend to agree that we could do with more of it in this time, and especially in this country.

I think a poor life is lived by any one who doesn't regularly take time out to stand and gaze, or sit and listen, or touch, or

smell, or brood, without any further end in mind, simply for the satisfaction gotten from that which is gazed at, listened to, touched, smelled, or brooded upon. We all know, however, that the climate of Western life, and particularly of American life, is not conducive to this kind of thing; we are all too busy making a living. This is another cliché, of course. And still a third cliché says that we should learn from Oriental society how to give more of ourselves to the life of the spirit, to contemplation and meditation, and to the appreciation of what is satisfying or beautiful in its own sole right. This last is not only a cliché, but a fallacy, since most Orientals are even more preoccupied than we are with making a living. I hope that I myself am not making a gross and reductive simplification when I say that so much of Oriental contemplative and aesthetic discipline strikes me as a technique for keeping one's eyes averted from ugliness and misery.

Every civilization and every tradition of culture seem to possess capacities for self-cure and self-correction that go into operation automatically, unbidden. If the given tradition goes too far in one direction it will usually try to right itself by going equally far in the opposite one. There is no question but that our Western civilization, especially in its American variant, devotes more mental energy than any other to the production of material things and services; and that, more than any other, it puts stress on interested, purposeful activity in general. This is reflected in our art, which, as has been frequently observed, puts such great emphasis on movement and development and resolution, on beginnings, middles, and endings—that is, on dynamics. Compare Western music with any other kind, or look at Western literature, for that matter, with its relatively great concern with plot and over-all structure and its relatively small concern with tropes and figures and ornamental elaborations; think of how slow-moving Chinese and Japanese poetry is by comparison with ours, and how much it delights in static situations; and how uncertain the narrational logic of non-Western fiction tends to be. Think of how encrusted and convoluted Arabic poetry is by contrast even with our most euphuistic lyrical verse. And as for non-Western music, does it not almost always, and literally, strike us as more monotonous as ours?

Well, how does Western art compensate for, correct, or at least qualify its emphasis on the dynamic—an emphasis that may or may not be excessive? And how does Western life itself compensate for, correct, or at least qualify its obsession with material production and purposeful activity? I shall not here attempt to answer the latter question. But in the realm of art an answer is beginning to emerge of its own accord, and the shape of part of that answer is abstract art.

Abstract decoration is almost universal, and Chinese and Japanese calligraphy is quasi-abstract—abstract to the extent that few occidentals can read the characters of Chinese or Japanese writing. But only in the West, and only in the last fifty years, have such things as abstract pictures and free-standing pieces of abstract sculpture appeared. What makes the big difference between these and abstract decoration is that they are, exactly, pictures and free-standing sculpture—solo works of art meant to be looked at for their own sake and with full attention, and not as the adjuncts, incidental aspects, or settings of things other than themselves. These abstract pictures and pieces of sculpture challenge our capacity for disinterested contemplation in a way that is more concentrated and, I daresay, more conscious than anything else I know of in art. Music is an essentially abstract art, but even at its most rarefied and abstract, and whether it's Bach's or the middle-period Schoenberg's music, it does not offer this challenge in quite the same way or degree. Music tends from a beginning through a middle toward an ending. We wait to see how it "comes out"—which is what we also do with literature. Of course, the *total* experience of literature and music is completely disinterested, but it becomes that only at a further remove. While undergoing the experience we are caught up and expectant as well as detached—disinterested and at the same time interested in a way resembling that in which we are interested in how things turn out in real life. I exaggerate to make my point—aesthetic experience *has* to be disinterested, and when it is genuine it always is, even when bad works of art are involved—but the distinctions I've made and those I've still to make are valid nevertheless.

With representational painting it is something like what it is with literature. This has been said before, many times be-

fore, but usually in order to criticize representational painting in what I think is a wrong-headed when not downright silly way. What I mean when I say, in this context, that representational painting is like literature, is that it tends to involve us in the interested as well as the disinterested by presenting us with the images of things that are inconceivable outside time and action. This goes even for landscapes and flower pieces and still lifes. It is not simply that we sometimes tend to confuse the attractiveness of the things represented in a picture with the quality of the picture itself. And it is not only that attractiveness as such has nothing to do with the abiding success of a work of art. What is more fundamental is that the meaning—as distinct from the attractiveness—of what is represented becomes truly inseparable from the representation itself. That Rembrandt confined impasto—thick paint, that is—to his highlights, and that in his later portraits especially these coincide with the ridges of the noses of his subjects is important to the artistic effect of these portraits. And that the effectiveness of the impasto, as impasto—as an abstract element of technique—coincides with its effectiveness as a means of showing just how a nose looks under a certain kind of light is also genuinely important. And that the lifelike delineation of the nose contributes to the evocation of the personality of the individual to whom the nose belongs is likewise important. And the manner and degree of insight into that individual's personality which Rembrandt exhibits in his portrait is important too. None of these factors can be, or ought to be, separated from the legitimate effect of the portrait as a picture pure and simple.

But once we have to do with personalities and lifelikeness we have to do with things from which we cannot keep as secure a distance for the sake of disinterestedness as we can, say, from abstract decoration. As it happens, the whole tendency of our Western painting, up until the later stages of Impressionism, was to make distance and detachment on the part of the spectator as insecure as possible. It laid more of a stress than any other tradition on creating a sculpture-like, or photographic, illusion of the third dimension, on thrusting images at the eye with a lifelikeness that brought them as close as possible to their originals. Because of their sculptural vividness, Western

paintings tend to be far less quiet, far more agitated and active—in short, far more explicitly dynamic—than most non-Western paintings are. And they involve the spectator to a much greater extent in the practical and actual aspects of the things they depict and represent.

We begin to wonder what we think of the people shown in Rembrandt's portraits, *as* people; whether or not we would like to walk through the terrain shown in a Corot landscape; about the life stories of the burghers we see in a Steen painting; we react in a less than disinterested way to the attractiveness of the models, real or ideal, of the personages in a Renaissance painting. And once we begin to do this we begin to participate in the work of art in a so-to-speak practical way. In itself this participation may not be improper, but it does become so when it begins to shut out all other factors. This it has done and does, all too often. Even though the connoisseurs have usually been able in the long run to prefer the picture of a dwarf by Velasquez to that of a pretty girl by Howard Chandler Christy, the enjoyment of pictorial and sculptural art in our society has tended, on every other level than that of professional connoisseurship, to be excessively "literary," and to center too much on merely technical feats of copying.

But, as I've said, every tradition of culture tends to try to correct one extreme by going to its opposite. And when our Western tradition of painting came up at last with reservations about its forthright naturalism, these quickly took the form of an equally forthright antinaturalism. These reservations started with late Impressionism, and have now culminated in abstract art. I don't at all wish to be understood as saying that it all happened because some artist or artists decided it was time to curb the excesses of realistic painting, and that the main historical significance of abstract art lies in its function as an antidote to these. Nor do I wish to be understood as assuming that realistic or naturalistic art inherently needs, or ever needed, such a thing as an antidote. The motivations, conscious and unconscious, of the first modernist artists, and of present modernists as well, were and are quite different. Impressionism itself started as an effort to push naturalism further than ever before. And all through the history of art—not only in recent times—consequences have escaped intentions.

79

It is on a different, and more impersonal and far more general level of meaning and history that our culture has generated abstract art as an antidote. On that level this seemingly new kind of art has emerged as an epitome of almost everything that disinterested contemplation requires, and as both a challenge and a reproof to a society that exaggerates, not the necessity, but the intrinsic value of purposeful and interested activity. Abstract art comes, on this level, as a relief, an arch-example of something that does not have to mean, or be useful for, anything other than itself. And it seems fitting, too, that abstract art should at present flourish most in this country. If American society is indeed given over as no other society has been to purposeful activity and material production, then it is right that it should be reminded, in extreme terms, of the essential nature of disinterested activity.

Abstract art does this in very literal and also in very imaginative ways. First, it does not exhibit the illusion or semblance of things we are already familiar with in real life; it gives us no imaginary space through which to walk with the mind's eye; no imaginary objects to desire or not desire; no imaginary people to like or dislike. We are left alone with shapes and colors. These may or may not remind us of real things; but if they do, they usually do so incidentally or accidentally—on our own responsibility as it were; and the genuine enjoyment of an abstract picture does not ordinarily depend on such resemblances.

Second, pictorial art in its highest definition is static; it tries to overcome movement in space or time. This is not to say that the eye does not wander over a painted surface, and thus travel in both space and time. When a picture presents us with an illusion of real space, there is all the more inducement for the eye to do such wandering. But ideally the whole of a picture should be taken in at a glance; its unity should be immediately evident, and the supreme quality of a picture, the highest measure of its power to move and control the visual imagination, should reside in its unity. And this is something to be grasped only in an indivisible instant of time. No expectancy is involved in the true and pertinent experience of a painting; a picture, I repeat, does not "come out" the way a

80

story, or a poem, or a piece of music does. It's all there at once, like a sudden revelation. This "at-onceness" an abstract picture usually drives home to us with greater singleness and clarity than a representational painting does. And to apprehend this "at-onceness" demands a freedom of mind and untrammeledness of eye that constitute "at-onceness" in their own right. Those who have grown capable of experiencing this know what I mean. You are summoned and gathered into one point in the continuum of duration. The picture does this to you, willynilly, regardless of whatever else is on your mind; a mere glance at it creates the attitude required for its appreciation, like a stimulus that elicits an automatic response. You become all attention, which means that you become, for the moment, selfless and in a sense entirely identified with the object of your attention.

The "at-onceness" which a picture or a piece of sculpture enforces on you is not, however, single or isolated. It can be repeated in a succession of instants, in each one remaining an "at-onceness," an instant all by itself. For the cultivated eye, the picture repeats its instantaneous unity like a mouth repeating a single word.

This pinpointing of the attention, this complete liberation and concentration of it, offers what is largely a new experience to most people in our sort of society. And it is, I think, a hunger for this particular kind of experience that helps account for the growing popularity of abstract art in this country: for the way it is taking over in the art schools, the galleries, and the museums. The fact that fad and fashion are also involved does not invalidate what I say. I know that abstract art of the latest variety—that originating with painters like Pollock and Georges Mathieu—has gotten associated with progressive jazz and its cultists; but what of it? That Wagner's music became associated with German ultranationalism, and that Wagner was Hitler's favorite composer, still doesn't detract from its sheer quality as music. That the present vogue for folk music started, back in the 1930's, among the Communists doesn't make our liking for it any the less genuine, or take anything away from folk music itself. Nor does the fact that so much gibberish gets talked and written about abstract art compro-

mise it, just as the gibberish in which art criticism in general abounds, and abounds increasingly, doesn't compromise art in general.

One point, however, I want to make glaringly clear. Abstract art is not a special kind of art; no hard-and-fast line separates it from representational art; it is only the latest phase in the development of Western art as a whole, and almost every "technical" device of abstract painting is already to be found in the realistic painting that preceded it. Nor is it a superior kind of art. I still know of nothing in abstract painting, aside perhaps from some of the near-abstract Cubist works that Picasso, Braque, and Léger executed between 1910 and 1914, which matches the highest achievements of the old masters. Abstract painting may be a purer, more quintessential form of pictorial art than the representational kind, but this does not of itself confer quality upon an abstract picture. The ratio of bad abstract painting to good is actually much greater than the ratio of bad to good representational painting. Nonetheless, the very best painting, the major painting, of our age is almost exclusively abstract. Only on the middle and lower levels of quality, on the levels below the first rate—which is, of course, where most of the art that gets produced places itself—only there is the better painting preponderantly representational.

On the plane of culture in general, the special, unique value of abstract art, I repeat, lies in the high degree of detached contemplativeness that its appreciation requires. Contemplativeness is demanded in greater or lesser degree for the appreciation of every kind of art, but abstract art tends to present this requirement in quintessential form, at its purest, least diluted, most immediate. If abstract art—as does happen nowadays—should chance to be the first kind of pictorial art we learn to appreciate, the chances are that when we go to other kinds of pictorial art—to the old masters, say, and I hope we all do go to the old masters eventually—we shall find ourselves all the better able to enjoy them. That is, we shall be able to experience them with less intrusion of irrelevancies, therefore more fully and more intensely.

The old masters stand or fall, their pictures succeed or fail,

82

on the same ultimate basis as do those of Mondrian or any other abstract artist. The abstract formal unity of a picture by Titian is more important to its quality than what that picture images. To return to what I said about Rembrandt's portraits, the whatness of what is imaged is not unimportant—far from it—and cannot be separated, really, from the formal qualities that result from the way it is imaged. But it is a fact, in my experience, that representational paintings are essentially and most fully appreciated when the identities of what they represent are only secondarily present to our consciousness. Baudelaire said he could grasp the quality of a painting by Delacroix when he was still too far away from it to make out the images it contained, when it was still only a blur of colors. I think it was really on this kind of evidence that critics and connoisseurs, though they were almost always unaware of it, discriminated between the good and the bad in the past. Put to it, they more or less unconsciously dismissed from their minds the connotations of Rubens' nudes when assessing and experiencing the final worth of his art. They may have remained aware of the pinkness as a *nude* pinkness, but it was a pinkness and a nudity devoid of most of their usual associations.

Abstract paintings do not confront us with such problems. Or at least the frequenting of abstract art can train us to relegate them automatically to their proper place; and in doing this we refine our eyes for the appreciation of non-abstract art. That has been my own experience. That it is still relatively rare can be explained perhaps by the fact that most people continue to come to painting through academic art—the kind of art they see in ads and in magazines—and when and if they discover abstract art it comes as such an overwhelming experience that they tend to forget everything produced before. This is to be deplored, but it does not negate the value, actual or potential, of abstract art as an introduction to the fine arts in general, and as an introduction, too, to habits of disinterested contemplation. In this respect, the value of abstract art will, I hope, prove far greater in the future than it has yet. Not only can it confirm instead of subverting tradition; it can teach us, by example, how valuable so much in life can be

made without being invested with ulterior meanings. How many people I know who have hung abstract pictures on their walls and found themselves gazing at them endlessly, and then exclaiming, "I don't know what there is in that painting, but I can't take my eyes off it." This kind of bewilderment is salutary. It does us good not to be able to explain, either to ourselves or to others, what we enjoy or love; it expands our capacity for experience.

Saturday Evening Post, August 1959; *Adventures of the Mind*, ed. Richard Thruelsen and John Kobler, 1960 (unrevised).

1960

18. Modernist Painting

Modernism includes more than art and literature. By now it covers almost the whole of what is truly alive in our culture. It happens, however, to be very much of a historical novelty. Western civilization is not the first civilization to turn around and question its own foundations, but it is the one that has gone furthest in doing so. I identify Modernism with the intensification, almost the exacerbation, of this self-critical tendency that began with the philosopher Kant. Because he was the first to criticize the means itself of criticism, I conceive of Kant as, the first real Modernist.

The essence of Modernism lies, as I see it, in the use of characteristic methods of a discipline to criticize the discipline itself, not in order to subvert it but in order to entrench it more firmly in its area of competence. Kant used logic to establish the limits of logic, and while he withdrew much from its old jurisdiction, logic was left all the more secure in what there remained to it.

The self-criticism of Modernism grows out of, but is not the same thing as, the criticism of the Enlightenment. The Enlightenment criticized from the outside, the way criticism in its accepted sense does; Modernism criticizes from the inside, through the procedures themselves of that which is being criticized. It seems natural that this new kind of criticism should have appeared first in philosophy, which is critical by definition, but as the 19th century wore on, it entered many other fields. A more rational justification had begun to be demanded of every formal social activity, and Kantian self-criticism, which had arisen in philosophy in answer to this demand in the first place, was called on eventually to meet and interpret it in areas that lay far from philosophy.

We know what has happened to an activity like religion,

which could not avail itself of Kantian, immanent, criticism in order to justify itself. At first glance the arts might seem to have been in a situation like religion's. Having been denied by the Enlightenment all tasks they could take seriously, they looked as though they were going to be assimilated to entertainment pure and simple, and entertainment itself looked as though it were going to be assimilated, like religion, to therapy. The arts could save themselves from this leveling down only by demonstrating that the kind of experience they provided was valuable in its own right and not to be obtained from any other kind of activity.

Each art, it turned out, had to perform this demonstration on its own account. What had to be exhibited was not only that which was unique and irreducible in art in general, but also that which was unique and irreducible in each particular art. Each art had to determine, through its own operations and works, the effects exclusive to itself. By doing so it would, to be sure, narrow its area of competence, but at the same time it would make its possession of that area all the more certain.

It quickly emerged that the unique and proper area of competence of each art coincided with all that was unique in the nature of its medium. The task of self-criticism became to eliminate from the specific effects of each art any and every effect that might conceivably be borrowed from or by the medium of any other art. Thus would each art be rendered "pure," and in its "purity" find the guarantee of its standards of quality as well as of its independence. "Purity" meant self-definition, and the enterprise of self-criticism in the arts became one of self-definition with a vengeance.

Realistic, naturalistic art had dissembled the medium, using art to conceal art; Modernism used art to call attention to art. The limitations that constitute the medium of painting—the flat surface, the shape of the support, the properties of the pigment—were treated by the Old Masters as negative factors that could be acknowledged only implicitly or indirectly. Under Modernism these same limitations came to be regarded as positive factors, and were acknowledged openly. Manet's became the first Modernist pictures by virtue of the frankness with which they declared the flat surfaces on which they were painted. The Impressionists, in Manet's wake, ab-

86

jured underpainting and glazes, to leave the eye under no doubt as to the fact that the colors they used were made of paint that came from tubes or pots. Cézanne sacrificed verisimilitude, or correctness, in order to fit his drawing and design more explicitly to the rectangular shape of the canvas.

It was the stressing of the ineluctable flatness of the surface that remained, however, more fundamental than anything else to the processes by which pictorial art criticized and defined itself under Modernism. For flatness alone was unique and exclusive to pictorial art. The enclosing shape of the picture was a limiting condition, or norm, that was shared with the art of the theater; color was a norm and a means shared not only with the theater, but also with sculpture. Because flatness was the only condition painting shared with no other art, Modernist painting oriented itself to flatness as it did to nothing else.

The Old Masters had sensed that it was necessary to preserve what is called the integrity of the picture plane: that is, to signify the enduring presence of flatness underneath and above the most vivid illusion of three-dimensional space. The apparent contradiction involved was essential to the success of their art, as it is indeed to the success of all pictorial art. The Modernists have neither avoided nor resolved this contradiction; rather, they have reversed its terms. One is made aware of the flatness of their pictures before, instead of after, being made aware of what the flatness contains. Whereas one tends to see what is in an Old Master before one sees the picture itself, one sees a Modernist picture as a picture first. This is, of course, the best way of seeing any kind of picture, Old Master or Modernist, but Modernism imposes it as the only and necessary way, and Modernism's success in doing so is a success of self-criticism.

Modernist painting in its latest phase has not abandoned the representation of recognizable objects in principle. What it has abandoned in principle is the representation of the kind of space that recognizable objects can inhabit. Abstractness, or the non-figurative, has in itself still not proved to be an altogether necessary moment in the self-criticism of pictorial art, even though artists as eminent as Kandinsky and Mondrian have thought so. As such, representation, or illustration, does not attain the uniqueness of pictorial art; what does do so is the associations

of things represented. All recognizable entities (including pictures themselves) exist in three-dimensional space, and the barest suggestion of a recognizable entity suffices to call up associations of that kind of space. The fragmentary silhouette of a human figure, or of a teacup, will do so, and by doing so alienate pictorial space from the literal two-dimensionality which is the guarantee of painting's independence as an art. For, as has already been said, three-dimensionality is the province of sculpture. To achieve autonomy, painting has had above all to divest itself of everything it might share with sculpture, and it is in its effort to do this, and not so much—I repeat—to exclude the representational or literary, that painting has made itself abstract.

At the same time, however, Modernist painting shows, precisely by its resistance to the sculptural, how firmly attached it remains to tradition beneath and beyond all appearances to the contrary. For the resistance to the sculptural dates far back before the advent of Modernism. Western painting, in so far as it is naturalistic, owes a great debt to sculpture, which taught it in the beginning how to shade and model for the illusion of relief, and even how to dispose that illusion in a complementary illusion of deep space. Yet some of the greatest feats of Western painting are due to the effort it has made over the last four centuries to rid itself of the sculptural. Starting in Venice in the 16th century and continuing in Spain, Belgium, and Holland in the 17th, that effort was carried on at first in the name of color. When David, in the 18th century, tried to revive sculptural painting, it was, in part, to save pictorial art from the decorative flattening-out that the emphasis on color seemed to induce. Yet the strength of David's own best pictures, which are predominantly his informal ones, lies as much in their color as in anything else. And Ingres, his faithful pupil, though he subordinated color far more consistently than did David, executed portraits that were among the flattest, least sculptural paintings done in the West by a sophisticated artist since the 14th century. Thus, by the middle of the 19th century, all ambitious tendencies in painting had converged amid their differences, in an anti-sculptural direction.

Modernism, as well as continuing this direction, has made

it more conscious of itself. With Manet and the Impressionists the question stopped being defined as one of color versus drawing, and became one of purely optical experience against optical experience as revised or modified by tactile associations. It was in the name of the purely and literally optical, not in the name of color, that the Impressionists set themselves to undermining shading and modeling and everything else in painting that seemed to connote the sculptural. It was, once again, in the name of the sculptural, with its shading and modeling, that Cézanne, and the Cubists after him, reacted against Impressionism, as David had reacted against Fragonard. But once more, just as David's and Ingres' reaction had culminated, paradoxically, in a kind of painting even less sculptural than before, so the Cubist counter-revolution eventuated in a kind of painting flatter than anything in Western art since before Giotto and Cimabue—so flat indeed that it could hardly contain recognizable images.

In the meantime the other cardinal norms of the art of painting had begun, with the onset of Modernism, to undergo a revision that was equally thorough if not as spectacular. It would take me more time than is at my disposal to show how the norm of the picture's enclosing shape, or frame, was loosened, then tightened, then loosened once again, and isolated, and then tightened once more, by successive generations of Modernist painters. Or how the norms of finish and paint texture, and of value and color contrast, were revised and re-revised. New risks have been taken with all these norms, not only in the interests of expression but also in order to exhibit them more clearly as norms. By being exhibited, they are tested for their indispensability. That testing is by no means finished, and the fact that it becomes deeper as it proceeds accounts for the radical simplifications that are also to be seen in the very latest abstract painting, as well as for the radical complications that are also seen in it.

Neither extreme is a matter of caprice or arbitrariness. On the contrary, the more closely the norms of a discipline become defined, the less freedom they are apt to permit in many directions. The essential norms or conventions of painting are at the same time the limiting conditions with which a picture must comply in order to be experienced as a picture. Modern-

Autonomy = masturbation?

ism has found that these limits can be pushed back indefinitely before a picture stops being a picture and turns into an arbitrary object; but it has also found that the further back these limits are pushed the more explicitly they have to be observed and indicated. The crisscrossing black lines and colored rectangles of a Mondrian painting seem hardly enough to make a picture out of, yet they impose the picture's framing shape as a regulating norm with a new force and completeness by echoing that shape so closely. Far from incurring the danger of arbitrariness, Mondrian's art proves, as time passes, almost too disciplined, almost too tradition- and convention-bound in certain respects; once we have gotten used to its utter abstractness, we realize that it is more conservative in its color, for instance, as well as in its subservience to the frame, than the last paintings of Monet.

It is understood, I hope, that in plotting out the rationale of Modernist painting I have had to simplify and exaggerate. The flatness towards which Modernist painting orients itself can never be an absolute flatness. The heightened sensitivity of the picture plane may no longer permit sculptural illusion, or *trompe-l'oeil*, but it does and must permit optical illusion. The first mark made on a canvas destroys its literal and utter flatness, and the result of the marks made on it by an artist like Mondrian is still a kind of illusion that suggests a kind of third dimension. Only now it is a strictly pictorial, strictly optical third dimension. The Old Masters created an illusion of space in depth that one could imagine oneself walking into, but the analogous illusion created by the Modernist painter can only be seen into; can be traveled through, literally or figuratively, only with the eye.

The latest abstract painting tries to fulfill the Impressionist insistence on the optical as the only sense that a completely and quintessentially pictorial art can invoke. Realizing this, one begins also to realize that the Impressionists, or at least the Neo-Impressionists, were not altogether misguided when they flirted with science. Kantian self-criticism, as it now turns out, has found its fullest expression in science rather than in philosophy, and when it began to be applied in art, the latter was brought closer in real spirit to scientific method than ever before—closer than it had been by Alberti, Uccello, Piero

90

della Francesca, or Leonardo in the Renaissance. That visual art should confine itself exclusively to what is given in visual experience, and make no reference to anything given in any other order of experience, is a notion whose only justification lies in scientific consistency.

Scientific method alone asks, or might ask, that a situation be resolved in exactly the same terms as that in which it is presented. But this kind of consistency promises nothing in the way of aesthetic quality, and the fact that the best art of the last seventy or eighty years approaches closer and closer to such consistency does not show the contrary. From the point of view of art in itself, its convergence with science happens to be a mere accident, and neither art nor science really gives or assures the other of anything more than it ever did. What their convergence does show, however, is the profound degree to which Modernist art belongs to the same specific cultural tendency as modern science, and this is of the highest significance as a historical fact.

It should also be understood that self-criticism in Modernist art has never been carried on in any but a spontaneous and largely subliminal way. As I have already indicated, it has been altogether a question of practice, immanent to practice, and never a topic of theory. Much is heard about programs in connection with Modernist art, but there has actually been far less of the programmatic in Modernist than in Renaissance or Academic painting. With a few exceptions like Mondrian, the masters of Modernism have had no more fixed ideas about art than Corot did. Certain inclinations, certain affirmations and emphases, and certain refusals and abstinences as well, seem to become necessary simply because the way to stronger, more expressive art lies through them. The immediate aims of the Modernists were, and remain, personal before anything else, and the truth and success of their works remain personal before anything else. And it has taken the accumulation, over decades, of a good deal of personal painting to reveal the general self-critical tendency of Modernist painting. No artist was, or yet is, aware of it, nor could any artist ever work freely in awareness of it. To this extent—and it is a great extent—art gets carried on under Modernism in much the same way as before.

And I cannot insist enough that Modernism has never meant, and does not mean now, anything like a break with the past. It may mean a devolution, an unraveling, of tradition, but it also means its further evolution. Modernist art continues the past without gap or break, and wherever it may end up it will never cease being intelligible in terms of the past. The making of pictures has been controlled, since it first began, by all the norms I have mentioned. The Paleolithic painter or engraver could disregard the norm of the frame and treat the surface in a literally sculptural way only because he made images rather than pictures, and worked on a support—a rock wall, a bone, a horn, or a stone—whose limits and surface were arbitrarily given by nature. But the making of pictures means, among other things, the deliberate creating or choosing of a flat surface, and the deliberate circumscribing and limiting of it. This deliberateness is precisely what Modernist painting harps on: the fact, that is, that the limiting conditions of art are altogether human conditions.

But I want to repeat that Modernist art does not offer theoretical demonstrations. It can be said, rather, that it happens to convert theoretical possibilities into empirical ones, in doing which it tests many theories about art for their relevance to the actual practice and actual experience of art. In this respect alone can Modernism be considered subversive. Certain factors we used to think essential to the making and experiencing of art are shown not to be so by the fact that Modernist painting has been able to dispense with them and yet continue to offer the experience of art in all its essentials. The further fact that this demonstration has left most of our old value judgments intact only makes it the more conclusive. Modernism may have had something to do with the revival of the reputations of Uccello, Piero della Francesca, El Greco, Georges de la Tour, and even Vermeer; and Modernism certainly confirmed, if it did not start, the revival of Giotto's reputation; but it has not lowered thereby the standing of Leonardo, Raphael, Titian, Rubens, Rembrandt, or Watteau. What Modernism has shown is that, though the past did appreciate these masters justly, it often gave wrong or irrelevant reasons for doing so.

In some ways this situation is hardly changed today. Art criticism and art history lag behind Modernism as they lagged behind pre-Modernist art. Most of the things that get written about Modernist art still belong to journalism rather than to criticism or art history. It belongs to journalism—and to the millennial complex from which so many journalists and journalist intellectuals suffer in our day—that each new phase of Modernist art should be hailed as the start of a whole new epoch in art, marking a decisive break with all the customs and conventions of the past. Each time, a kind of art is expected so unlike all previous kinds of art, and so free from norms of practice or taste, that everybody, regardless of how informed or uninformed he happens to be, can have his say about it. And each time, this expectation has been disappointed, as the phase of Modernist art in question finally takes its place in the intelligible continuity of taste and tradition.

Nothing could be further from the authentic art of our time than the idea of a rupture of continuity. Art *is*—among other things—continuity, and unthinkable without it. Lacking the past of art, and the need and compulsion to maintain its standards of excellence, Modernist art would lack both substance and justification.[1]

Forum Lectures (Washington, D. C.: Voice of America), 1960; *Arts Yearbook* 4, 1961 (unrevised); *Art and Literature*, Spring 1965 (slightly revised); *The New Art: A Critical Anthology*, ed. Gregory Battcock, 1966; *Peinture-cahiers théoriques*, no. 8–9, 1974 (titled *"La peinture moderniste"*); *Esthetics Contemporary*, ed. Richard Kostelanetz, 1978; *Modern Art and Modernism: A Critical Anthology*, ed. Francis Frascina and Charles Harrison, 1982.

1. In 1978, Greenberg added a postscript to a reprinting of "Modernist Painting" (*Esthetics Contemporary*, ed. Richard Kostelanetz). He wrote:
"The above appeared first in 1960 as a pamphlet in a series published by the Voice of America. It had been broadcast over that agency's radio in the spring of the same year. With some minor verbal changes it was reprinted in the spring 1965 number of *Art and Literature* in Paris, and then in Gregory Battcock's anthology *The New Art* (1966).
"I want to take this chance to correct an error, one of interpretation and not of fact. Many readers, though by no means all, seem to have taken the 'rationale' of Modernist art outlined here as representing a position adopted by the writer himself: that is, that what he describes he also advocates. This

19. Louis and Noland

The arrival of American painting has been demonstrated more tellingly by a younger generation of good second-rate artists than by an older generation of major ones. The latter may have made American painting exportable in the first place, but the former prove that it is. We used to have first-rate artists, like Eakins, Ryder, and Homer, or Maurer and Hartley, who filled a provincial situation to its limits but could never quite break out of these, and who therefore remained unexportable. Now we have artists who get shown and known abroad while still relatively young, and though none of them has yet done anything that warrants his being mentioned in the same breath with Eakins, Eakins still has to be rated a provincial artist and they manifestly do not. The paradox is one which the future may resolve, but for the time being it has to be endured.

What this paradox has already taught us in America is that the fact of not being provincial has an effect all its own. A certain vehemence, a certain confidence, and even authority, make themselves felt in hollow as well as resounding works of

may be a fault of the writing or the rhetoric. Nevertheless, a close reading of what he writes will find nothing at all to indicate that he subscribes to, believes in, the things that he adumbrates. (The quotation marks around *pure* and *purity* should have been enough to show that.) The writer is trying to account in part for how most of the very best art of the last hundred-odd years came about, but he's not implying that that's how it *had* to come about, much less that that's how the best art still has to come about. 'Pure' art was a useful illusion, but this doesn't make it any the less an illusion. Nor does the possibility of its continuing usefulness make it any the less an illusion.

"There have been some further constructions of what I wrote that go over into preposterousness: That I regard flatness and the inclosing of flatness not just as the limiting conditions of pictorial art, but as criteria of aesthetic quality in pictorial art; that the further a work advances the self-definition of an art, the better that work is bound to be. The philosopher or art historian who can envision me—or anyone at all—arriving at aesthetic judgments in this way reads shockingly more into himself or herself than into my article." [Editor's note]

art. The pitch of everything gets heightened. Artists are buoyed up by a sense of vast possibilities of attention and reputation, by the feeling that the eyes of art history are focused not too far away from the place they happen to be in. But this situation has its handicaps as well as advantages, and in the last ten years the former have increasingly outweighed the latter in New York. Kinds of art that would otherwise have faded into the background, or never even come to be, acquire a destructive virulence and set a bad example. Never before in New York has there been so much false and inflated painting and sculpture, never before so many false and inflated reputations.

In a previous number of this magazine William Rubin dealt with some of the brighter as well as darker aspects of the present situation of New York art. While agreeing with much of what he said, I still found him a little too kind toward many of the artists he discussed. They may have set their faces against the loose-brushed, dry-bristled, scumbled, and lathered surfaces of the de Kooning and Kline school, with its Cubist hangover, but not one among the New York painters Mr. Rubin mentioned has quite succeeded in breaking out of the cycle of virtuosity which began with that school. Virtuosity implies performance, and performance implies conformity with received tastes. There is a little too much of the received and the performed in even the best of the New York painters Mr. Rubin wrote about. I myself admire, or at least enjoy, the works of Raymond Parker, Ellsworth Kelly, Jack Youngerman, and Jasper Johns, but find them a little too easy to enjoy. They don't challenge or expand taste. This may not condemn their art, but it has made it, so far, less than major in its promise. And I do not see any reason why we, in America, should go back to celebrating what is less than major.

It is no coincidence that among all the painters Mr. Rubin discussed, neither of the two I consider serious candidates for major status (leaving Helen Frankenthaler and Paul Jenkins to one side as special cases) works in New York. I mean Morris Louis and Kenneth Noland, who both live in Washington, D.C., which fact is not unrelated to the quality of their work. From Washington you can keep in steady contact with the New York art scene without being subjected as constantly to

its pressures to conform as you would be if you lived and worked in New York. This circumstance, both Louis and Noland have known how to exploit—there are other artists living at a similar distance from New York, whether in Washington or elsewhere, who have not benefited from it at all. Louis and Noland are curious about what goes on in New York, they show there, and have learned a lot there. But what they have learned mostly is what they do not want to do, and how to recognize what they do not want to do. When they return to Washington to paint it is to challenge the fashions and successes of New York, and also its worldly machinery. (No New York museum has yet shown or bought the work of either.) Mr. Rubin says, rightly, that Raymond Parker's new painting carries with it a moral decision; so, I think, does the painting of Louis and Noland—a decision not eased in their case by the fact that 250 miles separate them from the new Babylon of art. Those miles also isolate them, and in so far as they accept the consequences of their isolation they make all the more of a moral decision.

Louis, who is now in his late forties, found himself only some seven or eight years ago. Until then he had been doing abstract pictures in a Late Cubist vein that belonged more to the 1930's than the 1940's; the enormous accomplishedness of these pictures did not make them any the less provincial. His first sight of the middle-period Pollocks and of a large and extraordinary painting done in 1952 by Helen Frankenthaler, called *Mountains and Sea*, led Louis to change his direction abruptly. Abandoning Cubism with a completeness for which there was no precedent in either influence, he began to feel, think, and conceive almost exclusively in terms of open color. The revelation he received became an Impressionist revelation, and before he so much as caught a glimpse of anything by Still, Newman, or Rothko, he had aligned his art with theirs. His revulsion against Cubism was a revulsion against the sculptural. Cubism meant shapes, and shapes meant armatures of light and dark. Color meant areas and zones, and the interpenetration of these, which could be achieved better by variations of hue than by variations of value. Recognitions like these liberated Louis's originality along with his hitherto dormant gift for color.

The crucial revelation he got from Pollock and Frankenthaler had to do with facture as much as anything else. The more closely color could be identified with its ground, the freer would it be from the interference of tactile associations; the way to achieve this closer identification was by adapting watercolor technique to oil and using thin paint on an absorbent surface. Louis spills his paint on unsized and unprimed cotton duck canvas, leaving the pigment almost everywhere thin enough, no matter how many different veils of it are superimposed, for the eye to sense the threadedness and wovenness of the fabric underneath. But "underneath" is the wrong word. The fabric, being soaked in paint rather than merely covered by it, becomes paint in itself, color in itself, like dyed cloth: the threadedness and wovenness are in the color. Louis usually contrives to leave certain areas of the canvas bare, and whether or not he whitens these afterwards with a thin gesso—as he has taken to doing lately—the aspect of bareness is retained. It is a gray-white or white-gray bareness that functions as a color in its own right and on a parity with other colors; by this parity the other colors are leveled down as it were, to become identified with the raw cotton surface as much as the bareness is. The effect conveys a sense not only of color as somehow disembodied, and therefore more purely optical, but also of color as a thing that opens and expands the picture plane. The suppression of the difference between painted and unpainted surfaces causes pictorial space to leak through—or rather, to seem about to leak through—the framing edges of the picture into the space beyond them.

This kind of painting requires a large format. Abstract painting in general has begun to require it, and abstract "color" painting in particular requires it. Even Monet, toward the end of his life, required it. Louis is "confined" to the huge canvas as inevitably as Clyfford Still is. This is not the place to go into all the internal reasons involved in this necessity of largeness, but one of them is, most definitely, the need to have the picture occupy so much of one's visual field that it loses its character as a discrete tactile object and thereby becomes that much more purely a picture, a strictly visual entity. As it seems to me, the "aesthetic" of post-Cubist painting—by which I mean painting after Kline, after Dubuffet, and even

after Hans Hofmann—consists mostly in this renewal of the Impressionist emphasis on the exclusively visual.

The logic of Kenneth Noland's art does not demand an outsize format, but only because that logic in itself is so purely visual. Noland, who is now in his middle thirties, came under the same influences as Louis at the same time that Louis did, and was then influenced, on top of that, by Louis himself. Only within the last two years has he been able to break free and begin speaking with his own voice. However, just as the predominantly vertical movement of Louis's later paintings was already apparent in his earlier ones, so the centered movement of Noland's most recent pictures had already entered many of those he painted before. And he, too, was a highly accomplished artist before he was ever an original one.

With Noland, the denial of the picture's orientation to gravity, thus of its weight as well as of its palpability, amounts to an obsession. But it is an inspiring obsession, and only when he was at last able to act upon it without qualms did Noland become a mature painter. It was then that he began to let the centered, revolving movement of his earlier pictures crystallize out into compass-drawn concentric bands of flat color, or into ruled lozenge shapes, or into wavering cruciform patterns. The picture, composed of a single motif, was "planted" in an almost absolute symmetry, with the difference between top and bottom as well as between right and left indicated in only the smallest ways and the canvas itself always square. As Mr. Rubin pointed out, Noland's motifs do not possess the quality of images; they are present solely in an abstract capacity, as means solely of organizing and galvanizing the picture field. Thanks to their centeredness and their symmetry, the discs, the diamonds, and the crossed arms create a revolving movement that spins out over unpainted surfaces and beyond the four sides of the picture to evoke, once again, limitless space, weightlessness, air. But just as in Louis's case—and the middle-period Pollock's—the picture succeeds, when it does succeed, by reaffirming in the end (like any other picture that succeeds), the limitedness of pictorial space as such, with all its rectangularity and flatness and opacity. The insistence on the purely visual and the denial of the tactile and ponderable remain in tradition—and would not result in convincing art did they not.

98

Facture plays as essential a role for Noland as for Louis. He too works on unsized and unprimed cotton duck, but he usually leaves much more of the surface unpainted (seldom going so far even as to whiten it with gesso). The naked fabric acts as a generalizing and unifying field; and at the same time its confessed wovenness and porousness suggest a penetrable, ambiguous plane, opening up the picture from the back so to speak. And given that Noland uses "hard-edge," trued and faired forms, both the bare wovenness and the color-stained wovenness act further to suppress associations with geometrical painting—which implies, traditionally, a smooth, hard surface. Often Noland garnishes his discs and lozenges with painterly flicks and splashes, but whether he does so or not, the effects of geometrical art remain foreign to his purposes. But so too do those of painterly abstraction, especially now that painterliness in abstract art has degenerated almost everywhere into a thing of mannered and aggressive surfaces (or else has evolved into bas-relief). Noland's art owes much of its truly phenomenal originality to the way in which it transcends the alternative between the painterly and the geometrical. Perhaps Louis (and Frankenthaler) have set the precedent here, but Noland has confronted the issue more squarely, and I think that his solution has had an influence upon Louis in return. In both cases, the statement of the woven and threaded ground deprives the picture of that "made," precious-object look which now tends to afflict abstract pictures that get finished according to the conventional procedures of oil painting. The benefit that both artists have obtained in exchange is a freshness and immediacy of surface that are without like in contemporary art.

If Noland has to be categorized, I would call him a "color" painter too. His color counts by its clarity and its energy; it is not there neutrally, to be carried by the design and drawing; it does the carrying itself. Like Louis's, Noland's pictures lose more in black and white than most pictures of our time do; in fact, they lose almost as much as Barnett Newman's do. . . .

Mr. Rubin wrote that Louis may be comparable in stature to the "first-wave pioneers" of the new American painting—the artists of Pollock's vintage. I myself would say that Louis, Noland, and Sam Francis are the only painters to have come up in American art since that "first wave" who approach

its level. It is no accident that Francis, too, is a "color" painter, and that he likewise formed himself away from New York. But right now I am not half so sure about him as about the other two. Louis and Noland are not only far more fertile in invention; the quality of their art is also more upsetting, more profound.

Art International, May 1960; Michael Fried, *Morris Louis*, 1967 (abridged).

20. Letter to the Editor of *The New York Times*

To the Editor:

This letter is prompted by remarks in the article of May 15, on Harry Jackson's show of sculpture and drawings at Knoedler's. You write: ". . . . for six years—1948 to 1954—he (Mr. Jackson) was actively involved in abstract expressionism. He exhibited in some of the galleries that lead in the promotion of the New York School, and he received most favorable notice from esoteric sources. Mr. Jackson's reaction to his success seems to have been that if abstract expressionism was that easy, it wasn't worth fooling with. . . . "

This has just enough truth in it to defeat the truth. Mr. Jackson was shown at Kootz's in an exhibition called *Talent 1950*[1] and had two one-man shows of abstract paintings at the Tibor de Nagy Gallery. The only markedly favorable notice either show received was in *The New York Times* (which may or may not be an "esoteric source"), while *Art News* was mildly favorable on one occasion. Outside print, as I have reason to know, Mr. Jackson's painting was noticed with enthusiasm by about a handful of people, including myself. The new works in his third show, at the Martha Jackson Gallery, were entirely non-abstract.

I happen to be a friend of Mr. Jackson as well as an admirer

1. Greenberg, together with Meyer Schapiro, selected the artists for *Talent 1950* held at the Kootz Gallery. The painting exhibited by Harry Jackson was called *Triptych* (see vol. 3). [Editor's note]

of his talent, and the way it looked to me, his return to realism was made in despair. His first exhibition had contained what I thought were four or five remarkable pictures, but they were not enough to establish him as more than a very brilliant beginner. By the time of his second show he was having many difficulties. In the light of all this, the notion that he put abstract art aside as something he found it too easy to win success in seems nothing less than preposterous.

You also remark that "it is going to take Mr. Jackson longer to turn himself into a great realist than it did to become a nine-day abstract expressionist wonder." Mr. Jackson studied with Hans Hofmann and worked as hard at abstract art as anyone has ever worked at any other kind of art in order to make an auspicious debut at the age of 26. Nor were his previous years of academic training without a part in this.

I find the best art of our time to be preponderantly abstract, but I could wish it were not. All other things being equal (which never happens), I too prefer illusionist art. But art critics cannot have it their own way. It seems to me that you want it your own way so much that you let yourself distort the evidence. The fact that so much bad abstract art gets produced should be enough in itself to tell you how difficult it is to attain excellence in it.

Clement Greenberg
New York

The New York Times, 29 May 1960

21. The Early Flemish Masters

It would not be correct to say that the Flemish Primitives are overlooked, but they do get put to one side.[1] This happens to be far more the doing of artists than of critics, scholars or collectors. As far as I know, not a single important painter since the end of the sixteenth century has, in either works or words, betrayed any significant interest in anything in Flemish

1. The occasion for this essay was the exhibition, *Masterpieces of Flemish Art: Van Eyck to Bosch*, at the Detroit Institute of Arts. [Editor's note]

painting before Bosch. The interest of connoisseurs and art writers was attracted to the Flemish Primitives at about the same time in the last century that it was attracted to the Italian Primitives, but over the last hundred years artists have not been heard talking about Van Eyck or Van der Goes as they have talked about Giotto and Masaccio and Piero. This is true even of the painters who revived a sharp-focused realism; they have alluded to the Italians, to the nineteenth century, to the Dutch and to Holbein (who was himself markedly influenced by the first Flemish school), but not to the early Flemish painters who were the original masters of this kind of realism. It is as if Michelangelo's remarks on Flemish art became a binding negative precedent after the High Renaissance— binding, for instance, on even such a partisan of close-focused realism as Ruskin.

Michelangelo is reported to have said that Flemish painting was done "without reason or art, without symmetry or proportion, without skillful choice or boldness, and finally, without substance or vigor." Roger Fry repeated the same charge, in effect, when he wrote that the Flemish concern with a "minute and detailed verisimilitude" and their "indifference to the universal aspects of form" excluded them from the "great European tradition founded by Giotto." With one or two exceptions, Fry said, the early Flemish painters were unable to situate "volumes in credible space"; they neglected the "relations of volumes"; even Jan van Eyck was "insensitive . . . to plastic continuity." They had to rely solely on linear rhythms and "harmony of tone" for "unity of design." But even when they obtained harmony of tone, the "sense of color as a plastic function," as a means of specifying mass and depth, remained absent. In short, too much of fifteenth-century Flemish painting lacks that instantaneous, compact and monumental unity which the contemporaneous painting of Italy developed and to which Western pictorial taste has oriented itself ever since.

I think Fry is wrong in identifying this kind of unity so exclusively with the articulation of volumes in "credible" space; after all, abstract art, with its shallow or nonexistent depth, has shown itself capable of achieving it. But even at his most dogmatic Fry usually has hold of the truth somewhere, and here he has hold of a good piece of it. Where painters are

as fully committed to verisimilitude as the Flemings were, incoherences in the illusion will almost always be reflected in the surface pattern. Unity as such is an uncertain thing in even the best of early Flemish painting. The main tradition of European painting received a great deal from the Flemish Primitives in a piecemeal way, especially in regard to color and the shading of color, but it did not receive an integrated vision, a synthesis. And syntheses, not piecemeal triumphs, are what the artists of a ripened tradition look for in the remoter past.

Contrary, however, to a growing popular belief, artists are not always the best critics. There is a lot else to be said for early Flemish painting, as Fry himself would have been the first to admit (and had he lived longer he might have been pressed harder, and more fruitfully, on that and several other large topics). For me, Flemish art has been an acquired taste, but all the more precious because acquired, and acquired relatively late. The impression left by certain masterpieces of that art forced me to expand and revise old habits of vision, as a result of which I became aware, as not even with post-1880 Impressionism, of how much sheerly pictorial power color—translucent, vitreous color—is capable of even when it doesn't "hold the plane." It is the "detached" strength of Memling's color that makes me admire him more perhaps than is thought proper nowadays; and Gerard David's color, which is less "detached," makes him for me, in certain pictures (like both the Metropolitan Museum's and the Washington National Gallery's versions of *The Rest on the Flight to Egypt*), one of the greatest of all painters. An appreciation of "detached" color is eccentric no doubt to Western tradition and easier to acquire in connection with Persian rugs—where color not only holds but *is* the plane—than with easel pictures. One forgets, however, that this disembodied, floating kind of color is like that which makes the glory of the windows at Chartres, which are just as "Western" as Leonardo's painting. (It is also the kind of color that is closest to that in the best and most advanced of very recent easel painting in America.)

That color is the clue to the real excellence of the Flemings is borne out, obliquely, by the less ambiguous excellence, at least for latter-day taste, of Hieronymus Bosch's art. Bosch's color is tender and delicate like Memling's, but even less "plas-

tic" and far more lambent; it is a thing of flushes and suffusions and puffs; it asserts spatial relations but not volumes; it indicates objects quite vividly but barely defines their mass. Bosch's color is perhaps the least "plastic" there is in Flemish panel-painting between Van Eyck's (in a picture like the tiny *St. Francis Receiving the Stigmata* in Philadelphia) and Brueghel's but it is the color that is best integrated with the drawing and design with which it is found. The fact of this integration spells out how dogmatic and ultimately beside the point Fry's objections to Flemish color are. When that color found appropriate employment, as it did in Bosch, it contributed to a pictorial unity as monumental as any in European art. And it is significant that it is Bosch's drawing and design, *not* his color, that separate him so abruptly from all previous panel-painting in Europe.

Ludwig van Baldass derives Bosch's "synthetic," unmodeled and flattish way of drawing, which he calls the "soft style," from a kind of miniature painting, attributed both to Van Eyck or his school and to immediate predecessors of Van Eyck, that is found in the Turin *Book of Hours*. It seems to me that Bosch retains the startling and almost Impressionist naturalism achieved by the "soft style" in the Turin manuscript only in his landscape backgrounds; that elsewhere he simplifies it beyond naturalism or realism. But in doing this he heightens its anti-sculptural tendency, and I feel that it is this anti-sculptural tendency more than anything else that is responsible for Bosch's being the first Flemish master consistently to obtain firmness of design in large-scale group compositions.

Here we have a clue to some of the difficulties—not the excellences—of Bosch's predecessors. It seems to me that the original vision of the Flemish Primitives was of a realism conceived wholly in terms of the "soft style," and that Van Eyck's original enterprise was to transpose these into oil-on-panel painting. But precisely because it was a vision of realism, and because it had to be transposed into a larger size, the example of sculpture intervened. Sculpture was still far ahead of painting in point of consistent verisimilitude in Van Eyck's time. I think that, once he was faced with the task of shading and modeling the human figure in larger format, Van Eyck let sculpture seduce him away from the optical integrity of the

"soft style." Thanks to that seduction we have the marvelous *grisailles* of the Ghent Altarpiece. And thanks to it we also have the entire achievement of Rogier van der Weyden, the least "soft" of all the Flemish masters, and the one with whom the sculptural became conclusively installed in early Flemish painting.

But I also think that the sculptural was far more responsible for the Flemings' difficulties with design than was the literalness of their realism. Without the sculptural they might have soon found a way of making the literal "harmonious." As it was, their besetting fault was not that they did not model enough, as Fry thinks, but that they modeled too much and too closely. And that, when dealing with the full-length human figure, they imitated too literally the abundant lateral and vertical folds of drapery in Late Gothic carving. (The Italian Primitives had better luck with their sculptural models.) Over-modeling is what caused the Flemings the most trouble, apparently, when it came to the handling of volumes in their large group compositions—over-modeling and the "soft style." (But the "soft style" can wait for a moment.) The fact is that one could learn to model from sculpture, but not to arrange the results of modeling in space of more than bas-relief depth. This may be the reason why painters like Memling usually had more success with the wings of an altarpiece than with its middle, for the wings presented a narrow, niche-like space that was closest to the kind of space Gothic statuary itself occupied. The most frequent triumphs of Flemish painting in the fifteenth century tend to be portraits (if only because drapery does not intrude), single and paired figures, donor groups. Not that the Flemish masters do not succeed on more than a few occasions with large figure compositions, but even when they do the result still feels a little too loose: there is too much centrifugal movement, and the margins can seem crowded at the expense of the rest of the picture. At the same time figures will appear too monotonously or stiffly vertical, and with too much unarticulated space around them.

But not all of this is due simply to the fact that volumes won't stay in place frontally or laterally. It happens that all the Flemish Primitives, even Van der Weyden, retained something of the "soft style" in the outdoor backgrounds they favored.

And the discrepancy between this background, which manages to be present even when there is no vista, and the sculptural handling of their large foreground masses is perhaps the deepest source of their difficulty in situating volumes (as well as being responsible for some of the most charming passages in their pictures). The disjunction between a highly modeled foreground and a background handled so flatly it could not seem any thing but abruptly distant prevented the artist from arriving at a plausible middle-ground. The crux was lack of spatial, not of plastic, continuity. And this lack could throw everything else in the picture out of kilter.

Bosch solves the problem by bringing the "soft style" into the foreground. He broadens and generalizes and flattens his modeling even in his half-length, close-up figures. And at the same time that he renounces detailedly sculptural modeling he renounces that concern with the texture and grain of surfaces which, in early Flemish painting, is as much bound up with closely sculptural modeling as it is with anything else. The "soft style" is for the first time integrated in oil-on-panel painting in a way that does not smack of tour de force. A stable and abiding synthesis is achieved. It is with Bosch, in a picture like his Prado *St. Anthony*, rather than Massys, that Flemish painting really enters the "central" tradition.

Arts Magazine, December 1960; *Arts Yearbook 6*, 1962 (unrevised).

1961

22. The Jackson Pollock Market Soars

No other American artist, not even Whistler (if we consider him an American artist), has created such a furor in the world as the late Jackson Pollock.[1] Pollock died in an automobile accident in August, 1956, at the age of 44, but even before that his name had begun to be a byword, soon known to Jack Paar as well as Alfred Barr, for what is most far-fetched in contemporary abstract art.

An American critic has called Pollock "the most controversial figure . . . perhaps in all twentieth-century art." He is supposed to have started a whole new movement in painting and to have influenced not hundreds, but thousands, of fellow-painters. In Europe he is spoken of as a kind of demiurgic genius, one who led art out of the "circle of culture" into a new realm of spontaneity. A Pollock was one of the first works acquired by the Tate Gallery in London for its newly established American wing. Another of his oils, measuring a little over three by eight feet, was sold several months ago in New York for more than $100,000. Owners of his really large paintings are reluctant to sell them for any sane price, it would seem.

This is not to say that Pollock's art is universally accepted, or that there are not people who find it wildly arbitrary, chaotic, or, at best, a matter of aimless decoration. Yet such negative reactions have so far only provided more grist for the mill of Pollock's fame. Many of his admirers also find him arbitrary, but exalt this quality into a virtue and claim that his triumph consists precisely in having liberated painting from all discipline and made it an entirely personal means of self-expression. To take these same admirers at their word, his paintings are

1. The title was chosen by the editors of *The New York Times Magazine*; Greenberg has disavowed it on several occasions. [Editor's note]

really oversize doodles that stand as records solely of self-revelatory "gestures."

These and other equally improbable notions have gone to transform Pollock's reputation into a myth that swallows admirers and detractors alike. Sir Herbert Read has characterized his works as the products of a "vacuous nihilism that . . . scribbles a graph of its uncertainty on the surface of a blank consciousness." Yet in his latest survey of modern art Sir Herbert treats Pollock as he would a consecrated master.

It is not so surprising that the skeins of flung and spattered paint in the pictures of Pollock's best known phase should be taken for unedited statements of raw feeling and sensation. What is surprising is that, being taken for this, his paintings should also be taken for art—even bad art. Part of the distressing answer lies in the fact that the notion of an "art of raw sensation" meets certain cherished preconceptions about what Americans are capable of in the way of original art.

Abroad, Grandma Moses' pictures used to stand for native American art, and one of her landscapes was the first American work acquired by the Musée de l'Art Moderne in Paris. Now, however, European critics dwell on how unmistakably Pollock's "untutored, barbaric force"—which supposedly violates rules that Grandma Moses still observes—conveys the youthful energies and recklessness of a people still unschooled in the traditions and refinements of art. And they also say that he has rediscovered sources of artistic inspiration from which polite art was cut off millennia ago. This makes Pollock not only an original artist, but a culture hero—in European eyes the first and only genuinely American culture hero since Walt Whitman.

A great misunderstanding is involved here; and a different poet than Whitman springs to mind. Dylan Thomas, who died in 1953, is the object of a myth whose likenesses to Pollock's are more instructive. In both his and Pollock's case the public has had a valid sense of a real achievement. Thomas did write some of the very best poetry of our time, and Pollock actually did do some of its very best painting. Their reputations as such are not inflated.

What is inflated, and exaggerated and distorted, are the accompanying interpretations. Thomas' poetry, too, was first

taken for the undisciplined effusions of a possessed man. But because it was quite plain that his verse scanned and even rhymed, and also because literary taste is relatively well informed, that part of Thomas' myth that had to do with his artlessness died early.

It is much harder to discern the "scansion" and the "rhymes" in Pollock's art. Contemporary taste in painting (and sculpture) is quite uninformed by comparison with taste in literature, and it is as though Pollock's art were sent on purpose to expose its helplessness. Without that helplessness, and without the pusillanimity and intellectual bad faith of art critics, the idea of Pollock as a kind of cosmic primitive, and of his art as an affair of automatic gestures, would have been exploded long ago.

It is true that Pollock himself once said that he got his main inspiration from his unconscious, and that he felt unaware of what he was doing when he was first "in the painting." Later on, however, he seems to have been bothered by the conclusions he heard being drawn from these remarks.

In 1951 he stated, in qualification of what he had previously said (and one smiles at the way he had to put it): "When I am painting I have a general notion as to what I am about."

He was one of the people least likely not to know that art was impossible without the observance of norms and conventions. No one had ever worked harder than he to learn the norms and conventions, and to master the skills they implied. He began his artistic apprenticeship when he was 16; it included years of study with an artist as academic as Thomas Hart Benton, and he did not finish it until he was 30.

The art of Pollock's maturity did not come out of the blue, or solely from his own temperament. It also came from the art before him, from Picasso and Miró and Klee, from Matisse, and from Siqueiros, Orozco, and Ryder. And he did not appear on the scene alone: he entered it in the company of a number of other American painters in New York who found themselves in the Nineteen Forties in a way that likewise attracted the world's notice in the end. Three or four of these other painters have gone even further than Pollock in point of innovation, if not with results so immediately startling.

For all its initial violence, Pollock's originality was not such as to compel him to break with certain canons of style laid down by the Cubists. This may sound surprising, but one has to remember that advanced art has always turned out in the long run to be less advanced, less removed from tradition, than it first looked.

As with Mondrian, underneath the strange look of Pollock's art a set of more or less familiar conventions continues to operate. What is strange and new is not the "words," but their inflections.

Pollock's paintings of 1941−46 develop things found in Picasso's brightly colored Late Cubism of the early Thirties, with its ornamental patterns and heavy, cursive lines (see the Museum of Modern Art's *Girl Before a Mirror* of 1932). On the other hand, his "all-over" paintings of 1947−50 ("all-over" because their design repeats itself all over the surface) continue Braque's and Picasso's earlier, monochromatic Cubism of 1910−12, with its shutter-work of planes.

Braque and Picasso themselves abandoned this kind of Cubism (which is called Analytical because it "analyzes" volumes into planar units) for fear it would lead them into completely abstract art.

The interstitial spots and areas left by Pollock's webs of paint answer Picasso's and Braque's original facet-planes, and create an analogously ambiguous illusion of shallow depth. This is played off, however, against a far more emphatic surface, and Pollock can open and close his webs with much greater freedom because they do not have to follow a model in nature.

By means of subtle variations within the minimal illusion of depth, he is able, moreover, to inject dramatic and pictorial unity into patterns of color, shape, and line that would otherwise seem as repetitious as wallpaper.

For the spectator the problem is to learn to recognize this kind of unity. Pollock is not always able to achieve it, and when one can tell the difference, which is the difference between the success and failure of his pictures, then one has mastered what is essential in the art of his all-over phase.

Even so, it is not the unity as such that counts in the last

resort, but what the unity communicates. Pollock's art catches even the untutored imagination, thanks above all to the richness and variety of feeling it conveys—and not because it makes an assault on the eye.

When I first began to admire Pollock's painting it was for its intensity and force; later on, it was for its clarified splendor and eloquence; right now I would praise it most for its range of mood. That range, that reach, is of a kind attainable only through the nearest contemporary thing to a truly grand style.

Contrary to the prevalent impression, Pollock was already an original artist, and painted what remain some of his best works, in the four or five years before he adopted his so-called "drip" technique. Hans Hofmann had used it before he did, and Pollock resorted to this technique for much the same reason that Hofmann had: not for shock effect, but out of impatience with the facile, "artificial" edges left by the brush, the palette knife, or even the tip of the brush handle, with all that these instruments reflect of the too habitual dexterity of finger, wrist, and elbow.

Pollock learned to control flung and dribbled paint almost as well as he could a brush; if accidents played any part, they were happy accidents, selected accidents, as with any painter who sets store by the effects of rapid execution.

Contrary again to the prevalent notion, Pollock often revised and retouched his paintings. He had as much capacity for self-criticism as any other artist I have known. As far as I can see, it was his own sense of a loss of authenticity in the things he did after 1952 that led him to stop painting almost entirely in the last year and a half of his life.

Much has been made of Pollock's way of working: how he spread his canvases on the floor and walked around and even over them, whipping paint from a stick or spilling it from a can. But his smaller pictures were not made in quite this way, or the larger ones he did before 1947. Until he adopted his "drip" technique he painted—like Bonnard—on unstretched canvas tacked to the wall, because, as he explained, he preferred a resistant surface.

Like any other artist, he worked rapidly or slowly. He might lay out the "skeleton" of a large picture in twenty min-

utes, but from then on he would stop periodically to study the results, and his execution was often very careful and deliberate. I have seen people paint landscapes faster than Pollock could pictures of equivalent size. Like so many other things about him, the unconventionality of his procedure has been exaggerated.

Paul Klee and the Surrealist painters Joan Miró and André Masson anticipated him in reliance upon "automatic" drawing or doodling in order to get a picture started, and Pollock applied just as much taste and control as they in the finishing of a picture.

In the final analysis, perhaps, myths about artists like Pollock and Dylan Thomas feed less on their art than on their personalities. Pollock, like Thomas, had his troubles with alcohol, and his behavior under its influence conformed all too well to popular notions about how geniuses react against convention.

Sober, Pollock was a shy man who did not find it easy to talk. He had no artist's airs and cut no figure. His feelings of clumsiness and of social and intellectual inadequacy made it hard for him to show how much was going on inside him.

Of such stuff, too, are legends, as well as artists, formed, and Pollock's death at a relatively early age sealed as well as swelled the outlines of a legend already in the making (just as Thomas' premature death added the final touch to his already flourishing legend).

Where myth and legend have taken over with a vengeance is with regard to Pollock's early life. That he was born in Wyoming and spent his boyhood on truck farms in the Southwest have caused many people to visualize him as a kind of frontier character and therefore all the more of a primitive. It was even rumored, unfoundedly, that he had been a cowboy, which threw many of his European admirers into raptures.

Pollock himself was not entirely guiltless in this matter. When in the country, he continued to wear high-heeled cowboy boots—like many another man from the far West—until he was close to 40. (This predilection led Harold Rosenberg, in last February's issue of *Art News*, to conclude that Pollock was an actor. Ironically enough, a 1952 essay of Mr. Rosen-

berg's called "The American Action Painters" was, if only inadvertently, a main factor in the creation of the myth about the arbitrariness of Pollock's painting.)

The truth is that Pollock and his four older brothers were raised by a mother filled with cultural aspirations, and when he began to study art at high school in Los Angeles, it was in the footsteps of his oldest brother Charles, a painter who now teaches at Michigan State University. Pollock himself always regretted that he had not gone on to college and become more of an intellectual. He was only 18 when he came East to continue studying art, and the rest of his life was passed in New York and in East Hampton, Long Island.

After supporting himself by all sorts of odd jobs, he was employed from 1938 to 1942 on the W.P.A. Arts Project, that great incubator to which American painting owes most of the head start it got on the world in the Nineteen Forties.

If any one "discovered" Pollock, it was John Graham, himself a painter as well as a connoisseur, who organized a show of French and American painting at a New York gallery in 1940 in which work by Arshile Gorky and Willem de Kooning as well as Pollock was included.

In 1943 Pollock's first one-man show opened in a West Fifty-seventh Street gallery run by Peggy Guggenheim and Howard Putzel, and in every year thereafter until 1953 he had a one-man show in New York. In 1945 he married a fellow painter, Lenore Krasner, and moved out to East Hampton—which was where, eleven years later, he had his fatal accident.

Nor was Pollock's personal presence as exceptional as has been made out. A man of medium height, well-built but not conspicuously so, blond and prematurely bald, he made a point of dressing conventionally when away from home, and before he grew a beard he would have been taken more readily for a civil engineer than an artist. It took a second glance to notice his taut face and unusually grave eyes. Pollock belonged very much to the New York art world, and for all his own taciturnity was as interested in its talk and gossip as everybody else in it.

Perhaps he was more interested than most in serious and

relevant discussion of art. When he himself talked about art it was with what I found to be unusual pertinence and insight: in fact, what stands out in my memory is how much more Pollock knew what he was about than most artists do.

All this went by the board, however, when he had even a small amount of alcohol in him. It is on his drunken behavior that the stories of his noisy self-assertiveness are founded—a self-assertiveness that had singularly little direct relation to either his art or his serious self.

Obviously, the novel complexion of Pollock's art seems to many people to be best accounted for by the fact that he came out of the unsophisticated West; the same or similar people find the turgid images of Dylan Thomas' poetry best explained by his coming from a Celtic land with a tradition of raving bards.

These are less than simplifications, they are stereotypes; and with, alas, a certain encouragement from the facts, they have, in Pollock's as in Thomas' case, attracted further stereotypes.

Indeed, it is as though both these extraordinarily gifted young men had acted out the last years of their lives with a set of stereotypes in mind. They both became stellar examples of the syndrome of the *artiste maudit*—the damned or cursed artist, self-destructive in his impatience with the ordinariness of life, self-consuming in the service of his art.

Why the public is so fascinated by the spectacle of this kind of suffering cannot be discussed here. Suffice it to say that the completeness with which Pollock appears to have exemplified the syndrome of the *artiste maudit* has invested his legend with a resonance like that of van Gogh's and Modigliani's.

As one who was a friend of Pollock, I can only deplore this. Glamour is cast over a lot of wretchedness that in principle had little to do with art. And somehow the false glamour interferes with the recognition of the great and sophisticated qualities of his art itself.

The New York Times Magazine, 16 April 1961; *Macula* 2, 1977 (titled *"Pollock cinq ans après"*).

23. Letter to the Editor of *The New York Times Magazine*

To the Editor:

I agree the drawing [by Jackson Pollock, after Michelangelo] contains distortions.[1] But it is quite obvious that these are not of a kind due to ineptitude. Notice that there are no errors of proportions or positioning. The distortions are matters of emphasis. I do not see anything grossly inaccurate in the rendering of the torso, and the calf "jumps" only when you focus on it to the exclusion of everything else; otherwise, it seems a necessary accent.

As for Mr. Lortz's remarks,[2] the inability to discern the difference within a class of things—or people—to which one is new has always to be reckoned with. Didn't Europeans used to say of Chinese—and Chinese say of Europeans—that they all looked alike?

Clement Greenberg
New York

The New York Times Magazine, 30 April 1961

24. A Critical Exchange with Thomas B. Hess about *Art and Culture*

To the Editor:

Thomas B. Hess's review of my book *Art and Culture* is exceedingly complimentary, but exaggerates my role as a champion of advanced American art in an embarrassing way. Until late in 1947 I praised rather little in that art outside the sculpture of David Smith, the painting of Pollock and Arshile

1. The drawing was illustrated in Greenberg's article, "The Jackson Pollock Market Soars." B. H. Friedman objected to the inclusion of such an "early effort" by Pollock as evidence of Pollock's competence as an artist. [Editor's note]
2. Richard Lortz had written to the editor to suggest that Pollock's difficulties stemmed from his endless repetitions of himself. [Editor's note]

Gorky, and the teaching of Hans Hofmann. (See the surveys I wrote for *Les Temps Modernes* in Paris and for *Horizon* in London, in 1946 and 1947 respectively.) But even afterwards, I did hardly any talking up of American art from lecture platforms, in "sidewalk gabbles," in cafeterias, or at cocktail parties. That's all too highly colored to be true. Nor have I ever been anything like a "baron" among New York abstract artists. Ask them.

On the other hand, it is incorrect to say that I "never" accepted the art of Willem de Kooning or Franz Kline. I praised de Kooning's first show in 1948 in *The Nation*, and several years later did the catalogue note for a retrospective show he had in Washington, D. C. The advertisement in *The Times* for Kline's first show in 1950 carried a short blurb by me, and two years later I wrote in praise of him in *Partisan Review*.[1] (If anything, I was perhaps more deeply "immersed" in Kline's "aims" for a moment in 1950 than in those of any artist before him.)

Clement Greenberg
New York

To the Editor:

I am astonished at Mr. Greenberg's sudden modesty. I seem to recall, when I first met him in 1948, that he spoke loudly and clearly on all occasions about vanguard American art and artists. Also I seem to remember attacks under his byline on Arshile Gorky's paintings and that Mr. Greenberg later publicly apologized for them at a symposium where I happened to be the moderator. Perhaps this was all a dream? His attacks on Hans Hofmann's paintings must have been real enough for Mr. Greenberg to compel him to admit these errors in his re-edited essays.

I defer to his renunciation of a barony; the aristocracy is a slippery class; "brigadier general" might have been a more appropriate rank; I'll check with some abstract artists.

The fact that Mr. Greenberg changed his mind about

1. The reviews and essays referred to by Greenberg bear him out (see vols. 2 and 3). [Editor's note]

Franz Kline and Willem de Kooning indicated to me that he had "never" misunderstood their contributions. But I stand corrected by the author and suggest that he accepted them "inconclusively."

There is one real inaccuracy in the review. As it stands it implies that one is irritated by Mr. Greenberg's lapses into the "third-person plural." I had written "first-person plural." Mr. Greenberg usually is great on "they" and "them." It is when he speaks for "us" and as "we" that I, for one, find his assumptions of leadership exaggerated and immodest.

<div align="right">

Thomas B. Hess
New York
</div>

The New York Times Book Review, 9 July 1961

25. Statement as Juror of an Exhibition in Oklahoma City

Man is fallible.

Third Annual Exhibition of Southwest American Art, Oklahoma Art Center, Oklahoma City, September–October 1961

26. The Identity of Art

In the long run there are only two kinds of art: the good and the bad. This difference cuts across all other differences in art. At the same time, it makes all art one. No matter how exotic, a given body of art—as Chinese painting, African sculpture, Persian weaving—will begin to assimilate itself to the art with which we are already familiar as soon as we recognize the difference between the good and the bad in it. This is what keeps the infinite variety of art—rather, the infinite variety of artists and of art traditions—from being a bewildering variety. It means that, ultimately, the experience of art is the same in kind or order despite all differences in works of art themselves.

The error made by too many partisans of non-decorative abstract art is to think that the kind of experience they get from it is different from the kind of experience they get from representational art—to think, in fact, that it is an utterly new kind of experience. This idea only puts ammunition in the hands of the opponents of abstract art. These latter will readily agree that it provides an altogether new kind of experience, but they will argue that, for precisely this reason, it is not *artistic* experience, and that works of abstract art cannot be classified as art, properly speaking. And they will be against abstract art *in toto* just as too many champions of abstract art are for it *in toto*.

One cannot validly be for or against any particular body of art *in toto*. One can only be for good or superior art as against bad or inferior art. One is not for Chinese, or Western, or representational art as a whole, but only for what is good in it. Experience itself—and experience is the only court of appeal in art—has shown that there is both good and bad in abstract art. And it has also revealed that the good in one kind of art is always, at bottom, more like the good in all other kinds of art than it is like the bad in its own kind. Underneath all apparent differences, a good Mondrian or good Pollock has more in common with a good Vermeer than a bad Dali has. A bad Dali has far more in common, not only with a bad Maxfield Parrish,. but with a bad abstract painting.

But how do we decide this? Only through experience, and through reflection upon experience. Quality in art can be neither ascertained nor proved by logic or discourse. Experience alone rules in this area—and the experience, so to speak, of experience. This is what all the serious philosophers of art since Immanuel Kant have concluded.

Yet, quality in art is not just a matter of private experience. There is a *consensus* of taste. The best taste is that of the people who, in each generation, spend the most time and trouble on art, and this best taste has always turned out to be unanimous, within certain limits, in its verdicts. One connoisseur may prefer Raphael, and another Titian, but if the first did not enjoy Titian greatly, and if the second did not enjoy Raphael greatly, neither would be taken seriously as connoisseurs.

Too many people simply refuse to make the effort of humility—as well as of patience—that is required to learn how to experience, or appreciate, art relevantly. Such people do not have the right to pronounce on any kind of art—much less abstract art. Left to themselves, they would not be able to tell the difference in quality between a calendar picture by Petty and a nude by Rubens. Unfortunately, they are too often just the ones who will stand up in audiences, or write letters to magazines or newspapers, to protest vehemently against modernist art in general, abstract and non-abstract. There are still other people, however, who, having made themselves familiar with the art of the past, let their initial puzzlement with abstract art dissuade them from making any further effort to acquaint themselves with it. Among these are to be found the dogmatic opponents of abstract art. They, too, lack the right to pronounce on abstract art, because they have not taken the trouble to amass sufficient experience of it, and it makes no difference in this respect how much experience they have in other fields of art. Without experience enough to be able to tell the good from the bad in abstract art, no one has the right to be heard on this subject.

There is, of course, experience and experience. What is meant here is experience that involves a certain exertion. I know people who visit galleries and museums constantly, but never expand their taste beyond certain limits because they have become too lazy-minded to attempt to discriminate between the good and the bad in kinds of art with which they are unfamiliar. More than a few art critics are among them.

Yet there is a particular delight and a particular edification to be found in learning how to tell the good from the bad in art that is unfamiliar. Let the reader to whom abstract art is still a mystery try it for himself. Let him practice "at" taste by making the effort to decide, wherever he sees more than one work of abstract art, just which he likes better or best. Then let him return at a later date to see whether he will change his mind. It is a game that demands time and. patience, but I know of none that is more certain to be profitable.

Last and perhaps least: There is no hard and fast line between good and bad, and art abounds in borderline cases. Yet

this qualifies nothing in what I have said. The practiced eye tends always toward the definitely and positively good in art, knows it is there, and will remain dissatisfied with anything else.

Country Beautiful, November 1961

1962

27. After Abstract Expressionism

Twenty-odd years ago all the ambitious young painters I knew in New York saw abstract art as the only way out. Rightly or wrongly, they could see no other way in which to go in order to say something personal, therefore new, therefore worth saying. Representational art confronted their ambition with too many occupied positions. But it was not so much representation *per se* that cramped them as it was illusion. Schematic representation survived in Picasso (as it does today in Dubuffet) and in Léger, Braque, Klee, and Miró, but the art of these masters was felt as virtually abstract, and so even was some of Matisse's. It was from this art, in fact, along with Mondrian's, that the painters I am speaking of got their most important lessons in abstraction. [1]

In those years serious abstract art seemed inseparable from the canons of Synthetic Cubism, which meant cleanly marked contours, closed and more or less regular shapes, and flat color. It may not have been necessary to observe all these canons literally, but it was necessary to keep oriented to them. Because this orientation was accepted so implicitly, without idea of an alternative, it became by the end of the 1930's something cramping and constricting in its own right. Despite the appreciation of Klee (whose influence freed at least Tobey, Ralph Rosenborg, and even Loren MacIver), and though the early abstract pictures of Kandinsky were beginning to be admired in New York, most of the young artists I have in mind continued to believe that the only way to real style in abstract art lay through trued and faired, silhouetted and flattened forms. Any

1. This essay elicited a critical response from Max Kozloff (*Art International*, June 1963), the lengthiest attack on Greenberg's critical position to this point in time. It also prompted an essay by Harold Rosenberg ("After Next, What?" *Art in America*, April 1964. [Editor's note]

other way seemed an evasion or, at best, too idiosyncratic for more than one artist to take at a time.

This was pretty much the plight of abstract art in New York up into the early 1940's—and I say "plight" advisedly. Good abstract painting was produced in New York during that time: not only by Stuart Davis, but also by Bolotowsky, Cavallon, Diller, Ferren, Glarner, Balcomb and Gertrude Greene, George L. K. Morris, and a few others, all of whom adhered to "closed" Cubism. Some of Gorky's work of that period looks more independent now than it used to, and de Kooning was then doing what I think remain his supreme paintings, unshown though they were. Nevertheless, the sense of how confining serious abstract art had become under the canons of closed Cubism betrayed itself in the feeling that Stuart Davis had to be overcome rather than emulated. This was unfair, but I can see in retrospect why it may have been necessary. As good as he was—and still is—Davis remained a provincial artist, and there was a dim, unspoken feeling in the air that provincialism was what had most to be overcome. Yet it seemed at the same time harder than ever before to paint ambitiously enough to break out of provincialism.

This helps explain why Baziotes' Surrealist-influenced pictures of 1942 came like a breath of fresh air. Daring to hint at illusionist space, they somehow (unlike Matta's paintings of that time) got away with it, and did not strike one as taking the easy way out—or at least not altogether. The real break-out came, however, with Pollock's and Hofmann's first one-man shows, in October 1943 and March 1944 respectively. There I saw abstract paintings that were painterly in what impressed me as being for the first time a full-blown way. The earlier Kandinsky looked clean-shaven by comparison, and Klee like a tidy miniaturist: neither had been quite so loose or open, much less so extravagant in his use of paint. The only precedent lay in representational painting, and that Pollock and Hofmann were not completely abstract in their first shows had its significance.

It was like a general thaw. In 1943 and 1944 Gorky, too, became much more painterly, under the influence of landscape and the early Kandinsky. Several students and former students of Hofmann began painting abstract pictures under Bonnard's

or Rouault's influence. De Kooning, whose abandonment of closed, if not exactly Synthetic, Cubism, dates from around 1946, was in another few years accepting the influence of Soutine. And even some of the old stand-bys of the American Abstract Artists group were starting to loosen up.

"Painterly" was not the word used, but it was what was really meant, as I see it, when Robert Coates called the new open abstract art in New York "Abstract Expressionism." It was, in effect, a painterly reaction against the tightness of Synthetic Cubism that at first used the vocabulary itself of Synthetic Cubism. Painterliness, combined with what remained an essentially Cubist feeling for design, was what artists as different as Gorky and Pollock had in common in the middle 1940's. If the label "Abstract Expressionism" means anything, it means painterliness: loose, rapid handling, or the look of it; masses that blotted and fused instead of shapes that stayed distinct; large and conspicuous rhythms; broken color; uneven saturations or densities of paint, exhibited brush, knife, or finger marks—in short, a constellation of qualities like those defined by Wölfflin when he extracted his notion of the *Malerische* from Baroque art. As we can now see, the displacing of the quasi-geometrical as the dominant mode in New York abstract art after 1943 offers another instance of that cyclical alternation of painterly and non-painterly which has marked the evolution of Western art (at progressively shorter intervals after Manet) since the 16th century. Painterly abstraction tended to be less flat, or less taut in its flatness, than closed abstraction, and contained many more velleities towards illusion. The Kandinskys of 1910–1918, so like landscapes, had already revealed this, and Abstract Expressionism again revealed it, and continued to reveal it. This should not have been surprising. The painterly had started out as a means, first and foremost, to a heightened illusion of three-dimensional space, and in the course of painting and time uneven saturations of paint and color, and broken or blurred outlines, came to evoke space in depth more immediately and automatically than perspective lines did. Whereas space in depth in the abstract or near-abstract art of the 1920's and 1930's had been a matter largely of "diagram" and association, in the painterly 1940's and 1950's it could not help becoming once again a matter

more of *trompe-l'oeil* illusion. Not that space in depth became deeper—not at all—but it did become more tangible, more a thing of immediate perception and less one of "reading." In June 1948, *Partisan Review* published a communication from George L. K. Morris in which he took me to task for, among other things, preferring what he called "behind-the-frame" painting. My rejoinder was that Mr. Morris had succumbed to the kind of dogmatism that held that one species of art must in a given period be better than any other species. Nevertheless, his dogmatism did not take away from the acuteness of his "behind-the-frame" characterization, especially in its implications, as I only later came to recognize. Hofmann's and Pollock's and Gorky's pictures did stay further behind their frames than Mondrian's or Picasso's post-1913 pictures did. This in itself said nothing about their relative aesthetic value, and Mr. Morris was altogether wrong in inferring that it did, but he did have a real point in insinuating that painterly abstraction was headed backwards in terms of the evolution of style (even if going backwards in these terms was, at that time, almost the only way to go forward in terms of major quality).

Later, as the 1950's wore on, a good deal in Abstract Expressionist painting began fairly to cry out for a more coherent illusion of three-dimensional space, and to the extent that it did this it cried out for representation, since such coherence can be created only through the tangible representation of three-dimensional objects. It was most logical therefore that when painterly abstraction in New York finally crystallized into a set manner, it did so in a series of outspokenly representational works, namely de Kooning's "Women" pictures of 1952–1955. This manner, as returned to abstract art by de Kooning himself and the countless artists he has influenced, I call "homeless representation." I mean by this a plastic and descriptive painterliness that is applied to abstract ends, but which continues to suggest representational ones. In itself, "homeless representation" is neither good nor bad, and maybe some of the best results of Abstract Expressionism in the past were got by flirting with representation. Badness becomes endemic to a manner only when it hardens into mannerism. This is just what happened to "homeless representation" in the mid-1950's, in de Kooning's art, in Guston's, in the post-1954 art

of Kline, and in that of their many imitators. It is on the basis therefore of its actual results that I find fault with "homeless representation," not because of any *parti pris*; it's because what were merely its logical contradictions have turned into artistic ones too.

Something similar has happened to the two main tendencies of the European version of painterly abstraction, which likewise emerged during the war. In Europe, too, painterly abstraction presses towards the three-dimensional; but if one tendency leans, like our "homeless representation," towards the three-dimensionality of illusion, the other leans towards the literal three-dimensionality of piled-on paint, and for its part could be called "furtive bas-relief." Yet the latter tendency happens to be more closely affiliated with representation, even if only schematic representation, because it took its start from Dubuffet and Fautrier, and came to a head—though not to an extreme—in the representational works de Staël did in his last years. The former, the "homeless representation," tendency got its start, on the other hand, from the linear abstraction of Hartung, Wols, and Mathieu. I do not profess to be able to explain the logic at work in this situation, but I think that one clue to it lies in the extent to which the strongest exponents of "furtive bas-relief" rely on the non-painterly use of line, and at the same time on monochromatic effects that do not need the coherence achieved through tangible representation, because they have the coherence that belongs automatically to literally three-dimensional space. For the rest, painterly abstraction in Europe has likewise degenerated into an affair largely of mannerisms, whether those of "furtive bas-relief" or those of "homeless representation." And there, too, a vast quantity of abstract art that is bad because mannered is relieved, within the orbit of the mannerisms, only by felicitous minor art. For our Johns and Diebenkorn, Europe has its Tápies and Sugai to show. This comparison may be unfair to Diebenkorn, whose case is so exemplary that it is worth pausing over. His development so far is what one might say the development of Abstract Expressionism as a whole should have been. Earlier on he was the only *abstract* painter, as far as I know, to do something substantially independent with de Kooning's touch (and it makes no difference that he did it

with the help of Rothko's design). More recently, he has let the logic of that touch carry him back (with Matisse's help) to representational art, and one might say that this consistency of logic is partly responsible for his becoming at least as good a representational as he was an abstract painter. That de Kooning's touch remains as unmistakable as before in his art does not diminish the success of this change. Uneven densities of paint, as produced by smearing, swiping, scrubbing, and scumbling, had in de Kooning's own hands created gradations of light and dark like those of conventional shading; though these were kept from actually modeling back into deep space by the declamatory abruptness with which they were juxtaposed, deep space is, nevertheless, increasingly suggested in almost everything de Kooning has done lately. By letting this suggestion become a forthright statement, Diebenkorn (along with another Californian, Elmer Bischoff) has, in effect, found a home for de Kooning's touch where it can fulfill itself more truthfully, though modestly, than it has been able to do so far in de Kooning's own art. There are painters in New York, too, who have begun to put de Kooning's manner to the uses of outright representational art, but until now their success has been less consistent or less significant. Jasper Johns, however, should not be classed with them, even though, strictly speaking, he too is a representational artist. His case is another exemplary one, for he brings de Kooning's influence to a head by suspending it clearly, as it were, between abstraction and representation. The motifs of Johns' paintings, as William Rubin pointed out in these pages a few years ago, are always two-dimensional to start with, being taken from a repertory of man-made signs and images not too different from the one on which Picasso and Braque drew for the stenciled and affixed elements of their 1911–1913 Cubism. Unlike the two Cubist masters, Johns is interested in the literary irony that results from *representing* flat and artificial configurations which in actuality can only be *reproduced*; nonetheless, the abiding interest of his art, as distinguished from its journalistic one, lies largely in the area of the formal or plastic. Just as the vivid possibility of deep space in photographs of signs or housefronts, or in Harnett's and Peto's paintings of pin-up boards, sets off the inherent flatness of the objects shown, so the paint-

erly paintedness of Johns picture sets off, and is set off by, the flatness of his number, letter, target, flag, and map images.

By means of this "dialectic" the arrival of Abstract Expressionism at homeless representation is declared and spelled out. The original flatness of the canvas, with a few outlines stenciled on it, is shown as sufficing to represent adequately all that a picture by Johns really does represent. The paint surface itself, with its de Kooningesque play of lights and darks, is shown, on the other hand, as being completely superfluous to this end. Everything that usually serves representation and illusion is left to serve nothing but itself, that is, abstraction; while everything that usually serves the abstract or decorative—flatness, bare outlines, all-over or symmetrical design—is put to the service of representation. And the more explicit this contradiction is made, the more effective in every sense the picture tends to be. When the image is too obscured the paint surface is liable to become less pointedly superfluous; conversely, when the image is left too prominent it is liable to reduce the whole picture to a mere image (an image, that is, on the order of Johns' "sculptures," which, even when their bronze surfaces are left unpainted, amount to nothing more than what they really are: cast reproductions of man-made objects that, as far as three-dimensional art is concerned, could never be anything other than merely reproducible). The effect of a Johns picture is also weakened, often, when it is done in bright colors instead of neutral ones like black and gray, for these, being the shading hues *par excellence*, are just those that become the most exhibitedly and poignantly superfluous when applied to ineluctably flat images.

I do not mean to imply that the effectiveness of Johns' painting depends on a device. There is far more to it than that; otherwise I would not get the kind of pleasure from it that I do. But the fact that as much of his art can be explained as has been explained here without the exertion of any particular powers of insight would indicate a certain narrowness. Johns sings the swan song of "homeless representation," and like most swan songs, it carries only a limited distance.

Echoes of Analytical Cubism and of its transition to Synthetic Cubism are not found in Johns alone among the Abstract Expressionists, early and late—far from it. The whole

evolution of Abstract Expressionism could, in fact, be described as a devolution from a Synthetic kind of abstract Cubism to an Analytical kind. By 1911, original Analytical Cubism itself had arrived at homeless representation: a way of depicting objects in planar segments kept parallel to the picture plane that ended up by effacing the objects themselves. In the all-over Pollock and in the de Kooning of the last seven or eight years, analogous planar segments are analogously deployed (smaller in Pollock, larger in de Kooning), with the principal difference being in their articulation or jointing, which is no longer governed by a model in nature. Yet, as I have tried to show, de Kooning's large facet planes seem to grope for such a model; nor does the indeterminate space created by Pollock's webs and blotches always function as abstract space. Whereas Analytical Cubism had arrived at the brink of outright abstraction by pursuing both art and nature, Abstract Expressionism returned to the verge of nature by pursuing, apparently, art alone. In several of his black and white pictures of 1951 Pollock signalled this return; de Kooning, in his "Women" series of 1952—1955, which marked his real transition from Synthetic to Analytical Cubism, did more than signal it.

Meanwhile another return was being made, though not under the auspices of Abstract Expressionism proper. Analytical Cubism, besides being a case of homeless representation, had embodied a synthesis of the painterly and non-painterly. Synthetic Cubism and Mondrian had dissolved this synthesis in favor of the non-painterly, and Abstract Expressionism, as we have seen, reacted violently in the opposite direction. Just before 1950 something like a new synthesis of painterly and non-painterly began to emerge in New York abstract art, as if to complete its inverted recapitulation of the evolution of original Cubism.

Actually, most of the New York painters first called Abstract Expressionists have not been painterly in a consistent or committed way. This is true even of Hofmann; the best things he has done in recent years, and they are among the best he has ever done, move towards a synthesis of their own in which the painterly is fused with the linear at the same time that Fauvism is fused with Cubism. Kline turned painterly only

after 1954, to the cost of his art, as is negatively confirmed by the improvement it showed whenever he reverted, as he frequently did in the last two years or so of his life, to his old sharp-edged manner. Motherwell has been painterly off and on, and several of his masterpieces of the late 1940's were quite so, but most of his successful pictures still tend towards the non-painterly. Gottlieb likewise wavers between the painterly and non-painterly, and though he has done some superb pictures in both manners, his wavering somehow has the effect of making him disloyal to his greatest gift, which is for color. As regards that gift he would have done well, I feel, to take a hint from the example of three New York painters who stand somewhat apart from Abstract Expressionism. They are Newman, Rothko, and Still, who have renounced painterliness, or at least the painterliness associated with Abstract Expressionism, for the sake, precisely, of a vision keyed to the primacy of color.

Like so much of painterly art before it, Abstract Expressionism has worked in the end to reduce the role of color: unequal densities of paint become, as I have said, so many differences of light and dark, and these deprive color of both its purity and its fullness. At the same time it has also worked against true openness, which is supposed to be another quintessentially painterly aim: the slapdash application of paint ends by crowding the picture plane into a compact jumble—a jumble that is another version, as we see it in de Kooning and his followers, of academically Cubist compactness. Still, Newman, and Rothko turn away from the painterliness of Abstract Expressionism as though to save the objects of painterliness—color and openness—from painterliness itself. This is why their art could be called a synthesis of painterly and non-painterly or, better, a transcending of the differences between the two. Not a reconciling of these—that belonged to Analytical Cubism, and these three Americans happen to be the first serious abstract painters, the first abstract painters of *style*, really to break with Cubism.

Clyfford Still, who is one of the great innovators of modernist art, is the leader and pioneer here. Setting himself against the immemorial insistence on light and dark contrast, he asserted instead color's capacity to act through the contrast of

pure hues in relative independence of light and dark design. Late Impressionism was the precedent here, and as in the late Monet, the suppression of value contrasts created a new kind of openness. The picture no longer divided itself into shapes or even patches, but into zones and areas and fields of color. This became essential, but it was left to Newman and Rothko to show how completely so. If Still's largest paintings, and especially his horizontal ones, fail so often to realize the monumental openness they promise, it is only because he will choose a surface too large for what he has to say; it is also because too many of his smaller color areas will fail really to function as areas and will remain simply patches—patches whose rustic-Gothic intricacies of outline halt the free flow of color-space.

With Newman and Rothko, temperaments that might strike one as being natively far more painterly than Still's administer themselves copious antidotes in the form of the rectilinear. The rectilinear is kept ambiguous, however: Rothko fuzzes and melts all his dividing lines; Newman will insert an uneven edge as foil to his ruled ones. Like Still, they make a show of studiedness, as if to demonstrate their rejection of the mannerisms which have become inseparable by now from rapid brush or knife handling. Newman's occasional brushy edge, and the torn but exact one left by Still's knife, are there as if to advertise both their awareness and their repudiation of the easy effects of spontaneity.

Still continues to invest in surface textures, and there is no question but that the tactile irregularities of his surfaces, with their contrasts of matt and shiny, paint coat and priming, contribute to the intensity of his art. But by renouncing tactility, and detail in drawing, Newman and Rothko achieve what I find a more positive openness and color. The rectilinear is open by definition: it calls the least attention to drawing and gets least in the way of color-space. A thin paint surface likewise gets least in the way of color-space, by excluding tactile associations. Here both Rothko and Newman take their lead from Milton Avery, who took his from Matisse. At the same time color is given more autonomy by being relieved of its localizing and denotative function. It no longer fills in or specifies an area or even plane, but speaks for itself by dissolving all definiteness of shape and distance. To this end—as Still was the

first to show—it has to be warm color, or cool color infused with warmth. It has also to be uniform in hue, with only the subtlest variations of value if any at all, and spread over an absolutely, not merely relatively, large area. Size guarantees the purity as well as the intensity needed to suggest indeterminate space: more blue simply being bluer than less blue. This, too, is why the picture has to be confined to so few colors. Here again, Still showed the way, the vision of the two- or three-color picture, as E. C. Goossen calls it, being his in the first place (whatever help towards it he may have got from the Miró of 1924–1930).

But Newman and Rothko stand or fall by color more obviously than Still does. (Where Newman often fails is in using natively warm colors like red and orange, Rothko in using pale ones, or else in trying to *draw*, as in his disastrous "Seagram" murals.) Yet the ultimate effect sought is one of more than chromatic intensity; it is rather one of an almost literal openness that embraces and absorbs color in the act of being created by it. Openness, and not only in painting, is the quality that seems most to exhilarate the attuned eyes of our time. Facile explanations suggest themselves here which I leave the reader to explore for himself. Let it suffice to say that by the new openness they have attained, Newman, Rothko, and Still point to what I would risk saying is the only way to high pictorial art in the near future. And they also point to that way by their repudiation of virtuosity of execution.

Elsewhere I have written of the kind of self-critical process which I think provides the infra-logic of modernist art ("Modernist Painting"). The aim of the self-criticism, which is entirely empirical and not at all an affair of theory, is to determine the irreducible working essence of art and the separate arts. Under the testing of modernism more and more of the conventions of the art of painting have shown themselves to be dispensable, unessential. By now it has been established, it would seem, that the irreducible essence of pictorial art consists in but two constitutive conventions or norms: flatness and the delimitation of flatness; and that the observance of merely these two norms is enough to create an object which can be experienced as a picture: thus a stretched or tacked-up canvas already exists as a picture—though not necessarily as a success-

ful one. (The paradoxical outcome of this reduction has been not to contract, but actually to expand the possibilities of the pictorial: much more than before lends itself now to being experienced pictorially or in meaningful relation to the pictorial: all sorts of large and small items that used to belong entirely to the realm of the arbitrary and the visually meaningless.)

As it seems to me, Newman, Rothko, and Still have swung the self-criticism of modernist painting in a new direction simply by continuing it in its old one. The question now asked through their art is no longer what constitutes art, or the art of painting, as such, but what irreducibly constitutes *good* art as such. Or rather, what is the ultimate source of value or quality in art? And the worked-out answer appears to be: not skill, training, or anything else having to do with execution or performance, but conception alone. Culture or taste may be a necessary condition of conception, but conception is alone decisive. Conception can also be called invention, inspiration, or even intuition (in the usage of Croce, who did anticipate theoretically what practice has just now discovered and confirmed for itself). It is true that skill used to be a vessel of inspiration and do the office of conception, but that was when the best pictorial art was most naturalistic pictorial art.

Inspiration alone belongs altogether to the individual; everything else, including skill, can now be acquired by any one. Inspiration remains the only factor in the creation of a successful work of art that cannot be copied or imitated. This has been left to artists like Newman and Mondrian to make explicit (and it is really the only thing Newman and Mondrian have in common). Newman's pictures look easy to copy, and maybe they really are. But they are far from easy to conceive, and their quality and meaning lies almost entirely in their conception. That, to me, is self-evident, but even if it were not, the frustrated efforts of Newman's imitators would reveal it. The onlooker who says his child could paint a Newman may be right, but Newman would have to be there to tell the child *exactly* what to do. The *exact* choices of color, medium, size, shape, proportion—including the size and shape of the support—are what alone determines the quality of the result, and these choices depend solely on inspiration or conception. Like Rothko and Still, Newman happens to be a convention-

132

ally skilled artist—need I say it? But if he uses his skill, it is to suppress the evidence of it. And the suppression is part of the triumph of his art, next to which most other contemporary painting begins to look fussy.

It is because of this that the admiration of some of the strongest among the newer or younger American abstract artists goes out to Newman particularly. Newman's rejection of virtuosity confirms them in what they themselves renounce, and it also confirms them in what they dare. It confirms painters like Louis and Noland because, paradoxically enough, they have not been directly influenced by Newman—or, for that matter, by Still or Rothko either. They may pursue a related vision of color and openness, but they do so all the more resolutely because it is not a derived one. Louis and Noland do not make two- or three-color pictures, for one thing, and for another, they have been influenced in both vision and means by Pollock more than by any one else. Yet this takes nothing away from Newman, Rothko, or Still, and I stress the point only to clear up misconceptions circulated by journalists and curators. The fact that, so far, the direct influence of these three has been a crushing one, and that the only younger artist who has yet been able to assert himself under it is Sam Francis, may attest, indeed, to the very power of their art.

The crux of the matter of the aftermath of Abstract Expressionism has, in any case, little to do with influence in itself. Where artists divide in the last resort is where safe taste leaves off. And this is as true in what begins to look like the aftermath of Abstract Expressionism as it ever was. The painters who follow Newman, Rothko, or Still, individually or collectively, are as safe by now in their taste as they would be following de Kooning or Gorky or Kline. And I have the impression, anyhow, that some of those who have chosen to do the first, and not the second, have done so because they feel frustrated, *merely* frustrated, by the going versions of Abstract Expressionism in New York.

This applies even more, I feel, to those other artists in this country who have now gone in for "Neo-Dada" (I except Johns), or construction-collage, or ironic comments on the banalities of the industrial environment. Least of all have *they* broken with safe taste. Whatever novel objects they represent

or insert in their works, not one of them has taken a chance with color or design that the Cubists or Abstract Expressionists did not take before them (what happens when a real chance is taken with color can be seen from the shocked distaste that the "pure" painting of Jules Olitski elicits among New York artists). Nor has any one of them, whether he harpoons stuffed whales to plane surfaces, or fills water-closet bowls with diamonds, yet dared to arrange these things outside the directional lines of the "all-over" Cubist grid. The results have in every case a conventional and Cubist prettiness that hardly entitles them to be discussed under the heading "After Abstract Expressionism." Nor can those artists, either, be discussed under this heading whose contribution consists of depicting plucked chickens instead of dead pheasants, or coffee cans or pieces of pastry instead of flowers in vases. Not that I do not find the clear and straightforward academic handling of their pictures refreshing after the turgidities of Abstract Expressionism; yet the effect is only momentary, since novelty, as distinct from originality, has no staying power.

Art International, 25 October 1962; *New York Painting and Sculpture, 1940–1970*, ed. Henry Geldzahler, 1969 (slightly revised); *Aesthetics: A Critical Anthology*, ed. George Dickie and R. J. Sclafini, 1977; *Pop Art: The Critical Dialogue*, ed. Carol Ann Mashun, 1989.

28. Introduction to an Exhibition of Ernest Lindner

I have come to doubt more and more that naturalism, or realism, is the besetting sin of what we now call academic art. The longer and closer I look the more apparent it becomes to me that what's most generally wrong with academic and commercial art is, on the contrary, its incomplete naturalism. Bastien-Lepage or Bouguereau, James Montgomery Flagg or even Maxfield Parrish—they would have all made better pictures had they been more faithful to nature, more scrupulously and literally faithful.

The satisfaction I get from Ernest Lindner's art helps me see

this even more clearly.[1] The camera (which is not to be despised) may draw as accurately as he does, but it is helplessly wrong in the face of color. Lindner's art excels by the truth of its color as well as of its drawing and design. And by its truth of color his art points forward, transcending every note of quaintness. For, as I see it, the present and future of pictorial art belong to color in a fuller sense than heretofore. And it doesn't matter whether the color is abstract or descriptive. I want to emphasize that. I find more imagination and modernity in Ernest Lindner's sharply focused rendering of a tree trunk than in the largest part of current abstract painting.

Ernest Lindner, Norman MacKenzie Art Gallery, Regina, Saskatchewan, December 1962–January 1963

29. How Art Writing Earns Its Bad Name

Twenty years ago who expected that the United States would shortly produce painters strong enough, and independent enough, to challenge the leadership of Paris? The more knowing you were about art the more surprised you were when it happened. For a long while after it had actually happened you refused to believe it. You were convinced only when confirmation arrived from, of all places, Paris itself.

Jackson Pollock had a show there in 1952, and it made such an impression that, though hardly a picture was sold, his art began to be taken more seriously in certain quarters of the Paris art world than anywhere else, including New York. And along with Pollock, the new American abstract painting in general began to be taken more seriously in the same quarters. As it then seemed to me, it was over a year before news of this effectively reached New York. From that time the success in America itself of the new American painting dates, at least as far as collectors and museums and art journalism are concerned.

But it is as though a fatality dogged the success: a fatality

1. Ernest Lindner (1897–1988) was a participant in the Emma Lake Artists' Workshop that Greenberg conducted in Saskatchewan in August 1962. [Editor's note]

of misinterpretation that was also a fatality of nonsense. I call it a fatality—though it might be more proper to call it a comedy—because the misinterpretation and the nonsense have come not from those who professed to reject the new American painting, but from friends or supposed friends. It was as though the critics of modern art set out to justify everything that philistines have said about them.

Late in the same year as Pollock's Paris show, an article by Harold Rosenberg appeared in *Art News* in New York under the title "Action Painting" [*sic*].[1] Though it named no names, it was taken as a first attempt to throw real light, friendly or hostile, on the intentions of the new American painters. Transposing some notions from Heidegger's and Sartre's Existentialism, Mr. Rosenberg explained that these painters were not really seeking to arrive at art, but rather to discover their own identities through the unpremeditated and more or less uncontrolled acts by which they put paint to canvas. For them the picture surface was the "arena" of a struggle waged outside the limits of art in which "existence" strove as it were to become "essence." "Essence," or the identity of the painter, could be recognized by the painter himself only in the very act of painting, not in the result, it being presumed, apparently, that acts in themselves identified you as results or consequences could not. The painted "picture," having been painted, became an indifferent matter. Everything lay in the doing, nothing in the making. The covered canvas was left over as the unmeaning aftermath of an "event," the solipsistic record of purely personal "gestures," and belonging therefore to the same reality that breathing and thumbprints, love affairs and wars belonged to, but not works of art.

Mr. Rosenberg did not explain why the painted left-overs of "action," which were devoid of anything but autobiographical meaning in the eyes of their own makers, should be exhibited by them and looked at and even acquired by others. Or how the painted surface, as the by-product of acts of sheer self-expression ungoverned by the norms of any discipline, could

1. Greenberg's incorrect title for Rosenberg's essay has led to some confusion. The proper title is "The American Action Painters" (*Art News*, December 1952). [Editor's note]

convey anything but clinical data, given that such data is all that raw, unmediated personality has ever been able to convey in the past. Nor did Mr. Rosenberg explain why any one by-product of "action painting" should be valued more than any other. Since these things, and the action that "caused" them, belonged to no discernible branch of social activity, how could they be differentiated qualitatively? There were still other things that Mr. Rosenberg's eloquence left unexplained, but they need not detain us here.

When his essay first appeared it was read by many people as an exposure of the new abstract painting. To those who could not make head or tail of Pollock's middle-period paintings, it offered a plausible explanation: if these things were not really art you had every right to be baffled by them. A corollary was that those who claimed to be able to tell the difference between good and bad "dripped" Pollocks (and Mr. Rosenberg, patently, did not so claim) were deluding themselves and others. Abstract art was under renewed attack in the early 1950s and "Action Painting" was greeted—or resented—as a veiled blow at "extremist" art. As that, it was soon on its way to being forgotten, as movingly written as it was.

That it finally did not get forgotten was mainly the fault of a young English art critic named Lawrence Alloway. Almost two years after its original appearance it was Mr. Alloway who rescued Mr. Rosenberg's article and set its ideas and terms in effective circulation. Not that Mr. Alloway was an opponent of "extremist" art. On the contrary, he was an ardent champion of it, and especially of the new American kind—being, for that matter, an equally ardent, practically a sectarian champion of most things American. Mr. Rosenberg's notions seem to have struck him as offering the right kind of subversive and futurist explanation of the subversive and futurist and very American species of art that Pollock seemed to represent. The very flavor of the words, "action painting," had something racy and demotic about it—like the name of a new dance step—that befitted an altogether new and very American way of making art—a way that was all the newer, all the more avant-garde, and all the more American because the art itself was not really art, or at least not art in the way the stuffy past had known it. At the same time, it all sounded, in Mr. Rosen-

berg's rhetoric, so dramatically modernistic and opaquely profound—like Rimbaud and Sartre and Camus rolled into one—and avant-garde art critics have a special weakness for the opaquely profound.

Not only did Mr. Alloway take Mr. Rosenberg's amphigoric piece of art interpretation as a manifesto in favor of its subject (and he was but the first among many to do so); he also took it (again, as but the first among many) as a legitimate statement of the aims of "Pollock & Co." as professed by Pollock himself. There was just enough truth in this to make it ironic. Two or three painters close to Pollock in the early 1950s, but who painted in a quite different direction, did rant about "the act," and did say that what mattered was not to have your art appreciated and recognized, but simply to perform the "act" of making *good* art; what happened after that was of small consequence; for all he cared, one of them is reported as saying, his finished pictures could be burned. The artists in question (every one of whom has since become renowned, and rightly so) were not making much headway in the world at that time, and it would not be unjust to characterize their talk in this vein as sour grapes. How much of it Mr. Rosenberg heard, I cannot say. Pollock told me, very sheepishly, that some of the main ideas of the "action painting" article came from a half-drunken conversation he had had with Mr. Rosenberg on a trip between East Hampton and New York (if so, Pollock had been parroting in that conversation things he heard from his friends). Mr. Rosenberg has denied this in print, asserting that his *"literary discoveries* [were] outside his [Pollock's] range" (Mr. Rosenberg's italics). Be all this as it may, Pollock and his friends took Mr. Rosenberg's "literary discoveries," when they were made public, for a malicious representation of both their work and their ideas. After all, it was *good* art, and no other kind, that they were interested in. (If Pollock was the one least upset, though seeming the one most directly aimed at, it was because he could not help feeling that "Action Painting" was a big spoof; and he felt that all the more because he thought he was partly responsible for it.)

Mr. Alloway could not have been expected to know all this seven or eight years ago in London. But he still might have waited for some corroboration before proceeding on the as-

sumption that "Action Painting" was a faithful statement of the intentions of the new American painters. As it was, he propagated Mr. Rosenberg's notions with such conviction and verve, and with such confidence, that "action painting" became current overnight in England as the authorized brand name and certified label of the new abstract painting from America. That it connoted a freakish, new-fangled way of applying paint to canvas made it seem all the more appropriate to what struck most people as being a freakish, new fangled kind of art—or non-art. And though English art-lovers joined Mr. Alloway (or were led by him into doing so) in reading Mr. Rosenberg's piece as sympathetic to its subject, they found a reassurance in it much like that which Americans had found on its first appearance.

It had been one of the certitudes of the forward-looking English art person that however little the English themselves might possess the art of painting, the Americans possessed it still less; and it was another certitude that the French possessed that art supremely and absolutely, after whom came the Latins in general, and then the rest of the non-Protestant or non-Anglo-Saxon world. Imagine the shock, then, when it transpired that the wild new stuff from the United States was being taken seriously in Paris and even exerting an influence on the newest art there. At this juncture the "action painting" business came in opportunely to restore morale, at least for the moment.

For if, as Mr. Rosenberg said, the new American painting was not actually art, then that made it still right for the English to have questioned, and to continue to question, the American capacity for pictorial art, whatever else the Americans *were* capable of. The way out for most English art critics (Patrick Heron is the only exception I know) became to react to Mr. Rosenberg's explanation of the new American painting rather than to the painting itself. Basil Taylor spoke of the "record of a gesture armed with a paint brush." Sir Herbert Read (in *Encounter*, July 1955) called it "wildly arbitrary," a "reflex activity, completely devoid of mental effort, of intellection," the product of a "vacuous nihilism that renounces the visible world and even the inner world of the imagination, and scribbles a graph of its uncertainty on the surface of a

blank consciousness." But Sir Herbert mentioned no names and refrained, with well-placed caution, from an outright condemnation.

It was from England and nowhere else that Mr. Rosenberg's notions, with the prestige conferred upon them by Mr. Alloway, were exported to the Continent and back to the United States. That prestige seemed to grow with the prestige of the new American painting itself. What made it wonderful was that nobody stopped to ask what "action painting" could possibly be if it was not supposed to be art. Avant-garde art critics everywhere invoked and quoted Mr. Rosenberg's rhetoric—and not only with regard to American painting—and then went on to talk about art and artistic qualities to show that they had not grasped a single implication of his ideas. For Mr. Alloway as for everybody else who "dug" "action painting," there were superior and inferior exponents of it, superior and inferior examples of it. Just as if it had not been Mr. Rosenberg's point throughout his essay to exclude the possibility of such discriminations.

Yet this muddle attested precisely to the fact that the new American painting was making its way in the world on the basis of qualities more substantial than those allowed it by "Action Painting." It was making its way as art, unmistakable art, not as a super-avant-garde stunt or as an interesting aberration. Its very real success, worldly and other, no less than the concurrent, if ironical, success of his article—or rather the muddled reading of his article—may be what now leads Mr. Rosenberg to talk as if it had been meant from the first as a wholly sympathetic treatment of the new American painting. He has also let it be known recently that it was mainly "de Kooning & Co." he had in mind, not Pollock. This last will confound, whether they admit it or not, all those art writers who took it for granted all along that Mr. Rosenberg had written about and for Pollock, and for whom de Kooning was, or is, too European (or "civilized") to qualify as an "action painter." But these writers deserve to be confounded for not having been confounded by Mr. Rosenberg's article in the first place.

Sense, the tortoise, usually overtakes nonsense, the hare, even in this not quite perfect world. It begins to dawn on art-

lovers here and there that they have not yet really seen any kind of painting that conforms to Mr. Rosenberg's description. Art turns out to be almost inescapable by now for any one dealing with a flat surface, even if it is mostly bad art. The works of the "gestural" painters, of the "action" athletes, downtown in New York and elsewhere (I'm not referring to the artists originally aimed at by Mr. Rosenberg) reveal themselves as mannered with mannerisms borrowed from de Kooning for the most part, but also from Kline, Gorky, Pollock, and Still, and more lately from Monet too, and maybe even from Magnasco; and their main trouble is disclosed to be a want, not an excess, of spontaneity. It is discovered that flung paint can be as thoroughly controlled and as carefully manipulated as patted or stroked paint. And now that the accidental has been completely assimilated to the tradition of the painterly, even the donkey's tails and the painting chimpanzees and parrots expose themselves as abjectly derivative—and we no longer have to know what artists their owners or keepers admire. Like the wildest painter on 10th Street or in the 14th *arrondissement*, they can't get out of their systems, moreover, the habit of being guided by the shape of the support.

Pollock's art turns out at the same time to rely far less on the accidental than had been thought. It turns out, in fact, to have an almost completely Cubist basis, and to be the fruit of much learning and much discipline. The same is true, perhaps excessively true, of de Kooning's art. It was the first look of the new American painting, and only the first look, that led Harold Rosenberg to take it for a mystification beyond art on to which he could safely graft another mystification. (That his "literary discoveries" could seem to anyone to throw light on anything is explained only by the supposition that the blind actually prefer being led by the blind. This would also help explain Sir Herbert Read's present status as an authority on art.)

But if it is left to Mr. Alloway, apparently, the comedy will not end quite yet. Nor will it if it is left to that estimable French art writer, Michel Tapié,[2] with whom it embraces post-

2. Michel Tapié de Céléyran (he is a cousin of Toulouse-Lautrec) happens to have one of the keenest eyes of our time for painting. He was among the very first to recognize the merits of Dubuffet, Mathieu, Pollock, and Morris Louis, and it was under his auspices that Pollock had his first show in Paris.

war art in Europe as well as America. Both Mr. Alloway and M. Tapié can *see*, and they do not want for courage either. Mr. Alloway, in particular, I always find refreshing to read. But like M. Tapié, he seems to lack a sense of perspective, and it is this that makes them both inveterate futurists, votaries of false dawns, sufferers from the millennial complex—and to that extent comedians like Mr. Rosenberg, who back in 1952 greeted the beginning of the end of painting as an art.

M. Tapié considers postwar abstract painting an almost completely revolutionary phenomenon because, as he thinks, it incorporates new formal structures analogous to the kinds of new structure being investigated by physics and mathematics today. I am far from sure that I understand him, but even so, I fail to discern anything in the new abstract painting that is that new. I can see nothing essential in it that cannot be shown to have evolved out of either Cubism or Impressionism (if we include Fauvism in the latter), just as I cannot see anything essential in Cubism or Impressionism whose development cannot be traced back to the Renaissance. In the way of intellectual journalists nowadays (though he is far more than that), M. Tapié has gone in search of something newer than new in order to explain things whose newness is eventually—and must be—self-explanatory.

Mr. Alloway succumbs to the same fallacy of exaggerated newness when he writes, in *Art International*, that the "existentialist description of abstract art" is the "best one currently available." That description consists in the "idea of art as perilous performance and the resultant artefact as unique but [*sic*] absurd." Here the cup of rhetorical novelty runs over. As if every successful work of art since art began were not unique and absurd in the sense that Sartre or Merleau-Ponty gives these words. And as if success in the creating of art, whether Fra Angelico's or Pollock's, could possibly not involve the peril of failure. And as if the peril had not been as great for Rembrandt in his "performance" as for Mondrian or Pollock or Newman in theirs.

His ideas, which are another thing, are found in his catalogue notes for the exhibitions of the artists he has sponsored over the last ten years and more at various Paris galleries (mainly the Galerie Stadler). [Author's note]

It is typical of the best, not worst, art writing of our time that propositions applicable to all successful art are applied to contemporary art as though relevant to the latter alone and expressing insights which the latter alone has made possible. The strongest of avant-garde critics—and Mr. Alloway is one of them—sin out of ignorance, or for lack of an elementary grounding in aesthetics. The same is true, moreover, of an academic avant-garde critic like Robert Goldwater (what with the speeding up of history, camp-followers are no longer as patient as they used to be), whose essay on Mark Rothko, which is part of the catalogue for the Rothko retrospective now touring Europe, says hardly anything about its subject which is not equally relevant to Velasquez or Takanobu. It is further typical of contemporary art writing, as Dr. Goldwater's essay again shows, to imply, when praising a living artist, that he has come out of nowhere and owes practically nothing to anything before him. It's as though art began all over again every other day.

All in all, the only place where the absurd has made a new lodgement in the area of art is its criticism. There it flourishes with greater vigor perhaps than anywhere else in our culture (which is, of course, saying a lot). Contemporary art criticism is absurd not only because of its rhetoric, its language, and its solecisms of logic. It is also absurd because of its repetitiousness. Since Manet every step in the evolution of modernist art has been hailed, or condemned, as a revolutionary break with the past, and in each instance the passing of only a little time has refuted this claim. Yet this deters hardly anybody, and the epochs of art succeed one another faster than ever. Repetition has a cumulative effect, however, and the absurdity of art writing has become systematic where it used to be merely whimsical. Vistas of inanity open up that would have made Apollinaire or Elie Faure blanch. Things that would get expelled from other kinds of writing by laughter multiply and flourish in art writing. In a recent book on Pollock (by an Englishman) we read of his "attempt to disrupt the time flux and invoke a new contingency"; in a recent book on de Kooning (by an American) we read of colors that "erupt through the ceiling, coherent in their poetry of ambiguity"; in another book on Pollock (by an American) we read that one of Pollock's

paintings is a "scornful, technical masterpiece, like the *Olympia* of Manet. . . . one of the most provocative images of our time, an abyss of glamour encroached upon by a flood of innocence."[3] (This, about a picture that Pollock himself considered a failure.)

What is there about art writing that encourages this sort of thing? What is there in the people who read art writing that makes them tolerate it? Why is art writing the only kind of writing in English that has lent itself to Existentialist and Phenomenological rhetoric? What is there about modern art itself that leads minds like Herbert Read's and Harold Rosenberg's astray? The answer is not one, I think, that reflects on modern art. It has to do with the speed with which modernist painting and sculpture have outrun the common categories of art criticism, invalidating them not only for the present or future but also for the past. (This has not been a revolution; it has been a clarification.) The widening of the gap between art and discourse solicits, as such widenings will, perversions and abortions of discourse: pseudo-description, pseudo-narrative, pseudo-exposition, pseudo-history, pseudo-philosophy, pseudo-psychology, and—worst of all—pseudo-poetry (which last represents the abortion, not of discourse, but of intuition and imagination). The pity, however, is not in the words; it is in the fact that art itself has been made to look silly.

Encounter, December 1962; *The Second Coming Magazine*, March 1962. (Although "How Art Writing Earns Its Bad Name" was first published in *The Second Coming Magazine*, the version that attracted most attention appeared several months later in *Encounter*. For that reason, and because it is both longer and more explicit, the version from *Encounter* is reprinted here. [Editor's note])

3. Greenberg's references are to Bryan Robertson, *Jackson Pollock* (London: Thames and Hudson, 1960); Thomas B. Hess, *Willem de Kooning* (New York: George Braziller, 1959); and Frank O'Hara, *Jackson Pollock* (New York: George Braziller, 1959). [Editor's note]

1963

30. A Critical Exchange with Herbert Read on
"How Art Writing Earns Its Bad Name"

To the Editor:

It is often difficult, and in any case not sufficiently reward-
ing, to define the *ressentiment* that causes a critic to indulge in
baseless attacks on his colleagues. I refer in particular to Mr.
Clement Greenberg, whose article on "Art Writing" in your
December issue seems to be concerned mainly with the short-
comings of the American critic, Harold Rosenberg, who has
of late challenged Mr. Greenberg's supremacy in that field.
Mr. Rosenberg can take care of himself, and now that his
book, *The Tradition of the New*, is available in this country,
your readers will be able to appreciate for themselves the wit
and intelligence that give distinction to his writing.[1] I can also
leave Mr. Alloway, Mr. Goldwater, and M. Tapié to take care
of themselves, but since I am, much to my surprise, included
in Mr. Greenberg's distribution of sly insinuations and back-
handed compliments, you will perhaps allow me to make two
comments.

One is by way of addition to the historical record. If we in
England appreciated the paintings of Pollock a little earlier

1. Rosenberg's collection of articles and essays, *The Tradition of the New*,
which included "The American Action Painters," appeared in 1959, two
years before Greenberg's *Art and Culture*. The high international acclaim that
Abstract Expressionism had acquired by the early 1960s helped ignite a
vehement debate about whether Greenberg or Rosenberg had the better in-
terpretive model for understanding the movement. Partisans of both Green-
berg and Rosenberg used their books to further the debate, and the two
protagonists joined in. It was not the first time the two critics had sparred
in print; in the May–June 1942 issue of *Partisan Review*, Rosenberg criti-
cized Greenberg for not restricting his critical opinions to literature. [Edi-
tor's note]

than some of Mr. Greenberg's colleagues, as he admits, it was not due in the first place to "a young English art critic named Lawrence Alloway," who came on the scene rather later, but to Pollock's earliest and most generous patron, Peggy Guggenheim, whose name Mr. Greenberg ungenerously fails to mention. Miss Guggenheim was writing to me about her "new discovery" as early as 1943, but she was in New York and I was in England. It was not until early in 1946 that I was able to visit New York and see the Pollocks in her collection. I am not concerned to vindicate my own percipience—I was at first puzzled rather than appreciative. But I think we all, Mr. Alloway no less than myself, were eventually enlightened about the significance of this new American painting by the critic Mr. Greenberg seems so concerned to denigrate. Nothing that Mr. Greenberg or anyone else has written has been so illuminating on the subject as the various articles written by Mr. Rosenberg.

Mr. Greenberg's second line of attack, and really the main purpose of his article, is to imply that the various art critics who have written about "action painting" have merely obscured the issue by their confused and rhetorical writing. Is his own writing such a model of clarity? I will quote only one sentence, near the conclusion of his article:

> The widening of the gap between art and discourse solicits, as such widenings will, perversions and abortions of discourse: pseudo-description, pseudo-narrative, pseudo-exposition, pseudo-history, pseudo-philosophy, pseudo-psychology, and—worst of all—pseudo-poetry (which last represents the abortion, not of discourse, but of intuition and imagination).

Mr. Greenberg accuses me of being blind, and certainly I am unable to visualize a widening gap that "solicits" an abortion of discourse. If this is Mr. Greenberg's ideal of "art writing," then give me the relative clarity of what he calls "Existentialist and Phenomenological rhetoric."

In general, Mr. Greenberg in his censure of "art writing" fails to acknowledge the unprecedented task given to art critics in our time, which is to try to convey to a public, generally outraged and ignorant, the sincere but obscure motives that cause our painters and sculptors to express themselves in "pro-

vocative images." Criticism has become an art—the art of interpretation—and there is no branch of literature in Europe, certainly not poetry or fiction, that has carried so much *good* writing in our time.

Herbert Read
Stonegrave, York

Clement Greenberg replies:

Sir Herbert gets the progress of Pollock's reputation confused with what I wrote about the progress of the influence of Mr. Rosenberg's "action painting" essay. I nowhere in my article mentioned Mr. Alloway's role—which was considerable—in connection with the former. Nor did I "admit" that the appreciation of Pollock's art came earlier in England than to "some" of my "colleagues." (Quite a few critics in France and America appreciated Pollock before any critic I know of in England did. In any case the first English critic to take the new American painting seriously was, to the best of my knowledge, Patrick Heron.) It was the appreciation, such as it was, of Mr. Rosenberg's essay that I said came earlier in England, and it was for that I made Mr. Alloway responsible. If this is a fair example of the way Sir Herbert reads, it may help account for his satisfaction with contemporary art writing.

Even misreading does not excuse the business about Miss Guggenheim, which leaves it open to inference that, through her, much of the credit for the "earlier" appreciation of Pollock in England belongs to Sir Herbert. This is not the only thing in his letter I should have thought beneath him. Aside from which, he can find out from Miss Guggenheim herself about how "ungenerous" I have been in giving her her due for the launching of the new American painting.

Sir Herbert has me on "solicits," but he is being disingenuous about the clarity, as distinguished from articulation, of the sentence in which it occurs. And to indulge in tit for tat: Where is the antecedent of "that field" in the second sentence of his first paragraph?

It won't do to leave Mr. Rosenberg to take care of himself. My attack is not only on his essay; my attack is also on those

who find it illuminating, and it is up to Sir Herbert, as one who does, to point out why *he* thinks my attack baseless. He owes it to our dispute to show how the relevance of such statements in Mr. Rosenberg's essay as, "The new painting has broken down every distinction between art and life," clarified his own experience of the painting in question. And how puzzlement was changed into appreciation by utterances like: "With traditional aesthetic values discarded as irrelevant, what gives the canvas its meaning is not psychological data but *role*, the way the artist organises his emotional and intellectual energy as if he were in a living situation." Sir Herbert also owes it to our dispute to state whether *he* thinks that the new American painting is *art*.

Finally, Sir Herbert owes it to our dispute to say whether it was after being enlightened by Mr. Rosenberg that, in these same pages back in 1956, he called the new American painting "wildly arbitrary," a "reflex activity, completely devoid of mental effort," and the product of a "vacuous nihilism that renounces the visible world and even the inner world of the imagination, and scribbles a graph of its uncertainty on the surface of a blank consciousness."

Was that how "we in England appreciated the paintings of Pollock a little earlier . . ."? Was that how, after ten years of acquaintance with Pollock's work, one "interpreted" this artist's "sincere but obscure motives" to a "generally outraged and indignant" public? I have been hard on Sir Herbert, and not only in this *Encounter* article. And I have been hard on Mr. Rosenberg for his essay. But since when have critics lost the right to come down hard on other critics for sowing confusion?

P.S.—Only a few days ago an article by Lawrence Alloway that appeared in the *Listener* of October 23rd, 1958, under the title "Art in New York Today," was brought to my attention. I feel that I must quote from it by way of amends to Mr. Alloway. In that article, written after his first visit to New York, he says that the "myth" of the American abstract painter as a "type of noble savage, freer than Europeans from preconceptions and habits about art" was something for which "the American critic Harold Rosenberg is partly responsible. . . ." And he goes on to say: "The term Action Painting, often used to describe the New York school, has created confusion in Eu-

rope. When I taxed Rosenberg, who coined the term, about this he said that he hoped that it had been 'fruitful confusion.' . . . Although 'action' was a good word to stress the importance of the creative action of the artist, it has been mistaken as a full description of the art instead of recognised for what it is, a polemical, melodramatic label. What I needed to discover was that action was not the end result but a process in the discovery of aesthetic order." In other words, "action" was hardly different from the "automatic painting" that Surrealists like Miró and Masson had practised in order to get their pictures started, which procedure was in turn not much different from that to which Klee often resorted.

<div align="right">Clement Greenberg
New York City</div>

Encounter, February 1963

31. Introduction to an Exhibition of Morris Louis, Kenneth Noland, and Jules Olitski

Until a year or so ago these three painters were working against the prevailing tide in New York abstract art. But now that tide has turned and begun to accompany if not actually follow them. Kenneth Noland has become a "name," and Morris Louis's posthumous reputation grows from day to day. Recognition has come slower to Jules Olitski, but the tide has started to swirl around him too: the Museum of Modern Art in New York has just acquired one of his pictures (which it has not yet done in Louis's or Noland's case) and last year he won the Second Prize for Painting at the Carnegie International in Pittsburgh.

This does not mean that these works come to Saskatchewan with ribbons tied to them. They are still too "difficult" for that, and the greatest part of the institutional or official art world in New York still feels too much challenged by this kind of art, as indeed most artists and critics in New York still do. Indifference towards it may have changed to nervousness, but it is the nervousness felt in the face of a threat to established

tastes. And it is also nervousness about missing the boat, a kind of nervousness that afflicts the New York art world chronically. Nobody likes anything that makes him nervous, and the art of Louis, Noland, and Olitski seems destined, for the time being, to be treated unamiably in New York even while it is noticed and followed.

Still in all, I am not so sure but that the enlightened art public of western Canada won't find the challenge more exhilarating than anything else. I don't want to win that public over by flattery, but it strikes me as being less set in its ways than most publics. I have a notion that the apparent simplifications of these three painters will find more immediate appreciation, at least on the part of the "professionals" among you, than they found in New York. I don't think it a mere accident that a good deal of the art being produced right now in Saskatchewan is far less provincial than most of that shown downtown on Tenth Street in New York today.

Maybe I am encouraged in my expectations by the unusual circumstances of this show. That a place as institutional as a university art gallery which is also by way of being a municipal one should exhibit three such very new artists in more than one example each is as unusual in the United States as it must be in Canada.[1] What is even more unusual is that they should be exhibited all by themselves, without being surrounded and muffled by a larger number of not so new artists. The only place north of the Rio Grande where it has been done before is, to the best of my knowledge, Bennington College in Vermont, where all three of these painters have had one-man shows, and artists like Pollock, Gottlieb, Motherwell, and Newman were given retrospectives before anyone else ventured to do so. (But then Bennington College's gallery is hardly more institutional than an artists' co-operative. The Norman Mackenzie Art Gallery is larger, statelier, better equipped, and above all more accessible to the general public.)

This show is also in the nature of a *vernissage*. The three Olitskis present, all of them done since the artist's last New

1. Greenberg organized the exhibition for the Norman Mackenzie Art Gallery, which was associated with the School of Art, Regina College, University of Saskatchewan. [Editor's note]

York show and marking an important new development in his style, have been seen before only at Bennington College. Two of the Louises, *Gamma* and *Number 33*, have not been shown anywhere before; nor have two of the Nolands, *New Problem* and *Gift*. Eventually these pictures will be shown in many other places (if they are not sold too soon), but I take what is perhaps irrational satisfaction in their being exhibited first in Regina.

The three Olitskis have a special significance. Olitski was already exceptional when he was a portrait painter, and he remained so as the maker of thickly impasted pictures in a European vein of abstraction, and more recently as an explorer of high-keyed combinations of very flat color. The work he showed over the last two years in New York was some of the most unconventional to be seen anywhere in American painting. Yet hardly anything he has done before matches the three present canvases in resolved strength or in clarity and harmony. He departs in these from his immediately previous manner only in paint quality, but what a great difference this has made. At the same time that it brings his art closer to that of the other two painters in this show, this change enhances the expression of his individuality. In a more general way it demonstrates how crucial such a supposedly minor aspect of pictorial art as paint quality can become.

Louis was the discoverer here—Louis, whose recent death was all the more of a loss to art because he died at the height of his powers. Back in 1953, which was the first year of his artistic maturity, Louis discovered that the ambitious abstract painter could no longer safely take anything for granted in the making of a picture, not the shape of its support, not the nature of its surface, not the nature of its paint covering, not the implement with which he applied the paint, and not the way in which he applied it. In the thinness of paint and in an absorbent surface (whose absorbency he could control, if he chose, with the right dosage of size or glue) Louis found his means to a new integrity of color. Cézanne had been the first to take a conscious step in this direction when he transferred his watercolor touch to oil. At about the same time the young Vuillard was beginning to use distemper (glue and water) instead of oil and turpentine. For much the same reason, if for

quite different effect, Matisse, later on, resorted to consistently thin paint: in order, that is, to exclude reflections, tactile associations, and anything else that might detract from the sheerness of color. Louis, going further in the same direction, diluted his paint (for which he chose acrylic resin) to an extreme, and *soaked* it into untreated sailcloth so that it became one with the fabric—a stain instead of a discrete covering coat. Up to this point he was still taking hints from the Pollock of 1950, and from Helen Frankenthaler, herself influenced by Pollock; the next steps in his procedure became entirely his own, however. In 1954 he began to lay transparent veils of paint in different hues one over the other so as to mute their separate intensities into so many neutral and ambiguous shades of a single low-keyed color. *Gamma*, in this show, is one of the last examples of a picture he executed in this way, and it is a rare example because it is a relatively small one. (The majority of paintings Louis left behind are at least three times its size.) The effects we see in it are what first established Louis's originality on the American art scene. Nevertheless when his feeling for color changed he did not hesitate to abandon his "veils," for truth to *his* feeling was what he cared for most.

Louis's stain had a decisive initial influence on Noland, who was a friend and neighbor of his in Washington, D.C. But in the last year and a half of Louis's life Noland returned the influence, as Louis himself was the first to admit. His art would have evolved anyhow, I feel, towards intenser and more opaque color, and vertical stripings were already emerging from under his "veils" in the years previous. Noland's influence served, however, to speed their emergence, and his example also demonstrated the uses of the off-white of the unprimed cotton duck as a field on which to float vertical as well as concentric stripes. One of the effects achieved was that of boundlessness, of anonymous and ambiguous space, and the particular triumph of Noland's painting is the way in which it specifies and at the same time generalizes off-white (or for that matter, brown or yellow or red) "space," making it seem both very literal and very abstract.

I want to warn the observer that the configurations in the paintings of these three artists are not meant as *images* and do

not act as images; they are far too abstract. They are there to organize the picture field into eloquence. And it is for the sake of eloquence, not for the sake of "symbols," that these artists have abandoned representational painting. Louis is not interested in veils or stripes as such, but in verticality and color. Noland is not interested in circles as such, but in concentricity and color. Olitski is not interested in openings and spots as such, but in interlocking and color. And yet the color, the verticality, the concentricity, and the interlocking are not there for their own sakes. They are there, first and foremost, for the sake of feeling, and as vehicles of feeling. And if these paintings fail as vehicles and expressions of feeling, they fail entirely.

Three New American Painters: Louis, Noland, Olitski, Norman Mackenzie Art Gallery, Regina, Saskatchewan, January–February 1963; *Canadian Art*, May–June 1963 (unrevised).

32. Painting and Sculpture in Prairie Canada Today

When *Canadian Art* asked me to do a report on the situation of painting and sculpture in Manitoba, Saskatchewan, and Alberta I was a bit taken aback. Didn't they know about that situation in Ottawa? Was that how difficult communication was between prairie Canada and the rest of the country? Northern Ontario and the Canadian Rockies were, apparently, great isolating factors. But then I remembered how little we in New York knew about the situation of American art outside New York, and that the reason was not geographical but simply the assumption that that situation was not worth finding out about. On the basis of this assumption one hardly bothered to read the "letters" in the New York art magazines reporting on the art scene "out of town." The case, I concluded, must be more or less analogous in Canada. Montreal and Toronto as leading centers of art, with Ottawa as a headquarters if not center, and Vancouver in the role of San Francisco, took it for granted that prairie art was nothing but provincial—and were all the readier to do so because they themselves felt in a provincial relation, art-wise, to Paris and

New York. For this reason I saw prairie art in Canada as being wrapped in double obscurity.

My visit to western Canada this past summer (which started off, importantly for me, with two weeks at the Emma Lake Artists' Workshop of the University of Saskatchewan at Regina) modified this view.[1] It might have been the correct one a year or so ago, but since then eastern Canada had become aware at least of art in Regina. This, I surmised, was what had actually prompted *Canadian Art* to think of this survey, and then ask me to do it (when it learned that I was going to be in western Canada anyhow). Eastern Canada did want to hear more about what was going on with art in prairie Canada, and the isolation of the latter was indeed beginning to be penetrated. And it was for good reason: much better reason than we in New York would have for penetrating the isolation, say, of art in Los Angeles.

Abstract Painting

REGINA. The vitality of art in Regina does constitute an unusual phenomenon. It may involve, immediately, only a small group of artists, but five such fired-up artists would amount to a lot in New York, let alone a city of 125,000. I am tempted to attribute it all, ultimately, to the spirit of the province itself—especially since Saskatoon has begun to show a similar vitality in art. Saskatchewan could be considered, I suppose, the remotest or most isolated of the provinces of western Canada that border on the United States. Manitoba has Minnesota directly below it, while British Columbia has next to it the Pacific Ocean and the American Northwest, in whose proximity Alberta seems to share; but Saskatchewan has only North Dakota and Montana to the south. What makes Saskatchewan unique, however, in my experience is not its isolation as such, but that its inhabitants seem to face up so squarely to the fact of it. That this is not an eccentric impression on my part is confirmed by what an English artist named Robert Dalby, who has lived for a good while in the north of

1. Previous leaders of the Emma Lake Artists' Workshops, which were founded in 1955, included Jack Shadbolt, Will Barnet, Barnett Newman, John Ferren, and Herman Cherry. Twenty-four artists participated in the workshop led by Greenberg. [Editor's note]

the province, told me about Saskatoon, which he thought a remarkable place because of its awareness of how much, in its remoteness and newness, it needed the rest of the world. I found this state of mind pretty much present elsewhere in Saskatchewan. Unlike Podunk or San Franscisco, the place does not waste its mental energy in conjuring up illusions of itself as a rival to New York or London; it frankly acknowledges that it is in a provincial situation. If it is true that the truth shall make you free, it is also true that looking an obstacle straight in the eye is the first step in overcoming it. This may explain why I found both Regina and Saskatoon far less provincial in atmosphere than I had expected.

The specialness of art in Regina consists most of all in a state of mind, of awareness, and of ambition on the part of five abstract painters who live there, and whose activity is centred around the Norman Mackenzie Art Gallery, of which one of them is the director. (The gallery is attached to the Regina campus of the University of Saskatchewan.) Not that the specialness does not consist in achievement too—particularly in seven or eight pictures that Arthur McKay did in the winter and spring of 1962. But it is even more because of McKay's spirit, and the spirit of his colleagues, that I find something wonderful going on in Regina art.

That spirit expressed itself in what the Germans would call a fateful way when Ronald Bloore, Roy Kiyooka, and Arthur McKay proposed that the painter, Barnett Newman, be invited to come from New York to conduct the 1959 session of the Emma Lake workshop. (Emma Lake is near Prince Albert National Park.) They had discovered Newman in the reproductions accompanying an article in *Art News* (Summer 1958) by E. C. Goossen (the first article ever devoted to Newman in any magazine), and what they could make out of his startlingly simplified art from black and white photographs convinced them, apparently, that it offered the kind of challenge they were looking for. Newman came to Emma Lake without bringing any of his paintings along, and he did no painting while he was there, but according to all reports his personality and his ideas had a galvanizing effect on the artists who attended his "seminar." The new seriousness with which some among them began to take themselves as artists after Newman's visit

became a main factor in the creation of the informal group of painters now known as the "Regina Five."

They are Ronald Bloore (originally from Ontario and the present director of the Norman Mackenzie Art Gallery), Ted Godwin, Kenneth Lochhead, Arthur McKay, and Douglas Morton. (Lochhead was away on a Canada Council grant at the time of Newman's visit, but felt its after-effects. Kiyooka has in the meantime moved to Vancouver.) Every one of these painters is more or less what I would call a "big attack" artist, by which I mean an artist of large and obvious ambition, with an aggressive and up-to-date style, and with a seriousness about himself that makes itself known in his work as much as in his demeanor. Though not the only "big attack" artists in prairie Canada, the Regina Five form the only concentration of them in that region, and this, as much as anything, makes Regina the art centre it is.

There is relatively little of Newman's direct influence to be seen in their work aside from a tendency to clean-edged drawing and open design, and maybe something in Bloore's use of white on white. Kenneth Peters, who is in his early twenties and not a member of the Five, is the only painter I saw in Saskatchewan who had taken something integral from Newman—his linearism, namely, and his warm dark color—but Peters still has his own way of handling paint itself. He would rate in New York as a "far out" artist and there is already something more confidently individual in his art than in that of one or two of the Five themselves, but a wariness of artists who break through before reaching thirty makes me hesitate in commending him.

I think it can be said without offending any one that Bloore is the "leader" of the Regina Five: and certainly he was the most formed and distinctive artist of the group before the advent of McKay's new paintings. This does not mean that I like what he does. It's a little sour and at the same time too elegant in its impasted whites; and there is also a somewhat trite relation between his regular, geometrized configurations and the shape itself of the picture; here he could have learned a lot more than he did from Newman. All the same, Bloore remains very much an individual, and remaining that, he may yet force me to eat my words. And even if that does not happen, the

School of Regina will remain in debt to him for his leadership, which brought in a certain influence that kept certain other, more noxious influences out. This, too, I think, was a most important factor in the formation of the Regina Five. By introducing Borduas' direction, Bloore warded off that of New York abstract painting in the fifties, with its mannered brush swipes and smears and spatters, and its deceptively hackneyed scaffoldings of light and dark. The influence of this New York manner has been one of the most blighting, as well as most infectious, that I know of in modern art. Borduas' influence may carry some Paris "pastry" with it, which can be just as bad as New York "lather," but Borduas' integrity seems somehow to have communicated itself to his influence, at least in Regina, and prevented it from having too deleterious an effect there. With one or two exceptions, the other "big attack" painters I came across in prairie Canada were victims of the New York influence, and the difference between what they were doing and what the Five were doing made clear how great was the service Bloore-Borduas had performed for Regina art. (Ironically, Borduas himself derived from New York, but from the New York of Pollock, not of de Kooning, in so far as his art won its first distinction by Gallicizing Pollock's ideas. And it is really Pollock, as polished and interpreted by Borduas' palette knife, that is at the bottom of the "all-over" pictures that both Godwin and McKay were doing up until a year or so ago.)

The Bloore-Borduas influence in Regina has been, as it now turns out, of positive as well as negative benefit. Through it Arthur McKay has been able to realize himself. In the already mentioned seven or eight pictures that he painted before last summer, McKay converted Bloore-Borduas knife-handling into something altogether his own, and did with it some of the best as well as most ambitious painting I have seen anywhere in Canada since I came on the later work of Jack Bush three years ago in Toronto. Working in a lower key than any abstract artist in Regina other than Peters, McKay sets rounded squares, blunted ovals, or trued discs, sometimes solid, sometimes open, but always pale, against very dark grounds that are infused with luminous blues, or greens. Where McKay's originality declares itself as much as anywhere

is in the curiously spacious way in which his central motifs are related to the shape of the support. (Bloore could have learned something from him too in this respect.) This is no merely technical matter, but has a lot to do in McKay's case, as in Mathieu's, Fautrier's, and even Clyfford Still's, with a new specification of pictorial feeling; it marks a break from the Cubist "box" as we still see it in Soulages, de Kooning, Riopelle, Guston, and many others, and embodies a new response to experience. These new pictures of McKay's would be as new in Paris or New York as they are in Regina.

The turn Kenneth Lochhead's painting took in the summer of 1962 toward color and concentricity should make him the next among the Five to be reckoned with importantly. Emerging from under the influence of Bloore-Borduas monochrome, he has broken through to pure flat color stated in shapes that approach "geometry" without really touching it. This new direction relates to nothing else in contemporary Canadian painting, for which reason Lochhead's latest pictures are perhaps a more surprising apparition even than McKay's. It remains to be seen whether this accomplished and versatile artist will pursue his new vision of color with the required tenacity, and, above all, nerve.

Ted Godwin, too, is in transition, and he too seems to be on the point of breaking out of the hitherto accepted channels of abstract art. The ideas that appear in his recent oils remind me at most of things glimpsed in East European or Levantine contemporary art—I mean the art of abstract or semi-abstract painters from those regions who work within the West European tradition of easel painting. But to say this is to be less than just to the originality of Godwin's new conceptions. Right now his problem is to realize these conceptions pictorially; they are still more a matter of illustration than of painting in the full sense; they still rely too much on allusions to the third dimension, which is not necessarily wrong, but in his case causes the picture rectangle and the picture surface to jam up and flow over. Here Godwin reminds me strongly of the paintings of Arshile Gorky in the period (1943–44) when the latter was trying to accommodate ideas derived from the early Kandinsky and Matta to a space shallower than theirs. Gorky had already found the solution, in the openness and looseness

of crayon drawings done from landscape subjects a year earlier, and all he had to do in the end was bring his oils closer to these. It strikes me as being more than a mere coincidence, in view of certain vague resemblances to Gorky that I find in his latest oils, that Godwin should have, as I think, his own solution pre-figured in the very successful openness of the gouaches and watercolors he did at about the same time.

Douglas Morton, the remaining member of the Five, offers the case of an artist whose sheer facility stands in the way of self-discovery. Morton can do anything with paint, but has scattered himself in too many directions so far; he has not yet arrived at what he, and only he, can do and has to do. Though several of the paintings of his that I saw in Regina attained a high level of success—particularly the one most lately acquired by the Norman Mackenzie Art Gallery—I would still consider him a largely unknown quantity in terms of realization. But that a real capacity is there I do not doubt.

SASKATOON. The only unmistakably "big attack" painter I found in Saskatoon was Otto Donald Rogers, whose vision manifests both breadth and depth but is kept from fulfillment by too great an infusion of the New York manner of the 1950s. His art does not present the most extreme case of the "Tenth Street touch" that I chanced on in prairie Canada, but it is one of the most regrettable of such cases precisely because with Rogers that touch belies a fullness of inspiration rather than covering a want of it. Which is not to say that some of his pictures are not brought off; they are. Some of them belong with the very best abstract art I saw in western Canada; yet their viscous paint and dragged brushstrokes, with all that these connote of fashion and convention, keep them from being more than very good local art.

There are several other abstract painters in Saskatoon in whose favor I may be prejudiced because I was with them at Emma Lake last summer. Henry Bonli and William Perehudoff do not yet have the attitude of "big attack" artists, but the stripped-down kind of painting they have both begun to do strikes a less provincial note than Rogers' kind, and it depends only on their steadfastness and nerve whether they become artists of more than local importance. If they do, a lot of

fresh air will have been let into Canadian abstract art by the "Saskatoon School."

Among other things that attested to the surprisingly high general level of art in Saskatoon were the small and modest, but original and complete, paintings, in a Klee-ish vein, of Wilbur Lepp, a very young artist whom I likewise met at Emma Lake. On the other hand, the two or three pictures each I saw by Louis Frischolz and Stan Day in Saskatoon struck me as unresolved, though they were definitely not *routine*. Nor were the promising but incomplete quasi-geometric paintings of Joan Rankin of Moose Jaw routine—she was another abstract artist I met at Emma Lake, where almost everybody, to my surprise, turned out to be a "pro." And I mean a "pro" in the fullest sense.

EDMONTON. Abstract art in Edmonton, which was the first place I visited in Alberta, was more provincial than in Saskatchewan. Art in Edmonton has the benefit of a municipally supported art centre whose collection is not to be sniffed at, and whose director, John Macgillivray, is active as well as informed. And Edmonton also has an artists' co-operative, the Focus Gallery. But the art being produced there seemed to me to lack the *élan* of art in Saskatchewan; nor did I get as vivid a sense of a coherent artists' community. Maybe this was because Edmonton is in such a rapid state of expansion. It reminded me curiously of New York. Even more curiously, its abstract art showed the highest frequency of New York influence that I found in prairie Canada.

The pictures of Ethel Christensen and Les Graff were not only soaked in Tenth Street mannerisms, they were also brash and aggressive in a Tenth Street way. This is no verdict on the potentialities of these two artists, but it does reflect very much on their taste. In Douglas Haynes' touched-up prints I was even more surprised to see the lay-out of Adolph Gottlieb's *Burst* paintings unabashedly present (though Gottlieb is the antipodes of Tenth Street). This lay-out was handled, all the same, with a certain felicity, so that I had to conclude that Haynes had added something of his own to the idea by reducing it in size.

One of the better abstract painters of Edmonton was Jean

Richards, in one of whose pictures I was again surprised to detect Gottlieb's influence, though assimilated and almost hidden in an "imaginary landscape" that was quite unlike the "imaginary landscapes" Gottlieb himself did ten years ago. Another work that showed real feeling was C. R. Kaufman's semi-figurative painting, where something was germinating under a manner that seemed both familiar and uncertain. Still another abstract artist of interest was Detta B. Lange, who did silk-screen prints in a semi-abstract, stylizedly "primitive" manner; Miss Lange presented one of those comparatively rare cases of an artist whose work benefited from increasing abstractness.

The most professional and accomplished of all the abstract painters whose work I saw in Edmonton was John B. Taylor, whose example (not style) may be responsible for the fact that most of the abstract art there stays close enough to nature to be called semi-figurative. The fault I found with him lay, however, precisely in his professionalism: in the fact that his art was so completely and seamlessly encased in a rather familiar manner derived from Klee, prismatic Cubism, and what I call "Northwest Indian" abstraction. And I felt (I hope Mr. Taylor will excuse my presumption in saying so) that he could have put his high talent to better use in more forthrightly representational art.

CALGARY. Calgary, too, struck me as being more of an American than Canadian place, but the situation of its art and of its artists was quite different from that in Edmonton. Its artists' community is of longer standing, and has many more members—more members, apparently, than any other artists' community in prairie Canada. It also has a first-rate commercial gallery in the Canadian Art Galleries, as well as a very active and commodious art centre under the expert directorship of Archibald Key. Nevertheless, the general impression made by the abstract art I saw there was one of timidity and irresolution—there was certainly nothing in it to match the aggressiveness I saw in Edmonton.

I could, however, recognize one unmistakably "big attack" painter in Calgary besides Stanley McCrea (who lives in Lethbridge and brought his work to Calgary for me to see). That

was Ronald Spickett. The fact that his art had a French and Franco-Oriental cast spoke for the case of abstract painting in general in Calgary, which showed surprisingly little American influence of the Tenth Street variety. I had already seen five or six large paintings by Spickett in Edmonton, where they were about to be hung in the Art Gallery, and one of them, barely reminiscent of Mathieu, with a sparse linear motif on an empty but pregnant ground of saffron (or something like saffron) remained, and remains, in my mind as the boldest abstract painting I saw in prairie Canada, and the best and most ambitious I saw outside Regina. But nothing else of Spickett's that I saw could be compared with it; everything else was too much involved in silken and gilded graces; his smaller paintings were all brought off, but too well brought off. In other words, he had failed to recognize his "message" when it came.

Stanley McCrea of Lethbridge is far more immersed in New York mannerisms than Rogers of Saskatoon is, but his plight is a similar one. Like Rogers, McCrea has something to say, but it is almost completely muffled under a paint surface that is as inexpressive as it is agitated. Forceful configurations that have nothing intrinsic to do with trowelled paint or poured soup barely manage to make themselves seen. Nonetheless, McCrea is a painter to watch.

I saw the work of more than twenty other abstract or quasi-abstract painters in Calgary. Most of it was thoroughly competent, none of it gave me anything like a real surprise. A small lithograph-and-metal print by Deli Sacilotto that had a nice and—for once—American kind of openness, was the best single abstract picture that I saw at the Calgary Allied Arts Council, but even this was a little on the tasteful side, and set the key for the less enterprising tastefulness of most other things present, in which every vein of polite Cubism current since 1930 was represented (and also what I took for the strong influence of Seattle). On the whole I found the watercolors, gouaches, drawings, and prints superior to the oils, three-quarters of which were done by the same hands. Among the best both in oil and in watercolor was Marion Nicoll, who revealed the helpful influence of Will Barnet (the first of the New York artists to come, in the summer of 1958, to Emma Lake). There was a nice oil by Illingworth Kerr, who was fur-

ther represented by a perhaps over-tasteful Klee-like sand drawing. Other oils that, for all their circumspection, caught my eye were by William Brownridge, George Wood, Frank Palmer, Janet Mitchell, and Luke Lindoe. Frank Palmer was perhaps the most finished painter I saw in Calgary, aside from McCrea and Spickett and Maxwell Bates, but he demonstrated far more strength in his representational pictures. I would say the same of Bates, whose oil was far too European-stylish, even though his half-abstract watercolor was eloquent. A batik wall hanging by Clifford Robinson betrayed some distinction, as did a watercolor by Velma Foster, another artist in whom I thought I discerned Barnet's influence, and a watercolor by Joseph Tillman. Exceptionally, Janet Middleton's color lithograph showed her to be better in an abstract than in a representational vein.

Among the abstract pictures that I thought were betrayed by their timidity and mere tastefulness were those of Harold P. Patton, Stanford Perrott, F. Douglas Motton, Wayne K. Whillier, Stanford E. Blodgett, Rolf Ungstad, George Angliss, and John Snow (another who showed to better advantage when working from nature). Kenneth Sturdee's tondo and the very competent Gorky-infected painting of George Michalcheon were about all I saw in Calgary that approached New York flashiness. Iain Baxter's painted screens may come even closer to the Paris-*cum*-Pollock kind of flamboyance, but I hesitate to say, since I know them only from black and white photographs.

WINNIPEG. Abstract art in Winnipeg revealed a little less timidity than it did in Calgary, but maybe even greater irresolution. I had been told that Winnipeg was pretty much dominated by tendencies emanating from the art departments of the Midwestern universities to the south, but I was still surprised to see how much in its painting reflected the present stagnation of abstract art in the Midwest. (Winnipeg has a thriving art centre, directed by Ferdinand Eckhardt, but it seemed to have proportionately fewer active artists than any other place in prairie Canada, even though its ratio of wholly professional artists seemed larger.)

The only painter who looked aggressively up-to-date in the

impromptu showing Dr. Eckhardt put on for my benefit at the art centre was Winston Leathers, in whose picture I recognized the Chicago abstract manner of the 1950s: a combination of Gorky, Matta, and Joan Mitchell; but there were enough Tenth Street notes in Leathers' painting to justify calling it New York stuff with a Chicago accent. Anthony Tascona, the local "whiz" and ostensibly a "big attack" artist, came out of an earlier Chicago, the Chicago of the late forties, when what I call "Whitney Annual abstraction" flourished widely in the United States: a composite kind of thing, of "free" shapes and Picassoid and Miró-esque loops and curves (Seong Moy's style was the epitome of it) in shallow illusionist space. This standardized manner was not consistently present in the seven or eight recent paintings of Tascona's that I saw, but it was there enough to give them a rather old-fashioned and provincial look. Not that I object to the old-fashioned in itself; what I found objectionable in Tascona's art was its failure to say anything, its lack of content.

The small abstract paintings in mixed media on paper of Robert Bruce verged on preciousness, but did try to get something said by dint of their painterly color, and even his landscape straight out of late Picasso had some personal feeling in it. The color of Bruce Head, too, in a pair of oils otherwise bogged down in the tasteful lights and darks of juicy paint, was strong enough to make me feel he was one of the more promising abstract painters of Winnipeg. Frank Mikuska, to judge from his "ink graphics," was trapped in an eclectic, catch-all, painterly conventionality like and unlike Bruce's and Head's that, coming out of both New York and Paris, was hard to label but easy to recognize. The conventionality of James Willer's half-abstract landscape was easier to define: decorative prismatic Cubism, but pleasant at that. George Swinton's quasi-abstract drawings were better, but their thinness gave far from an accurate measure of the capacities of this artist.

Of all the abstract artists whose work I came on in Winnipeg, Donald Reichert was the one who seemed to have the most possibilities. Almost everything I saw in a show of his at a commercial place, the Grant Gallery, was involved in the effort to say something. The main trouble was that it all went off in too many different directions no one of which seemed

exactly the right one for this artist. It will be interesting to see whether Reichert will be able to find the right one without leaving Winnipeg.

An unusually adept painter whose work I saw at the Winnipeg Art Gallery was Jack Markell, who perhaps should not yet be classed as abstract. His earlier pictures derived from the Boston school of Jewish expressionism—Jack Levine's and Aronson's—and were no better and no worse than their prototypes. A later picture, which was more abstract, did not make Markell seem any the less of a virtuoso. And, in fact, I found Winnipeg abstract art too much occupied in general with *cuisine* and mechanics and virtuosity.

Landscape Painting

WINNIPEG. On the whole I found abstract art in prairie Canada faring no better than it has, lately, in Chicago or Montreal or Los Angeles, or Brussels or Munich. The going styles in Paris and New York are reflected in Calgary, say, after a greater lapse of time perhaps, but the consequences in terms of actual quality are not much different. What I myself notice is that the fashions of abstract and quasi-abstract art do more to stifle personality than the fashions of academic representational art ever did. Far be it from me to call for a return to nature. Art goes where it goes, heedless of calls, pleas, or commands. Still, straightforward representational painting seems to me to suffer far less nowadays from the repetition of stereotypes and clichés. With the artist who works directly from nature, personal feeling about his subject will often break through whatever stereotyped effect he may be striving for and put enough of itself in the result to make it minimally interesting. With the artist who works without the direct help of a subject in nature, personal feeling has to insist on itself much more strongly in order to make itself evident, and often the artist has to summon up his courage in a more conscious way in order to let the expression of his feeling take him away from over-studied effects. This may be part of the reason why the challenge to major originality is largely confined nowadays to abstract art, but it is also the reason why—given that most artists, like most people, lack the courage to be consciously and effectively themselves—a much greater proportion of abstract than of

representational art remains hopelessly derivative and boring. If the very best art of our time is abstract, so is the very worst, and most of the very worst. In other words, quality, even if it is only minor quality, is far more frequent even today in painting and sculpture done directly from nature than it is in any other kind of painting and sculpture.

It is not so surprising therefore to find that what makes a visit to Canadian art, in the present as well as the past, most generally rewarding is its landscape painting. It had not been Riopelle (an empty artist, at least in oil) or even Borduas (who can be overrated) who awoke my interest in Canadian art in the first place, but Goodridge Roberts, with a landscape that I came across at the Carnegie International of 1955. Since then I have gotten to know and relish the Group of Seven, Morrice, Cullen, Emily Carr, Milne, Lemieux, Tonnancour, Humphrey, Cosgrove, and quite a few other Canadian landscape painters. Landscape painting is where Canadian art continues, I feel (allowing for Borduas, Bush, McKay), to make its most distinctive contribution. Even the landscapes of Varley, who devotes more attention to the figure and portrait, seem to me to surpass by far the rest of his work (two or three landscapes of his that I came on in the permanent collection of the Calgary Art Centre struck me as being among the very best things I have ever seen in Canadian art). Nothing in Canadian landscape painting contributes to the "mainstream," exactly; nothing in it amounts, that is, to major art. But this hardly dilutes my pleasure in its freshness and authenticity, or makes it less valuable. Least of all does it justify condescension. In praising it I make no allowances whatsoever.

One could speculate that the distinctiveness of Canadian landscape painting is owed to the character of its favourite terrain, the pre-Cambrian shield country. I myself feel that the northernness at least of this country has something to do with the hallucinatory note I find in many Canadian landscape paintings—a note that gives an unmistakably Canadian feeling to even the *handling* of landscapes done by an artist so recently out of England as Robert Dalby, who lives on Lac La Ronge in north-central Saskatchewan.

But I also feel that the distinctiveness of Canadian landscape

166

painting in this century comes in part from the assimilation of Fauvism-*cum*-Impressionism to Anglo-Saxon temperaments and northern subjects. The liberated color and brushwork of this fusion of modernist French styles has proved particularly congenial to American painters too—painters like Marin, Hartley, Avery, and Arnold Friedman. It is as though any other approach to the wild or half-wild northern landscape would have been, for these Americans as well as for their Canadian counterparts, too stately and formal. And by and large, the transplantation of French Modernism to this side of the Atlantic has produced better landscape art than the transplantation of anything previous, including Constable and the Barbizon School.

The tale of landscape painting, both in Canada and the United States, is far from told. I would hazard that more good landscape painting is still being turned out today in both countries than painting of any other kind.

This certainly proved true in prairie Canada, where landscape painting everywhere but in Saskatchewan rescued situations I would otherwise have had to report as discouraging. Reversing the direction of my tour, I start this part of my report with Winnipeg, where George Swinton's northern landscape in pinks, oranges, and reds, with overtones of Varley, in the permanent collection of the Winnipeg Art Gallery Association made a tremendous impression on me. If Swinton has other pictures of this quality to show, then he should be rated as one of the luminaries of North American art.

Kevin Clark's filmy, Passmore-like landscape was successful but in a much more tenuous way. Another good representational picture I saw in Winnipeg was Ivan Eyre's Bonnard-influenced interior with figure, which was much stronger than his pencil-and-crayon essays in Beckmann-ish Expressionism. But after Swinton's landscape, I took pleasure in, above all, Barbara Cook's large academic watercolor of a river with houses, the truth of which was felt in every unpretentious and straightforward square inch of its handling. Among the other "modest" representational painters whose things I liked at the Art Gallery Association in Winnipeg were Pauline Boutal, Victor Friesen, and Denise Chivers. (And I would have liked

their pictures anywhere: in New York, Paris, or London. I bother to say this lest some reader think I'm being patronizing toward Winnipeg.)

CALGARY. My discovery among landscape painters in Calgary was W. L. Stevenson, whose style does not suffer by its closeness to Goodridge Roberts'. I had the good fortune to see a show of Stevenson's at the Focus Gallery in Edmonton, and can't understand why he is not known all over Canada. I also saw a retrospective show of Maxwell Bates' work on the eve of its hanging at the Canadian Art Galleries in Calgary, and thought that the landscapes were consistently the best among his paintings, although a French street scene in grays and blues out of Marquet gave the clearest indication of what this artist could do at his best, and I was disappointed not to see more pictures like it in this show. Among other things I saw at the Canadian Art Galleries were an excellent landscape by Frank Palmer, of whose work in this vein I would have liked to see more, and a good street scene by William Welch.

A view of shacks in grays, whites, and tans by Heinz Foedisch, in the show put on at the Calgary Allied Arts Council for my benefit, struck me as being the best oil painting, abstract or other, in the whole show—as though to refute everything I've said above, for it was only vaguely Canadian in subject, and hardly at all so in its slightly "Expressionist" realism. Foedisch's largely pencilled watercolor was, also, for me the best of all the watercolors in the show. Foedisch is, obviously, not a "big" artist, but on the basis of the evidence at the Calgary Allied Arts Council, he is a very true and gifted one, and I wondered where he came from, with his German name, and why he too was not better known.

Among other landscapes or near-landscapes that I liked in Calgary were a Hartleyan oil by W. F. Irwin, a rather pretty one by Annora Brown, a pleasant if somewhat amateurish one by Harry G. Hunt, a tight watercolor by Herbert Earle, and two other watercolors by John Snow and Edith Carleton respectively; the latter also showed a very successful oil, but my notes do not indicate what its subject was. All they say is: "Maybe the best color in the lot."

Nothing in the figure or portrait paintings and drawings I

saw in Calgary impressed me markedly, but I did notice the potentialities revealed if not realized in several pictures in different mediums by Ursula Zandmer. Her three-quarter-length drawing of a girl showed, by its superiority to Mrs. Zandmer's other works, that sentimentality was her trouble—which, as was to be expected, was least restrained in her oil painting.

EDMONTON. Edmonton, too, had its share of good representational painting, with landscapes again in the lead. Douglas Barry showed two landscapes that were successful, and one of which, though it may have owed something of its emphasis to Goodridge Roberts, exhibited unusual temperament. Murray MacDonald's watercolor landscape was a perfect work within its limits, while his diving view of three boats was another picture that betrayed unusual temperament, and despite the fact that it was less self-evidently realized than his landscape, it may have been the best painting I saw by an Edmonton artist at the Art Gallery. Mary Parris' landscape fantasy showed originality of feeling, whereas Barbara Roe Hicklin's two landscapes, one in oil and the other in watercolor, succeeded in a more familiar and straightforward manner. The straightforwardness of Margaret Chappelle's landscape was even more felicitous and poetic; she too is a superior representational painter (though I may be prejudiced in her favor by the fact that I met her at Emma Lake). J. P. Nourry (Mrs. Douglas Barry) is a semi-figurative artist of competence, but the one picture of hers that I saw told me very little else. The more forthrightly representational work of Thelma Manaray was definitely stronger than that of hers which was more abstract, and would have benefited, I felt, by coming even closer to nature.

H. G. Glyde's village scene in oil was shot through with "Canadian" feeling—though the artist, I was told, was English-born; its thorough professionalism did not compensate, however, for a certain lack of accent or modulation. Violet Owen's figure paintings were more than accomplished, which is no small thing in a figure painting today, but needed more of an individual approach to their subjects, as I felt. Were Miss Owen to solve the problem she proposed herself in her seated figure of a woman, and get real anecdotal interest as well as an

explicitly abstract harmony from the result, she would be doing something that seems beyond the capacities of most painters of this day.

SASKATOON. Saskatoon was the only place in prairie Canada where I saw the prairie itself really tackled as a subject for landscape. Elsewhere, for the most part, I saw the "bush" being painted, or parkland, or hills, or bodies of water. In Saskatoon, however, the prairie seemed to enter into almost everything (and for an Easterner like me the prairie was a far stranger sight than the "bush," which you can see in Maine and Quebec too). The problem was how to master the prairie's lack of feature, and the most usual solution was to find a town on it, or a clump of trees, or a conspicuous slope.

One could see the prairie in a very good small landscape by Otto Donald Rogers, and as Andrew Hudson has suggested, it might also be glimpsed in the new openness of Henry Bonli's and William Perehudoff's abstract paintings (though I am not one to dwell much on the jumping-off places in nature of abstract art). Suffice it to say that Perehudoff's "real" landscapes, which were done earlier, were more than nice.

Among the outspokenly representational painters of merit in Saskatoon was Reta Cowley, who renders the villages and towns of central Saskatchewan with delicacy and fresh feeling. She demonstrates that one can learn from Cézanne and Klee how to make nature more, not less, vivid in pictorial art. Wynona Mulcaster's landscapes show a penchant for a wilder nature and the germs of a temperament of force, a temperament that might demand a less gentle way of being asserted. The neatness and prettiness of Robert N. Hurley's watercolors of prairie farms and towns have, I gather, made them popular in almost a commercial way, but that should not be held against them; they are as genuine and affecting as they are modest. Nicholas Semenoff's landscapes, like Perehudoff's, had a happy sturdiness to them; that is, they were less "optical" and more "plastic" than those of Cowley, Mulcaster, and Hurley—which did not make them *necessarily* better, as good as they were. Margaret Turel's landscapes were both sensitive and firm, as well as displaying a curiously deep sophistication, which was borne out by the "intimism" of her still lifes and

interiors; she has to watch out, however, for the sentimentality with which she tends to treat the human figure.

Mrs. Turel was not the only foreign-born artist who had something to do with the sustaining of the surprisingly high general level of painting in Saskatoon. There was also Andrew Hudson, a year out of England, who is a completely accomplished representational artist, at home in all *genres*. Then there was the Austrian-born Ernest Lindner, whose sharp-focused, high-keyed literalism, as displayed in watercolors of astonishing skill, struck a note entirely different from anything else I had come across in prairie Canada except for the tiny engraved landscapes of the late H. E. Bergman, another foreign-born artist, who lived in Winnipeg. Lindner's close-up vision of the forest interior and its tangle is all his own, and includes high color as well as tight drawing and modelling; but it has had to be aerated and loosened and opened up in order to declare itself rightly. I had the good fortune to see this happen under my very eyes at Emma Lake this past August.

The handicap of art in Saskatoon is a diffidence and modesty I find characteristic of Anglo-Canadian art as a whole. Diffidence is better, as I find out increasingly, than brashness; it tends to guarantee honesty. But there comes a point where its disadvantages outweigh its advantages. For one thing, it entails the reluctance to take oneself seriously enough as an artist. For another, where nerve and pretention can falsify the truth diffidence can diminish it. Dorothy Knowles (Mrs. William Perehudoff) is not the only artist in Saskatoon who suffers from diffidence, but the whole problem of it seems lately to have come to a head for her. Aside, possibly, from George Swinton, she was the only landscape painter I came across in prairie Canada whose work tended toward the monumental in an authentic way. The Group of Seven failed with the large landscape, as it seems to me, because their feeling for color was one whose intensity demanded concentration in space as well as time, and could not be maintained adequately over a large canvas or in one that had to be executed in more than one or two "sittings." Miss Knowles, however, does have a color gift of the size required, and that gift has the benefit, moreover, of being informed by the experience of abstract art.

For her the question is whether she has the nerve, not to take further advantage of the "liberties" offered by modernist art, but to come closer to nature and literalness. . . .

REGINA. It would be a shame if the prominence of abstract art in Regina hid from view another woman painter, Mollie Lawrence, whose Chinese-tinged, largely abstract landscape fantasies, off-printed from oil paintings, deserve a much wider public. These prints say something, albeit in a subdued way, that has not been said anywhere else. Another woman painter of Regina who contributes to the high level of art in Saskatchewan is Margaret Messer; her straightforwardly representational paintings ring true—truer than her abstract ones. F. J. Miller, on the other hand, is a painter whose development appears to be carrying him inexorably—which is the only way to be carried—toward the abstractness he has hitherto disdained. I feel that Miller has hardly begun to make his most serious move, as complete an artist as he is—and even though his murals in the new Regina courthouse, and in a new Catholic church in the same city, exhibit a better command of the pictorial resources of the mosaic medium than any yet shown, as far as I know, by any artist, avant-garde or academic, who has had a chance to work at it in the United States.

Sculpture

French Canada has a tradition of folk sculpture, but somehow one doesn't expect to find much in the way of sculpture in Canada at large. This may be a prejudice on my part that comes from the American experience. We had, relatively, a lot of sculptors in the nineteenth century, but none of them came to much (though two or three of them are not utterly negligible in their however abject neo-classical way). But even today, with American painting in the ascendant, we have very few sculptors of really large quality, despite all the ballyhoo to the contrary. After David Smith, after Seymour Lipton, after the somewhat over-rated Calder, who is there?

Indeed, I did not come across many sculptors on my tour of prairie Canada. But among the few I did come on, not only did the work of most of them prove to be very much worth looking at, but a piece done by one of them—to which I shall

return below—gave me perhaps the biggest moment I had anywhere outside Regina.

In Winnipeg—to start there again—the Ukrainian-born Leo Mol turned out be a good and sensitive modeller of figures and heads who proved, once again, that academic sculpture still has some life left in it. Richard Williams' welded construction-sculpture showed, in contrast, all the liabilities that afflict the new "open" sculpture of modernism; there was no denying Williams' ability and taste—only that taste was outmoded in the wrong way, and the ability was put to the service of the "biomorphic" and ornamental clichés that have become current in abstract sculpture since the 1940s.

Unavoidable difficulties prevented my seeing any sculpture in Edmonton, but I was told the name of one sculptor there, Bill Millott. The nearest thing to sculpture that I saw in Regina were the incised-wood bas-reliefs of Helmut Becker, which were pleasant enough, but seemed to me to belong more to pictorial art. Calgary, having as it did more artists than any other place in prairie Canada (or having at least more artists in evidence), turned out to be a different story. Katie von der Ohe revealed herself to be one of those rarest of all artists in North America, a good abstract sculptor, doing tight and beautifully sensed little monoliths in terra cotta; surprisingly, the one representational work of hers I saw was weak. But that was amply compensated for by the more than half life-size nude figure of a girl done in terra cotta by one of Miss von der Ohe's pupils, Jane Gerrish, which was as haunting in its sentiment as it was simple and direct in its slightly stylized handling. Of Roy Leadbeater's abstract sculpture in "found object" wood, the best I can say is that it had something at work in it which showed this artist to be still in the process of searching— which is perhaps more than can be said of most of the other abstract artists whose works I saw in Calgary.

I discovered Saskatoon to have the best as well as most advanced public sculpture I've seen this side of the Atlantic, even though it consisted of only two pieces. There was Robert Murray's fountain sculpture on the plaza in front of the new city hall, an open construction in welded metal that was both powerful and elegant in the distance it kept from the geometrical. Murray was one of the artists inspired by contact with Barnett

Newman at Emma Lake in 1959; formerly a painter, he now works in New York, where he has abandoned welding for the time being for modelling in bronze. If anything he does in the latter medium in the near future matches the quality of his fountain in Saskatoon he will have established himself as one of the stronger abstract sculptors of this continent.

The second piece of the public sculpture for which Saskatoon should be notable is Eli Bornstein's open and "drawn" geometrical construction in stainless steel directly in front of the Teachers Union building. The over-all conception of this work, which must be almost three times the height of a man, is magnificent, and the artist responsible for it stands or falls as a major artist and nothing else. It is true that the piece is marred, and from certain angles of vision even destroyed, by the excessive busyness of the small steel "cards" that articulate its interior space, but its over-all conception survives, and it was that that I carried away with me and really retain, not the fussiness of the "cards." Bornstein, I learned, was an American from Wisconsin who teaches art at the University of Saskatchewan in Saskatoon. I was also told that he is an adherent of Charles Biederman's ideas, according to which the only truly fruitful way left open today to painting and sculpture is strictly geometric abstract construction-sculpture either in the round or in bas-relief. I saw one of Bornstein's colored bas-relief constructions in the hall of one of the university buildings, and though I was dissatisfied with it, felt that it too revealed a major hand and a major ambition. Whether he should be considered a Canadian artist, I don't know, but Bornstein is, or should be, a very important artist. It would be unfortunate, however, if the power of his art gave added weight to his program for art. I don't happen to think that the ideas that program involves are beside the point or crazy; I once knew Charles Biederman, and I respect his imagination if not his art (Bornstein's is far more inspired), but it would be dreadful if his ideas gained the least bit of legislative force outside the minds of artists who, like Bornstein, seem to find them congenial to start with.

So much for contemporary art in prairie Canada as seen by this outsider. I know that my report is incomplete, and I am aware that it may seem distorted by favoritism toward Sas-

katchewan. I honestly don't feel that it is distorted in this respect, but I hope that those who disagree and those better acquainted, in part or whole, with the ground I have tried to cover will not hesitate to make themselves heard from.[2]

Canadian Art, March–April 1963; *Documents in Canadian Art*, ed. Douglas Fetherling, 1987.

2. Greenberg's "hope" was met; the editor of *Canadian Art* was flooded with letters from those who took issue with Greenberg's account of painting and sculpture in prairie Canada. [Editor's note]

1964

33. The "Crisis" of Abstract Art

In Paris abstract art is said to be in a crisis. *Preuves*, the monthly that is the "French equivalent of *Encounter*," is doing a symposium on the "present situation of 'Informel' art." To start it off, the magazine has sent out a mimeographed text (in English as well as French) containing excerpts from statements about contemporary painting solicited from half a dozen French writers.[1] All of them express apprehension about the fate of art at the hands of Informel painting, which most of them take to be what the coinage, *"informel,"* means: unformed or formless. Yves Bonnefoy writes that painting "has become a devout contemplation of depths at which all form disappears." Jean Cassou: "For the *informel* artist, to create is not so much to produce a work of art as it is to perform an act." Roger Caillois affirms that the *"informel* painter does not seek to paint nature, but rather to *create* as nature does," and that he is guilty of a "profound and sterile betrayal of the special gifts which nature has placed at the disposal of the human species. . . ." André Chastel asks: "What can the 'death of art' mean to the artist? Or to the public?" Pierre Schneider, who is the only one to deny that Informel art is formless, writes: "It may be that painting is dying precisely from its having finally come to understand itself. . . ." Wladimir Weidle is satisfied to repeat the old complaint about the failure of abstract art to communicate.

These remarks constitute a sort of document, but one that has little to do, properly, with such a thing as a crisis of art. What it documents is a crisis not of art, but of its criticism: a

1. In addition to Greenberg, participants in the symposium were Jacques Audiberti, Yves Bonnefoy, Roger Caillois, Jean Cassou, Robert Klein, Robert Lebel, Stéphane Lupasco, André Masson, Herbert Read, Pierre Restany and Harold Rosenberg. [Editor's note]

crisis that is also by way of being a scandal. Reams of similar stuff have been written about postwar abstract art, and by non-French as well as French writers. There is nothing new in the *Preuves* document; one is surprised only by the confidence with which the contributors to it express received ideas. What's more, these writers (with the exception of Mr. Schneider), like all the others who retail the same ideas, seem to be pretty sure they are not repeating the mistakes made by past critics of avant-garde art. They at least take Informel—and Abstract Expressionist—painting very seriously; they regard it as a genuine expression of the times; they certainly don't treat it as a hoax or outrage, the way past critics treated avant-garde art. If what they say about postwar abstract painting amounts to calling it mindless non-art, they are only repeating—they can claim—what is said about it by spokesmen approved of, supposedly, by the artists themselves—artists, at least, like Georges Mathieu.

If they are right, if what these "spokesmen" and those who parrot them say has any validity at all, then it means that the further evolution of modernist art has finally redeemed the more egregious mistakes made about it by hostile critics in the past; and that these mistakes were not so much mistakes as insights, expressed prematurely, into the real direction in which modernist art was heading all along.

In 1875 Albert Wolff wrote of the Impressionists that "grabbing canvases, paints and brushes, they throw on a few tones haphazardly and sign the whole thing! . . . [they] have raised the negation of all that constitutes art to the level of a principle; they have tied an old paint rag to a broomstick and made a banner of it." To judge from what has been said about postwar abstract art by nine out of ten of its sympathetic critics, Wolff had a correct sense of the ultimate tendency of modernist painting. He was wrong only in sensing it too soon. And the critics and writers who say the same thing about Informel and Abstract Expressionist painting that Wolff said about Impressionism are right where he was wrong only because that tendency waited so long to reveal itself fully. By rights they should commend Wolff for his prophetic insight. And they should also commend all those other critics who denounced the subsequent phases of modernist art in terms

like Wolff's. They too cried rat—or wolf—when the rat—or wolf—was still only on his way. Now that the wolf has finally arrived, how can anyone deny that they were not justified?

By now I myself would commend Wolff for at least saying what he felt about Impressionism in disapproving instead of rapt and reverential tones. In being outraged at what he took for non-art he was at least true to art as he understood it, and true to his own experience. Nowadays non-art, or what is taken for that, is rhapsodized about. Even the apprehension felt about the fate of art under the sway of "formlessness" is expressed deferentially, wistfully. Contemporary art writers not only repeat, they compound Wolff's mistake. Having made the same initial blunder that he did in taking new art for non-art, they go on to demonstrate, in addition to their aesthetic incompetence, their pusillanimity and intellectual irresponsibility. They weigh the merits of the formless as though it were possible to tell the difference between good and bad in non-art, and they discuss it all gravely and portentously.

Why art writing happens to be as bad as it is can only be speculated on, and I don't want to do any speculating here. What concerns me much more at this moment is art itself. The worst aspect of the present foolishness of art criticism in taking new art for non-art is that so much bad art gets shielded thereby from appropriate value judgments. A lot of banal art which ought to be called that gets garlanded instead with phrases about the pure act, action, the absolute, prayer, rites, the subconscious, gestures, and so on. Amid this palaver the degeneration of Informel and Abstract Expressionist art at the hands of its practitioners of the second generation has gone largely unnoticed. Some of the emptiest art ever created has been treated with the blindest respect. And it has taken a financial, not an artistic, crisis to even begin to open eyes to a part of this.

What the French call Informel, and we Abstract Expressionist or "Action" painting, continues the centuries-old tradition of painterly—*malerisch*—"loosely" executed, "brushy" painting. I myself prefer to call both Informel and Abstract Expressionist painting "painterly abstraction," which I consider to be more accurate as well as more inclusive than either

of the other terms. Connotations of the spontaneous and even the accidental cling to all painterly art—Boldini's as well as that of the Chinese. This is why the painterly used to be so often identified with the unfinished. And this is part of the reason why, when the painterly stopped serving representation, as it did in postwar abstract art, it became so widely identified with the formless, which is, notionally, the unfinished *par excellence*.

To see Painterly Abstraction as formless seems to me to be just as self-evidently absurd as it was to see Corot as unfinished or Impressionism as lacking in "structure." Where it is a matter of self-evidence one can only point, not argue. I cannot argue form into an "all-over" Pollock any more than I can argue it into any other kind of painting: you either see it there or you don't see it there. All the diagrams on earth won't make you see it there if you don't in the first place. For me, Pollock's slapdashness is self-evidently just as much organized by its abstract functions as Tintoretto's or Constable's slapdashness is by its illustrative ones. And the success of a Pollock, like that of a Tintoretto, Constable, Magnasco or Soutine, depends on the extent to which the look of the haphazard is made to belie itself in the interests of communication and expression. And just as a successful Pollock succeeds in terms of form and art, so when a Pollock fails it fails in terms of form and art. There is nothing more to it than that.

If there is a crisis, it is not one of abstract art in general, but one of Painterly Abstraction in particular—and it is a crisis of form and quality, not of art and non-art. This crisis, such as it is, was touched off by the long stock-market decline in the winter and spring of 1962, which had nothing to do with art intrinsically. That it was able to precipitate what is now called a crisis of art was due to the fact that a crisis—rather a *débâcle*—had been long overdue for the kind of abstract art I call Painterly Abstraction.

By 1955 at the latest the expressive possibilities of abstract painterly appearance—of pure painterly, pure *malerisch* appearance—had been exhausted for the time being. Painterly Abstraction had turned by and large into an assortment of ready-made effects. The smears, swipes and lumps of paint left

by a brush or spatula, and the shapes in which liquid paint disposed itself when spilled on a flat surface, had begun to connote the mannered and stereotyped far more than the spontaneous or fresh. The look of the accidental had become an academic, conventional look. This eventuality had already been pointed to in the late forties, when the abstract daubs of three-year-olds began to look completely like art, not because of their "free-ness," but because they were being overtaken by convention. If the crisis of Painterly Abstraction means the end of anything, it is the end of painterliness, at least for the time being, as a means of releasing spontaneity for expressive ends in abstract art. If a painting by a chimpanzee now legitimately qualifies as art, it is because it assimilates itself by its painterly, accidental look to what has become a new type of defective human art. Defective art, bad art, is still art; it still possesses form; defective art is indeed just the kind of art we are most familiar with in daily life.

Painterly Abstraction has collapsed not because it has become dissipated in formlessness, but because in its second generation it has produced some of the most mannered, imitative, uninspired and repetitious art in our tradition. The grafting of painterliness on a Cubist infrastructure was, and will remain, the great and original achievement of the first generation of Painterly Abstraction, and the merits of that first generation are not in dispute here. But in the hands of those who came later this achievement degenerated into a blatant formula. Far from being formless, second-generation Painterly Abstraction is overformed, choked with form, the way all academic art is. Do I have to remind the reader that form as such is a neutral element as far as artistic quality is concerned? Thanks to Painterly Abstraction and the total experience of abstract painting, sensibility can by now invest with pictorial form almost any object constituting itself primarily as a flat, circumscribed surface—sidewalk squares, defaced walls, tattered posters, empty canvases. The young chimpanzee creates recognizable pictorial form as he paints by showing that he acknowledges the shape of the flat support as a limiting factor. Yet the fact that pictorial form as such has become so much easier to achieve does not make pictorial quality any easier to achieve than it ever

was. It remains as rare as before, and subject to the same general conditions as before.

Being unable to identify Painterly Abstraction as art, contemporary art writers are even less able to identify it as a style with a set of distinguishing characteristics like any other style. The contributors to the *Preuves* document identify it, apparently, with abstract art in general, and seem to think that it exhausts all the important possibilities left to abstract art. Now it is true that Painterly Abstraction shares its Cubist infrastructure with all the other successful kinds of abstract painting in our tradition—that, like these, it too relies on a *created* flatness, a created absence, or positive negation so to speak, of illusion. But Painterly Abstraction is also defined by its painterliness, and its painterliness limits it the way any other defining characteristic would. It limits it particularly with regard to color, the purity and intensity of which are more or less abated by the light and dark accents that are inseparable from painterly handling. Surprising as it may sound, Painterly Abstraction remains altogether within the tradition of value painting—of painting that relies for its main emphases on contrasts of light and dark.

What looms beyond, and grows out of, Painterly Abstraction is a newer (though not necessarily superior) kind of abstract art that puts the main stress on color as hue. For the sake of this stress painterliness is being abandoned, not to be replaced by the geometrical or the "hard-edged," but rather by a way of paint-handling that blurs the difference between painterly and non-painterly. Harking back in some ways to Impressionism, and reconciling the Impressionist glow with Cubist opacity, this newer abstract painting suggests possibilities of color for which there are no precedents in Western tradition. An unexplored realm of picture-making is being opened up—in a quarter where young apes cannot follow—that promises to be large enough to accommodate at least one more generation of major painters.

Arts Yearbook 7, 1964; *Preuves*, February 1964 (titled *"La 'crise' de l'art abstrait"*).

34. A Famous Art Critic's Collection

All the paintings and most of the sculpture in our place came as presents from the artists.[1] In no case has this put me under an obligation. I feel as free as before to say publicly whatever I choose about the work of these artists. (They were all kind enough, incidentally, to let me have my pick.)

To explain my tastes is part of my job as an art critic, and I can't begin to go into that here. It's not because of any desire to be consistent that most of the things we have are abstract. There are many, many contemporary representational artists whose work I admire—to name only a few close to home: Milton Avery, Arnold Friedman, Richard Diebenkorn, Elmer Bishcoff, Paul Granlund, Sidney Laufman, Edwin Dickinson, Edward Hopper, Andrew Wyeth, John Chumley, Lennart Anderson, Goodridge Roberts of Canada. But with the exception of Friedman (who died in 1946), I never got as involved with artists like these, or as militantly excited about their work, as I did with some of the abstract artists who came up in my time. There is no question in my mind but that the most profoundly ambitious, the major art of the last thirty years has been altogether abstract—just as a lot of the worst art of that time has been.

Big abstract paintings turn out to be astonishingly easy to live with—easier maybe than any but the sketchiest of big representational paintings. A certain kind of abstract art that has emerged recently, and which is predominantly in our living room, exudes a characteristic airiness. Representational, illusionistic pictures of the same size, though presumably opening up the walls behind them, would eat up a lot more of the surrounding space; their contents have a way of coming forward as well as receding. Abstract painting, especially of the postwar American variety, tends to hold the wall more the way that Far Eastern painting does.

1. Photographs accompanying the article (by Hans Namuth) make it clear that "our place" refers to the Greenbergs' apartment off Central Park West, New York City. Among the illustrated paintings and sculptures owned by the Greenbergs are works by Hans Hofmann, Morris Louis, Robert Motherwell, Barnett Newman, Kenneth Noland, Jules Olitski, Jackson Pollock, and David Smith. [Editor's note]

Another fact of my experience that may seem surprising is
how little the matching or consistency of color matters. A
picture that works seems to fit in anywhere, regardless of the
colors in the rooms or of the other pictures near it; and regard-
less, too, of styles or periods. I have yet to be shown that
consistency in these respects is an aesthetic virtue.

Vogue, 15 January 1964

35. Four Photographers: Review of *A Vision of Paris*
 by Eugène-Auguste Atget; *A Life in Photography* by
 Edward Steichen; *The World Through My Eyes* by
 Andreas Feininger; and *Photographs by Cartier-
 Bresson*, introduced by Lincoln Kirstein

The art in photography is literary art before it is anything else:
its triumphs and monuments are historical, anecdotal, repor-
torial, observational before they are purely pictorial. Because
of the transparency of the medium, the difference between the
extra-artistic, real-life meaning of things and their artistic
meaning is even narrower in photography than it is in prose.
And as in prose, "form" in photography is reluctant to become
"content," and works best when it just barely succeeds in con-
verting its subject into art—that is, when it calls the least
attention to itself and lets the almost "practical" meaning of
the subject come through.

This is why there are so many pictures made with documen-
tary intent among the masterpieces of photography. But they
have become masterpieces by transcending the documentary
and conveying something that affects one more than mere
knowledge could. The purely descriptive or informative is al-
most as great a threat to the art in photography as the purely
formal or abstract. The photograph has to tell a story if it is
to work as art. And it is in choosing and accosting his story,
or subject, that the artist-photographer makes the decisions
crucial to his art. Everything else—the pictorial values and
the plastic values, the composition and its accents—will more
or less derive from these decisions.

The art of Eugène Atget, who was born in 1856 and died in 1927, is the art of the Complete Photographer. I can think of no one else who can be called that. Atget's activity as a photographer—he had tried to be a painter and an actor—was confined to the last three decades of his life. He lived and worked in and around Paris, and the time and the place must help explain his achievement as they do that of all the other great artists who were his contemporaries and neighbors. Atget's vocation, as he himself was conscious of it, was to make *"documents pour artistes."* If ever an artist humbled himself before his subjects, Atget did. He was not after beautiful views; he was out to capture the identity of his subject, and the success with which he did so has to be called "classical."

The passing of time adds to the aesthetic value of many photographs, and does so legitimately, which is part of the reason why photography is the historical art *par excellence*. The way, however, in which Atget makes the animate and inanimate surfaces of the Paris of the *belle époque* speak transcends period flavor in the way that art of the remoter past does, and in the way, too, that the boulevard views painted by the Impressionists do. An abstracting, organizing eye had its part in this, and Atget was a tremendous pictorial as well as illustrative artist; yet it derived from his feeling for the illustrated subject, and his "pictorialism" was largely, and properly, unconscious.

Like other great photographers, Atget could at times extract a more intensely human—i.e., literary—interest from signs and traces of the human presence than from that presence itself. His views of undistinguished facades, and of articles displayed outside or just inside storefronts, were perhaps the first works of art to direct attention to the commercial (not industrial) environment in a completely artistic way—in a way, that is, which was *distanced*. In this respect, as in others, much sophisticated art photography since Atget has been influenced by him—and so, too, has Pop Art, whether Pop artists know it or not. Involved here is an attitude even more than a subject or a method.

The present book offers a fair sampling of Atget's art, and is therefore worth having. But many of its plates are poorly printed, in a sepia meant to approximate the golden browns

with which the original prints were tinted. And I would question the usefulness of the caption-quotations taken from Proust, which breathe a spirit of self-conscious nostalgia that is foreign to Atget.

Edward Steichen's work contains examples of almost every trend and fashion in photography over the last seventy-five years. Only a few of the photographs reproduced in this book are successful, yet this book makes me think better of Steichen than I did before. His account of his career as a photographer has, in addition to its historical interest, the charm of its plainness, and in the light of that account many of the photographs in his book become more interesting. Four or five of them are superb in their own right: an 1899 portrait of the artist's sister, a *Self-Portrait with Sister* of 1900, and two genre pictures of high life at the Paris races in 1905. But one wonders at what must have been the lack of a capacity for self-criticism that let Steichen abandon the straightforwardness of these works for the painting-like Whistlerian and Carrièresque effects of most of his other photographs of the 1900's. These may have made him famous, but they have not worn well as art—not nearly so well as similar painting-like photographs made by several other Americans in that period who worked in this style with an inspiration which was missing in Steichen's case.

One last photograph in his book, however, taken in 1921, but unusual in his work at that time, provides a text in the aesthetics of photography. It was taken in the Acropolis at Athens. In the foreground a woman's shapely arms are raised vertically with half-open hands from behind a stone parapet that conceals the rest of her body; beyond the arms we see the stolid marble maidens of the Porch of the Erechthyum. The picture is nicely composed and the shadeless scene suppresses any jarring contrasts of black and white, yet the photograph would be artistically inert were it not for what the woman's arms both state and evoke of attractive femaleness, of young, firmly soft, sexed flesh—living flesh with responding muscle inside it—by contrast with the stone women in the background. The whole thing could have been impossibly arty, what with the tritely "artistic" gesture of the woman's fingers (she was one of Isadora Duncan's group) and the setting, but

the story told of life versus trimmed and carved stone has a force, as well as a message, that cancels out artiness.

I have said that the purely formal or abstract is a threat to the art in photography. This threat manifests itself in a variety of ways, of which the worst is not the forthrightly abstract photograph but the trick shot and the odd shot; the long exposure of moving objects, the reversed negative, the close-up or magnified view that brings out the curious, abstractly curious, configurations any sort of object will reveal when seen in microscopic detail. This kind of photography may contribute to knowledge, but it has never been anything but abortive as art: and it is offered as that and taken as that only by people whose experience of pictorial art in general is defective.

Gas masks and insects' heads seen close up, lit-up Christmas trees on Park Avenue at dusk, the skeleton of a fish, wind patterns in sand, the web-like pattern left by the lights of a climbing helicopter at night, the wheels and rods of industry, trees in color, the bulbous breasts and midriff of a Lachaise bronze seen at a distance of five feet—Andreas Feininger throws all this and more into the same basket. Well, that's what the world is like—and *Life* says so every week. But it's not what life is like and it's not at all what art is like. On the evidence of the book at hand Feininger is not interested in people, and he is right not to be—again on the evidence of the book at hand, which shows him as being very reluctant to do such a thing as take a straight look at the human form. When faces and bodies appear, they do so as pieces of equipment among the other pieces of equipment, that clutter up his other-planet view of the world. Except when they appear as art, Feininger's photographs of sculpture are among the best such photographs I have seen. All the sculpture Feininger illustrates in this book happens to be of the female nude, and his photographs of living nudes are disastrous by comparison. Cézanne's approach to live flesh was not unlike Feininger's, but Cézanne could not only get away with it, he could exploit it, and that was because he was a painter and the decisions he made in painting a pebble or a chair were just as crucial, artistically, as those he made in painting a face. The case is not the same for photographers, and they ought to be thankful for

186

that—who wouldn't rather be a literary than an abstract artist, so long as he did not have to sacrifice ambition or quality?

Photography's advantage over painting, if advantage it is, lies less in its realism—put to it, painting could match and even outmatch that—than in the enormously greater ease and speed with which it achieves its realism. This speed and ease have radically expanded the literary possibilities of pictorial art. All visible reality, unposed, unalerted, unrehearsed, is open to instantaneous photography. But it is only within the last thirty years or so—with the perfecting of the miniature camera—that more than a very few ambitious photographer-artists have concentrated on the snapshot.

Cartier-Bresson is one of these, and he is one of the best photographers of our day. Like so many other art photographers, he was trained as a painter, but even among painter-photographers he stands out by the sophistication of his art consciousness. I am not sure that this is an altogether good thing. It involves too much of an awareness of what photography should do in the light of what painting and even sculpture have already done. There is a frozenness about many of Cartier-Bresson's unposed pictures that still suggests the posed, if only because their pictorial and even sculptural qualities are so conspicuous, and this accounts for a suggestion of the arty (that plague of art photography) in some of the photographs in this book. This doesn't mean that Cartier-Bresson has not produced some art that is successful enough to be permanent; he has indeed. But he doesn't set a good example. Nor are the pictures in this book various enough in their effect. The pictorial values in the snapshots of such an unsophisticated artist as Weegee (who worked for the tabloids) cannot be compared with those in Cartier-Bresson's, but Weegee's photographs show a sharper sense of life and movement and variety. Weegee is demotic, but Cartier-Bresson is almost conventionally esoteric, and in this art the demotic eye is the one more apt to discover unexploited possibilities of "literature." And this is so even when such an eye is acquired only by super-sophistication as it is in Walker Evans's case.

New York Review of Books, 23 January 1964

36. David Smith's New Sculpture

Short-windedness is supposed to be endemic to American art-
ists—and writers—in this century, but of late it seems to have
become just as prevalent among artists of other nationalities.
The long career in which development continues throughout
has become a rather rare phenomenon. David Smith's stamina
as an artist is almost a unique one. By the early 1950's he had
already done enough to make him the best sculptor of his gen-
eration anywhere, and had he stopped then and taken to re-
peating himself his achievement would still have been enough
to assure him an important place in the art of our time. But
far from stopping or falling off, his art renewed itself in those
years, as if to answer whatever questions about it remained. It
manifested a new breadth and at the same time a new depth.

In an article in *Art in America* written in 1956 I remarked
on what had used to be Smith's radical unevenness, and on
how in the two or three years just preceding it had ceased
being so radical.[1] Today I would say that this unevenness has
become almost entirely a thing of the past. Where ten to fif-
teen years ago his misses far outnumbered his hits, in the last
years his misses have become not just relatively, but absolutely
rare. And he has not had to play it safer in order to make it so:
he remains as adventurous as ever, and if anything, he has
become even more prolific. This, too, is a phenomenon.

Smith's way of exploring and exploiting his conceptions has
evolved along with almost everything else in his art. In the
past he tended to overdo or overload the single piece; he would
try to say too much, or say it in too much of a hurry. Now he
lingers over his conceptions as they come to him, explores
them more thoroughly, and—what is more surprising in the
light of his past—tries to clarify what is essential in them.
Smith's taste can still be bad, but somehow it no longer gets
in the way very much, no longer turns what could have been
successful pieces into bad ones—or into pieces that look bad

1. "David Smith," *Art in America* 44, Winter 1956–1957 (reprinted in
vol. 3). The present essay was written to introduce *David Smith: Sculpture &
Drawings*, an exhibition of new work held in February–March 1964 at the
Institute of Contemporary Art, University of Pennsylvania, Philadelphia.
[Editor's note]

at least on first sight and which have to "age" in order to reveal whatever merits they have. Now Smith seems to ride over his bad taste and make it peripheral.

Back in the late 1940's he had already begun, rather sporadically and rather hesitantly, to work out certain ideas in series of pieces that were like variations on a single theme. Significantly, the proportion of successes to failures in these series was much higher than it was in Smith's other work of that time. But only in the early 1950's did he commit himself to doing series in a regular way, and it was then too that each series became more extended. Where they used to run to no more than a half-dozen sculptures each, they now began, as in the "Agricola" and "Tanktotem" groups, to run to as many as two dozen or more. And as the pieces in each series multiplied, they became less abrupt as variations, more nuanced. But the nuancing, instead of making Smith's manner more involved or ambiguous, only made it more logical and direct.

Smith has never worked in a single direction or vein within any given span of time; he has from the start practiced several manners concurrently—and sometimes they were more than several, to the confusion of the art public and the cost of his public "image." Over the last years, however, his different manners or veins separate themselves in a more consistent and distinct way. This, too, is part of his ongoing development. Three clearly demarcated veins are now distinguishable in his work: a strictly geometrical "cube-shaft-and-plate" manner in stainless steel; a less apparently geometrical "flat cut-out" manner in painted sheet-metal; and a freehand, only roughly geometrical "rod-and-disc" manner in steel and iron, using both found or pre-fabricated and expressly forged or cast elements. All three manners go back more or less to the beginnings of Smith's maturity, but the last goes back the furthest and brings to their fullest and best fruition a cluster of ideas whose seed lies in things Smith did as long ago as the late 1930's. This last manner is the one exclusively represented in the present selection of sculptures.

These come from a group of twenty-six divided into three series called respectively "Voltri-Bolton," "Voltron," and "V.B." The roman numerals by which the pieces are individually identified run continuously, however, beginning with

"Voltri-Bolton" and ending with "V.B." Because of this and because of the homogeneity of style throughout, the entire group can be considered a single unified series that can be referred to most conveniently as "Voltri-Bolton Landing." Smith started the series in the fall of 1962 on his return to his home in Bolton Landing, N.Y., from a short but crowded stay in Italy, and he finished it (if it is finished) late this past fall. He had had a crate of massive old tongs, pincers, wrenches, and other tools shipped home with him from Voltri, and one or more of these is incorporated in every piece of the series (though nothing in it is directly related either stylistically or thematically to the monumental works he created, in one pro-digious burst of energy and inspiration, while in Voltri.)

The pretext—I would hardly call it the theme—of all the "Voltri-Bolton Landing" pieces is the upright human figure. Not so long ago it had had to compete with the bird and animal figure in Smith's imagination. Now it has become com-pletely dominant, and not only in the "rod-and-disc" vein but also in the stainless-steel one. The human figure suggests—or is suggested by—verticality, narrowness, tapering. Connota-tions of solidity used, however, to cling to it as they did not to the bird figure, which was a far more obvious pretext for open, calligraphic design. Now Smith has expunged every last one of these connotations from his "rod-and-disc" sculptures. If any such remain in his art, they are confined to stainless steel or, even more uncertainly, to sheet metal. The "Voltri-Bolton Landing" pieces are given over entirely to transparency and cursiveness.

But the cursiveness of Smith's drawing-in-air is not as cur-sive, not as nervous, as it once was. In the "Voltri-Bolton Landing" series as elsewhere in his art, his drawing takes on more and more of geometrical regularity. It becomes more and more the kind of drawing that moves from the elbow or shoul-der rather than from the wrist or fingers. And it converges with the newest developments in abstract painting, where the smears and squiggles of painterliness are ceding to cleaner, more anonymous handling. Smith's art was never notable for the excrescences, the fuzzed and irregular surfaces, and the curlicues that mark most of postwar abstract sculpture, but whatever it did show of such things has almost completely

disappeared by now. As geometrical as Smith's drawing and design may become, nothing in his art associates itself with geometrical art as we know it from the past. There is no flavor in it of De Stijl or of the Bauhaus or even of Constructivism (much less of streamlined "modernism"). This is because the geometrical does not enter Smith's art by doctrinal right and impose itself as a restriction. He chooses it as but a means among other means available to him, and he prefers it simply for the sake of its directness and economy. The regularity of contour and surface, the trued and faired planes and lines, are there in order to concentrate attention on the structural and general as against the material and specific, on the diagrammatic as against the substantial; but not because there is any virtue in regularity as such.

It would not do, however, to dwell too long on the geometrical aspects of Smith's art in the present case. Contradictory impulses are at work, and the triumph of the art lies—as always—in their reconciliation. Hardly a piece in the "Voltri-Bolton Landing" series makes the impression of geometrical regularity as a whole. If there is geometry here, it is geometry that writhes and squirms. Only when we inspect parts or details do we notice how simplified and trued and faired everything—or almost everything—is. The relatively simple and forthright has been put together to form unities that are complex and polymorphous. Smith's drawing itself may have become less nervous, but the unities of structure which it creates remain almost as much so as before.

The absence in many cases of applied color or finish of any sort in these particular sculptures is part of the directness and part of the nervousness. The raw, discolored surfaces of the iron or steel members may be found a little repellent here and there, but by the same token they tend to efface themselves. As I have said, Smith aims at the diagrammatic as against the substantial and textured. Here the diagrammatic enters by paradoxical means. The discoloration is too natural, too casual, to make anything but a negative contribution. Polished or painted surfaces might in particular instances, if not in others, attract the eye too much, and the attracted eye lingers, while the unattracted eye hastens towards the essential. (I am not playing on words here, but reporting my own experience.) For

all that, the question of color in Smith's art (as in all recent sculpture along the same lines) remains a vexed one. I don't think he has ever used applied color with real success, and the "Voltri-Bolton Landing" pieces benefit by his having abstained from it. . . . Felicity comes more easily to Smith than it used to. But it is still by no means an easy felicity. I am not able to talk about the content of Smith's art because I am no more able to find words for it than for the ultimate content of Quercia's or Rodin's art. But I can see that Smith's felicities are won from a wealth of content, of things to say; and this is the hardest, and most lasting, way in which they can be won. The burden of content is what keeps an artist going, and the wonderful thing about Smith is the way that burden seems to grow with his years instead of shrinking.

David Smith: Sculpture & Drawings, Institute of Contemporary Art, University of Pennsylvania, Philadelphia, February—March, 1964; *Art International*, May 1964 (unrevised); *David Smith*, ed. Garnett McCoy, 1973.

37. Post Painterly Abstraction

The great Swiss art historian, Heinrich Wölfflin, used the German word, *malerisch*, which his English translators render as "painterly," to designate the formal qualities of Baroque art that separate it from High Renaissance or Classical art. Painterly means, among other things, the blurred, broken, loose definition of color and contour. The opposite of painterly is clear, unbroken, and sharp definition, which Wölfflin called the "linear." The dividing line between the painterly and the linear is by no means a hard and fast one. There are many artists whose work combines elements of both, and painterly handling can go with linear design, and vice versa. This still does not diminish the usefulness of these terms or categories. With their help—and keeping in mind that they have nothing to do with value judgments—we are able to notice all sorts of continuities and significant differences, in the art of the present as well as of the past, that we might not notice otherwise.

The kind of painting that has become known as Abstract

Expressionism is both abstract and painterly. Twenty years ago this proved a rather unexpected combination. Abstract art itself may have been born amid the painterliness of Analytical Cubism, Léger, Delaunay, and Kandinsky thirty years earlier, but there are all kinds of painterliness, and even Kandinsky's seemed restrained by comparison with Hofmann's and Pollock's. The painterly beginnings of abstract and near-abstract art would appear, anyhow, to have been somewhat forgotten, and during the 1920's and 1930's abstract art had become almost wholly identified with the flat silhouettes and firm contours of Synthetic Cubism, Mondrian, the Bauhaus, and Miró. (Klee's art was an exception, but the smallness of his works made their painterly handling relatively unobtrusive; one became really aware of Klee's painterliness only when it was "blown up" later on by artists like Wols, Tobey, and Dubuffet.) Thus the notion of abstract art as something neatly drawn and smoothly painted, something with clean outlines and flat, clear colors, had become pretty well ingrained. To see this all disappear under a flurry of strokes, blotches, and trickles of paint was a bewildering experience at first. It looked as though all form, all order, all discipline, had been cast off. Some of the labels that became attached to Abstract Expressionism, like "*informel*" and "Action Painting," definitely implied this; one was given to understand that what was involved was an utterly new kind of art that was no longer art in any accepted sense.

This was, of course, absurd. What was mostly involved was the disconcerting effect produced by wide-open painterliness in an abstract context. That context still derived from Cubism—as does the context of every variety of sophisticated abstract art since Cubism, despite all appearances to the contrary. The painterliness itself derived from a tradition of form going back to the Venetians. Abstract Expressionism—or Painterly Abstraction, as I prefer to call it—was very much art, and rooted in the past of art. People should have recognized this the moment they began to be able to recognize differences of *quality* in Abstract Expressionism.

Abstract Expressionism was, and is, a certain style of art, and like other styles of art, having had its ups, it had its downs. Having produced art of major importance, it turned

into a school, then into a manner, and finally into a set of mannerisms. Its leaders attracted imitators, many of them, and then some of these leaders took to imitating themselves. Painterly Abstraction became a fashion, and now it has fallen out of fashion, to be replaced by another fashion—Pop art—but also to be continued, as well as replaced, by something as genuinely new and independent as Painterly Abstraction itself was ten or twenty years ago.

The most conspicuous of the mannerisms into which Painterly Abstraction has degenerated is what I call the "Tenth Street touch" (after East Tenth Street in New York), which spread through abstract painting like a blight during the 1950's. The stroke left by a loaded brush or knife frays out, when the stroke is long enough, into streaks, ripples, and specks of paint. These create variations of light and dark by means of which juxtaposed strokes can be graded into one another without abrupt contrasts. (This was an automatic solution for one of the crucial technical problems of abstract painting: that of asserting the continuity of the picture plane when working more or less "in the flat"—and it's one of the reasons why the "Tenth Street touch" caught on the way it did.) Out of these close-knit variations or gradations of light and dark, the typical Abstract Expressionist picture came to be built, with its typical density of accents and its packed, agitated look.

In all this there was nothing bad in itself, nothing necessarily bad as art. What turned this constellation of stylistic features into something bad as art was its standardization, its reduction to a set of mannerisms, as a dozen, and then a thousand, artists proceeded to maul the same viscosities of paint, in more or less the same ranges of color, and with the same "gestures," into the same kind of picture. And that part of the reaction against Painterly Abstraction which this show tries to document is a reaction more against standardization than against a style or school, a reaction more against an attitude than against Painterly Abstraction as such.

As far as style is concerned, the reaction presented here is largely against the mannered drawing and the mannered design of Painterly Abstraction, but above all against the last. By contrast with the interweaving of light and dark gradations

in the typical Abstract Expressionist picture, all the artists in this show move towards a physical openness of design, or towards linear clarity, or towards both. They continue, in this respect, a tendency that began well inside Painterly Abstraction itself, in the work of artists like Still, Newman, Rothko, Motherwell, Gottlieb, Mathieu, the 1950—54 Kline, and even Pollock. A good part of the reaction against Abstract Expressionism is, as I've already suggested, a continuation of it. There is no question, in any case, of repudiating its best achievements.

Almost a quarter of the painters represented in this show continue in one way or another to be painterly in their handling or execution.[1] One of them, John Ferren, even retains the "Tenth Street touch," but by boxing it within a large framing area he somehow manages to get a new expressiveness from it. Sam Francis's liquefying touch is of a kind familiar to Abstract Expressionism at large, but even in his closed and solidly filled paintings of the early 1950's that touch somehow conveys light and air. Helen Frankenthaler's soakings and blottings of paint, which go back almost as far, open rather than close the picture, and would do so even without the openness of her layout. Arthur McKay's heavily inlaid surfaces relate to Painterly Abstraction in France, but the linear clarity, and plainness, of his design fend off what might be oppressive associations.

Clarity and openness as such, I hasten to say, are relative qualities in art. In so far as they belong to the physical aspects of painting they are but means, neutral in themselves and guaranteeing nothing in the way of ultimate aesthetic value. There is far more ultimate clarity and ultimate openness in an otherwise crowded and murky picture by Rembrandt than in many another painter's clear hues and unmarked areas. The physical clarity and openness of the art in this show do not make it necessarily better than other kinds of art, and I do not claim that the openness and clarity which these artists favor are what make their works necessarily succeed. I do claim, however, that it is to these instrumental qualities that the

1. Greenberg selected all the artists represented in the exhibition, except for those from California, who were selected by James Elliott, curator, Los Angeles County Museum of Art. The exhibition travelled to the Walker Art Center, Minneapolis, and to the Art Gallery of Toronto. [Editor's note]

paintings in this exhibition owe their *freshness*, as distinct from whatever success or lack of success they may have as aesthetic finalities. And I do claim—on the basis of experience alone—that openness and clarity are more conducive to freshness in abstract painting at this particular moment than most other instrumental qualities are—just as twenty years ago density and compactness were.

Having said this, I want to say, too, that this show is not intended as a pantheon, as a critic's choice of the best new painters. It is meant to illustrate a new trend in abstract painting. It includes a number of artists who I do think are among the best new painters, but it does not include all of these. Even if it did, it still would not be a show of "the best new painters." Thirty-one is simply too large a number for that. . . .[2]

Among the things common to these thirty-one, aside from their all favoring openness or clarity (and all being Americans or Canadians), is that they have all learned from Painterly Abstraction. Their reaction against it does not constitute a return to the past, a going back to where Synthetic Cubist or geometrical painting left off. Some of the artists in this exhibition look "hard-edged," but this by itself does not account for their inclusion. They are included because they have won their "hardness" from the "softness" of Painterly Abstraction; they have not inherited it from Mondrian, the Bauhaus, Suprematism, or anything else that came before.

Another thing the artists in this show, with two or three exceptions, have in common is the high keying, as well as lucidity, of their color. They have a tendency, many of them, to stress contrasts of pure hue rather than contrasts of light and dark. For the sake of these, as well as in the interests of optical clarity, they shun thick paint and tactile effects. Some of them dilute their paint to an extreme and soak it into unsized and unprimed canvas (following Pollock's lead in his black and white paintings of 1951). In their reaction against

2. John Coplans, reviewing the exhibition as editor-at-large of *Artforum* (Summer 1964), rejected Greenberg's disclaimer. Coplans wrote that Greenberg had "Structured the exhibition to assert a personal notion of style; that is, to reveal what in his opinion the major ambitious art after Abstract Expressionism *ought to look like* and what means it *ought to employ* to gain this look." [Editor's note]

the "hand-writing" and "gestures" of Painterly Abstraction, these artists also favor a relatively anonymous execution. This is perhaps the most important motive behind the geometrical regularity of drawing in most of the pictures in this show. It certainly has nothing to do with doctrine, with geometrical form for its own sake. These artists prefer trued and faired edges simply because these call less attention to themselves as drawing—and by doing that they also get out of the way of color.

These common traits of style go to make up a trend, but they definitely do not constitute a school, much less a fashion. That may come yet, but it hasn't so far. Otherwise many of the painters in this show would be better known than they are right now. Right now it's Pop art, which is the other side of the reaction against Abstract Expressionism, that constitutes a school and a fashion. There is much in Pop art that partakes of the trend to openness and clarity as against the turgidities of second generation Abstract Expressionism, and there are one or two Pop artists—Robert Indiana and the "earlier" James Dine—who could fit into this show. But as diverting as Pop art is, I happen not to find it really fresh. Nor does it really challenge taste on more than a superficial level. So far (aside, perhaps, from Jasper Johns) it amounts to a new episode in the history of taste, but not to an authentically new episode in the evolution of contemporary art. A new episode in that evolution is what I have tried to document here.

Post Painterly Abstraction, Los Angeles County Museum of Art, April–June 1964; *Art International*, Summer 1964; *Readings in American Art since 1900: A Documentary Survey*, ed. Barbara Rose, 1968 (abridged); *The Great Decade of American Abstraction: Modernist Art 1960 to 1970*, ed. E. A. Carmean, Jr., 1974

38. Review of *Andrea del Sarto* by S. J. Freedberg

Great writing about art is rarer than great art, and apparently just as hard to recognize at first. Otherwise Dr. Freedberg's *Painting of the High Renaissance in Rome and Florence*, which came out over two years ago, would be far better known by

now. I know of no book on art that matches it in closeness of perception or writing. I know of no book that digs so tenaciously into the substance of actual works of art. I know of no writing on art that keeps itself more pertinent throughout, with a truer sense of what belongs and does not belong in the discussion of art *as art*, and of what in a given historical context counts and does not count in this connection.

Dr. Freedberg is an art historian who teaches at Harvard. But he writes as a critic before he writes as an art historian or scholar. As a critic he is concerned first with quality—that is, with art as art, and not as a "subject" or "field." Quality is what makes art art, and more than craft. The history of art is the history of artistic quality before it is anything else. No one has studied quality more single-mindedly than Dr. Freedberg has. I have my own ideas about what should be included in the study of quality, and they don't always agree with Dr. Freedberg's: thus I think he is wrong to leave aside questions of material medium—the differences among oil, fresco and distemper often did have a lot to do with differences of quality in classical painting—nevertheless I can well surmise and appreciate his reasons for omissions like these.

Dr. Freedberg has a sense—entirely unexpected in an art historian—of the *working* life of art that is confirmed by what I know about how art gets carried on in the present. This makes him "professional" in a way unheard of among his colleagues. He is aware of the kind of uncertainty that accompanies ambition, and which has to do with the ineluctable precariousness of quality. He shows the wrestle for that as being always problematic, never settled. And in showing this he also shows how entirely the creation of art is in and of history, and not to be abstracted from it. Leonardo, Michelangelo, Raphael and the others of their time and place, as they are followed from work to work, are shown as open cases, with their artistic personalities not yet set or solved: copying as well as discovering, acted upon as well as acting. All this emerges, without requiring too many inferences from the biographical data, in questions of quality, of the goodness and badness of specific works of art.

Dr. Freedberg's prose has given some reviewers a pretext for not dealing with what he actually says. I, too, wince at coin-

ages like "movemented," "ponderated," "deliberated," and I mind foreign terms like "*Existenzbild*"; I, too, wish that his phrasing and word order were more natural in places. But Dr. Freedberg's prose has the virtues of its faults. I do not see how he could help forcing language in order to report the discriminations of pictorial quality that he makes. And the forcing is well worth it on the whole. Some of his formulations of pictorial experience are among the most telling I have ever come across. A typical example from this new book of his (which is less strenuously written than the more ambitious one on the High Renaissance) is when he calls the "rhythmic structure" of Andrea del Sarto's *Birth of the Virgin* fresco "articulately suave." Whatever impropriety there may be in the yoking of these two abstract words is more than justified by the revelatory precision the yoking achieves. Rereading only confirms the impression that Dr. Freedberg's prose justifies itself—and it takes rereading in any case to read him adequately, not because of the difficulty of his prose, but because of the packed superabundance of his matter.

The present Andrea del Sarto volumes are an outgrowth of Dr. Freedberg's labors on the High Renaissance book. The critical text expands as well as extends the material on Andrea in the latter. The *catalogue raisonné* includes both paintings and drawings, and in addition to giving a full bibliography, reproduces and discusses all the biographical sources. By closing with Raphael's death in 1520 the High Renaissance book seemed to imply that nothing important in principle had been added to classical painting in Rome and Florence after that date. And though Dr. Freedberg points out in the book at hand that the grand climax of Andrea's art came between 1524 and 1527 (he died in 1530), I think we are still meant to accept this. Andrea had superlative gifts—as a draftsman and, practically alone among the Central Italian masters of his day, as a colorist—but his achievement was not quite a superlative one. This is the traditional view of his case, and Dr. Freedberg, as he himself acknowledges, subscribes to it: "Andrea is the 'faultless' painter, able absolutely to match his hand to the purpose of his eye and mind. The hand, the eye, and the mind, in the sense of what we have defined as an aesthetic intelligence, are all of them of the highest order that can be attained

in art, but the dimension of spirit that controls all these is not . . . the experience of the picture may become, on occasion, primarily an experience of paint: admirable, of ultimate mastery, but not the whole of art. Where a picture has more to say, more urgently than is Andrea's wont, faultless painting and an equally faultless apparatus of design seem less memorable than they are in him, and less deserving of remark."

Aside from his portraits, most of the easel paintings of Andrea's that I know seem to me to suffer from sentimental perversions of color and a tremulous, mannered shading derived from Leonardo's *sfumato* but making greater play with reflected secondary lights (the gleams inside the shadows on retreating surface). Dr. Freedberg's text makes me realize, however, how fragmentary my acquaintance with Andrea's art is. The drawings reproduced in his book give me further pause. Nobody has drawn better from the model than Andrea. "As documents of naturalism," Dr. Freedberg writes, "the drawings are, exactly like Andrea's paintings, the most truthful of the Renaissance." He adds, however, that though Andrea's drawings "may reveal aspects of personality that are more shaded in the finished work . . . there is hardly an accomplishment of importance in his draughtsmanship that his painter's brush does not transcribe." On the evidence of the drawings Dr. Freedberg himself reproduces I would question this last. There is a swift, embracing straightforwardness in some of them that I do not find present to the same degree anywhere in the paintings (assuming that reproductions can tell us enough here). For me this puts the question of Andrea's capacities in a different light than the traditional one.

Andrea's naturalism, as Dr. Freedberg says, made his art a source eventually for the new naturalism that succeeded Mannerism in Italy in the late sixteenth century. Might not what Vasari calls Andrea's "diffidence" be seen as partly due to the fact that the taste of his time and place could not possibly give his naturalism free rein? And might not what I myself see as his falseness of feeling be due to his effort—characteristic of naturalistic artists when unsure of themselves—to illustrate feeling too explicitly? The strongest parts of his failed pictures strike me so often as being the ones done most directly from nature, and the weakest as those most obviously idealized.

(One sees the same thing in the lesser Flemish Primitives.) Dr. Freedberg's own words provoke these remarks. His book, in spite of everything, is by way of being a rehabilitation of Andrea.

The only things in this book I take exception to have to do with aesthetic principle. Dr. Freedberg speaks of the "effort . . . of intellectual apprehension" required for the full appreciation of High Renaissance painting like Andrea's. But nowhere does he point to anything in the art he discusses, either in this or the previous book, that demands *intellectual* effort as I understand it. "Intellectual" means ratiocinative or it means nothing, and nobody has yet been able to show to my satisfaction anything of essential quality in any kind of art that called on one's reasoning powers for either its appreciation or its creation. (I am not alone in maintaining this. Kant and Croce say the same in essence.)

Dr. Freedberg refers several times to the "ethical content" of the art he scrutinizes. This, like "moral seriousness," belongs to the cant of recent literary criticism. References to the real experienced content of any work of art cannot be made that conceptually precise. If they could be, art would cease being art.

Again Dr. Freedberg takes too much for granted in his terms when he distinguishes between Andrea's "ultimate mastery" of "form" and what he "says" through it. Experience does not discriminate qualitatively between "form" and "content" in art. Where the one excels or fails so does the other, and to the same extent. The less that "form" has to say the less effectively it works as "form." If Raphael's art is more moving than Andrea's, it is because its "form," as well as its "content," is more moving; by the same token Raphael's form is more "memorable" and "deserving of remark." In the actual experience of art "content" can never put "form" into the shade. That happens only in reflection upon experience, and by an error of reflection that hypostatizes "form" and "content," but which further reflection can correct. Andrea's mastery of form could not be ultimate without having the ultimate in content to master. What might, however, be said is that Andrea showed ultimate mastery in *partial* aspects of form, those aspects under which he had the ultimate to say, and that his art

is of less than the highest order because what he had to say did
not call for ultimate mastery in *enough* aspects of form. This
lack, which may have belonged to his temperament, but
which may have also been due to circumstances, makes itself
known in his art just as much through its form as through
whatever experience can construe as its content. All of which
is truism, or should be.

Arts Magazine, November 1964

39. Portrait of the Artist: Review of *The Diaries*
 of Paul Klee, 1898–1918, edited by Felix Klee

This book appears to pay more than the usual price for being
translated. The reproduction of several pages and passages
from the original manuscripts reveals a savor to Paul Klee's
German that the English version generally loses. This modern
painter did have certain literary pretensions, but I don't think
he was ever as pretentiously literary as the English here some-
times makes him out to be—or as aridly abstract either.

These diaries, which are both more and less than the record
of day-to-day events, were meant as self-communing, and no
one else saw them until after the writer's death. He recopied,
cut and revised them from time to time, but simply out of an
obsession with orderliness, not in order to present himself in
an arranged light. Post-adolescent musings on sex are obvi-
ously left in all their original callowness, as is the equally pu-
erile callousness of his feelings about a first (and apparently
only) mistress. The amazing degree of self-knowledge that
Klee gained later on could not have been a studied thing ei-
ther. Sometimes this self-knowledge amounts to clairvoyance,
as when he writes in 1914: "I cannot live for a long time or
for a short time." He died in 1940 at the age of 60.

Klee must have been a very nice man, which is not so usual
among artists who make their mark. When he was young, he
worried about his "ethical" development. By his middle twen-
ties, however, he had begun to feel how necessary it was to
protect his "creative instincts" and renounce other things. One

gets the sense, from that time on, of a progressive withdrawal from absorbing relations with other people. Having settled sex once and for all, apparently, and his deepest need for intimacy by an early engagement, he concentrates more and more on becoming a "professional" artist. This means to Klee proficiency not only in the practice of art but also in the *placing* of himself in relation to art. And perhaps the highest interest of these diaries lies in the evidence they contain of the process by which he became more than a provincial artist.

In 1906 (the same year in which he finally married and decided to remain permanently in Munich) he discovered himself as, in his own words, a *linear* artist. But he was not able to exploit his self-discovery in a resounding way until after 1910, when he woke up to avant-garde art in France since the Post-Impressionists; only then did he begin to recognize the "tasks" particular to art in his time. The breakthrough that made him the Klee we know came, by his own account, in 1911. In 1910 the tone of his diary entries already quickens markedly, to reach a crescendo of exhilaration in the running account of his trip to Tunisia in April, 1914.

The outbreak of war three months later makes a jolt but not an interruption. The exhilaration does not change into something else. Klee had become a German citizen, and he went on living in Munich, but the magnitude of the events going on around him does not seem to have distracted him. Like most other artists of his generation—and under the circumstances it was unique in this respect—he was profoundly apolitical. His second explicit reference to the war comes only in 1915: "What the war meant to me was at first something largely physical: that blood flowed nearby. That one's own body would be in danger, without which there is no soul!"

In March, 1916, he is drafted into the army, and his diary becomes the unabashed record of the petty concerns of a private in any army: leaves, food and the avoidance of arduous duties. The Kaiser's army treated Klee gently: after five months of infantry training he spent the rest of his three years of service in the office of a flying school not too far from Munich, where he had the chance to paint both on and off duty. And his art continued to flower in those years.

In two or three entries toward the end of the diaries it

emerges, however, that the apolitical Klee identified himself completely with his adopted country. On the eve of defeat, October 20, 1918, he writes: "Will my hope also be shattered that inner dignity will be preserved and that the idea of destiny will keep the upper hand over common atheism? We now have an opportunity to be an example of how a people should endure its downfall." That Klee succumbed for a moment to all too typical German political rhetoric is not half so significant as the feeling for Germany that these rather silly words betray.

I had had—nay, I had been given—the impression that Klee considered himself a Swiss: a German Swiss, it is true, but even then a partly French one, and one torn between French and German culture. The genealogical table that his son, the editor of this book, prints shows him to be altogether Germanic in descent (despite the fact that his mother happened to be born in France). And his diaries show that Klee himself made no bones about his Germanness in nearly every other respect. That Hitler's advent led him to return to his native Berne at the end of 1933 does not change this.

The diaries close with Klee's discharge from the army on December 16, 1918, two days before his 39th birthday. From then on, it would seem, he no longer had to commune with himself by means of the written word; his art sufficed. His reputation had grown considerably during the war, and he had obviously become more confident of himself. Or maybe he stopped keeping a diary simply in the interests of economy of effort: the teaching as well as the making of art was to fill his next thirteen years. I do not know what the effects of Klee's teaching were—perhaps they have not been important in any *direct* way—but on the evidence of these diaries he had the makings of a great art teacher.

New York Times Book Review, 27 December 1964

1965

40. Contemporary Sculpture: Anthony Caro

"Breakthrough" is a much-abused word in contemporary art writing, but I don't hesitate to apply it to the sculpture in steel that Anthony Caro, of London, has been doing since 1960. During the fifties, abstract sculpture seemed to go pretty much where David Smith took it. None of the promises made by other sculptors during that time was really fulfilled; some of them produced good things, but the good things remained isolated, did not add up. Caro is the only sculptor who has definitely emerged from this situation and, in emerging from it, begun to change it. He is the only new sculptor whose sustained quality can bear comparison with Smith's. With him it has become possible at long last to talk of a generation in sculpture that really comes after Smith's.

Caro is also the first sculptor to digest Smith's ideas instead of merely borrowing from them. Precisely by deriving from Smith he has been the better able to establish his own individuality. Unquestionably, he was led to the use of ready-made materials by Smith's example, which may also have shown him how it was possible to achieve "free" effects with geometrical elements. But Caro's sculptures invade space in a quite different way—a way that is as different almost from Smith's as it is from Gonzalez's—and they are more integrally abstract. Caro is far less interested in contours or profiles than in vectors, lines of force and direction. Rarely does a single shape in Caro's sculpture give satisfaction in itself; the weight of his art lies preponderantly in what Michael Fried calls its "syntax," that is, in the relations of its discrete parts. In his catalogue text for the first show of Caro's post-1959 work at the Whitechapel Gallery in London in September and October of 1963, Mr. Fried writes: "Everything in Caro's art that is worth looking at—except the color—is in its syntax." This emphasis on

syntax is also an emphasis on abstractness, on radical unlike-ness to nature.

No other sculptor has gone as far from the structural logic of ordinary ponderable things. Certainly not Calder, whose mobiles so obviously evoke plant forms with their spinal and nodal symmetries. Symmetry enters Caro's art too, but only at the last moment as it were, surreptitiously and indirectly. Planar and linear shapes of steel (there are no solidly enclosed volumes in Caro's vocabulary) gather together in what the surprised eye takes at first for mere agglomerations. Seldom is there an enclosing silhouette or internal pattern with readily apparent axes and centers of interest; these, when they emerge, do so tangentially and ex-centrically. That the ground plan will at times echo as well as interlock with the superstructure or elevation (as in the superb *Sculpture Two* of 1962) only renders the unity of a piece that much harder to grasp at first. Yet just those factors that make for confusion at first make most for unity in the end.

Despite all that it owes to pictorial art, and despite its radical rejection of monolithic structure, Caro's work is less pictorial than Smith's. His pieces ask to be looked at from many different, and dramatically different, points of view; and in some cases the spectator has to look *down* as well as straight ahead. Caro's "roundness" is the more paradoxical because there is so little in his vocabulary of forms that leads the eye into depth. Almost all surfaces and edges are rectilinear, and almost all their changes of direction are strictly rectangular. Far from being anything like calligraphic, Caro's drawing is not even cursive (it shies away from curved forms the way British engineering design tends to, or used to tend to). But the relationships of the rectangular details in Caro's sculpture, while necessarily angular, are themselves only sparingly *rect*-angular: it is as if the rectangular were set up in one aspect only to be the more tellingly countered in another. By the tilting, tipping and odd-angle cantilevering of his rectangular shapes Caro achieves a kind of sprawling cursiveness that is all his own, and which makes everything that would otherwise look separate and frontal move and fuse.

The play of light against heavy is interwoven, fugally, with the play of open against closed, and of irregular against regu-

lar. Or at least this is so in most of the steel sculpture that Caro did at home in England. Five of the seven pieces he made in this country during 1963–64 (while teaching at Bennington College) show a marked change of manner in which lightness and regularity override nearly everything else. Relationships become almost altogether rectangular and boxlike, and there is a plain, emphasized symmetry. This forthright symmetry has a startling effect in so far as it suggests a syntactic massiveness, so to speak, that takes over the work of the literal massiveness of heavy steel in Caro's English-made sculpture. Caro's American pieces are for the most part smaller and made of much lighter and thinner steel, but the foursquare squatness that is imposed on them by their rectangular symmetry makes them look less fragile than one would expect. The spectacular inner and outer play of Caro's English-made sculpture is missing, but the effect is almost as new intrinsically.

Nothing of the preceding applies to Caro's two last American-made works *Titan* and *Bennington*, which he finished before his return to London in June of 1964. These are perhaps more purely, more limpidly, masterpieces than anything he has done before. In them that search for a low center of gravity which is one of the most constant features of his originality finds a perfect fulfillment. Ground-flung, wide-open enclosures (in "L" and "T" form respectively) that are relieved by two or three vertical elements no more than four feet high, the two pieces strike the heroic, grand-manner note even more resonantly than the best of Caro's large English sculptures do. I say more resonantly, because less expectedly, less in terms of the historic connotations of the grand manner. (Though Caro's roots in English art tradition—roots that go back literally to Perpendicular Gothic—become more evident the longer one looks. A grand, sublime manner has been a peculiarly English aspiration since the eighteenth century. Henry Moore and Francis Bacon are possessed by it in their separate ways just as much as Haydon, John Martin and even Turner were in theirs. Without maintaining necessarily that he is a better artist than Turner, I would venture to say that Caro comes closer to a genuine grand manner—genuine because original and unsynthetic—than any English artist before him.)

Michael Fried speaks aptly of Caro's "achieved weightless-

ness." It is a kind of weightlessness that belongs, distinctively, to the new tradition of non-monolithic sculpture which has sprung from the Cubist collage. Part of Caro's originality of style consists in denying weight by lowering as well as by raising the things in his sculpture that signify it. The prewar Giacometti had a glimpse of this possibility, but only a glimpse, even though he made several masterpieces from it. Caro works the possibility out. By opening and extending a ground-hugging sculpture laterally, and inflecting it vertically in a way that accents the lateral movement, the plane of the ground is made to seem to move too; it ceases being the base or foil against which everything else moves, and takes its own part in the challenge to the force of gravity.

Applied color is another of the means to weightlessness in Caro's art, as Michael Fried, again, points out. It acts—especially in the high-keyed off-shades that Caro favors—to deprive metal surfaces of their tactile connotations and render them more "optical." I grant the essential importance to Caro's art of color in this role, but this is not to say that I, for one, find his color satisfactory. I know of no piece of his, not even an unsuccessful one, that does not transcend its color, or whose *specific* color or combination of colors does not detract from the quality of the whole (especially when there is more than one color). In every case I have the impression that the color is aesthetically (as well as literally) provisional—that it can be changed at will without decisively affecting quality. Here, as almost everywhere else in Western sculpture, color remains truly the "secondary" property that philosophers used to think color in general was. . . .

It ought to be unnecessary to say that Caro's originality is more than a question of stylistic or formal ingenuity. Were it that it would amount to no more than novelty, and taste would not, in the event, find itself so challenged by it. Caro's art is original because it changes and expands taste in order to make room for itself. And it is able to do this only because it is the product of a necessity; only because it is compelled by a vision that is unable to make itself known except by changing art.

Arts Yearbook 8, 1965; *Studio International*, September 1967 (unrevised); *Anthony Caro*, Kröller-Müller State Museum, Otterlo, Holland, 1967; *Anthony Caro*, ed. Richard Whelan, 1974.

41. Letter to the Editor of *Art International* about Morris Louis

To the Editor:

In her "New York Letter" in the February 1965 number of *Art International*, Lucy R. Lippard writes of ". . . [Morris] Louis's much discussed principles of non-composition, his supposed lack of interest in formal relationships to the extent that he refused to decide the final dimensions of his canvases. In 1960–61 Louis still depended heavily on accident. . . ." These are egregious misconceptions. I know they have been current since Louis's death in September 1962, but I had hoped that further acquaintance with his art would dispel them even if their inherent preposterousness did not. Now I realize that I was too optimistic (what passes for art criticism in connection with Pollock should have told me that) and I want to take this opportunity to try to set things right.

The public source of these misconceptions is, apparently, an article by Daniel Robbins, of the Guggenheim Museum, in *Art News* (New York) of October 1963 (though Mr. Robbins must have already put them in oral circulation some time before, to judge from Louis's obituary in the October 1962 *Art News*). In his article Mr. Robbins wrote: "To him [Louis], it did not matter if the color ran down for a mile or a foot. . . ." Louis, Mr. Robbins claims, had a "calculated concept of un-compositional painting." Also: " . . . he did not calculate optical effects."

I knew Louis well enough, and long enough, to be able to say that "calculated concept of un-compositional painting" would have struck him as inane, whether applied to his own or anybody else's art. It mattered very much to him whether his color ran down an inch or half an inch; and he would have as little dreamt of refusing "to decide the final dimensions of his canvases" as of letting someone else paint on them. As for depending "heavily on accident" in other respects—as distinct from depending on a painterly (*malerisch*) execution—the big "unfurled" paintings of 1960–61 to which Miss Lippard refers do not do so any more essentially than Rubens's oil sketches. One does not have had to know at first hand how careful Louis's procedures were in order to perceive this. One should be able

to see for oneself that the placing and trickling of the wavering stripes in these huge canvases, as well as the choosing of their colors, are highly controlled. . . . Last and least, Louis was completely indifferent to "optical effects," calculated and uncalculated.

As he tells in his article, Mr. Robbins got his notion of Louis's "un-compositional painting" from a note on an artist's loan form that accompanied a 1961 painting of Louis's, *Burning Stain*, that had been sent to the *American Abstract Expressionists and Imagists* show at the Guggenheim in 1961. Louis had left the line for "size of picture (without frame)" blank, appending a note saying: "I have not filled in the size of the picture—I will leave the actual measurements to you once it is stretched." Louis lived in Washington. The rolled canvas of *Burning Stain*, which he had painted unstretched, as he did all his pictures after 1953, arrived in New York cut precisely to the size and shape in which he intended it to be stretched, allowing for the lap-over needed to secure it to the sides of the stretcher. Almost all Louis's stretchers after at least 1957 were made in New York, and his canvases would be sent there rolled and either marked or already cut for stretching. Naturally, the exact *measurements* of a picture—i.e. the figures in inches—had to be left until the canvas was taut on a stretcher.

In leaving the "actual measurements" of *Burning Stain* to the Guggenheim people, Louis did not mean at all to leave to them the *determination* of the picture's size or shape. The idea would have shocked him. Nor did Mr. Robbins, or anybody else at the Guggenheim, actually misunderstand him, for *Burning Stain* was stretched exactly as he had intended it to be: that is, in exactly the shape and size to which Louis had cut the canvas it was on, with a minimum of lap-over left for the tacking or stapling. And after that it was measured in accordance with his written request. Just when, subsequently, Mr. Robbins chose to misinterpret that request, I don't know. It is significant that nowhere in his article does he mention just *who*, other than the artist himself, ever decided the final dimensions of a Louis painting. Certainly, his stretchermakers never did, or his dealers.

There may have been good intentions behind all this on Mr. Robbins' part—he may have wanted to show that Louis was

the furthest-out painter yet. But the truth, with respect at least to Louis's concern with composition, is the contrary. Actually, he agonized over the size and shape of his pictures, and did so all the more because he would find his way to the nuances of size, scale, and shape largely in the process of finishing a painting. The width of the canvases he left behind is clearly marked in green crayon wherever it is not self-evident—and it is not so only in a few of the pictures that come before the vertically banded ones of 1961–62. In these latter Louis often hesitated till the end in deciding just where to mark top or bottom, but one or the other was always indicated in the *paint* itself. He hesitated as long as he did because he felt the decision as to height to be the more crucial one in this kind of picture, and preferred to make it at the last moment, just before the picture was sent off for stretching. When Mr. Robbins writes that "it did not matter whether the color ran down for a mile or a foot," it sounds to those of us who knew Louis's procedures as if he were making fun of them. [1]

Another error of fact about Louis occurs, by implication, in E. C. Goossen's article on Paul Feeley in the December 1964 *Art International*. Professor Goossen writes ". . . that in Louis's first show in . . . 1957, there was one painting which had been done exclusively by the soak-stain method, virtually an all-over curtain . . . out of this one stained painting Louis . . . developed an extensive *oeuvre*." The untitled painting in question (now in the William Rubin collection) was actually done in 1954, along with at least some twenty others very like it in look and method. There may have been more—Louis regularly destroyed part of his production—but these twenty are what have survived. Five or six of them were shown in Louis's exhibition at French and Co., in New York, in 1959. I myself,

1. Greenberg's explanation of Morris Louis's painting procedures and of how Louis determined the size and shape of his canvases did not put an end to uncertainty surrounding the issue. Some years later Greenberg felt obliged to write an addendum (*Arts Magazine*, December 1972–January 1973). "It mattered very much where Louis's canvases were 'cut,'" Greenberg wrote, "and it continues to matter very much. The responsibility of stretching the many canvases he left unstretched at his death in 1962 fell upon me. I have followed his indications wherever I could find them, and where I could not I have followed his practice. In either case there was plenty of guidance." [Editor's note]

and several other people, had already seen nine others of the "soak-stain" pictures in the fall of 1954. Louis did still more in 1955, but without the "veiling" or "curtaining" and in more forthright color; all these, as I happen to know definitely, he destroyed in the same year. In 1956 he abandoned his "soak-stain" technique entirely, but returned to it late in 1957, after his show of that year at the Martha Jackson Gallery. All but three or four of the paintings he did between these dates were likewise destroyed.

Art International, May 1965

42. America Takes the Lead, 1945–1965

At the beginning of the 1940s the strongest new impulses of American painting were making themselves felt in the area of abstract art. The quality of work done in the late 1930s and early 1940s by abstract painters like Stuart Davis, Ilya Bolotowsky, Giorgio Cavallon, Burgoyne Diller, Balcomb Greene, Fritz Glarner, George L. K. Morris, Albert Swinden, I. Rice-Pereira and a few others looks higher now than it did then. The annual exhibitions of the American Abstract Artists group, to which most of these artists belonged, were the most important occasions of those years as far as advanced art in New York was concerned. To these exhibitions the subsequent sophistication of New York painting owed a great deal.

Hans Hofmann's school was another important factor in the situation of advanced art in New York in those same years. It acted as a center for the exchange of experiences and ideas; and through Hofmann himself, painters in general, not just his students, had access to an artistic culture that was uniquely wide and deep. That culture had assimilated Klee, Kandinsky, Mondrian and Miró at a time when these masters were still being generally overlooked in Paris; and, thanks to Milton Avery as well as Hofmann, it continued to give a large place to Matisse when the avant-garde elsewhere was dismissing him as old-fashioned. The W.P.A., with its Federal Art Project,

had had its part, too, in raising the level of artistic culture in New York. Thanks to the Project, many younger painters had been able to devote themselves entirely to art at a period in their lives when this was most essential. The high seriousness and high ambition which propelled the most advanced American painting in the later 1940s would be hard to account for otherwise.

The war brought famous European artists, and also critics, dealers and collectors, to New York. For the first time one had the feeling, in that city, of living in the center rather than in a backwater of art. This feeling was far more important than anything American artists learned directly from these visitors. It made for a new self-confidence. And Americans started producing major painting for the first time—painting that defined rather than derived from the mainstream of art in their time—while the war was still on and Paris was still cut off.

Jackson Pollock's first show and Adolph Gottlieb's first show of mature work both took place in 1943. Nineteen hundred forty-four saw the first shows of Hofmann, William Baziotes and Robert Motherwell; 1945 saw Arshile Gorky's first show of oils and Mark Rothko's first show. Clyfford Still's first New York show came in 1946. (Pollock, Gottlieb, Hofmann, Rothko and Still were all more or less introduced by the late Howard Putzel, who was Peggy Guggenheim's assistant at her Art of This Century Gallery before he opened a gallery of his own.) By 1946 Abstract Expressionism was well under way: the smooth and clearly linear handling that had ruled in abstract painting all through the 1920s and 1930s (and which still dominated the American Abstract Artists annuals) was being supplanted by a loose, rapid, *painterly* execution in which the *look* of improvisation and accident had a much larger part. The main influences on all this painting were still, conspicuously, those of Miró and of Picasso of the 1930s and, far less conspicuously, of Matisse, but this took nothing away from its originality.

In 1947 Pollock went over to his "all-over" composition and "drip" technique in a consistent way. Nineteen hundred forty-eight saw Willem de Kooning's first show and the "joining up" with Abstract Expressionism of Bradley Walker Tom-

lin, Jack Tworkov, Philip Guston and James Brooks, artists who until then had been working in directions relatively distant from painterly abstraction. Nineteen hundred fifty was another year of gathering momentum and at the same time a climax. Barnett Newman and Franz Kline had their first shows in New York in that year, while over in Paris Sam Francis arrived at the manner of his maturity. By this time most of the leading Abstract Expressionists had been having annual shows regularly in New York for some years, and this practice—which had a lot to do with the crystallizing of an avant-garde art public in New York—was to continue through most of the 1950s.

As that decade wore along, the hallmark of Abstract Expressionism became increasingly an execution that involved the smearing, smudging, slapping and dripping of paint, and this execution became in turn established as the hallmark of advanced painting in general, whether abstract or representational. Hundreds and then even thousands of painters all over this country followed where de Kooning first of all, but also where Kline, Pollock and Still led. In California Richard Diebenkorn and Elmer Bischoff, after starting out as abstract painters, in 1955 began applying typically Abstract Expressionist methods of execution to figure and landscape painting. That year also saw the real beginnings of the public and commercial success of Abstract Expressionism, which soon became international in dimension. This marked the first time *ever* that American art received widespread and serious attention in Europe; it also marked the first time in over a hundred years that Paris's supremacy as an art center began to be questioned.

In the meantime Gorky (1948) and Tomlin (1953) had died. Pollock died in 1956; Kline was to die in 1962, and Baziotes in 1964. In the meantime, too, currents running against the tide of Abstract Expressionism began to manifest themselves.

The first such counter-current to become noticeable in a programmatic way was that embodied in the art of Jasper Johns and Robert Rauschenberg, which represents a culmination of Abstract Expressionist technique and at the same time a cancelling out of the vision of Abstract Expressionism: the

214

Abstract Expressionist way of handling paint is preserved and even exaggerated, but it is applied to the representation, both pictorial and sculptural, of man-made objects or signs that are normally produced by mechanical procedures. The smoothly painted pictures, with large simple shapes or divisions of flat color, that Ellsworth Kelly began showing in New York in 1955 break more decidedly with Abstract Expressionism, while still owing to it all the subtle inflections of color and drawing that differentiate his paintings from geometrical painting of any standard kind. In Washington, D.C., Morris Louis (who was to die in 1962) began doing very thinly painted pictures in 1954 that had more or less of a painterly aspect but which by 1960 had developed almost as far away from Abstract Expressionism as Kelly's. Likewise in Washington, Kenneth Noland emerged in 1958 with concentric bands and stripes of flat color that moved away from Abstract Expressionism even more rapidly; and the same is true of Frank Stella's banded paintings, which first appeared in 1959. A painter who is related to Louis and Noland by his vision of color, but who continues and expands rather than breaks with Abstract Expressionism, is Jules Olitski, who began to show at around the same time as Stella.

In the spring of 1962 there came the sudden collapse, market-wise and publicity-wise, of Abstract Expressionism as a collective manifestation. The fall of that year saw the equally sudden triumph of Pop art, which, though deriving its vision from the art of Rauschenberg and especially Johns, is much more markedly opposed to painterly abstraction in its handling and general design. Assemblage art came along almost simultaneously, and now optical art and kinetic art have appeared, to swell the reaction against Abstract Expressionism. To the untidy "handwriting" of the latter, all these tendencies—including the ones mentioned in the previous paragraph—oppose clarity, flatness, openness, linearity, the renunciation of thick paint and turbid color. This nominal stylistic consensus covers up vast differences of quality, however, which should not go unnoticed.

Nor have the achievements of the original generation of Abstract Expressionist painters been diminished by recent events.

Those achievements seem, on the contrary, to grow all the larger as they recede in time—this, aside from the fact that some members of that first generation are working as well as they ever did, or even better.

American abstract sculpture ran more or less parallel, stylistically, with American abstract painting in these same twenty years. But it hardly matched painting in point of qualitative achievement. By 1940 Alexander Calder was already on the scene as a mature artist, and David Smith was entering on it. (Gaston Lachaise, truly a major sculptor, had, in effect, just left it.) Calder's reputation grew enormously in the next two decades, but his role as an influence has never been commensurate with that reputation. It has been almost the reverse with Smith, the only American sculptor whose art has attained a resonance like that of leading Abstract Expressionist painters.

Smith's sculpture grew out of Synthetic Cubism, with its clean drawing, and it never forgot Synthetic Cubism. But by the mid-1940s it had loosened up in what can be called an Abstract Expressionist direction, and it was doing so independently of painting and perhaps even earlier. It was left, however, to Ibram Lassaw and Theodore Roszak to carry sculpture all the way into Abstract Expressionism. More or less geometrical vocabularies gave way in both cases, in the late 1940s, to exuberantly calligraphic plant- and insect-like forms with worked-over, "painterly" surfaces. Similar forms and similar surfaces emerged at around the same time in the abstract sculpture of Herbert Ferber and Seymour Lipton, but with a relative restraint that makes their art "Baroque" as against the "Rococo" of Lassaw and Roszak. Richard Lippold's constructions in wire, as strictly geometrical as they are, likewise deserve to be called Rococo.

All this sculpture belonged to the new tradition of open, draftsman-like, three-dimensional art born out of the Cubist collage and bas-relief construction in which the alternatives of carving and modeling seemed to be transcended. All significant abstract sculpture does not belong in this vein; good abstract sculpture has been made in the old monolithic tradition; yet in this country that tradition has practically died out for the purposes of abstract art. The younger abstract sculptors who came to the fore in New York in the 1950s worked in the

new open tradition, and this has continued to be the case in the 1960s. Yet there has been a singular lack of continuity in other respects. Hardly any of the newer sculptors (and the same seems to be more or less true in Europe and elsewhere) have shown staying power, the capacity for sustained development. There have been many bright beginnings, but only scattered, isolated realizations. That the spell of Abstract Expressionism has now worn off, in sculpture as well as in painting, seems to make little difference. Geometrical or near-geometrical shapes and smooth surfaces again prevail in abstract sculpture, but achievement remains spasmodic for the most part. The rise of *assemblage*—which can be defined as three-dimensional art in a two-dimensional or pictorial context which yet escapes the confines of bas-relief—has not changed this situation either, although it has made the name of Louise Nevelson prominent. Nor has the rise of Pop art, which has promoted a revival of figurative art in sculpture as well as in painting, changed it.

Art in America, August–September 1965; *The Artist in America*, intro. Lloyd Goodrich, 1967 (unrevised—but incorporating an addendum *not* written by Greenberg).

43. Introduction to a Group Exhibition in Saskatchewan

The artists whose works were eligible for inclusion in this exhibition had to be present residents of Saskatchewan. The works themselves had to be relatively recent. I don't think anything in the show I have chosen was done before 1964.

Saskatchewan abounds in good minor art. I don't pretend that my selection would, as a whole, make a case for the province as a center of major art. Nevertheless, some small part of it would stand up in the company of the most important art being produced anywhere else at this time.

The next two or three years are going to be crucial ones for

painting and sculpture in Saskatchewan. The question is whether the great promise that manifests itself here and there in this exhibition will turn into a sustained development.

Diamond Jubilee Exhibition of Saskatchewan Art, Norman Mackenzie Art Gallery, Regina, October–December 1965

44. Letter to the Editor of *Artforum* about Franz Kline

To the Editor:

My friend Friedel Dzubas was somewhat inaccurate in his interview with Max Kozloff in the September, 1965, number of *Artforum*, about what went on when Meyer Schapiro and I went around choosing our *Talent 1950* show for the Kootz Gallery in New York. There was, in fact, very little disagreement between Dr. Schapiro and myself. It's true that all the paintings we saw in Franz Kline's place were in "color," but it's also true that we both found ourselves rejecting them. I happened to light somewhere in the studio, on two line drawings in black pencil (I'm not sure; they may have been in ink) on white paper, and Dr. Schapiro immediately agreed with me in preferring them. Our only disagreement was about which of the two to pick for the show. He wanted the smaller one, I the larger one. Dr. Schapiro asked Kline himself to decide, and he—quite naturally, I thought, putting myself in his place—chose the larger one.[1] That's all there was to it.

My conjecture is that it was Kline himself, later on (at the Cedar Street Tavern), who was partly responsible for the account that Mr. Dzubas gives of our visit to his studio. That account may be flattering to me but it is, I repeat, inaccurate.

Clement Greenberg
New York, N.Y.

Artforum, November 1965

1. The title given by Franz Kline to the drawing was *Vawavitch*. The brief introduction by Greenberg and Schapiro to *Talent 1950* is republished in vol. 3. [Editor's note]

1966

45. Matisse in 1966

Matisse is there as no one else is for ambitious painters in this moment: there as a fixed pole of quality as well as a guiding influence. More than any other predecessor, he establishes a *relevant* and abiding standard of quality; without being the greatest painter of the past, he tells us in our time, more pertinently than any other master can, what the art of painting is fundamentally about.

The personality of the artist fades into the radiance of his art. Matisse cuts no figure. He is not talked about the way Picasso is. There are no myths about him, no apocryphal stories to clear away. From most accounts, he was a cold man, and certainly a sober and posed one. It belongs to the success of his art that it makes the issue of coldness versus warmness irrelevant. In an age of crisis, but also of crisis-mongering, he produced an art that was seldom anything but serene. He was never distracted in his art by current events. Maybe this was a symptom of his coldness, but it was to the benefit of his art, and of art in general.

The course of Matisse's art was unique in a sense that the course of Picasso's was not. Picasso's was carried along in its best years by the unfolding logic of Cubism; Matisse's was not borne up by anything nearly so self-evident to himself. Fauvism had its own logic, to be sure, but that logic did not seem to be as compelling as that of Cubism was. After 1914, when Matisse came under Cubist influences, Fauvism seemed not just to have been superseded but to have been left unfinished, and it appeared all the more superseded and unfinished after 1917, when he returned to a way of painting much like that of the Impressionists in the early 1870's. Matisse was able, nevertheless, to maintain, and more than maintain, the qualitative continuity of his art without the supporting "logic" of a

coherent style. His very best painting, perhaps, comes be-
tween 1914 and 1917. And in a way it is "styleless" painting,
or at least it does not fall easily into any of the established
stylistic categories of the twentieth century. If ever the conti-
nuity and coherence of a man's art were maintained by sheer
quality, they were in Matisse's art in those years and in the
years afterward. The kind of painting he did in the decade after
1917 is not original in a major way; it does not advance the
historical front of art. He shades and models with conventional-
seeming grays and browns, and pictorial space is not handled
differently than in Manet. The lambent, *fragrant*, yet sharp
color in the pictures of this period does make a difference, but
the revelation of this kind of color had come to Matisse years
before; it was not new in principle. All the same, more than a
few of these "unheroic" pictures are works of matchless perfec-
tion. Look, for example, at the *White Plumes* of 1919, or *The
Artist and His Model* of the same year, or—to jump out of the
post-1917 decade—the exquisite *Still Life with Three Vases* of
1935. Here pictorial quality as separate from the factor of his-
torical originality or ambition is distilled as purely as it ever
could be—as purely as in Fantin-Latour's wonderful and near-
academic paintings of roses or anemones.

In the end Matisse does "finish" Fauvism as a historical
style, does develop it to its limits: if not quite in the large
interiors of 1947−48, then in the largest and most abstract of
the paper cut-outs (*gouaches découpées*) that he did in the last
years of his life. (There is one example, but only *one*, in the
1966 retrospective: *The Sheaf* of 1953.[1]) And it would seem
that Fauvism, when its conclusions were finally drawn, arrived
in the same place that Cubism already had: altogether flat ab-
stract art.

I see Matisse's *touch* as the most constant factor of his style
and quality. This may seem paradoxical, because he makes so
little case of his touch in the ways in which touch, in painting,

1. There were two Matisse retrospectives in the United States in 1966,
one organized by Lawrence Gowing for the Museum of Modern Art, New
York (*Henri Matisse: 64 Paintings*), and one organized by the University of
California, Los Angeles (*Henri Matisse: Retrospective, 1966*), in cooperation
with the Art Institute of Chicago and the Museum of Fine Arts, Boston.
Greenberg is referring to the latter. [Editor's note]

is usually exploited. He never uses impasto, he never kneads or mauls his paint, he never makes it juicy. What, however, he does use his touch for, with all the feeling it communicates, is to suppress that which might connote or suggest other attributes of being than visibility. Color is a matter of the eye's choice, but Matisse's touch goes a long way to carry out that choice. If his color sings, it's because his touch sings too. Very much depends on the exact pressure with which he puts brush to canvas and with which he moves it over the canvas. Very much depends on the fact that he *soaks* his brush with paint rather than loads it. The primed surface is covered with a fluid, not a stuff, and makes itself felt as one with its covering. Matisse knows also how to exploit the seen priming, which he sometimes lets show between his brush strokes in order to breath air and lightness into his color. As far as I know, he was the first to do this deliberately (with Cézanne the naked priming, as much as it contributes to certain of his pictures, is evidence that the picture was not finished). Always, Matisse minimizes the tactile substance—the paint, the pigment— that bodies color forth; and his color becomes all the more vividly and intensely itself because it declares nothing but its visibility. Color dissolves all tactile associations, and tactile associations are dissolved *in* color—and yet in *flat*, not atmospheric, color: color that remains flat even when it is not opaque.

In his "Notes on Matisse as a Draftsman" in the catalogue of the 1966 retrospective, William S. Lieberman writes that the "essence" of Matisse's art "lies in the rhythm of his line." I would not want to indicate the essence of anybody's art, and in Matisse's case I would hesitate even to point to his touch. But certainly, before pointing to his line, I would point to his way of laying a picture out, of apportioning its surface in terms of color and size as well as shape: that is, I would point to his design or "composition." Line or silhouette is only a part of that, and for Matisse usually not a decisive part. Indeed, where he does make line decisive in any way (as in *Pink Nude* of 1935) it tends to throw the picture off. Matisse is a superb draftsman, but he is a still better painter, and as a painter he is an orchestrator of color areas before he is anything else. It is in his sculpture rather than in his painting that I see his decisions

as to line or contour coming close to being crucial—and in his sculpture his touch (which is as inspired there as in his painting) becomes his line, *is* his draftsmanship. And yet *even* in his sculpture I see the way in which he arranges, roughs in, his masses as still more crucial.

According to everything we know of his personality, Matisse was a very thoughtful and deliberate artist. There were times when he revised and edited endlessly, and not always to the benefit of the results, either aesthetically or physically. But there is remarkably little evidence in the paintings themselves of a deliberate or slow *hand*; Picasso's often seems far slower, and even heavier, by contrast. This would indicate that deliberation, with Matisse, usually preceded execution and was kept out of it. Once he picked up his brush he moved it swiftly, in an almost slapdash way, even if within limits already laid out by his thinking eye. Thus he rendered another issue, that of spontaneity versus reflection, beside the point. That issue has afflicted the discussion of art for many years. Like most afflicting issues in art, it is a false one. Mondrian executed his paintings far more slowly and neatly than Matisse did, but that provides no reason for concluding that he was really a less spontaneous artist. He and Matisse, like everyone else who has made respectable art, depended on intuition in the last resort, and intuition is neither fast nor slow. Nor is spontaneity. Matisse's art, and his example, brush many false issues aside and clarify many real ones. In this respect alone does he deserve to be called that "simplifier" which his teacher, Gustave Moreau, predicted he would be.

Boston Museum Bulletin 64, 1966

46. David Smith: Comments on His Latest Works

David Smith's death last May was untimely in every sense. At fifty-nine he was as vigorous as he had ever been. Nor had the pace of his art shown any signs of slackening. On the contrary, it was developing faster than before. New conceptions were pouring into it, and more than ever it was Smith's problem, not to generate, but to sort and clarify them.

The works discussed here are all from the last five years of Smith's life. They were photographed in the places where he had put them around his house and workshop, which he called The Terminal Iron Works, in Bolton Landing, New York.[1] Some of these pieces are final in their quality, others in the nature of work in progress. But to say this is not to deny them their quality, too. Smith was not an artist to make much of his "touch," but everything he did bears it.

As far as Smith's artistic development is concerned, its closing-off by death is an accident. His oeuvre, in all its un-evenness and sprawl, in all its bewildering diversity, somehow remains open, unfinished. No amount of classifying or cata-loguing, of art-historical or art-critical scrutiny, will ever change that for me.

Tanktotem IX, 1960, painted steel, about 7½ feet high

The look of fragility in this piece is enhanced and at the same time overcome by the delicateness with which its discrete parts are related to one another. The sliced-off drumhead (or tank lid) barely rests on the elongated rectangle of sheet steel, which the curved and bent rod-legs barely support, while themselves barely resting on the ground. And yet the effect of the whole is of something both planted and lithe—like a tree or a human being. As well as being a big feat of art, this work is a little feat of engineering and welding. It shows, too, how much better Smith could draw in the air than on paper or canvas, how much better he drew in unframed than in framed space.

Zig IV, July 1961, painted steel, about 8 feet high

The *Zig* (from "ziggurat") series contains some of Smith's most original inventions, and also some of his sheerest masterpieces. *Zig IV* is one. In it he escapes entirely from the allusions to the natural world (which includes man) that abound elsewhere in his art. Abstract form—with perhaps some references to urban landscape—and the coordinates of the force of gravity

1. The article was accompanied by photographs of David Smith's works in situ. Greenberg's comments formed part of a special tribute to Smith by "old friends, new friends, artists, writers, photographers and critics," edited by Cleve Gray. [Editor's note]

(up and down) guide the eye exclusively here. The tilt of the square platform is all-important, creating as it does the slanting thrust of the forms attached to it in strict perpendicularity. The play of curved against straight comes right out of Analytical Cubism, the functioning of the platform as support and frame out of the Cubist bas-relief collage. But Smith takes these things into areas of sculptural experience undreamt of by anyone before him. Note, too, how the whole piece *moves*.

Cubi I, 4 March 1963, stainless steel, about
 13 feet high

This work is numbered first of nearly thirty large stainless-steel sculptures called *Cubi*. All are strictly geometrical in form, yet do not belong to what we know as geometrical art—it was Smith's faculty to use geometrical elements without getting himself captured by the doctrinaire notions attached to geometrical art or anything like it; it was as though he used the geometrical only in order to negate it. The *Cubi* series began in 1963 and apparently was still to be added to at the time of the artist's death. In none of the subsequent variations to which he subjected the motif of stainless-steel cubes, shafts, discs and cylinders did he surpass the quality attained in *Cubi I*. There have been complaints about the over-use of the word, "monumental," but if ever its use were justified it is here: *Cubi I* seems to communicate the very essence of what that word truly means.

Menand III, 13 September 1963, steel, about
 2 feet high

Menand[s] is the name of a place near Albany. The eight painted steel sculptures in this series form perhaps the artist's most consistently successful venture in small-scale art. The pieces were all done in September and October of 1963. Their compact size evokes small bronzes, but this only helps to make one sense, by contrast, the weight and irreducible mass of the solid steel. Thanks to this—as well as to the trued and faired planing of its surfaces—*Menand III* seems to ask for much larger dimensions than it has. The frontal view brings out its anthropomorphic aspect; this is diminished when the sculpture is seen from either side; then two relatively massive flanking

buttresses come into view, to confer an effect on the whole that is more architectural than figurative. The three-dimensionality has an emphasis here that is not often seen in Smith's art.

Cubi XXIII, 30 November 1964, stainless steel, about
14½ feet long

This superb work hints at the influence of Anthony Caro, the English sculptor whom Smith himself had decisively influenced earlier on. It was part of Smith's fertility that he could assimilate ideas and suggestions from everywhere and anywhere without for one moment looking derivative. From his very beginnings as a sculptor (he started out as a painter) he had struggled with the problem of base or pedestal (or "frame"). Caro, who was twenty years younger, had eliminated the problem immediately and entirely when he went over into steel sculpture in 1960. Smith became acquainted with Caro, and with his work, when the English artist came to this country in 1963 for a teaching stint at Bennington College. He made no bones about his admiration for the younger man's art, got the point of it, and turned it to his own independent advantage. This was not the first time he used legs instead of a base or pedestal, but it was the first time he made them the theme of a work.

Wagon II, 16 April 1964, steel, about 9 feet long

Smith made two huge *Wagons* in 1964, harking back to the wheeled pieces he had left in Spoleto in 1962. Most of the elements of these *Wagons* come from the same place, the ironworks in Voltri where he made his sculptures for the Spoleto Festival. Smith had started to mount sculpture on wheels some ten years before, but they became a prominent feature only with his "Italian" period, when he began to pay more attention to the problem of gathering the base, pedestal or resting point of the sculpture up into its "body." *Wagon II* tellingly marries squatness with openness, rawness with cleanness.

Untitled, 17 March 1964, painted steel, about
6½ feet high

Save for the little wheels that carry it, this work is put together entirely of I-beams of different sizes and proportions. It is the

only such work that Smith left behind, and a largely successful one—although the wheels inject a note of cuteness of a kind that disrupts, sometimes quite irremediably, several other of his pieces. What is wonderful here is that the geometrical regularity and strictness of the drawing do not make for severity. Painted chrome-yellow, the piece has a rather intimate look when seen in the original. It seems to demand a frontal view, but this is deceptive—and Smith's art is often deceptive in this respect. Some of the strongest points of this sculpture reveal themselves only when one moves all around it.

Primo Piano I, 25 October 1962, painted steel, about
12 feet long

The open circle came to Smith's art from the paintings of his friend, Kenneth Noland. Several sculptures he did in 1961 and 1962 literally take off from the concentric color bands in Noland's pictures of 1958–62. In *Primo Piano I* (*primo piano* means "first floor" in Italian) he fills the circles almost completely, turning them into perforated discs. Flatness is emphasized at the cost of "transparency," though there is plenty of that elsewhere in the piece. I myself do not find it wholly successful; it looks uncomfortably straddled between the linear and the planar, or between "drawing in air" and mural painting. Similar equivocations trouble other of his "pictorial sculptures." The drawing, instead of being stripped-down, and swift, is merely blunt; and even Smith disliked the flat white paint. But it would have taken a better *painter* than Smith was to have found color to redeem this work.

Untitled, 24 April 1965, painted steel, about
7½ feet high

In no period did Smith pursue one or even two directions exclusively. It was his way to explore three or four ideas, or manners, concurrently. At times two different manners would intersect. This is one example, a very late work, in which the vein of his flat painted ("mural") sculpture crosses that of his *Zig* series. As in a Synthetic Cubist painting, the flat "picture" plane is jolted into what seem two planes of different depth, only to have its "integrity" reasserted. This is done, as much pictorially as sculpturally, by the inflections of the dividing

ridge of steel, which cuts into and collects space on top of and outside the "picture" plane. Both the pictorial and sculptural seem here to transcend themselves in a new kind of unified medium. Yet, when seen in profile this work, painted black on brown and white, appears to be quintessentially sculptural.

Voltri-Bolton I, 6 December 1962, steel, about
9 feet high

This is one of Smith's most singing sculptures, the nominal start of the *Voltri-Bolton* series, which includes those called *Voltron* and *V.B.* as sub-series and runs to over twenty-five items. They all ring variations on themes first stated—and in general stated more crudely—during Smith's visit to Italy six months earlier. The big wrench-form is from among the old tools he had shipped back to him from Voltri. As in other works of this series and in an earlier *Tanktotem* series, vestigial rawness of the "found" steel parts, after their being steel-papered and lacquered, provides the right foil for the cursive grace with which the parts are made to flow into one another.

Becca, 30 April 1965, stainless steel, about 11 feet long

The signature plate of this sculpture bears only *Becca* by way of a title, and *Becca*, like *Dida*, appears on a number of other of Smith's late works. They are the diminutive names of his two daughters, Rebecca and Candida, aged ten and eight. Smith made no bones about being a "pictorial" sculptor whenever the spirit so moved him. He did not believe that sculpture *had* to be or have anything: if something worked as art, it worked, regardless of how it might be classified—in which point he agreed with Croce without, as I think, ever having read a word of him. Here in *Becca* Smith is being a "post-painterly" art-ist—a post–abstract expressionist painter-sculptor, yet with saving painterly graces as embodied in the scribbles of light on dark that were obtained (less deliberately here than in some of the other stainless steel pieces) in the process of polish-ing the metal surfaces. Nothing could be more traditionally Cubist than the way in which the rectangular plates overlap, but the silhouette this piece cuts out in the free air shifts it into a different context, the nearest thing to which, as far as I know, is Chinese architecture. I am not sure as to how suc-

cessful this work is, but the doubt is one that is created only by comparison with other works of David Smith's, and not by other art.

Workshop platform

The platform outside Smith's workshop in Bolton Landing remains as he and his assistant, Leon Pratt, left it on the day of his death. The stainless steel shaft-and-pole sculpture in back (*Cubi XXVI*, 12 January 1965) is perhaps his last completed work, which he did not have time to sign or date. It is directly related to *Cubi XXIII* among his previous works, and is even opener and more centrifugal in structure. The flattened lozenges of stainless steel laid out among the discs and the piled sheets of metal show that Smith was about to introduce a new item of vocabulary in his work in stainless steel. In Smith as in Picasso, the lozenge inevitably suggests the human head. No matter what, Smith returned periodically to the scheme— not so much the forms or contours—of the human figure as though to a base of operations. His art used to be filled with schematic allusions to many other things in the visible world: landscape, houses, furniture, animals—especially birds—and even plants. But as he turned increasingly abstract in latter years, in conception and scheme, not to mention execution, the human figure became more and more the one constant attaching him to nature. It was the soar of the human figure that held him, the uncompromising upward thrust it makes, the fight it carries on with the force of gravity.

Art in America, January–February 1966

47. Introduction to Jules Olitski at the Venice Biennale

From its first maturing in the latter 1950's until 1965 Olitski's art went through five phases.[1] No one of these remains as dis-

1. In addition to Jules Olitski, the United States was represented at the XXXIII Venice Biennale by Helen Frankenthaler, Ellsworth Kelly, and Roy

tinct from the one before or after as it seemed in its time. Through all of them runs Olitski's penchant for elliptical shapes, warm color, and open "fields," as well as his urge to escape from incisive drawing. In 1965 he began to paint entirely with the spraygun; linear drawing disappeared from his pictures, to reappear after a while in incandescent streaks of pastel inserted at their margins; then—and more radically—in ruled right-angled bands of contrasting color or value that framed the canvas on two sides or, in one or two cases, on three. It is by pictures inflected in this way that Olitski is represented in Venice.

That these pictures form a climax, I would be reluctant to say. Olitski has turned out what I don't hesitate to call masterpieces in every phase of his art. The masterpieces do seem to increase in frequency as color is given more and more rein. Yet if it is a question of climaxes, then Olitski's previous phase, that of 1964–1965 in which he made tall darkly stained pictures with slanting strips of gray-white canvas emerging at top or bottom, was already a climax, and a momentous one. Here linear drawing was confined to the upper and lower edges of the picture surface in order to give freer play to that less apparent kind of drawing which consists in the fusion and diffusion of color areas. In the first sprayed paintings linear drawing is displaced completely from the *inside* of the picture to its *outside*, that is, to its inclosing shape, the shape of the stretched piece of canvas. Olitski's art begins to call attention at this point, as no art before it has, to how very much this shape is a matter of linear drawing and, as such, an integral determinant of the picture's effect rather than an imposed and external limit. The degree to which the success of Olitski's paintings depends on proportion of height to width in their inclosing shapes is, I feel, unprecedented. Because they attract too little notice as shapes, and therefore tend to get taken too much for granted, he has had more and more to avoid picture formats that are square or approach squareness. He has had also to avoid picture formats that are long and narrow, simply

Lichtenstein. Catalogue essays were written by William Rubin, Henry Geldzahler, and Robert Rosenblum, in addition to Greenberg. [Editor's note]

because these tend to stamp themselves out as shapes less emphatically than formats that are tall and narrow do. . . .

The grainy surface Olitski creates with his way of spraying is a new kind of paint surface. It offers tactile associations hitherto foreign, more or less, to picture-making; and it does new things with color. Together with color, it contrives an illusion of depth that somehow extrudes all suggestions of depth back to the picture's surface; it is as if that surface, in all its literalness, were enlarged to contain a world of color and light differentiations impossible to flatness but which yet manage not to violate flatness. This in itself constitutes no artistic virtue; what makes it that—what makes Olitski's paint surface a factor in the creation of major art—is the way in which one of the profoundest pictorial imaginations of this time speaks through it.

XXXIII International Biennial Exhibition of Art, Venice, Smithsonian Institution, Washington, D.C., June–October 1966

48. The Smoothness of Turner: Review of *J. M. W. Turner: His Life and Work, A Critical Biography* by Jack Lindsay

Turner's present reputation, like the later Monet's, dates from the triumph of Abstract Expressionist and "*informel*" painting in the early 1950s. But even in the late 40s two or three artists and critics who belonged unimpeachably to the avant-garde had begun to recognize that the elimination of closed shapes in the last phase of Turner's art anticipated some characteristic features of painterly abstraction. Until then Turner had been almost altogether disregarded by people interested in advanced art. There is no question that an injustice has been repaired. Rehabilitations have, however, a way of getting overdone, and that seems to be happening now to Turner's. At his very best he does not match Constable's best, nor is he as important to subsequent major painting. If anything, he is more important to subsequent bad painting.

As different as Turner's art is from Reynolds's, it offers a

similar problem. Reynolds was the first to make cuteness—
"human interest" on almost its lowest level—plausible in so-
phisticated art, in some of his pictures of children (especially
those showing them with dogs). Yet Reynolds was a great
painter, at moments a very great painter (as, for example, in
his portraits of Lady Betty Hamilton and of Mrs. Gray in the
National Gallery in Washington), and maybe it took a great
painter to initiate this particular corruption of art. Turner in
his last twenty years initiated a different kind of corruption:
that induced by sweetness and prettiness as sheer effects of
color and design. And he, too, was a great painter, or nearly
one. So it must have taken a great painter to initiate this kind
of corruption too. Nor was it a mere coincidence that he
was likewise an Englishman. The cuteness and prettiness—if
not the salaciousness—in François Boucher look a good deal
quaint, while the same qualities in Reynolds and Turner look
up-to-date, and this difference must be attributed to the fact
that England was the most advanced of all countries in the
18th and early 19th centuries, for both good and bad.

Julius Meier-Graefe wrote in 1908: "The Turner farce is
unique in art history in having been the parody of something
whose original had not yet been produced." Meier-Graefe
meant modernist art, and specifically Impressionism. His ver-
dict is too harsh, but contains a germ of the truth. Up until
the last three or four years of Turner's life, the high-keyed,
diaphanous, contour-obliterating pictures of his last phase
come off with great consistency. But he buys this consistency
by lowering the terms of his success. The newness and origi-
nality of his art in this period lies, as much as in anything else,
in the manageability of its ingredients. The colors in many of
Monet's late paintings are as sweet as Turner's, and sometimes
sweeter, but the wholes into which they are combined are not
at all sweet; on the contrary, these wholes, these pictures, tend
to be difficult—so difficult that it has taken two generations
of avant-garde artists to catch up with them. It is quite differ-
ent with Turner's late paintings. Though, unlike Monet's, they
seldom fail, by the same token they tend to be too pat, too
accessible as wholes. The smoothness of the ingredients—the
high cobalt blues, the milky whites, the translucent gold-
yellows, the explicitly balanced design—contributes to the

smoothness of the total, final effect. Visual sensibility gets its satisfaction too easily, without being challenged or expanded. This is less true of many of Turner's watercolors, but it is true of them, too, to at least some extent. To say this is not to deny Turner high rank as an artist, but it does deny him the company of the absolute masters, to which Constable, Goya, and David belong.

Where the elderly Turner is not consistently successful on his own terms is in his Venetian scenes. But there is no question of difficult art here either, or of his having attempted too much. It is simply—and yet not so simply—that he had contracted a weakness for a certain shade of brownish red that he introduced in his shadows and reflections like a disturbing tic, and which for some—no doubt good—reason he usually abstained from when painting the open sea. (One is reminded of the aging Renoir's obsessive use of madder or alizarin—except that it now and then went into masterpieces, which Turner's brownish red never did.)

I prefer the earlier, less original Turner to the later, revolutionary one. I prefer his darker seascapes (even when the darkening is also due to age), with their sculptured heavings of water, to his opalescent ones. I prefer, above all, the smallish, Constable-like landscape "sketches" in oil that he did in his early 30s. All of which makes me conclude that Turner was a premature revolutionary in his last phase. He may have astounded the taste of his time, but he did not really break with it, or at least not in a radical way. As Meier-Graefe suggests, however unfairly, rather than anticipating Impressionism, he anticipated its banalization—the reflex taste for iridescent color that became universal in the West at the end of the 19th century.

Some of the contours of Turner's figure are made clearer by Mr. Lindsay's book, but others continue to remain blurred, mostly for lack of facts. He was born in the heart of London in 1775, the elder of two children. His father, whom he cherished, was a barber. His mother, given early on to uncontrollable rages, died in an insane asylum when Turner was 29; she seems to have cast a permanent cloud over his life. His sister died at the age of 11, when he was 14. Though not raised in penury, he had an incomplete education, both formally and

artistically; to judge from his writings, he never mastered English syntax—this may have had, however, something to do with his temperament as well as his education. He turned his great facility to conventional uses at first and won success by his early 20s, being elected an associate member of the Royal Academy when he was 24, and a full member three years later. After the close of the Napoleonic wars he traveled much on the Continent, doing, among other things, the landscape drawings and sketches from which the engravings were made that gave him his main income. At his death in 1851 he left an estate of more than half-a-million dollars.

Turner was not exactly the recluse his legend makes him out to be. He was active in the affairs of the Royal Academy, served as one of its officers, and lectured at its school. Nor was he a stranger to the social life of art; he had his friends among artists, patrons, and collectors. Art and the life of art had raised him out of plebeian meanness, and he seems never to have ceased being grateful. In his will he provided that the bulk of his fortune be used for a home for "Poor and Decayed Male Artists born in England and of English Parents only and lawful issue"; however, his relatives and connections frustrated this provision. He was, apparently, never quite at home in the milieus into which he had risen, and he remained somewhat of a plebeian in speech and appearance (also, he was very short and stocky). That he seems to have made a deliberate resolve not to ape gentility would help explain his bearishness, which nevertheless appears to have been exaggerated. On the other hand, insecurity may partly account for his need to hit the public with grand and spectacular effects (though he was by no means the only British artist of his time to go in for them). While he had his craft secrets, he was also not above letting himself impress onlookers by the speed and bravura with which he handled paint.

What he was really secretive about were money and sex. He had the reputation—not justified, according to Mr. Lindsay—of being grasping and miserly. A bachelor, he was not at all a celibate. He lived for 20 years with a widow, Sarah Danby, by whom he had two illegitimate daughters; and in the last decade and a half of his life he lived with another widow, Sophia Caroline Booth. A relative of Mrs. Danby,

Hannah Danby, was his housekeeper from around 1810 until his death, but it is not known whether she, too, was at any time his mistress. Very few of his friends seem to have known about these liaisons; while living with Mrs. Booth he went by the name of Booth himself in the neighborhood of her house. Mr. Lindsay attributes Turner's fear of marriage to the trauma left him by his unbalanced mother, and he sees surrogates of that mother in some of the menacing female figures in Turner's history-landscapes as well as in other things in his art.

Mr. Lindsay is a poet and critic of poetry, and he pays special attention to Turner's reading of poetry, to which he was addicted, and to his "scribblings" both in verse and in prose. Through these, no less than through his art, he tries to interpret Turner's general outlook. The insights here, such as they are, seem to me to be dulled by a tincture of pedestrian Marxism or, less often, of routine Freudianism. Not that Mr. Lindsay indulges in jargon, but he does simplify Turner into a right-thinking progressive and, in doing so, fails to see certain ambivalences that stare him in the face. He fares even worse as an art critic. Turner's pictures are put through the "parallels-and-diagonals, verticals-and-horizontals" hopper that constituted advanced pictorial analysis 30 years ago, and they come out all too neatly (though that, as I have suggested, may be Turner's fault too). Preposterous claims are made. In Turner's work "modern art is fully and definitely born"; Impressionism and Cubism deal with what are only partial aspects of the Turnerian revolution. Like so many other biographers, Mr. Lindsay succumbs to his subject instead of mastering it.

But when he is not an art critic and not an interpreter, he is a scrupulous scholar and sets straight many facts about Turner. Despite more than a few misprints and lapses of copyediting, his book does end up as a valuable reference work.

Washington Post Book Week, 11 September 1966

49. Picasso Since 1945

Picasso's painting started to fall off in quality after 1925, but it continued to count in the history of art for another dozen

years or so. It continued to germinate during that time even if it could no longer fully realize. During that same time, in 1930 and 1931, his sculpture came to a climax, of realization as well as invention, in the wrought-iron constructions he did with Gonzalez's technical help. (This climax might have been prolonged had he executed some of the sketches for sculpture he did in the year or two following—for example, the pencil drawings made in February 1933 that are grouped under the title *An Anatomy*.) But his sculpture, too, began to fall off a short while after that. The real turning point, for his sculpture no less than his painting, came, however, around the time of *Guernica*, in 1937. It does not matter so much that since then Picasso's failed works far exceed his successful ones in number; what does matter is that the terms of success themselves were from then on pitched a good deal lower than before. Picasso's art ceased being indispensable. It no longer contributed to the ongoing evolution of major art; however much it might intrigue pictorial sensibility, it no longer challenged and expanded it.

I know of only one painting that Picasso has done within the last thirty years which is an exception to what I have just said. It is the *Charnel House* of 1945, now in Walter P. Chrysler Jr.'s collection. For me it was the great, pause-giving surprise of the *Picasso Since 1945* show in Washington this past summer.[1] I had known the *Charnel House* only from reproductions before. Now that I have seen it in the flesh, I am tempted to say that it may be Picasso's last unqualified masterpiece in any medium.

It is not its quality alone that makes *Charnel House* a surprise (and I don't want to exaggerate that quality: Picasso did greater things before 1925); it is also the way in which it revises *Guernica*. To judge from photographs, the latter's first and exclusively linear state was better than any subsequent one. Without being entirely linear itself, the later painting recaptures something of the quality of that first state and improves on it. *Charnel House* was finished and brought off by being left unfinished. The whole upper third of the canvas on which it was painted contains nothing but black lines on

1. *Picasso Since 1945*, Gallery of Modern Art, Washington, D.C., June–September 1966. [Editor's note]

priming. The uncovered priming also runs along the other three sides of the canvas to form a narrow and irregular internal frame broken only here and there by extensions of the painted surface. And the priming reappears, crisscrossed by incompletely erased lines in charcoal, among the patches and wedges of black, grey, and grey-blue that fill the middle and bottom of the picture. In *Guernica* it's precisely the upper part of the picture that goes out of kilter most: the white shapes there fail to stay in place and relate themselves in a binding way to the pyramid of interlocking shapes below. And it's as though the "unfinished" state of the upper part of *Charnel House* betrayed a recognition of this. This is suggested further by the fact that *Guernica*'s central pyramid is more or less retained (along with the upturned face of the dead man in the lower left). It seems to me that in *Charnel House* Picasso also makes a specific correction of the color scheme of the earlier picture by introducing a pale grey-blue amid the blacks and greys and whites. This works, along with the use of priming instead of applied white, to give the later painting more ease of space, more air. *Guernica* suffers from being boxed-in, too compressed for its size. *Charnel House* has a more original as well as an easier relation to the proportions and size of its canvas. This is an effect of design, too, of the way in which the staccato rhythms in the lower left center open out into larger, arabescal ones as the main axis of the composition swings up into the upper right-hand corner.

Charnel House is a much smaller painting than *Guernica*, and Picasso's Cubism or neo-Cubism has never been comfortable in a very large format. *Guernica* tends to be jerky; it stops and starts, buckles and bulges. *Charnel House* flows, and flows throughout. *Guernica* aims at the epic and falls into the declamatory (though there are parts of it, but only parts, that are better than that—the central pyramid is one). *Charnel House* is magnificently lyrical—and Picasso at his best is usually lyrical. And it is fitting that this picture should be lyrical, for it is an elegy, not an outcry or even a protest, and it is fitting that an elegy should chant rather than intone.

Nothing in Picasso's subsequent work seems to follow up the vein opened in *Charnel House*, at least not qualitatively. He has, however, left other paintings "unfinished," to the benefit

of their openness. The best of such that I know is *Version L* (February 9, 1955) of the "Women of Algiers" series, which I was glad to see added to the Washington show. Like *Charnel House*, it is nearly monochromatic, but in a quite different way: the paint is laid on so thinly and unevenly that the priming shows through, which contributes, together with the kind of highlights created by the uncovered priming, to an effect of shading and modeling. (The influence of Wilfredo Lam is marked in this picture, which explains no doubt why it reminds me of a certain side of Arshile Gorky's art.) Another "unfinished" picture, with large areas of naked priming, in the Washington exhibition is *Les enfants* of 1956, which is more than twice as big as *Version L* but not nearly so successful. For the rest, Picasso still has a tendency to box in and nail down a painting as he did in the great days of his Synthetic Cubism, and his efforts to free himself from this seem too deliberate to be availing.

The show in Washington, though confined to American-owned works, makes about as good a case for the later Picasso as could be made in principle. There are more than a few quite successful things in it but, as I have said, the terms of success are not pitched as high as they once were. The impression remains that the evolution of Picasso's art over the last decades has been taking place in a side alley, and a blind one too, off the high road of art. There remains, too, the impression that the later Picasso is generally happier in gouache and in line drawing than in oil; and that, as in even the remoter past, his chances of success tend to increase the closer he comes to monochrome and the further away he stays from definitely warm color. The prints in this show, lithographs and linoleum cuts, are particularly consistent in quality. The sculpture too, most of it in bronze castings, is consistent, but it is never more than nice. Inspired as the playfulness that goes into it may be, it is not inspired enough to transcend itself as playfulness.

Very lately, Picasso seems to switch from one manner to another even faster; and there seem to be an even greater number of different manners. But this may be an illusion that time will dissipate. Picasso's various manners of the 1930s no longer look as different or divergent as they used to. What does seem certain, however, is that he has become more obviously explo-

sive and painterly (*malerisch*) and less firmly linear, especially over the last five years. It is as though his art were repeating at this late remove the great change that occurred in abstract painting during the 1940s, when the hard-edged gave way to the melting and the calligraphic. Certain pictures in Washington—the *Artist and His Model* of 1963 and the very bad *Femme nue* of 1964, for example—go in a direction that was anticipated by Pollock in 1943 (at a time when much in Pollock's own approach was derived from hints scattered through Picasso's art of the early and mid-1930s). I have no idea of what this means, especially since Picasso's awareness of recent art appears to be both erratic and furtive. (Samuel Kootz has told me that some years back Picasso said to him, producing a used blotter, that Pollock's art was impossible because it lacked "construction.")

There happen, moreover, to be several emphatically painterly pictures in the Washington show whose manner was anticipated by no one. The best of them, by far, is *Tête de femme assise No. 3* of 1965, with its curious, thinly swiped-on blues, greens, and buffs, white and earth-red background, and the dramatic entrances of black and grey in its subject's face. This is a striking, peculiarly felt, and personal work, one of the best things in the whole show; yet it does not manage to be major art. My immediate experience of it tells me that. When I consult my understanding, it tells me that the englobing conception of this picture isn't fresh or new enough to make it major; that Picasso is here repeating something that he originally stated, but could not realize, in the later 1930s, and that this time, though the conception is realized, it is not sufficiently transfigured. Be that as it may (and my *understanding* may tell me something different the next time I see *Tête de femme assise No. 3*), a smaller painting in the show, *Femme au bord de la mer* of 1961, moves and satisfies me more surely than *Tête de femme assise* does. I think this is because it makes no bones about being small and slight—like Picasso's gouaches, drawings, and prints in this same show, which succeed as often as they do precisely because of their modesty. That is, Picasso fares better, as a rule, nowadays, when he does not aim high.

The truth is that he no longer knows where high is. It is given to few artists ever to know that—that is, to know where

the high is located in their own day. It is given to even fewer to maintain such knowledge for more than a decade or so. It is given to still fewer to recover such knowledge after having lost it. Matisse's case is a rare example of the last. Picasso knew where the high was, where to look for it, and how to find it, for twenty years; and he knew for another dozen where to look for it even though he was no longer quite able to possess it. But then he lost this knowledge, no longer knowing where to look, much less to find. The high challenges and high "problems" of art in his own day became veiled from his sight. This is one more way of saying that he stopped creating major art. It is true, on the other hand, that he still knew, and knows, the more general, more abstract rules that govern the creating of it. He knows that the making of major art means taking chances, and he goes on taking what he thinks are chances. But they are taken by rote, mechanically and arbitrarily, their terms set not by the highest art and best taste of this present time, but by himself and his own retarded taste. Like some of the second-generation Abstract Expressionists in New York in the late 1950s, he tries in a sense to be "ugly." But the only ugliness he is capable of is a safe and contained kind—a kind that makes for botched pictures but which at the same time impresses what has become safe taste. This is by no means all there is to the later Picasso, but it is all there is to the later Picasso as a would-be major and advanced artist.

Artforum, October 1966

50. Manet in Philadelphia

Manet is far from being the only master who doesn't develop in a straight line, with one step following the other in readily intelligible order. Nor is he the only master whose total body of work doesn't make a coherent impression. But he is exceptional in his *inconsistency*. I don't mean the inconsistency of his quality. He is uneven, but less so than Renoir or Monet. I mean the inconsistency of his approach and of his direction. This is what struck me particularly at the large Manet show in the Philadelphia Museum of Art.[1]

In one and the same year, 1862, Manet painted a picture like *Young Woman Reclining in Spanish Costume* and a picture like *Gypsy with a Cigarette*; the first, with its undulations of plum and silvery little gleams of bright color, is a masterpiece; the showy brushing and illustrativeness of the second anticipate present-day magazine art. So in its own way does *Emilie Ambre in the Role of Carmen* of 1879–80, with its overdone highlights. But all three of these pictures are *well* painted. *Portrait of a Man* (1860), though it has real character, and *Angelina* (1865) are not; it is hard to believe that their spindly drawing and opaque modeling came from the same hand that did the beautifully sleek *Dead Toreador* of 1864; they seem much more related to the black paintings Cézanne was doing in those same years. The only other places where I can see Manet having equal trouble with his drawing are in some of his backgrounds of the same period and in his etchings (he did not handle an etching needle with the same ease that he did a brush or pencil).

1. *Eduard Manet 1832–1883*, Philadelphia Museum of Art, November–December 1966; the exhibition travelled to the Art Institute of Chicago in January–February 1967. {Editor's note}

Elsewhere, Manet's inconsistency has much more to do with what I would call, for lack of a better word, his orientation than with his taste or manner of painting. It is not that he dealt with a tremendous variety of subjects or tried different paint techniques. It is that he so often changed his notion of what a picture should be: built-up, put-together, and "composed," or random and informal, studied or spontaneous, intimate and subdued, or grand and imposing. All through the 1860s he kept one eye on the Old Masters, but it was an eye that wavered. *Déjeuner sur l'herbe* (1863), though its layout comes from Florence, goes toward Venice; *Olympia* (likewise 1863), with an arrangement that comes from Venice, goes toward Florence.

Yet Manet's best years were just those, the 1860s, in which he was most inconsistent. After the middle of the 1870s his approach becomes a little more settled, to some extent no doubt under the influence of the Impressionists. But it was no gain. His handling turned lighter and fluffier; he did some wonderful things with this handling, new things, but many of them represent a lowering of level. The pastel *Man with a Round Hat* and the very thinly painted *Young Woman* (both dating from around 1879) are perfect in their different ways but they, too, predict some of the banal and slick art of later times.

Manet's case makes it quite clear that consistency is not an artistic virtue in itself. It did not keep him, any more than his prodigious skill with the brush did, from creating great works of art that are not *tours de force* and have nothing to do with virtuosity. Nevertheless, his inconsistency does seem to offer an obstacle to many people. They find it difficult to get his art into clear focus. It's their own fault, of course, more than it is Manet's. One looks at one picture at a time, one looks a single works, not at a whole *oeuvre*. Or rather, one should.

Manet's inconsistency can be attributed more to his plight as the first modernist painter than to his temperament. The question of what you were supposed to paint, and with what intentions, was still wide open when he came on the scene. He was not the one to settle it—that was left to the Impressionists, who took their cue from Corot more than from anyone else. Unlike Corot, Manet had conventional ambitions and

wanted to shine in the Salons. He painted in the new and startling way that he did simply—and yet not so simply— because he wanted to get away from the "stews and gravies" (his own words) of orthodox painting in his time, with the black, brown, and grey murk of its close shading and shadowy backgrounds. He filled his own pictures with blacks, greys, and browns, but the blacks were usually local colors, and he gave the greys that he shaded with, and the occasional browns, a particularity and clarity like that of local color. That is, they no longer remained neutral. Manet was able to achieve this because of the new, syncopated kind of shading-modeling that he adopted. This kind of shading was not entirely new; there were precedents, among them the very recent one of photography. In frontally lit photographs especially, the shading becomes compact and patch-like because it skips so many of the intermediate gradations of light-and-dark value that the sculpturally oriented painting of Renaissance tradition contrived to see. By being juxtaposed more abruptly, without gradual transitions and blurrings, the different shading tones of grey or brown are allowed to come through as particularized colors in their own right. This has the effect, in turn, of letting the local colors that the greys or browns shade come through more purely—which means more flatly. For the sake of luminousness Manet was willing to accept this flatness (Courbet reproached him for it by saying that *Olympia* looked like a playing card—the "Queen of Spades coming out of her bath"). The Pre-Raphaelites, too, had wanted to do brighter pictures, but were unwilling to accept flatness, and so they had imposed detailed shading on their heightened color, imitating the Quattrocento Italians. But whereas the latter could get away with it because in their time and place they could get away with anything that served to increase the sculptural realism of their art, the Pre-Raphaelites could not. Their timidity in the face of the tradition of sculptural illusion led them into what proved to be a blunder of taste more than anything else. (A decade separated the beginnings of Pre-Raphaelitism [1848] from Manet's own beginnings, but the difference between them in artistic culture seems more like an aeon.)

Manet learned a lot about syncopated modeling from his teacher, the much-maligned Couture (who had an influence on

Homer and Eakins as well). Couture had his own glimmer of the new, and there are unconventionally sharp contrasts of light and dark, black and white in his more informal paintings. But he acted on his glimmer half-heartedly, confining its expression to his smallest and least ambitious works. Manet himself seems to have been harassed by the question of the difference between ambitious and unambitious efforts. During the first years of his artistic maturity he continued to believe, apparently, that a "machine," a picture big enough in size and complicated enough in subject and composition, was what a painter had to prove himself with. But composition in the accepted sense posited a strong illusion of relief or else of quasi-theatrical space. Both of these were denied to him by his flat handling. He had trouble always in managing the transition from foreground to middle- and background when the foreground was occupied by one or more figures of any size. (That its background falls away hurts *Déjeuner sur l'herbe*— which would have profited by having its canvas cut down at the top and sides.)

All through the 1860s it was as though each picture (save for the still lifes and the seascapes) confronted Manet with a new problem. It was as though he could accumulate nothing from experience. But this, precisely, worked to keep his art so fresh during that time. Each painting was a one-time thing, a new start, and by the same token completely individual. Nothing could have been more different from the way in which most of the Impressionists, and Cézanne and van Gogh too, went from one day to the next in their work. Their pictures tended to take their places in a sequence, like so many steps in the solution of a single set of problems. This by no means renders their art inferior to Manet's but it does tend to make their pictures less markedly individual among themselves, less markedly individual in the context, that is, of the given artist's *oeuvre*. (This is the way it is, too, with the Classical Cubist works of Picasso, Léger, and Braque; but it is not that way, for the most part, with Matisse's paintings.)

Manet's still lifes and seascapes show a greater consistency of approach, as well as a steadier level of quality, than anything else in the total body of his works in oil. When it came to dealing with fruit and flowers and fish his qualms about com-

posing disappeared. Actually, he handled still life a little more traditionally than he did other kinds of subject; or rather the absence of close modeling was less conspicuous within a small compass than within a large one. And in his seascapes the very nature of the subject relieved him automatically of "problems of composition" by offering him the simplicity of a single broad plane tilted against the vertical one of the sky and punctuated by relatively few three-dimensional objects. (It was the same, for that matter, with an outdoor subject that contained a large enough expanse of greensward.) Manet could have played it safe by confining himself to still lifes and seascapes. But had he done so he would have amounted to no more than a superior Fantin-Latour or Boudin. That would still have been a lot; it would in fact have been immense, but it wouldn't have been enough to compensate for the non-existence of paintings like *Olympia*, the *Déjeuner, The Luncheon* of 1868–69, *The Fifer* of 1866, the *Bon Bock* of 1873, the *Bar at the Folies-Bergère* of 1882, and more than a few others.

Some of those others, along with the *Bon Bock*, were to be seen in Philadelphia: *The Reader* (1861), the already mentioned *Young Woman Reclining in Spanish Costume* of 1862, the 1865 fragment, *Women at the Races, The Portrait of Théodore Duret* (1868), *Madame Manet* (1866), the two fragments from London of *The Execution of Emperor Maximilian* (1867), *The Rag-picker* of 1865, the *Blue Venice* of 1875 (which is *not* a seascape), the unfinished portraits of George Moore (circa 1879) and Emile Guillaudin (1870), and still more. To make up for the absence of most of the famous Manets, there were a good many things present in Philadelphia that were unfamiliar, at least to me. Also, there was an unusually large selection of prints, drawings, and watercolors. I could have wished, however, that the catalogue had gone into less detail about each print; the scholarly conscientiousness was altogether out of place. I could also have wished that the eight hideous color reproductions had been dispensed with. The awfulness of the color all by itself, not just in its infidelity, was an affront to Manet, and to art in general.

Artforum, January 1967

51. Jackson Pollock: "Inspiration, Vision, Intuitive Decision"

Pollock was not a "born" painter. [1] He started out as a sculptor, at sixteen, but before he was eighteen had changed over to painting. He had to learn with effort to draw and paint. Matisse was twenty-one when he made his first picture, but it immediately revealed his gift of hand. Whether Pollock's first attempts revealed anything like that, I very much doubt. This is not to say that he did not have a gift. Pollock's gift lay in his temperament and intelligence, and above all in his inability to be less than honest.

It did not, at any rate, take him too long, apparently, to learn to draw from nature correctly if not fluently. (There is the evidence of drawings made while he was still studying with Thomas Hart Benton at the Art Students League.) Years later, long after he had committed himself to abstraction, a sudden return to naturalism in the linear face of a man he did in a painting of 1951 called *Number 27* shows him drawing with almost stylish facility. It is as though his skill of hand had developed underground during the intervening years into something like virtuosity. After 1951 Pollock's general accomplishedness, called on to supply what inspiration no longer could, began to be all too obvious. Then his honesty declared itself in the refusal to go on painting. From 1954 until his death in 1956 he finished no more than three or four pictures.

But that he had been a practised painter all along should have been evident in even the most abstract things he did before 1951. That it was not evident to many people, and still is not, was the fault of his originality. The very unconventional way in which Pollock started to put paint to canvas in 1947 took people very much aback. And so did the equally unconventional way in which, a little earlier, he had begun to lay out or design his pictures. But even in his very first one-man show, in 1943, his apparent want of smoothness and finish had provoked resistance. (He was already painting great pictures

1. This article was commissioned to coincide with the opening of the major retrospective, *Jackson Pollock*, curated by Francis V. O'Connor for the Museum of Modern Art, New York. Greenberg was not involved in the organization of the exhibition. [Editor's note]

by that time, some of them as "difficult" and original as any-
thing he did later—*Totem I* of 1944, for example.)

Pollock's "drip" paintings, which began in 1947, elimi-
nated the factor of manual skill and seemed to eliminate the
factor of control along with it. Advanced painting had raised
the question of the role of skill in pictorial art before Pollock's
time, but these pictures questioned that role more disturb-
ingly if not more radically than even Mondrian's geometrical
art had. Mondrian's canon of ruled stripes and flat, even color
precludes the use of skill, but in compensation makes control
and order utterly explicit. Skill means difficulties overcome
swiftly and easily in the interests of control and order. These
last qualities Mondrian exhibits in the plainest conceptual
or mechanical terms, whether or not they are transmuted to
aesthetic ones (which they are when the picture succeeds).
Pollock's "all-over" "drip" paintings seem swiftness and spon-
taneity incarnate, but their arabescal interlacings strike the
uninitiated eye as excluding anything that resembles control
and order, not to mention skill.

Pollock's "all-over" layout has more to do with this impres-
sion, initially, than his "drip" method does. In most cases this
layout does not really repeat the same figure or motif from one
edge of the canvas to the other like a wallpaper pattern. If it
did that, an "all-over" Pollock would strike one as being al-
most as self-evidently controlled and ordered as a Mondrian,
sheer repetition being of the essence of control and order. An
"all-over" Pollock makes the impression of being chaotic be-
cause it promises the order of mechanical repetition only to
betray it. An "all-over" Pollock is only vaguely, ambiguously
symmetrical. When it is pictorially effective and moves and
excites the viewer, it does so in the same general way in which
all pictorial art does, by disrupting and restoring, by unbal-
ancing and balancing.

Where Mondrian wrests aesthetic from merely mechanical
order, Pollock wrests aesthetic order from the look of acci-
dent—but only from the look of it. His strongest "all-over"
paintings tend sometimes to be concentric in their pattern-
ing; often the concentricity is that of several interlocking or
overlapping concentric patterns (as in the marvellous *Cathedral*
of 1947). In other cases the patterning consists in a rhythm of

246

loopings that may or may not be counterpointed by a "system" of fainter straight lines. At the same time there is an oscillating movement between different planes in shallow depth and the literal surface plane—a movement reminiscent of Cézanne and Analytical Cubism.

True, all this is hard to discern at first. The seeming haphazardness of Pollock's execution, with its mazy trickling, dribbling, whipping, blotching, and staining of paint, appears to threaten to swallow up and extinguish every element of order. But this is more a matter of connotation than of actual effect. The strength of the art itself lies in the tension (to use an indispensable jargon word) between the connotations of haphazardness and the felt and actual aesthetic order, to which every detail of execution contributes. Order supervenes at the last moment, as it were, but all the more triumphantly because of that.

Like Mondrian, Pollock demonstrates that not skill or dexterity but inspiration, vision, intuitive decision, is what counts essentially in the creation of aesthetic quality. Inspiration declares itself in the overall conception of a work: the choosing, placing, and relating of what goes into it. Execution, in effect, takes care of itself. (Benedetto Croce, the Italian philosopher, perceived this long ago.) No matter how much execution may feed back to conception, the crucial decisions still belong to inspiration and not to manual skill. (Actually, manual skill itself is an affair of more or less inspired decisions, only they are mostly subliminal ones; inspiration in the larger sense is not exactly conscious either but it is nevertheless a good deal closer to that part of the mind which considers alternatives.)

Again like Mondrian, Pollock demonstrates that something related to skill is likewise unessential to the creation of aesthetic quality: namely, personal touch, individuality of execution, handwriting, "signature." In principle, any artist's touch can be imitated, but it takes hard work and great skill to imitate Hsia Kuei's, Leonardo's, Rembrandt's, or Ingres's. Mondrian's touch can be imitated, or rather *duplicated*, with no effort at all, by anybody. So, almost, can Pollock's touch in his "drip" period. With a little practice anybody can make dribbles and spatters and skeins of liquid paint that are indistinguishable from Pollock's in point purely of handwriting. But

Mondrian's and Pollock's quality can no more be duplicated than Leonardo's or Rembrandt's. Again, it is driven home that, in the last analysis, conception, or inspiration, alone decides aesthetic quality. Not that discipline, learning, awareness, and the conjunction of circumstances are less than indispensable to the making of important art. But without the factor of inspiration, these are as nothing.

Pollock was far less interested than Mondrian in making theoretical points. He made them in his art, but without particularly bothering about them. He took to working with liquid paint and a "drip"-stick, and finally a basting syringe, simply—and yet not so simply—because he wanted to get away from the habits or mannerisms of fingers, wrist, elbow, and even shoulder that are brought into play by the use of a brush, knife, or any other implement that touches the picture surface. Even more important was the fact that marked lines or contours did not hold that surface with the same inevitability as those which resulted from the falling or flowing of paint. Last but not least came Pollock's revulsion from "madeness," from the look of the intended and arranged and contrived and trimmed and "tickled." To him, almost all drawing with a brush or pencil began to look too deliberate. That in escaping "madeness" he went over into something like anonymity or impersonality of execution did not particularly strike Pollock—or any one else—at the time. The "naturalness" of this impersonality had, however, consequences for other, younger or later artists.

Ostensibly, the impersonality of handling that reigns in avant-garde art of the sixties is like Mondrian's. But it does not *feel* like Mondrian's, and this has to be explained in good part by the different interpretation of impersonality found in Pollock's "drip" paintings (as well as that found in Barnett Newman's only seemingly geometrical art). Ruled or compass-plotted edges don't feel as rigidly geometrical today as they did in geometrical art done in the past. The practice, descended from Pollock, of soaking pigment into raw canvas deprives these edges of their "cutting" power by making them bleed ever so slightly. But other, far less tangible factors are still more important, and it is hard to define these (and it would take too much space even to try to do so).

In any case, too much does not have to be claimed for Pollock. His art speaks for itself. Or it will eventually. Till now it has been, for the most part, extravagantly misunderstood. And what has been most misunderstood in it is its sophistication. Pollock's sophistication was of that ultimate kind which consists in an instinct for the relevant. He had also what Keats called Negative Capability: he could be doubtful and uncertain without becoming bewildered—that is, in what concerned his art. (It was quite different with his life, which was darkened by alcoholism.) People who knew Pollock personally were, I think, misled by his diffidence with words. They may also have been misled by his indifference to phrases and "ideas." He was beautifully right in that; in my opinion he saw more in art and knew more of it than did almost anybody (with the exception of his wife, the painter Leonore Krasner) who talked to him about it.

One of Pollock's deepest insights was that it was not necessary to *try* to hold on to the past of art; that it was there inside him anyhow, and that whether he wanted it to or not, the past remained implicated in everything he did. Unlike Gorky, de Kooning, and Hofmann, his nearest neighbors in New York art in the mid-forties, he did not believe in "good" painting, with its rules and cuisine. He believed only in good art. He saw that "good" painting was something every truly ambitious artist had to define all over again. Otherwise he would remain trapped in the provisional, not the abiding, past. It belonged to Pollock's sophistication that he could so well distinguish between the two. The provisional past was rules, precepts, craft practices, "paint quality," and canons of taste. The abiding past was concrete works of art and their quality.

Gorky, de Kooning, and Hofmann were naive by comparison with Pollock. I am not trying to launch a startling paradox when I say this; it was something I felt twenty years ago, when Gorky was still alive. Gorky did not remain naive: Though his very best painting was done in 1945, the things he did just before his death in 1948 open up vistas that are larger and extend beyond "good" painting, which fact made his death that much more of a tragedy. Hofmann's enduringly naive faith in "good" painting is, I hazard, partly responsible for the miscomprehension that continues to dog his reputation, but the

sheer force of his vision made him a great painter in spite of himself in the last ten years of his life—as great a painter as any in his time. De Kooning is the one who, for all his gift-edness and brightness, has suffered most from naive faith in "good" painting—from faith in cuisine, handwriting, and Old Master machinery. That he remains at this moment the most celebrated of these three *naïfs* is the crowning but not enduring irony of his case.

Plenty of the provisional past clung to Pollock's art too, and it could not be otherwise, as he himself recognized. In the decrepitude of his art, from 1952 to his death in 1956, during which time he displayed proficiency in an obvious enough way to win admission to any guild of "good" painters, that past did more than cling; it closed in. Pollock himself was among the first to register this. His vision had exhausted itself, at least for the time being; he was filling in with "good" paint-ing, and it was not enough.

Vogue, 1 April 1967; *Macula* 2, 1977 (titled *"Jackson Pollock: inspiration, vision, intuitive décision"*).

52. Recentness of Sculpture

Advanced sculpture has had more than its share of ups and downs over the last twenty-five years.[1] This is especially true of abstract and near-abstract sculpture. Having gathered a cer-tain momentum in the late Thirties and early Forties, it was slowed down in the later Forties and in the Fifties by the fear that, if it became markedly clean-drawn and geometrical, it would look too much like machinery. Abstract Expressionist painting, with its aversion to sharp definitions, inspired this fear, which for a time swayed even the late and great David

1. This essay was commissioned by Maurice Tuchman for *American Sculpture of the Sixties* (Los Angeles County Museum of Art, 1967), an exhi-bition that subsequently travelled to the Philadelphia Museum of Art. Other contributors to the catalogue were Lawrence Alloway, Wayne V. Andersen, Dore Ashton, John Coplans, Max Kozloff, Lucy R. Lippard, James Monte, Barbara Rose, and Irving Sandler. [Editor's note]

Smith, a son of the "clean-contoured" Thirties if there ever was one. Not that "painterly" abstract sculpture was necessarily bad; it worked out as badly as it did in the Forties and Fifties because it was too negatively motivated, because too much of it was done in the way it was done out of the fear of not looking enough like art.

Painting in that period was much more self-confident, and in the early Fifties one or two painters did directly confront the question of when painting stopped looking enough like art. I remember that my first reaction to the almost monochromatic pictures shown by Rollin Crampton in 1951 (at the Peridot Gallery) was derision mixed with exasperation. It took renewed acquaintance with these pictures (which had a decisive influence on Philip Guston at that time) to teach me better. The next monochromatic paintings I saw were completely so—the all-white and all-black paintings in Rauschenberg's 1953 show (at the Stable). I was surprised by how easy they were to "get," how familiar-looking and even slick. It was no different afterwards when I first saw Reinhardt's, Sally Hazlett's, and Yves Klein's monochromatic or near-monochromatic pictures. These, too, looked familiar and slick. What was so challenging in Crampton's art had become almost over-night another taming convention. (Pollock's and Tobey's "all-overness" probably helped bring this about too.) The look of accident was not the only "wild" thing that Abstract Expressionism first acclimatized and then domesticated in painting; it did the same to emptiness, to the look of the "void." A monochromatic flatness that could be seen as limited in extension and different from a wall henceforth automatically declared itself to be a picture, to be art.

But this took another ten years to sink in as far as most artists and critics in New York were concerned. In spite of all the journalism about the erased difference between art and non-art, the look of both the accidental and the empty continued to be regarded as an art-denying look. It is only in the very last years, really, that Pollock's achievement has ceased being controversial on the New York scene. Maybe he had "broken the ice," but his all-over paintings continued to be taken for arbitrary, aesthetically unintelligible phenomena, while the look of art as identifiable in a painter like de Koo-

ning remained the cherished look. Today Pollock is still seen for the most part as essentially arbitrary, "accidental," but a new generation of artists has arisen that considers this an asset rather than a liability. By now we have all become aware that the far-out is what has paid off best in avant-garde art in the long run—and what could be further out than the arbitrary? Newman's reputation has likewise benefited recently from this new awareness and from a similar failure of comprehension—not to mention Reinhardt and his present flourishing.

In the Sixties it has been as though art—at least the kind that gets the most attention—set itself as a problem the task of extricating the far-out "in itself" from the merely odd, the incongruous, and the socially shocking. Assemblage, Pop, Environment, Op, Kinetic, Erotic, and all the other varieties of Novelty art look like so many logical moments in the working out of this problem, whose solution now seems to have arrived in the form of what is called Primary Structures, ABC, or Minimal art. The Minimalists appear to have realized, finally, that the far-out in itself has to be the far-out as end in itself, and that this means the furthest-out and nothing short of that. They appear also to have realized that the most original and furthest-out art of the last hundred years always arrived looking at first as though it had parted company with everything previously known as art. In other words, the furthest-out usually lay out on the borderline between art and non-art. The Minimalists have not really discovered anything new through this realization, but they have drawn conclusions from it with a new consistency that owes some of its newness to the shrinking of the area in which things can now safely be non-art. Given that the initial look of non-art was no longer available to painting since even an unpainted canvas now stated itself as a picture, the borderline between art and non-art had to be sought in the three-dimensional, where sculpture was, and where everything material that was not art also was. Painting had lost the lead because it was so ineluctably art, and it now devolved on sculpture or something like it to head art's advance. (I don't pretend to be giving the actual train of thought by which Minimal art was arrived at, but I think this is the essential logic of it.)

Proto-Pop (Johns and Rauchenberg) and Pop did a lot of

flirting with the third dimension. Assemblage did more than that, but seldom escaped a stubbornly pictorial context. The Shaped Canvas school has used the third dimension mainly in order to hold on to light-and-dark or "profiled" drawing: painters whose canvases depart from the rectangle or tondo emphasize that kind of drawing in determining just what other inclosing shapes or frames the pictures are to have. In idea, mixing the mediums, straddling the line between painting and sculpture, seemed the far-out thing to do; in actual aesthetic experience it has proven almost the opposite—at least in the context of painting, where even literal references to the third dimension seem inevitably, nowadays if not twenty-five years ago, to invoke traditional sculptural drawing.

Whether or not the Minimalists themselves have really escaped the pictorial context can be left aside for the moment. What seems definite is that they commit themselves to the third dimension because it is, among other things, a co-ordinate that art has to share with non-art (as Dada, Duchamp, and others already saw). The ostensible aim of the Minimalists is to "project" objects and ensembles of objects that are just nudgeable into art. Everything is rigorously rectilinear or spherical. Development within the given piece is usually by repetition of the same modular shape, which may or may not be varied in size. The look of machinery is shunned now because it does not go far enough towards the look of non-art, which is presumably an "inert" look that offers the eye a minimum of "interesting" incident—unlike the machine look, which is arty by comparison (and when I think of Tinguely I would agree with this). Still, no matter how simple the object may be, there remain the relations and interrelations of surface, contour, and spatial interval. Minimal works are readable as art, as almost anything is today—including a door, a table, or a blank sheet of paper. (That almost any non-figurative object can approach the condition of architecture or of an architectural member is, on the other hand, beside the point; so is the fact that some works of Minimal art are mounted on the wall in the attitude of bas-relief. Likeness of condition or attitude is not necessary in order to experience a seemingly arbitrary object as art.) Yet it would seem that a

kind of art nearer the condition of non-art could not be envisaged or ideated at this moment.

That precisely is the trouble. Minimal art remains too much a feat of ideation, and not enough anything else. Its idea remains an idea, something deduced instead of felt and discovered. The geometrical and modular simplicity may announce and signify the artistically furthest-out, but the fact that the signals are understood for what they want to mean betrays them artistically.[2] There is hardly any aesthetic surprise in Minimal art, only a phenomenal one of the same order as in Novelty art, which is a one-time surprise. Aesthetic surprise hangs on forever—it is still there in Raphael as it is in Pollock—and ideas alone cannot achieve it. Aesthetic surprise comes from inspiration and sensibility as well as from being abreast of the artistic times. Behind the expected, self-canceling emblems of the furthest-out, almost every work of Minimal art I have seen reveals in experience a more or less conventional sensibility. The artistic substance and reality, as distinct from the program, turns out to be in good safe taste. I find myself back in the realm of Good Design, where Pop, Op, Assemblage, and the rest of Novelty art live. By being employed as tokens, the "primary structures" are converted into mannerisms. The third dimension itself is converted into a mannerism. Nor have most of the Minimalists escaped the familiar, reassuring context of the pictorial: wraiths of the picture rectangle and the Cubist grid haunt their works, asking to be filled out—and filled out they are, with light-and-dark drawing.

All of which might have puzzled me more had I not already had the experience of Rauschenberg's blank canvases, and of Yves Klein's all-blue ones; and had I not seen another notable token of far-outness, Reinhardt's shadowy monochrome, part like a veil to reveal a delicate and very timid sensibility. (Reinhardt has a genuine if small gift for color, but none at all for

2. Darby Bannard, writing in *Artforum* of December 1966, has already said it: "As with Pop and Op, the 'meaning' of a Minimal work exists outside of the work itself. It is a part of the nature of these works to act as *triggers* for thought and emotion pre-existing in the viewer. . . . It may be fair to say that these styles have been nourished by the ubiquitous question: 'but what does it mean?' " [Author's note]

design or placing. I can see why he let Newman, Rothko, and Still influence him towards close and dark values, but he lost more than he gained by the desperate extreme to which he went, changing from a nice into a trite artist.) I had also learned that works whose ingredients were notionally "tough" could be very soft as wholes; and vice versa. I remember hearing Abstract Expressionist painters ten years ago talking about how you had to make it ugly, and deliberately dirtying their color, only to render what they did still more stereotyped. The best of Monet's lily-pad paintings—or the best of Louis's and Olitski's paintings—are not made any the less challenging and arduous, on the other hand, by their nominally sweet color. Equations like these cannot be thought out in advance, they can only be felt and discovered.

In any case, the far-out as end in itself was already caught sight of, in the area of sculpture, by Anthony Caro in England back in 1960. But it came to him as a matter of experience and inspiration, not of ratiocination, and he converted it immediately from an end into a means—a means of pursuing a vision that required sculpture to be more integrally abstract than it had ever been before. The far-out as end in itself was already used up and compromised by the time the notion of it reached the Minimalists: used up by Caro and the other English sculptors for whom he was an example; compromised by Novelty art.

Still another artist who anticipated the Minimalists is Anne Truitt. And she anticipated them more literally and therefore, as it seems to me, more embarrassingly than Caro did. The surprise of the box-like pieces in her first show in New York, early in 1963 (at Emmerich's), was much like that which Minimal art aims at. Despite their being covered with rectilinear zones of color, I was stopped by their dead-pan "primariness," and I had to look again and again, and I had to return again, to discover the power of these "boxes" to move and affect. Far-outness here was stated rather than merely announced and signalled. At the same time it was hard to tell whether the success of Truitt's best works was primarily sculptural or pictorial, but part of their success consisted precisely in making that question irrelevant.

Truitt's art did flirt with the look of non-art, and her 1963

show was the first occasion on which I noticed how this look could confer an effect of *presence*. That presence as achieved through size was aesthetically extraneous, I already knew. That presence as achieved through the look of non-art was likewise aesthetically extraneous, I did not yet know. Truitt's sculpture had this kind of presence but did not *hide* behind it. That sculpture could hide behind it—just as painting did—I found out only after repeated acquaintance with Minimal works of art: Judd's, Morris's, Andre's, Steiner's, some but not all of Smithson's, some but not all of LeWitt's. Minimal art can also hide behind presence as size: I think of Bladen (though I am not sure whether he is a certified Minimalist) as well as some of the artists just mentioned. What puzzles me is how sheer size can produce an effect so soft and ingratiating, and at the same time so superfluous. Here again the question of the phenomenal as opposed to the aesthetic or artistic comes in.

Having said all this, I won't deny that Minimal art has brought a certain negative gain. It makes clear as never before how fussy a lot of earlier abstract sculpture is, especially that influenced by Abstract Expressionism. But the price may still not be worth it. The continuing infiltration of Good Design into what purports to be advanced and highbrow art now depresses sculpture as it does painting. Minimal follows too much where Pop, Op, Assemblage, and the rest have led (as Darby Bannard, once again, has already pointed out). Nevertheless, I take Minimal art more seriously than I do these other forms of Novelty. I retain hope for certain of its exponents. Maybe they will take still more pointers from artists like Truitt, Caro, Ellsworth Kelly, and Kenneth Noland, and learn from their example how to rise above Good Design.

American Sculpture of the Sixties, Los Angeles County Museum of Art, April–June 1967; *Art International*, 20 April 1967 (unrevised); *Minimal Art: A Critical Anthology*, ed. Gregory Battcock, 1968.

53. Seeing With Insight: Review of *Norm and Form* by E. H. Gombrich

Whether E. H. Gombrich's reputation among fellow art historians equals the one he enjoys among laymen, I do not know. I am a layman whom he both teaches and exasperates. He has, apparently, read everything that should be read for his purposes; and he really does look at works of art—which can't be said of every art historian. His big book, *Art and Illusion*, contains, for example, a small-seeming perception that is worth three-quarters of what I have read elsewhere about Cubism: he points out, namely, that in order to "prevent a coherent image of reality from destroying the pattern in the plane," Braque would make the devices of three-dimensional illusion that he used cancel one another out.

Mr. Gombrich is capable, too, of insights that illuminate larger areas of art. Composition was a notable strength of Italian painting in the 16th century, but the art writers of that time hardly touch on it because—he writes—the "Cinquecento took the achievement of order for granted" as a traditional achievement. "Even the most rigid and despised work of the *maniera bizantina* would place the Virgin in the center and the adoring angels or saints symmetrically on either side." (This is from the title essay of the present book, *Norm and Form*.)

What makes Mr. Gombrich exasperating to read, however, is his apparent inability to keep a train of argument going without involuntary or unavowed digressions, intrusive afterthoughts, contradictory qualifications. This is why his *Art and Illusion*, with all its riches in the way of perceptions and information, is so hard to follow. Mr. Gombrich has a tendency to rebel against logic even in small details. Thus in the sentence quoted at the end of the previous paragraph he gives one to understand, quite absurdly, that symmetry is not consonant with rigidity—not to speak of unesteemed art. It is as though he let the meanings of words, as well as of sentences and whole paragraphs, slip away into a more fluid realm than that of logic.

In this same essay, "Norm and Form," Mr. Gombrich says sensible things about the unreliability in the way of affirmative

definition of labels like Gothic, Mannerist, and Baroque, as well as showing that Heinrich Wölfflin's polarities of stylistic traits like "linear" and "painterly (*malerisch*)" have to do with differences of degree rather than with "true polarities." But he muddles the whole thing in trying to make his main point, which is that "order" or "composition" and "fidelity to nature" are mutually limiting principles: "The more a painting or a statue mirrors natural appearances, the fewer principles of order or symmetry will it automatically exhibit." As if the world of appearances, both "natural" and man-made, did not offer a wealth of symmetrical arrangements.

Having begged the crucial question of whether aesthetic order can be equated with conceptual or mechanical order (which it can't), Mr. Gombrich goes on to say that the photographer, too, "can be an artist" when he "achieves an ordered composition." But given the extent to which a technically adequate photography does mirror appearances, it remains very unclear as to how it could achieve enough of the author's kind of order to matter artistically. Or how even some of Vermeer's small paintings, which are in part literally photographic, could do so. (I don't want to be misunderstood; I myself happen to find, on the basis of experience and nothing else, that photography can be a high art.)

Mr. Gombrich also repeats the old chestnut about the Impressionists' tendency to abandon "order"; if they really did that at all it was when they addressed themselves to the simplest or most symmetrical motifs like a row of trees, a haystack, or the facade of a cathedral—motifs that were all too orderly in their simplicity or symmetry. And if a good deal of Impressionist painting did succeed as art—as I do not think Mr. Gombrich would deny—it could only have been through the achieving of aesthetic order, since there is no other way to artistic success than that. What he, and many other people, fail to recognize is that there are all kinds of aesthetic order, each of which in a given context can be a surprising kind. I begin to surmise that Mr. Gombrich's shortness of breath as a thinker is in some part both cause and effect of his surprising naiveté with regard to aesthetics.

"Norm and Form" and a related essay, "Raphael's *Madonna della Sedia*," are the things in this present collection that most

betray this naiveté. Other pieces, like "The Renaissance Conception of Artistic Progress and Its Consequences," suffer from pure and simple inconclusiveness. But there are still other pieces in which Mr. Gombrich leads to his strength, which is particularization, and away from his failings as a theorist. Three of these essays come in succession at the end of the book, and they are small triumphs of simple description and exposition. Two are "The Renaissance Theory of Art and the Rise of Landscape" and "The Style *all'antica:* Imitation." There is also "Leonardo's Methods for Working Out Compositions," which calls attention to the fact that Leonardo was the first Western painter to draw sketchily and without erasing or covering up his *pentimenti*; Mr. Gombrich stresses that this was part of Leonardo's insistence on pictorial art as a *cosa mentale*, an activity of mental invention, rather than a manual craft.

All these essays are addressed more or less to fellow specialists but, as always, Mr. Gombrich writes simply—which is not the same thing necessarily, as I have tried to show, as writing clearly. (Sir Herbert Read is a similar case.) They all, as the publisher puts it, "deal with what may be called the Renaissance climate of opinion about art and with the influence this climate has exerted on both the practice and the criticism of art." The book itself is handsomely designed, in the usual Phaidon format, and misprints and lapses of copy-editing are few.

New York Times Book Review, 23 April 1967

54. Where is the Avant-Garde?

The avant-garde is a unique phenomenon. There was nothing like it, anywhere, before the middle of the nineteenth century. It arose in response to a threat and a challenge. The threat lay in the fact that the highest standards of art were being increasingly exposed to the attrition of a market no longer governed by the tastes of a cultivated elite. The challenge lay in the even more definite fact that high art was no longer able to maintain itself without innovation (or renovation) of a kind more con-

stant and more radical-seeming than had been necessary in the four hundred years before. The avant-garde constituted itself in the persons of artists, writers, and composers who in effect protected their art from the market by innovations that made it too difficult to grasp at first for the educated—not to mention the uneducated—public.

Yet the difficulty has usually worn off with time, and as each succeeding phase of avant-garde art has receded into the past, the market has come round to it. This used not to affect the continuity of the avant-garde in a serious way. Its membership underwent a more or less steady turnover, and by the time one phase of avant-garde art was accepted the still more difficult art of the next phase would have emerged, and the cycle would start all over again. The tempo of this process of assimilation was not an even one, however: sometimes it would speed up, at other times it would slacken.

To confine myself to painting: it took less time for Manet and the Impressionists to become "respectable" than it did the Post-Impressionists. The Impressionists were more or less accepted by the 1890's, twenty years after their breakthrough: Cézanne, Seurat, even Gauguin and van Gogh became accepted by the larger art public only during the 1920's, which was the same time at which the Fauves were accepted and at which the Cubists were beginning to be. Yet the Post-Impressionists had had their breakthrough as far back as the 1880's, the Fauves only in the middle 1900's, and the Cubists but a few years after that. It can be seen that the tempo of assimilation, after slowing down between 1900 and 1920, speeded up again and to such an extent as to considerably close the gap between the art public and the avant-garde.

During the 1930's and most of the 1940's, however, there was another slowing down (the academically Surrealist painting of Dali's kind that became popular in those years was not fundamentally advanced painting). The next acceleration began around 1950, and there has been no slackening off, rather there has been a constant quickening since then in the rate at which the art public has assimilated avant-garde art: at the same time that public has grown enormously. So has the avant-garde. These two factors—the ever faster acceptance of avant-garde art and the growth of the more or less forward-looking

art public along with that of the avant-garde—have brought about a change in the situation of the avant-garde that is more than just quantitative. As Marx says, there comes a point at which quantity changes into quality.

The continuing culture and art boom has had a lot to do with this. In this country as elsewhere (this particular boom is international; it started in Germany under the Weimar Republic right after World War I, and in England in the 1930's) the boom was generated by a revulsion against nineteenth-century, middlebrow stuffiness, and a good part of its meaning lies in the increasing attraction that educated younger people in general feel towards avant-garde art of all vintages. Writers like Joyce and Eliot, a composer like Stravinsky, artists like Picasso and Pollock have become culture heroes, and in the pages of *Newsweek* and *Time* not least of all. Poets like Robert Lowell and Allen Ginsberg enjoy the status of celebrities; so does an artist like Andy Warhol. Rearguard actions are still conducted, like that for Andrew Wyeth; and it's not that his art is without real merits, or that he doesn't outsell almost any avant-garde painter in this country; yet he simply can not be made to *count*; no one responsible would dream of sending art like his abroad to represent this country at the Venice Biennale or the São Paulo Bienal. Artistic prestige—public prestige—lies elsewhere nowadays.

From all this it would look as though the educated public had not only assimilated the avant-garde past but that it had also caught up with the avant-garde present. It would look, too, as though the avant-garde in the present had become what it never was before, not even in Paris: a body of people and an area of activity that society at large accepted in an almost institutional way. And it is a fact that joining up with the avant-garde becomes less and less an adventurous, self-isolating step, and more and more a routine, expected one.

Twenty years ago there were very, very few authentically avant-garde painters and sculptors in New York. Today there are thousands of them, and thousands more all over the country—painters and sculptors whose postures and attitudes seem those of authentically avant-garde artists. Whether they are or are not authentically authentic can be told only from their art. The identity, the authentic identity, of the avant-garde has

consisted from the first in devotion to standards, to the highest level of achievement, regardless of non-artistic consequences. Till now only a very few artists and connoisseurs in any generation have been able to reach this level where it stood in the given moment. And not many more have been able to catch a glimpse of it.

If an appreciable proportion of the great number of new recruits to the avant-garde in latter years are genuinely what they pretend to be, then the result would be a vast increase in the amount of original high art now being produced. Yet as it looks to me, the run of nominally avant-garde painting and sculpture today, whether in this country or elsewhere, can not compare in frequency of original, ambitious, and excelling work with what it was twenty years ago, when so very much less avant-garde art in general, authentic and spurious, was being made. To all appearances, there has been a falling off, not a gain.

Ninety per cent or more of the mass of recruits to the painting avant-garde in the 1950's were recruits to Abstract Expressionism, then the dominant avant-garde style all over the world (in France it was called *tachisme* and *art informel*). Abstract Expressionism was unique among avant-garde styles in that it attracted crowds of artists and admirers while it was still a going, not quite superannuated, style. This is explained in good part by the fact that Abstract Expressionism took such a long time to die and that, while it was dying, it became increasingly stereotyped, thus easier both to imitate and to appreciate. Both the popularity and the badness of Abstract Expressionism in its terminal stage created the conditions for what happened in and to the kind of art that in the 1960's replaced it in the foreground of attention. Pop Art caught on with a public that had been created by Abstract Expressionism, and it caught on faster than any avant-garde style ever had before. All the other versions of Novelty art in the 1960's—Assemblage, Op, Environment, Neo-Realism, Erotic, et cetera—have caught on nearly as fast if not on as broad a front. No matter: both the scale on which and the speed with which these kinds of avant-garde art have won acceptance from the art public are unexampled.

Rather, they would be unexampled if Pop, Op, and the rest

of Novelty art actually were avant-garde art. But they turn out to be rather easy stuff, familiar and reassuring under all the ostensibly challenging novelties of staging—much closer to the middlebrow than to the highbrow, genuinely avant-garde thing. Nowadays every art student can handle, and every steady gallery-goer can savour, academic Cubist design. Abstract Expressionism in its throes handed that on to Pop Art. Despite all the conspicuous but unessential appearances to the contrary, the academic Cubist way of fitting everything into an imaginary grid and pinning down the corners of a literal or imaginary rectangle provides the felt basis of Pop and all the other kinds of Novelty art, whether in two or three dimensions. The pictorial sensibility that is satisfied by the stereotypes of de Kooning's school finds nothing really new enough in this art to tax it—least of all in its "literature."

Novelty art may be avant-garde in its allure, its come-on, in the style of its announced ideas, but it is not nearly venturesome enough to qualify as avant-garde art in its actual substance and quality. The speed with which the various forms of Novelty art have gone over (including even that latest and most sophisticated form known as Minimal art or Primary Structures) is no more unexampled, really, than the speed with which a previous form of middlebrow art, American Scene painting, went over in the 1930's (and Grant Wood was better than any Pop artist with the exception of the proto-Pop Jasper Johns).

What is new is that the larger art public now wants, and knows that it wants, contemporary art that looks like avant-garde art, that can be accepted as that and talked about as that. The art public is at last convinced that the most advanced art of the moment is the most enduring art of the moment. But it is only a little quicker than before to recognize genuinely advanced art when it first appears (it took Pollock ten years before he really began to sell; it took Morris Louis six or seven years). The public still has to wait until advanced art recedes into the past. In the meantime it is all the readier, all the more eager, to seize upon the emblems, tokens, signs, and stigmata of what it already knows and expects as advanced art. And the hypertrophied avant-garde is equally ready, in all sincerity, to provide these emblems and tokens: that is, art which is new

and advanced in everything but substance; art that is "hard" and "difficult" only on the outside, but whose inside is soft.

The hypertrophy of the avant-garde is what I think is really new and unprecedented (not even precedented in Paris in the 1920's, when a lot of geese were taken for avant-garde swans). Almost always, a discipline that receives a great and sudden influx of newcomers has to submit, at least at first, to a lowering of its standards. The avant-garde, as I have said, is constituted by the highness of its standards, which depend on distance from those of society at large.

Now this distance seems to be narrowing, to the point where the survival and continuity of avant-garde standards—and thus of high art itself—are more threatened than at any time, apparently, since the avant-garde began. To put it differently: the avant-garde would seem to have proven, finally, just as unable to protect itself from the infiltration of the middlebrow as every other department of culture in our society has been. And the middlebrow, not the lowbrow, has always been the avant-garde's most formidable enemy.

One may still be too close to this situation to be sure that it is as final and gloomy as I may have made it look. A genuine avant-garde still survives here and there, as an avant-garde within an avant-garde. A handful of painters and sculptors between the ages of thirty-five and fifty still produce high art, in this country and elsewhere. It will take a while before it can be known definitely whether there are younger artists coming up who will be able to take over their succession.

When and if Novelty art collapses in the public's esteem, as second-generation Abstract Expressionism did so suddenly in 1962, the situation may change again. The larger art public might then become disillusioned with contemporary avant-garde art in general and stop breathing down its neck. I know that this sounds terribly snobbish. It also sounds callous. If the public, and the market, should turn away from the market, should turn away from contemporary advanced art, the sum of unhappiness would increase for many artists. Alas, the interests of art do not always coincide with those of human beings. Had I to choose, I would most certainly give priority to the latter. But I am writing here about the welfare of art, not about the welfare of people. . . .

What I have not explicitly considered is that the avant-garde as an historical entity may be approaching its definite end. In that case the production of high art would have to be taken over by some other agency. What that other agency might be, I can not imagine or conceive. I can, however, conceive of the production of high art in general coming to an end along with the avant-garde. I don't mean that I think this likely, only that I find it more conceivable than that something other than an avant-garde, in one form or another, that is a dedicated, "snobbish" elite, should carry on high art in a society like ours.

Vogue, June 1967

55. Complaints of an Art Critic

Aesthetic judgments are given and contained in the immediate experience of art. They coincide with it; they are not arrived at afterwards through reflection or thought. Aesthetic judgments are also involuntary: you can no more choose whether or not to like a work of art than you can choose to have sugar taste sweet or lemons sour. (Whether or not aesthetic judgments are honestly reported is another matter.)[1]

Because aesthetic judgments are immediate, intuitive, undeliberate, and involuntary, they leave no room for the conscious application of standards, criteria, rules, or precepts. That qualitative principles or norms are there somewhere, in subliminal operation, is certain; otherwise aesthetic judgments would be purely subjective, and that they are not is shown by the fact that the verdicts of those who care most about art and pay it the most attention converge over the course of time to form a consensus. Yet these objective qualitative principles, such as they are, remain hidden from discursive consciousness:

1. This essay was part of series organized by *Artforum* under the heading "Problems of Criticism." In addition to Greenberg, the contributors were Robert Goldwater, Max Kozloff, Barbara Rose, Justin Schorr, Gabriel Laderman, Jack Burnham, and Rosalind Krauss. [Editor's note]

they cannot be defined or exhibited. This is why such a thing as a position or standpoint cannot be maintained in the judging of art. A position, a point of view, depends on definable or exhibitable qualitative criteria, and the entire experience of art shows that there are none. Art can get away with anything because there is nothing to tell us what it cannot get away with—and there is nothing to tell us what it cannot get away with because art has, and does, get away with anything.

Of all the imputations to which this art critic has been exposed, the one he minds most is that his aesthetic judgments go according to a position or "line." There are various reasons for this imputation, not least among them being, I suppose, the flat, declarative way in which he tends to write. But there is also a general reluctance, or even inability, to read closely, and an equally general tendency to assign motives. The only way to cope with this is the tedious one of disclaiming explicitly and repeatedly all the things you, the writer, are not actually saying or implying. And maybe in addition to that you have to call attention repeatedly to the rules of inference. And also pause to give little lessons in elementary aesthetics, like the one I have just recited.

To impute a position or line to a critic is to want, in effect, to limit his freedom. For a precious freedom lies in the very involuntariness of aesthetic judging: the freedom to be surprised, taken aback, have your expectations confounded, the freedom to be inconsistent and to like anything in art as long as it is good—the freedom, in short, to let art stay open. Part of the excitement of art, for those who attend to art regularly, consists, or should, in this openness, in this inability to foresee reactions. You don't expect to like the busyness of Hindu sculpture, but on closer acquaintance become enthralled by it (to the point even of preferring it to the earlier Buddhist carving). You don't, in 1950, anticipate anything generically new in geometrical-looking abstract painting, but then see Barnett Newman's first show. You think you know the limits of 19th-century academic art, but then come across Stobbaerts in Belgium, Etty and Dyce in England, Hayez in Italy, Waldmueller in Austria, and still others. The very best art of this time continues to be abstract but the evidence compels you to recognize that below this uppermost level success is achieved,

still, by a far higher proportion of figurative than of abstract painting. When jurying you find yourself having to throw out high-powered-looking abstract pictures and keeping in trite-looking landscapes and flower pieces. Despite certain qualms, you relish your helplessness in the matter, you relish the fact that in art things happen of their own accord and not yours, that you have to like things you don't want to like, and dislike things you do want to like. You acquire an appetite not just for the disconcerting but for the state of being disconcerted.

This does not mean that the situation of art at any moment is one of disorder. Time and place always impose a certain kind of order in the form of negative probabilities. Thus it appears unlikely that illusionist painting will be any more capable in the near future than in the recent past of creating truly major art. But the critic cannot proceed *confidently* on this proba-bility, and least of all can he have a *stake* in it, so that he will be embarrassed or disappointed if it should chance to be vio-lated (which it happens to be my very private prejudice to want to see happen). You cannot legitimately want or hope for anything from art except quality. And you cannot lay down conditions for quality. However and wherever it turns up, you have to accept it. You have your prejudices, your leanings and inclinations, but you are under the obligation to recognize them as that and keep them from interfering.

Art has its history as a sheer phenomenon, and it also has its history as quality. Order and logic can be discerned in both, and there is nothing illegitimate in the effort to discern them. But it is illegitimate to believe in, advocate, and prescribe such order and logic as you discern, and another frequent im-putation this writer minds is that he is for the order and logic *he* discerns. Because he has seen "purity" (which he always puts between quotes) and "reduction" as part of the immanent logic of modernist art, he is taken to believe in and advocate "pu-rity" and "reduction." As if "purity," however useful it may have been as an illusion, were anything more than an illusion in his eyes, and as if he ever wrote anything to indicate oth-erwise. Because this writer has dwelled on the fact that the most original sculpture of the recent past opens up the mono-lith in a radical way, he is also taken to be for "open" sculpture and against the monolithic kind. Yet there is nothing in what

he has written that can be interpreted as even implying this. That analysis and description without anything more should so often be inferred to be a program reveals something like bad faith on the part of those who do such inferring—not just laziness, obtuseness, or illiteracy. I can't help thinking this. The bad faith derives from the need to pin a critic down so that you can say, when you disagree with him, that he has motives, that he likes this and not that work of art because he wants to, or because his program forces him to, not because his mere ungovernable taste won't let him do otherwise.

Last and worst, however, is that most art-lovers do not believe there actually is such a thing as ungovernable taste. It is taken for granted that aesthetic judgments are voluntary. This is why disagreements about art, music, literature so "naturally" become personal and rancorous. This is why positions and lines and programs are brought in. But it is one thing to have an aesthetic judgment or reaction, another thing to report it. The dishonest reporting of aesthetic experience is what does most to accustom us to the notion that aesthetic judgments are voluntary. Not only are you ashamed to say that a Norman Rockwell may move you more than a Raphael does (which can happen); you are also afraid simply to sound inconsistent— this because it is also taken for granted that aesthetic judgments are rational as well as voluntary, that they are weighed and pondered. Yet rational conclusions can no more be chosen than aesthetic ones can. Thus even if aesthetic judgments could be arrived at through ratiocination, they would still be involuntary—as involuntary as one's acceptance of the fact that 2 plus 2 equals 4.

II

The only definition of "formalism" with regard to art that my unabridged Webster gives is: "Emphatic or predominant attention to arrangement, *esp.* to prescribed or traditional rules of composition, in painting and sculpture." My impression is that the word acquired its present broader, and different, meaning when it became the name of an avant-garde Russian literary movement of the time of the First World War that proclaimed "form" as the main thing in verse and prose. Soon afterwards it became another of the "isms" in the Bolshevik

lexicon of abuse, where it means modernist and avant-garde art and literature in general. Whatever its connotations in Russian, the term has acquired ineradicably vulgar ones in English. This is why I was surprised to see it come into currency not so long ago in American art writing. No proper literary critic would dream of using it. More recently certain artists have been referred to as belonging to a "formalist" school for no other reason than their having been championed by certain critics whom some other critics call "formalist." This is vulgarity with a vengeance.

One reason among others why the use of the term "formalism" is stultifying is that it begs a large part of the very difficult question as to just what can be sensibly said about works of art. It assumes that "form" and "content" in art can be adequately distinguished for the purposes of discourse. This implies in turn that discursive thought has solved just those problems of art upon whose imperviousness to discursive thinking the very possibility of art depends.

Reflection shows that anything in a work of art that can be talked about or pointed to automatically excludes itself from the "content" of the work, from its import, tenor, gist, or "meaning" (all of which terms are but so many stabs at a generic term for what works of art are ultimately "about"). Anything in a work of art that does not belong to its "content" has to belong to its "form"—if the latter term means anything at all in this context. In itself "content" remains indefinable, unparaphraseable, undiscussable. Whatever Dante or Tolstoy, Bach or Mozart, Giotto or David intended his art to be about, or said it was about, the works of his art go beyond anything specifiable in their effect. That is what art, regardless of the intention of artists, *has* to do, even the worst art; the unspecifiability of its "content" is what constitutes art as art.

All this has been said before, and there is no getting around it. Nor is there anything mystical about it. What has also been said before, but maybe not emphatically enough, is that the quality of a work of art inheres in its "content," and vice versa. Quality is "content." You know that a work of art has content because of its effect. The more direct denotation of effect is "quality." Why bother to say that a Velasquez has "more content" than a Salvador Rosa when you can say more simply, and

with directer reference to the experience you are talking about, that the Velasquez is "better" than the Salvador Rosa? You cannot say anything truly relevant about the content of either picture, but you can be specific and relevant about the difference in their effect on you. "Effect," like "quality," is "content," and the closer reference to actual experience of the first two terms makes "content" virtually useless for criticism. . . .

There are different kinds of anti-"formalism." I am not sure but that those more ambitious critics who try to deal with "content" in abstract as well as representational art are not less sophisticated intellectually than those whose anti-"formalism" compels them to deprecate abstract art in general. To say that Pollock's "all-over" art reflects the leveling tendencies of a mass society is to say something that is ultimately indifferent in the context of art criticism—indifferent because it has nothing to do with Pollock's quality. To say (as Robert Goldwater does) that Kline's art offers an "image . . . of optimistic struggle of an entirely unsentimental 'grace under pressure' " is to say something that is both indifferent and wanton. Good art is by definition unsentimental, and of what good art can it be said, moreover, that it does not show grace under pressure? And if I choose to feel that Kline is pessimistic rather than optimistic, who can say me nay? Where is the evidence on the basis of which Dr. Goldwater and I can argue about that? There is not even the evidence of taste. For you do not have to be able to *see* painting in order to say or not say that Kline's art shows either optimism or pessimism. I, who am considered an arch-"formalist," used to indulge in that kind of talk about "content" myself. If I do not do so any longer it is because it came to me, dismayingly, some years ago that I could always assert the opposite of whatever it was I did say about "content" and not get found out; that I could say almost anything I pleased about "content" and sound plausible.[2]

The anti-"formalist" whom I regard as more intellectually sophisticated concedes the case of abstract art but accuses the

2. Robert Goldwater responded to Greenberg's characterization of his critical writing in a letter to the editor of *Artforum* (December 1967), a letter to which Greenberg wrote a riposte in the same issue (see the following item). [Editor's note]

"formalist" of neglecting the crucial importance to pictorial and sculptural art, when it is representational, of the illustrated subject, whether as "form" or "content." I myself as a reputed "formalist," would deny this charge. It is quite evident that the illustrated subject—or let's say "literature"—can play, does, and has played, a crucial part in figural art. Photography (which my experience tells me is not necessarily inferior to painting in its capacity for art) achieves its highest qualities by "story-telling." Nonetheless, it remains peculiarly difficult to talk with relevance about the literary factor in painting or sculpture.

The meaning of an illustrated subject *qua* subject—the prettiness, say, of a girl, her coloring, her expression, her attitude, etc.—delivers itself to any eye, not just the one attuned to pictorial or sculptural art. The person who cannot tell the qualitative difference between a portrait by Ingres and one on the cover of *Time* perceives just as much of the subject *qua* subject as the person who can. Iconography is brilliantly practiced by people largely blind to the nonliterary aspects of art. It does seem that literary meaning as such seldom decides the qualitative difference between one painting or sculpture and another. Yet I say "seem" advisedly. For at the same time the illustrated subject can no more be thought away, or "seen away," from a picture than anything else in it can. The thing imaged does, somehow, impregnate the effect no matter how indifferent you may be to it. The problem is to show something of how this happens, and that is what I cannot remember having seen any art writer do with real relevance—with relevance to the quality of the effect. And I notice that even those fellow-critics who nowadays complain most about "formalism" will again and again in the showdown fall back on "formalism" themselves, because otherwise they find themselves condemned to repeat commonplaces or irrelevancies.

The art of Edvard Munch is a case in point. I know of nothing in art that affects me in anything like the way that his "literature" does. Yet the purely pictorial impact of his art (leaving his drawings and prints aside) remains something else, something less. His paintings, as successful as many of them are in their own pictorial terms, do not startle my eyes again and again the way great paintings do. Compared, say,

with Matisse, Munch never looks more than minor. How then does his illustration manage to carry so strongly and convey so intensely? I wish some non-"formalist" critic would enlighten me here, if only a little bit. I am eager to be instructed by example.

I am all the readier to be instructed by an example of this kind because it is otherwise so much easier to deal in words with literary considerations than with "abstract" or "formal" ones. It is easier to write plausible literary criticism than plausible art criticism. You can write at length about the questions raised by the kind of life depicted in an indifferent novel or even poem, and whether or not you make a contribution to general wisdom, the chances are that your failure to deal with the novel or poem as art won't be noticed. Ruskin, murmuring at a picture he otherwise liked, because it showed children drinking wine, would not sound half so silly were it a piece of fiction he was talking about. Not that literary critics, properly speaking, get way with their irrelevance in the long run. But men of letters do, and so do iconographers. Nor do I object to this—as long as men of letters and iconographers do not claim to be critics.

Artforum, October 1967; *Modernism, Criticism, Realism*, ed. Charles Harrison and Fred Orton, 1984 (unrevised).

56. Critical Exchange with Max Kozloff and Robert Goldwater about "Complaints of an Art Critic"

Letter to the Editor:

All the while we have been viewing him as the most hard-boiled ideologue, the affronted Mr. Greenberg has been considering himself the willing victim of the most unpredictable and involuntary aesthetic reactions. It is quite a surprise, especially in the light of the fact that, no matter how liberal he claims to be in private, he has for years chosen to *write* only about one tendency in art. That he sees this tendency as the most significant is his privilege, but to elevate it as *the* modernism stemming from and validated by *the* tradition of mod-

ern art is not only to confuse part with whole, or to revise a complex, highly differentiated history, but to erect a superstructure hemming in that very "quality" he generously judges to be so diffused in the experience of contemporary art.

Besides, if "quality" equals content, and content is undiscussable, it is also an absolute, an "effect" impenetrable or unmodifiable by thought, which happens to strike him (but perhaps not others) instantaneously. All works of art, no matter how antithetical or self-contained in their vision, have to be measured (or rather, schoolmasterishly graded), against those few which are said to possess this one unarguable, but vague ingredient called "quality." This contention does not seem very credible. But the trouble is, if "quality" can never be substantiated by criticism as a whole, mere description and analysis, parts of criticism, will do it even less justice. This is to reduce criticism to a mute apologia for a visceral reaction, and to short-circuit techniques that are capable of picturing an object, but not of probing an experience. Worse, Mr. Greenberg has the effrontery to imply that any writer on art who does not confine himself to its strictly visible features, is not a critic! The impulse governing this authoritarian idea is a demand for a rock bottom (and, I think, trivial) certainty.

Thus, he is forced to insist that criticism must be an objective operation because it eventuates in a consensus. But a really objective field, like physical science, doesn't need consensus precisely because it tests facts, rather than concerns itself with qualities of individual perceptions. No less weirdly also, Mr. Greenberg thinks that it is "so much easier to deal in words with literary considerations than with 'abstract' or 'formal' ones." (Although, "it remains peculiarly difficult to talk with relevance about the literary factor in painting or sculpture.") Since when is either one of these activities intrinsically easier or more difficult than the other? (Or, since when is its ease a gauge of a method's worth?) I always thought it depended on the imagination, talent, and sophistication of the man who practiced it. Finally, Mr. Greenberg exhibits a real abhorrence towards any statement on art which opens itself to argument, and which is vulnerable to discussion, because it is dealing with complexes of feelings and moods. If provability were the only justification of critical discourse, and a speechless, un-

touchable effect the only guidepost to artistic significance, we would be in a much sorrier, a much more poverty-stricken state than we are in. He shrinks away from many of the most interesting, because in part debatable, issues in our relation to art. How queasy of Mr. Greenberg, how fearful!

<div align="right">Max Kozloff
New York, N.Y.</div>

Clement Greenberg replies:

That it is much easier to deal in words with literary considerations does not at all contradict the assertion that it is hard to talk *relevantly* about the literary factor in painting or sculpture. "Relevantly" is the key word here.

To deal with the first and second sentences of Mr. Kozloff's third paragraph: all objectivity is not necessarily factual or scientific. Criticism becomes "objective" not because it "needs" a consensus, but because it produces one. Try to imagine what the consequences would be if the "qualities of individual perceptions" in art remained entirely or even largely "subjective" or private.

What Mr. Kozloff says in the second and third sentences of his first paragraph amounts in principle to the same thing as reproaching a critic for having chosen to write only about the Cubists and Matisse in the years between 1910 and 1920. The unwarranted inference is that the critic dismisses whatever he does not write about.

"To revise a complex, highly differentiated history" sounds good but begs the question of Mr. Kozloff's own discriminations. What does he himself consider more worthy and less worthy of writing about in the art of this time? How does he, as a critic of contemporary art, decide what to write about?

Last and least: the sarcasm in Mr. Kozloff's letter is on a level with its matter.

<div align="right">Clement Greenberg
New York, N.Y.</div>

Letter to the Editor:

Mr. Clement Greenberg has done me the singular honor of mentioning my name in his article in the October, 1967 *Art-*

forum. He has called me "wanton" and I must protest his easy assumption of superior virtue. He simply quotes out of context, performing a distortion which Hemingway (to whom in context the reference was clear and meaningful) would have recognized for what it is—a foul.

My essay on Franz Kline was a small attempt to proceed from accurate description of characteristics observable in his paintings to the feelings induced by those characteristics. Such attempts seem to me to be one of the important tasks of criticism which must be undertaken despite their obvious risks. It will be somewhat easier to obtain agreement upon a description of a painting than upon the feeling that flows from the qualities described. We do not need Mr. Greenberg to tell us that only an approximation is possible. Nor is this any reason for the critic simply to give up on trying to explain how what he sees is related to the way it makes him feel.

In his discussion of "subject *qua* subject," (iconography) Mr. Greenberg confuses "subject" and "content." This is a strange identification, since he makes an altogether rigid separation of the formal from the literary. One would have thought that after Wölfflin, Panofsky and Gombrich iconography and iconology could be distinguished. Granted that these are distinctions we are more accustomed to making in figurative art: they apply to abstract art as well, and are perhaps no harder to define there.

Apparently Mr. Greenberg assumes that the work of art is simply there, that its visual ("formal") characteristics are passively received on a good old-fashioned *tabula rasa* and can be objectively described, while in contrast their effects are altogether personal and ineffable. But vision is an active, organizing agent, influenced by a time and the art of that time, as well as by individual experience. Naive description is never simple; it can hardly be separated from analysis which projects a structure and an organization, and which contains constant implications of emphasis, choice and judgment. One would have thought that the critic, presumably more aware of these problems than his audience, must so describe what he sees that others will see with him—and feel with him. He will partially fail, but he must try. Indeed, if the critic can never carry his audience with him along the road from analysis to feeling and quality of feeling, why pay him any mind at all? What other

275

reason is there (except his own self-confidence) for believing him when he proclaims his instant recognition of "major" art. His simple assertion is hardly enough. One might just as well listen to the equally assured declarations of Tom, Dick or Harry, who also know what they like, or at the very least, to Hilton, Max or Larry.

Robert Goldwater
New York City

Clement Greenberg replies:

I did not write that Dr. Goldwater was "wanton," but that his words were. I happen to have an entire respect for Dr. Goldwater personally, and he is one of the last individuals in the art world whom I would characterize as "wanton."

The whole sentence of Dr. Goldwater's from which I quoted reads: "They (Kline's compositions) confront us with an image of directed movement through an expanding space, of strength under control, of optimistic struggle of an entirely unsentimental 'grace under pressure.' " (It is possible that the printer of the Marlborough-Gerson Gallery's Kline catalog, from which this is taken, omitted a comma after "struggle.")

About Dr. Goldwater's third and fourth paragraphs: I have to ask him to re-read me without drawing unfounded inferences. The "strange identification" of "subject" with "content" is one he makes *for* me. Where I use the word "meaning" without quotes I attach it to "illustrated subject" or say "literary meaning as such," precisely in order to make it clear that I am not talking about "content." But I grant that I could have made this still clearer by explaining that literary meaning is just as much part of "form" as plastic or purely visual meaning is. On the other hand, I wish Dr. Goldwater had really explained just what the distinction between iconography and iconology had to do with what he thought I was talking about.

Clement Greenberg
New York City

Artforum, November and December 1967

1968

57. Interview Conducted by Edward Lucie-Smith

Lucie-Smith: Clement Greenberg—whom most of us think the most influential critic of modern art now writing—lives in a large, comfortable apartment on Central Park West in New York. The living-room, unlike most New York apartments, has a good deal of wall-space, and on the walls hang paintings by the artists whom Greenberg has consistently supported, notably Kenneth Noland and Jules Olitski. Greenberg talks fluently but not formally. The extracts recorded here from our conversation give, I hope, something of the flavor of our talk as well as of its content. For the most part I haven't bothered to record my own questions, as these are obvious from the context.

Greenberg: I think certain younger Englishmen are doing the best sculpture in the world today—sculpture of originality and character. I'd also mention range: variety of affect. That's what makes for "big" art. Anthony Caro is a major artist—the best sculptor to come up since David Smith. (And I'm aware of European sculptors like Chillida, Jacobsen, Müller, Wotruba.) It's Caro, I gather, who set on fire the new English sculptors: King, Tucker, Annesley, Scott, Witkin, Bolus, and maybe still others. More than one, more than two, important artists are bound to come out of the group—though Witkin has immigrated to this country. I was disappointed with King's piece in the Guggenheim International Exhibition (of sculpture) this fall: it was inflated and declamatory. But every artist is entitled to his bad moments.

The renaissance of British sculpture after the war was a false one. In my opinion Moore is a minor artist; his best work was done before 1940. Butler, Chadwick, Armitage are less than minor. But they all did create a milieu for sculpture. You've got to take into account the sheer interest in the medium that's emerged in England since the thirties.

Lucie-Smith: What about Moore in relation to Francis Bacon?

Greenberg: Bacon and Moore share the capacity to impose oneself. Their work has presence—a treacherous quality because it is so evanescent. Colin MacInnes wrote in his text for the catalogue of Tim Scott's show at the Whitechapel that the trouble with Moore was that his stuff said right off that you were in the presence of a masterpiece. It's able to say that—for the time being—because it meets your expectation of what "big" modern art should look like. Tony Smith's sculpture does the same thing—and Smith's success is the fastest big success I've yet witnessed on the American art scene. Which is ominous. There are similar reasons for the speed of Bacon's success.

I tend to like Moore most when he's most modest. Bacon is a different question. He's not really as good a painter as Moore is a sculptor, yet he interests me much more at this time. I go for his things at the same time that I see through and around them. It's as though I can watch him putting his pictures together—which doesn't stop some of them from getting to me. In others I behold the cheapest, coarsest, least felt application of paint matter I can visualize, along with the most transparent, up-to-date devices—but I shouldn't say "others": I see all this in every picture of his I know of since the early fifties, in the ones that hook me as well as the ones that don't. Bacon is the one example in our time of *inspired* safe taste—taste that's inspired in the way in which it searches out the most up-to-date of your "rehearsed responses." Some day, if I live long enough, I'll look back on Bacon's art as a precious curiosity of our period. In the meantime I'm caught in the same period. Actually, I enjoy it: I mean I enjoy being taken in as long as I know I'm being taken in.

. . . Over here we used to mind the English coming over and telling us poor Americans what we were like. That started long before Matthew Arnold's visit. You like having attention paid you, but you really don't like being characterized. Now the tables seem to be turned, at least with regard to art—and maybe other things too. On my last visits to England I found you surprisingly sensitive, touchy, in a way that "enlightened" Americans no longer are.

The notion of the grand manner, grand style—*terribilità*—

found a very exceptional welcome in England two hundred years ago. There was Edmund Burke with his Sublime, and others before him. There were Barry, Haydon, John Martin, Turner. British art got its nose bloodied for a time on the grand manner. . . . Something else seems to have happened after Constable. . . . Incidentally, I think Reynolds an extraordinary master, for all his sins of taste. The older I get the more I see in him. What a paint-and-brush-handler, infinitely more than a virtuoso. . . . The dream of the grand manner has come up again in England. You see it even in Caro, not to mention Moore and Bacon. There is a lot of Englishness in Caro's taste, but his genius lies in his placing of it; were it anything else but English taste, given the concrete, physical contexts in which he makes it operate, the results would be freakish. I've not seen a happier conjunction in my time. . . . Caro is the Moses of English sculpture—not Moore; Moore's the Abraham maybe, a father, a generator, but not a leader, not even an example. What's more, Caro is a Moses who hasn't just gotten a Pisgah view of the Promised Land; he didn't merely point the way, he has walked into the land of Canaan and spread himself out in it. If the other new English sculptors want to spread themselves out, they'll have to go further and cross over the Jordan—which is what I think Tim Scott is doing.

English neatness, English patness—they're your weakness, I'm presumptuous enough to say. Cézanne said that painting involved crude, crass materials; the English artist seems shy of this generally. Maybe that's why he had to make watercolor, for the first time, a serious medium. But I'm the last one to turn my nose up at the likes of Girtin, Crome, Cotman, the younger Cozens, Cox. Don't misunderstand me about that. If you can't see how good the English watercolorists are you can't really see painting. . . . Since Horace Walpole the best taste in pictorial art has been English by and large. The National Gallery bears some testimony to that, being item for item the best collection of pictures I know of. But up to now your wonderful English pictorial taste has been able to function only at a distance in time—and that distance has not helped your own art.

Lucie-Smith: What about the postwar situation?

Greenberg: Postwar American painting got its first serious

attention abroad in Paris. When I got to Paris in the fall of 1954 certain Frenchmen were excited about it—the late Charles Estienne, Mathieu, Michel Tapié, Paul Facchetti. English awareness came slightly later and was more reticent. But it was keener, and contained more insight, all the same. The French talked such nonsense. Patrick Heron, William Scott, and Roger Hilton were the first in England to see American art, to my knowledge. Whether they or the French saw it first, doesn't matter—I don't quite understand why Heron has made such a full about that, or why Sir Herbert Read exaggerated his own role in this connection.[1]

Given the present situation in New York, I begin to think—actually I began to think of it as a possibility in the fall of 1963—that it may be up to the milieu formed by the new English sculptors to save the avant-garde. The New York art scene, since it became a *scene*, has been impossible. I don't know about Paris, or Rome, or Milan, or Munich, or Düsseldorf—my impression is that they're swamped in avant-garde good taste too.

I notice that the English stampede when it comes to art, towards a thing and then away from it. I get the idea that the educated English are concerned with being *knowing* about painting and sculpture—more so than with respect to the other arts; the cultivated Englishman doesn't bother that much about his taste in literature. Or does he? You do put up with a lot of utter crap on the part of your art critics—but maybe I have that impression only because your critics are more literate than ours and I tend to expect more of them for that reason. . . . Echolalia is the occupational malady of art criticism nowadays, and it seems to afflict your critics just a little more than ours.

Lucie-Smith: Tell me about the current situation in America.

Greenberg: I think sculpture in America has been consistently over-boomed and overrated. We have a much faster turnover than you do. In fact, we behave about sculpture in America much as I've said the English behave about contem-

1. Patrick Heron responded to these comments, and to several others as well, in "A Kind of Cultural Imperialism?" (*Studio International*, February 1968). [Editor's note]

porary art in general. We have sudden great enthusiasms and speedy forgetfulness—more with sculpture than with painting, much more—I don't know why.

I may be wrong, but I feel that the succession of phases of what I call Novelty Art that started in America with Pop Art is slowing to a halt. The last such phase, Minimal Art, has swept the museums and the magazines and the art buffs, but it doesn't sell commensurately because it's too hard to install. And with Novelty Art sales decide things; Pop, Op, Assemblage, Erotic, Neo-Figurative, and the rest don't persist in the face of economic adversity—just as second-generation Abstract Expressionism didn't. . . . Pop Art was discovered by collectors before dealers—much less critics—got to it. At least in New York. But I think that Pop Art really started in England. I also think that Peter Blake and David Hockney are better artists of their kind than any over here. Just as Martial Raysse is a better "general novelty" artist than any we have, and Vasarely a far better Op artist. That some Europeans always beat the Americans—Jasper Johns of 1955–60 excepted—at one or the other phase of Novelty Art is for me one of the symptoms of Novelty Art's inferiority, however. It would take me too long to explain what I mean here. But suffice it to say that the trouble with Novelty Art, all of it, is that it goes down like candy. It's middlebrow art masquerading as challenging, advanced art. If I found myself disliking the stuff, I'd have more hope for it.

Lucie-Smith: Can you give a definition of "avant-garde?"

Greenberg: You don't define it, you recognize it as a historical phenomenon. The avant-garde may be undergoing its first epochal transformation today. It has taken over the *foreground* of the art scene—that area of attention once occupied by artists like Bouguereau, Gérôme, and Alma Tadema. Since what is nominally avant-garde has done this, the term and notion themselves have changed. The question now is one of continuity: will the avant-garde survive in its traditional form? (And there's no paradox in juxtaposing "avant-garde" and "tradition.")

I like psychedelic posters the way I like Pop Art and Novelty Art in general—they're fun. Not *bad* art, but art on a low level—and fun on a low level too. I love rock-and-roll but it

doesn't do to me what Schubert does, and in any case it wears out too fast. Some day Pop Art is going to have a nice period flavor—just as there are pictures by Gérôme that we now enjoy for their period flavor. I've already said that about Bacon but this doesn't mean I equate his quality with Warhol's or Lichtenstein's—any more than I equate Bastien-Lepage's with Gérôme's.

Lucie-Smith: What about American parochialism?

Greenberg: It's very much there, and so is American chauvinism. New York art has been dying under it—and under other things too. The best American painters—and I do think the very best American painters are the best in the world right now—have to cope with the very claims that are made for them because these claims are part of a much larger inflated claim for contemporary American art as a whole. . . . The international recognition American painting won in the fifties has not been an unqualified benefit. Without it there would still be conformism, no doubt, just as there was conformism before, but the conformism wouldn't be as aggressive, as confident, as loud. Young artists quail and fail under it in New York; art students quail and fail under it in the Midwest. But you don't have to visit this country to find out about that; you can get it full blast from any recent number of *Art News* or *Arts*.

Studio International, January 1968

58. Poetry of Vision

A ten day trip through Ireland left the impression of something like visual understatement on the part of her inhabitants. They seem reluctant to adorn either their dwellings or themselves. The effect even of Dublin's famed Georgian architecture, reflection though it is of Anglicizing tastes, is of a pared elegance, or else of discreetness amid pomp. The ruined castles and abbeys that strew the beautiful countryside are gray and dim. The ordinary house in small town or village tends to be low, flat-fronted, and undecorated; often it is whitewashed.

But this does not take away from the effect of plainness. (In some localities the white was broken by house fronts in pastel greens, ochers, pinks, blues, or even reds—in response, I was told, to the suggestion of the Irish Tourist Board that the view be touched up for the benefit of tourists.) The people themselves don't dress up. Maybe that is the Celtic way, maybe not—the Highland Scots go in for costumes. Maybe it's the contrast with the English, who do dress up, that makes the Irish appearance seem so subdued.

Yet the Irish devise wonderful textile patterns and colors. And there are their splendid Early Medieval illuminated manuscripts, stone carvings, and ornamented objects. To deny that the Irish have a "visual sense," as so many cultivated Irishmen themselves do, seems a wrong way of putting it. The Irish fondness for self-criticism may be misplaced here. My definite impression is that they do have a "sense" for sculpture—or, to use an up-to-date term, "object-hood"—even if it has remained latent since the Middle Ages. That they have produced little in the way of significant art since then has to be explained by other factors than the absence of an innate gift.

There is a modest wealth of pictorial art to be seen in Ireland, even though most of it is imported. The National Gallery in Dublin has one of the very best middle-sized collections of Old Master paintings and drawings I have seen; and it is constantly being added to. The Municipal Gallery of Modern Art in the same city contains, thanks to its share of Sir Hugh Lane's bequest, more than a few works of the 19th century that deserve lingering over. I am informed that the Art Gallery in Belfast, too, contains some important paintings. All told, this amounts to a lot of high pictorial art of the past for a population of hardly four million (taking the Irish Republic and Northern Ireland together).

But very little important contemporary art gets seen in Ireland; in this respect it has been an isolated country. Now a move, a spectacular move, has been made to break this isolation. Thanks to the efforts of group of Irish art lovers a large show of very recent painting, all of it from abroad, was mounted in Dublin this past fall and early winter. (A committee chaired by an eminent architect, Michael Scott, who is something of a painter himself, set up the machinery; the costs

were borne by W. R. Grace & Co., in association with the Arts Council of Ireland and four government agencies: the Airlines, the Tourist Board, the Transport Authority, and Radio and Television.) The show itself was put together by a jury composed of Jean Leymarie of France, Willem Sandberg of Holland, and James Johnson Sweeney of the U.S.A. (the last acting as chairman). They had been asked to "choose 50 painters of the international scene, and from these to select from 2 to 5 paintings executed in the last four years."

The jury was also asked to choose a supplementary exhibition of Irish art from prehistoric times to the 12th century, and some sixty examples of such art were gathered together and shown in the National Museum in Dublin. The contemporary section was installed in the Royal Dublin Society building, a large place otherwise used for horse shows, fairs, expositions, and the like. A good-looking, painstakingly scholarly and extremely efficient catalog reproducing every item in both sections was issued.

The entire show was given a name: *"Rosc,"* which in Irish Gaelic means "the poetry of vision." (So Mr. Scott writes in his introduction to the catalog. But I was told that *rosc* also means an "exultant cry such as is uttered in battle"; how the two meanings connect was left unexplained by my informant, who knew Gaelic better than he did art.) *Rosc* is to be repeated every four years with different jurors, and perhaps even with different programs. In other words, it will be an international quadrennial without prizes.

Rosc of 1967 opened on November 13 and was scheduled to close on December 30, but in answer to popular demand it was extended another ten days. The total attendance was a phenomenal 80,000. People came from all over Ireland. The largest proportion of them were young, as I was told and also could see for myself on my two visits. The rising generation in Ireland is apparently hungry for modernity and, as elsewhere, sees a quintessential expression or token of it in advanced art. I found myself wondering what they made of the 146 works at the Royal Dublin Society. There were many, many dismal things among them. Did the visitors take these on faith? Probably. What else could they do? What else do most of the people do who throng exhibitions of contemporary

art in Chicago or Tokyo, in New York or Paris? And is a discriminating public so necessary to art in this time? Apparently not. An enthusiastic public seems to be enough.

Going from the contemporary show to the ancient Irish art displayed at the National Museum, I was struck by how unnervous the latter seemed by comparison. The ancient art included the marvelous *Book of Kells*, carved or incised stones from the Neolithic period to the 8th century A.D., and all sorts of articles of use, wear, ceremony, or devotion, in gold, silver, iron, bronze, or wood, dating from as far back as the second millennium B.C. to the 12th century A.D. Even the objects that quivered with the Celtic interlace had a kind of stolidity to them for an eye fresh from the contemporary section of *Rosc*. And that stolidity came as a relief after all the febrile uncertainties in which the contemporary section abounded.

Rosc 1967 could have been ever so much better chosen. That certain artists were not represented only because works by them were unobtainable does not excuse—is not enough excuse for—the inclusion of nearly half of those who were represented. The show had a nineteen-fiftyish cast to it, an unnecessary tiredness. This was due to the nature of the Continental European representation, which accounted for over two-thirds of the show. The failed fifties, not the still living fifties, seemed to be the theme the jurors were harping on there. It was as though they had set out, moreover, to demonstrate that nothing fresh had appeared in Continental painting since *art informel*; and the dirty colors of that kind of art cast a gray-brown pall over the entire exhibition.

The American and English sections did not do very much to relieve this pall. A de Kooning, a Rauschenberg, a Lester Johnson, or even a Bontecou can look as muddy as the muddiest Cobra artist, or as chromatically tired as a Soulages, a Zao Wou-Ki, a Lataster, or a late Picasso. A Davie can look as patched-together as a Millares or a recent Dubuffet. Nevertheless, the very best paintings in *Rosc* 1967, which were also the most luminous ones, did come from the hands of three Americans and one Englishman. Tobey's tall *Composition* of 1963, with its flutter of pinks, stood out radiantly; it was the finest (as well as largest) picture by this artist that I have ever seen—finer even than his *Tundra* of twenty years ago. Tobey

wears better and better in general; his truth seems to be en-
hanced by the contrast with it made by the "impact" art of the
sixties. The only other work in the show that could hold its
own, and maybe more than its own, with his big painting was
Noland's equilateral diamond of 1964, *Swing*. (I am aware that
I shall be accused of personal prejudice as well as chauvinism
when I say this; but I owe it to myself, not to Noland, to put
my reaction to this particular picture on record.) Paintings by
Newman and Nicholson also stood out; together with those by
Tobey and Noland, they formed a class apart at this show.

One of the surprises was how good the three paintings by
Alechinsky looked; I had always before found Alechinsky too
pat and set. Tapies, too, looked good, but that was no sur-
prise; and he did not look good enough to be more than minor.
Another good minor artist, Vasarely, could have been better
represented than he was. That Dine's painting-with-sculpture,
A. R. at Oberlin No. 5 was another among the better works
was only a half-surprise: I knew that Dine had a gift, but only
rarely do his "ideas" fail to get in its way; here his "idea" did
not altogether obliterate the effect of a beautifully mottled
blue canvas. An Appel of 1967, *Femme*, was the first new
painting of his I have seen in fifteen years that struck me as
having at least a little bit to say. And Latham's bas-relief con-
struction of 1965, *Manningtree*, was the first thing of his I had
ever seen that transcended mere tastefulness; as if to atone, his
other piece in *Rosc*, a clutch of books in drooping canvas, man-
aged to be in bad taste without exactly failing to be tasteful.
Two Indianas of 1966 were plausible and maybe more than
that. Two of the four Francises here, dating from 1963 and
1965, were no more than that, and showed him as not half the
artist he once was. Joseph Sima's modest and quasi-figurative
Métamorphose of 1966 persuaded me more with every succeed-
ing look. There were other modest but "true" paintings by
Jorn, Gea Panter, Pasmore, Sonderborg, Tal Coat, and Bram
van Velde. Poliakoff, as always, was "true"—but also awk-
ward; whether the passage of time will convert this awkward-
ness into something else remains to be seen, but I continue to
think that he, along with Hosiasson and Mathieu (neither of
whom was represented in *Rosc*), is one of those who redeem
French abstract painting over the last decade. The two Picassos

present had character; neither quite succeeded, nor would they have *added* much to art if they had, but only a great hand could have produced them. The three Mirós were dead, but the same applies to them—as it does not, alas, to the two Lams, which were among the thinnest works in Dublin.

Bacon was represented by two fair-sized paintings of 1967 that had the impact of "big" art, and on my first walk through the show they came forward in a way that put most things around them in the shade. But they somehow began to wilt when directly contemplated. The discrepancy between impact and substance in Bacon does not altogether compromise his art—at least not yet—but it does make him something less than the major artist *he* presents himself as being. (The same discrepancy has the same effect in the art of Frank Stella—who is another artist who should have been represented in *Rosc* 1967, but was not.)

There were four de Koonings in Dublin, all of them in his latest, dissolved-Fragonard manner. I had something of the same trouble getting them into focus as I have had with many other de Koonings done over the last fifteen years or so, but nevertheless I was touched by them—especially *Woman* of 1965—just as I was by four or five similar paintings in de Kooning's recent show at Knoedler's in New York. A pictorially, or artistically, valid pathos lay in the contradiction between their frantic brushing and the tenuous felicity of the results. Having abandoned all effort to knock the viewer's eye out with a "big attack," the artist finally and openly reveals—and in revealing turns to genuine account—his peculiar inability to finish or round off an ambitious statement. The best de Koonings I know of since the late 1940s are small paintings, often not fully painted paintings, works conceived as fragmentary—or casual—but not so in the result. (One such is *Woman Ocher* of *circa* 1952, now in the University of Arizona Art Gallery.) These latest paintings are, on the other hand, fragments intended to be finished yet remaining fragmentary. None of them is nearly as good as *Woman Ocher*, but they do gain a new interest, and a quality, from the frankness with which this contradiction, among several others, is displayed. The four de Koonings were among the less vapid works I saw at *Rosc*.

287

For all its sins of inclusion and omission, *Rosc* turned out to contain a good deal of information about the present state of painting, even for someone familiar with the New York scene. It offered another valuable opportunity to survey and compare. And maybe it was just as well that Ireland's first introduction to contemporary advanced art on a broad front did include so much of the fatigue of the fifties, and the fatigue of painting on the Continent. At this point all the novelty and razzmatazz of the sixties might have been too bewildering. Let that be saved for *Rosc* 1971. By then time may have done some winnowing—enough winnowing, I hope, to force the next jury's hand more than the 1967 jury's was.

Artforum, April 1968

59. Changer: Anne Truitt

The new wave is sculpture. The cry is out that "painting is finished." Art neophytes and art students are turning from making pictures to making "objects." The crest of the wave is ridden by the movement called Minimal Art or Primary Structures. Sculptural objects become Minimal by reducing themselves to primary geometrical shapes like cubes, right cylinders, rectangular sheets, triangles, cones.

It is hardly two years since Minimal Art first appeared as a coherent movement, and it is already more the rage among artists than Pop or Op ever was. And it has been accepted in the same wholesale way as Pop by critics, dealers, museum people, and collectors (notwithstanding the difficulty of installing raw-looking objects in private interiors). Seriously new art doesn't ordinarily win acceptance that fast. Minimal Art may indeed be a more promising manifestation than Pop, Op, or Assemblage of what I call Novelty Art (meaning "novelty" in the old-fashioned sense of novelties sold in stores), but so far it has not produced much more in the way of substantial artistic quality. Like Pop, Op, and Assemblage, most Minimal Art remains "soft," facile, and ultimately conventional under-

neath all the emblems of far-outness that it brandishes. As yet the sculpture boom remains largely a boom, not a renaissance.

But it almost always takes something of real significance to start even a boom off. The real, if limited, quality of the paintings and painted bas-reliefs done by Jasper Johns before 1960 got Pop Art under way in this country. The present sculpture boom got its first impulse from the direct-metal sculpture that Anthony Caro began making in England in 1960—and it may be an indication of the somewhat greater possibilities of the sculpture wave, as compared with Pop, that Caro is a major artist, while Johns, for all his earlier virtues, is not. But Caro, though he set an example and threw off hints and suggestions that spread far and wide, reaching even artists who professed indifference to his art, did not initiate the Minimal Art movement. Caro uses a more or less geometrical vocabulary, but his work *looks* no more "geometrical" than does that of the late David Smith who also used essentially geometrical elements. Nor does Caro rely on monolithic reductions, or on straight-out repetition, or on "serial progressions," as most of the Minimalists do.

Anne Truitt does not rely on these things either. And like Caro, and unlike the leading (and some not so leading) Minimalists, she does not have a "line" and refrains from talking or writing "doctrine." But if any one artist started or anticipated Minimal Art, it was she, in the fence-like and then box-like objects of wood or aluminum she began making, the former in 1961 and the latter in 1962. A big fuss has been made—irrelevantly—about how Minimal artists send their drawings or "blueprints" out to be translated into three dimensions by other people. Truitt put her first "fence" together herself: one of three-spaced pickets; but her second "fence," of juxtaposed boards, and all the box-like structures she designed subsequently were executed by a carpentry mill near her home in Washington, D.C., or by a metal-working shop in Tokyo. In 1962, several years before "commercial" execution had been introduced as a somewhat preposterous article of faith by Minimal artists in New York, this took some—but not a great deal of—courage.

Truitt's first New York show, at the André Emmerich Gal-

lery in February 1963, met incomprehension (from, among others, Donald Judd, today a Minimalist leader, who reviewed the show for *Arts*).[1] Her stepped boxes, ranging in size from that of a footlocker to that of a chiffonier, immediately posed the question of whether they were art, only to solve it the next instant with their painted surfaces, which acted and yet did not act like pictures. In the painting of these surfaces Truitt was strongly influenced by Barnett Newman. Rectangular zones of darkish color were usually, but not always, kept in subtle contrast by the suppression of the value (light-and-dark) differences between them. The success of the given piece depended on how its various silhouettes and surfaces, and chromatic divisions of surface interacted. It was hard to tell, in Truitt's art, where the pictorial and where the sculptural began and ended.

Had they been monochrome, the "objects" in Truitt's 1963 show would have qualified as first examples of orthodox Minimal Art. And with the help of monochrome the artist would have been able to dissemble her feminine sensibility behind a more aggressively far-out, non-art look, as so many masculine Minimalists have *their* rather feminine sensibilities. But Truitt is willing to stake herself on the truth of her sensibility, feminine or not, and this she does in her painting. Her originality may be more conspicuous in the sculptural aspects of her art, in the sheer boxiness, stepped and not stepped, that she proposes as sculpture; but the success and failure, artistically, of these "boxes" depend on what she does to them with color and drawing. And Truitt is one of the very, very few living sculptors who has used applied color with consistent success.

There were some notable successes in her first New York show. There were some even greater ones in her second, in February 1965. But she made the mistake of replacing most of these, when the show was only a few days old, with newer but weaker pieces done in aluminum in Japan. Whether this had any effect on the reception of Anne Truitt's art in New York, I do not know. What I do know is that her personal

1. Donald Judd challenged Greenberg's assessment of Anne Truitt's relationship to Minimalism in "Complaints: Part I" (*Studio International*, April 1969). [Editor's note]

distance from the New York art scene has had its effect. She remains less known than she should be as a radical innovator. She certainly does not "belong." But then how could a housewife, with three small children, living in Washington belong? How could such a person fit the role of pioneer of far-out art?

In 1964 Mrs. Truitt left Washington with her family for more distant "exile" in Japan, where her husband, James, had been sent as correspondent for a news weekly. This past summer the Truitts returned to Washington, but she is hardly any closer there to Max's Kansas City bar in New York City than she was in Tokyo.

Vogue, May 1968

1969

60. Avant-Garde Attitudes: New Art in the Sixties

The prevalent notion is that latter-day art is in a state of con-
fusion.[1] Painting and sculpture appear to be changing and
evolving faster than ever before. Innovations follow closer and
closer on one another and, because they don't make their exits
as rapidly as their entrances, they pile up in a welter of eccen-
tric styles, trends, tendencies, schools. Everything conspires,
it would seem, in the interests of confusion. The different me-
diums are exploding: painting turns into sculpture, sculpture
into architecture, engineering, theatre, environment, "partici-
pation." Not only the boundaries between the different arts,
but the boundaries between art and everything that is not art,
are being obliterated. At the same time scientific technology
is invading the visual arts and transforming them even as they
transform one another. And to add to the confusion, high art
is on the way to becoming popular art, and vice versa.

 Is all this so? To judge from surface appearances, it might
be so. A writer in the *Times Literary Supplement* of 14 March
1968 refers to " . . . that total confusion of all artistic values
which prevails today." But by his very words this writer be-
trays where the real source of confusion lies: namely, in his
own mind. Artistic value is one, not many. The only artistic
value anybody has yet been able to point to satisfactorily in
words is simply the goodness of good art. There are, of course,
degrees of artistic goodness, but these are not differing values
or kinds of value. Now this one and only value, in its varying
degrees, is the first and supreme principle of artistic order. By
the same token it is the most relevant such principle. Of order

1. This essay was originally delivered as a lecture at the University of
Sydney, Australia, on 17 May 1968. The lecture was the first in an annual
series on contemporary art named in memory of John Joseph Wardell Power.
[Editor's note]

established on its basis, art today shows as much as it ever has. Surface appearances may obscure or hide this kind of order, which is *qualitative* order, but they do not negate it, they do not render it any the less present. With the ability to tell the difference between good and bad, and between better and worse, you can find your way quite well through the apparent confusion of contemporary art. Taste, that is, the exertions of taste, establish artistic order—now as before, now as always.

Things that purport to be art do not function, do not exist, as art until they are experienced through taste. Until then they exist only as empirical phenomena, as aesthetically arbitrary objects or facts. These, precisely, are what a lot of contemporary art gets taken for, and what many artists want their works to be taken for—in the hope, periodically renewed since Marcel Duchamp first acted on it fifty-odd years ago, that by dint of evading the reach of taste while yet remaining in the context of art, certain kinds of contrivances will achieve unique existence and value. So far this hope has proved illusory. So far everything that enters the context of art becomes subject, inexorably, to the jurisdiction of taste—and to the ordering of taste. And so far almost all would-be-non-art-in-the-context-of-art has fallen rather neatly into place in the order of inferior art. This is the order where the bulk of art production tends to find its place, in 1968 as in 1868—or 1768. Superior art continues to be something more or less exceptional. And this, this rather stable quantitative relation between the superior and inferior, offers as fundamentally relevant a kind of artistic order as you could wish.

But even so, if this were the only kind of order obtaining in new art today, its situation would be as unprecedented, still, as common opinion says it is. Unprecedented even if not confused. The good and the bad might differentiate themselves as clearly as ever, but there would still be a novel confusion of styles, schools, directions, tendencies. There would still be *phenomenal* if not aesthetic disorder. Well, even here experience tells me—and I have nothing else to rely on—that the phenomenal situation of art in this time is not all that new or unprecedented. Experience tells me that contemporary art, even when approached in purely descriptive terms, makes sense and falls into order in much the same way that art did in

the past. Again, it is a question of getting through superficial appearances.

Approaching art in phenomenal and descriptive terms means approaching it, first of all, as style and as the history of style (neither of which, taken in itself, necessarily involves quality). Approached strictly as a matter of style, new art in the 1960s surprises you—if it *does* surprise you—not by its variety, but by the unity and even uniformity it betrays *underneath* all the appearances of variety. There are Assemblage, Pop, and Op; there are Hard Edge, Color Field, and Shaped Canvas; there are Neo-Figurative, Funky, and Environmental; there are Minimal, Kinetic, and Luminous; there are Computer, Cybernetic, Systems, Participatory—and so on. (One of the really new things about art in the 60s is the rash of labels in which it has broken out, most of them devised by artists themselves—which is likewise new; art-labelling used to be the affair of journalists.) Well, there are all these manifestations in all their variegation, yet from a steady and detached look at them through their whole range some markedly common stylistic features emerge. Design of layout is almost always clear and explicit, drawing sharp and clean, shape or area geometrically simplified or at least faired and trued, color flat and bright or at least undifferentiated in value and texture within a given hue. Amid the pullulation of novelties, advanced art in the 60s subscribes almost unanimously to these canons of style—canons that Wölfflin would call linear.

Think by contrast of the canons to which avant-garde art conformed in the 50s: the fluid design or layout, the "soft" drawing, the irregular and indistinct shapes or areas, the uneven textures, the turbid color. It is as though avant-garde art in the 60s set itself at every point in opposition to the common stylistic denominators of Abstract Expressionism, *art informel, tachisme.* And just as these common denominators pointed to what was one and the same period style in the later 40s and the 50s, so the common denominators of new art in the 60s point to a single, all-enveloping period style. And in both cases the period style is reflected in sculpture as well as in pictorial art.

That avant-garde art in the latter 40s and in the 50s was one, not many, in terms of style is now pretty generally rec-

ognized. Lacking the perspective of time, we find it harder to identify a similar stylistic unity in the art of this decade. It is there all the same. All the varied and ingenious excitements and "experiments" of the last years, large and small, significant and trivial, flow within the banks of one, just one period style. Homogeneity emerges from what seemed an excess of heterogeneity. Phenomenal, descriptive, art-historical—as well as qualitative—order supervenes where to the foreshortening eye all seemed the antithesis of order.

If this gives pause, the pause should be taken advantage of to examine more closely another popular idea about art in this time: namely, that it moves faster than ever before. The art-historical style of this period that I have so sketchily described—a style that has maintained, and maintains, its identity under a multitude of fashions, vogues, waves, fads, manias—has been with us now for nearly a decade and seems to promise to stay with us a while longer. Would this show that art is moving and changing with unprecedented speed? How long did art-historical styles usually last in the past— even the more recent past?

In the present context I would say that the duration of an art-historical style ought to be considered the length of time during which it is a leading and dominating style, the time during which it is the vessel of the largest part of the important art being produced in a given medium within a given cultural orbit. This is also, usually, the time during which it attracts those younger artists who are most highly and seriously ambitious. With this definition as measure, it is possible to see as many as five, and maybe more, distinctly different styles or movements succeeding one another in French painting of the nineteenth century.

First there was David's and Ingres's Classicism. Then from about 1820 into the mid-1830s, Romanticism. Then Corot's naturalism; and then Courbet's kind. In the early 1860s Manet's flat and rapid version of naturalism led the way, to be followed within less than ten years by Impressionism. Impressionism held on as the leading manner until the early 1880s, when the Neo-Impressionism of Seurat and then the Post-Impressionism of Cézanne, Gauguin, and van Gogh became the most advanced styles. Things get a little mixed up during

the last twenty years of the century, though it may be only in seeming. At any rate Bonnard and Vuillard in their early, Nabi phase appear during the 1890s, and Fauvism enters the competition by at least 1903. As it looks, painting moved faster between the mid-1880s and 1910 or so than at any other time within the scope of this hasty survey. Cubism took the lead away from Fauvism within hardly half a dozen years of the latter's emergence. Only then did painting slow down again to what had been its normal rate of change between 1800 and the 1880s. For Cubism stayed on top until the mid-1920s. After that came Surrealism (I say Surrealism for lack of a better term: Surrealism's identity as a *style* still remains undetermined; and some of the best *new* painting and sculpture of the latter 20s and the 30s had nothing to do with it). And by the early 1940s Abstract Expressionism and its cognates, *tachisme* and *art informel*, were on the scene.

Admittedly, this historical rundown simplifies far too much. Art never proceeds that neatly. Nor is the rundown itself that accurate even within the limits set it. (What I see as hurried stylistic change between the 1880s and 1910 may turn out under longer scrutiny to be less hurried than it now looks. Larger and unexpected unities of style may become apparent—in fact, they already are apparent, but this is not the place to touch on them, despite all they would do to strengthen my argument here.) But, for all the exceptions that can rightly be taken to my chronological schema and what it implies, I do think that there is enough unquestionable evidence to support my point, which is that art-historical styles in painting (if not in sculpture) have tended since the beginning of the nineteenth century (if not before) to hold their positions of leadership for on an average of between ten and fifteen years.

The case of Abstract Expressionism does more than bear out this average; it exceeds it, and would go to show that art actually moved and changed more slowly over the last thirty years than in the hundred years previous. Abstract Expressionism in New York, along with *tachisme* and *art informel* in Paris, emerged in the early 40s and by the early 50s was dominating avant-garde painting and sculpture to a greater extent even than Cubism had in the 20s. (You weren't "with it" at all in

those days unless you lathered your paint or roughed your surfaces; and in the 50s being "with it" began to matter ever so much more.) Well, Abstract Expressionism collapsed very suddenly back in the spring of 1962, in Paris as well as New York. It is true that it had begun to lose its vitality well before that, but nevertheless it continued to dominate the avant-garde scene, and by the time of its final retreat from that scene it had led art for close to twenty years. The collapse of Abstract Expressionism was as sudden as it was because it was long overdue, but even had its collapse come five or six years earlier (which is when it should have come) the span of time over which Abstract Expressionism held its leadership would still have been over the average for art styles or movements within the last century and a half.

Ironically enough, the seemingly sudden death of Abstract Expressionism in 1962 is another of the things that have contributed to the notion that art styles turn over much faster, and more abruptly, now than they used to. The fact is that the demise of Abstract Expressionism was an unusually lingering one. Nor did the art-historical style that displaced it come into view nearly so suddenly as the events of the spring of 1962 made it appear. The "hard" style of the 60s had already emerged with Ellsworth Kelly's first New York show in 1955, and with the renascence of geometricizing abstract art in Paris in the mid-50s as we see it in Vasarely. Thus there was an overlapping in time. There was an overlapping or transition in terms of style too: the passage from the "painterly" to the "linear" can be witnessed in the painting of Barnett Newman, for example, and in the sculpture of David Smith, and in an artist like Rauschenberg (to name only Americans). That the scene of art, as distinct from the course of art, has known abrupt changes and reversals lately should not mislead us as to what has actually happened in art itself. (It is again ironical that the overlapping, the very gradualness involved in recent stylistic change, made for the impression of confusion, at least in the first years of the 60s, as much as anything else did.)

What at first did surprise me in the new art of the 60s was that its basic homogeneity of style could embrace such a great heterogeneity of quality, that such bad art could go hand in hand with such good art. It took me quite a while to remem-

ber that I had already been surprised by that same thing in the 50s. Then I had forgotten that, because of the subsequent collapse of Abstract Expressionism, which seemed to me to separate the good from the bad in the art of the 50s pretty correctly. All the same, some of my surprise at the great unevenness in quality of new art in the 60s remained, and remains. Something new is there that was not there in Abstract Expressionism when it first emerged. All art styles deteriorate and, in doing so, become usable for hollow and meretricious effects. But no style in the past seems to have become usable for such effects while it was still an up-and-coming one. That is, as best as I can remember. Not the sorriest *pasticheur* or band-wagon-jumper of Impressionism, Fauvism, or Cubism in their first years of leadership fell below a certain level of artistic probity. The vigor and the difficulty of the style at the time simply would not let them. Maybe I don't know enough of what happened in those days. I will allow for that and still maintain my point. The new "hard" style of the 60s established itself by producing original and vigorous art. This is the way new styles have generally established themselves. But what was new, in scheme, about the way that the 60s style arrived was that it did so carrying not only genuinely fresh art but also art that *pretended* to be fresh, and was able to pretend to be that, as in times past only a style in decline would have permitted. Abstract Expressionism started out with both good and bad, but not until the early 1950s did it lend itself, as a style, to *specious* as distinct from failed art. The novel feature of the "hard" style of the 60s is that it did this from the first. This fact says nothing necessarily compromising about the best "hard-style" art. That best is equal to the best of Abstract Expressionism. But the fact itself would show that something really new, *in scheme*, has happened in the new art of the 60s.

This schematically new thing is what, I feel, accounts for the greater nervousness of art opinion that marks the 60s. One knows what is "in" at any given moment, but one is uneasy about what is "out." It was not that way in the 50s. The heroes of painting and sculpture in that period profiled themselves against a background of followers fairly early on, and for the most part they remained—and have remained—heroes. There was less question then than now of competing tendencies or

positions within the common style. Just who and what will remain from the 60s, just which of the competing sub-styles will prove out as of lasting value—this remains far more uncertain. Or at least it does for most critics, museum people, collectors, art-buffs, and artists themselves—for most, I say, if not exactly for all. This uncertainty may help explain why critics have lately begun to pay so much more attention to one another than they used to, and why even artists pay them more attention.

Another cause of the new uncertainty may be the fact that avant-garde opinion has since the mid-50s lost a compass bearing that had served it reliably in the past. There used to be self-evidently academic art, the art of the *salons* and the Royal Academy, against which to take position. Everything directed against or away from academic art was in the right direction; that was once a minimal certainty. The academy was still enough there in Paris in the 20s, and perhaps even in the 30s, to assure avant-garde art of its own identity (André Lhote would still attack a *salon* exhibition now and then during those years). But since the war, and especially since the 50s, confessedly academic art has fallen out of sight. Today the only conspicuous fine art—the exceptions, however numerous, are irrelevant—is avant-garde or what looks like or refers to avant-garde art. The avant-garde is left along with itself, and in full possession of the "scene."

This hardly means that the kind of impulse and ambition that once went into avowedly academic art has now become extinct. Far from it. That kind of impulse and that kind of ambition now find their way into avant-garde, or rather nominally avant-garde, art. All the sloganizing and programming of advanced art in the 60s, and the very proliferation of it, are as though designed to conceal this. In effect, the avant-garde is being infiltrated by the enemy, and has begun to deny itself. Where everything is advanced nothing is; when everybody is a revolutionary the revolution is over.

Not that the avant-garde ever really meant revolution. Only the journalism about it takes it to mean that—takes it to mean a break with the past, a new start, and all that. The avant-garde's principal reason for being is, on the contrary, to maintain continuity: continuity of standards of quality—the

standards, if you please, of the Old Masters. These can be maintained only through constant innovation, which is how the Old Masters had achieved standards to begin with. Until the middle of the last century innovation in Western art had not had to be startling or upsetting; since then, for reasons too complex to go into here, it has had to be that. And now in the 60s it is as though everybody had finally—finally—caught on not only to the necessity of innovation, but also to the necessity—or seeming necessity—of advertising innovation by making it startling and spectacular.

Today everybody innovates. Deliberately, methodically. And the innovations are deliberately and methodically made startling. Only it now turns out not to be true that all startling art is necessarily innovative or new art. This is what the 60s have finally revealed, and this revelation may indeed be the newest thing about the bulk of what passes for new art in the 60s. It has become apparent that art can have a startling impact without really being or saying anything startling—or new. The character itself of being startling, spectacular, or upsetting has become conventionalized, part of safe good taste. A corollary of this is the realization that the aspects under which almost all artistic innovation has made itself recognized these past hundred years have changed, almost radically. What is authentically and importantly new in the art of the 60s comes in softly as it were, surreptitiously—in the guises, seemingly, of the old, and the unattuned eye is taken aback as it isn't by art that appears in the guises of the self-evidently new. No artistic rocketry, no blank-looking box, no art that excavates, litters, jumps, or excretes has actually startled unwary taste in these latter years as have some works of art that can be safely described as easel-paintings and some other works that define themselves as sculpture and nothing else.

Art in any medium, boiled down to what it does in the experiencing of it, creates itself through relations, proportions. The quality of art depends on inspired, felt relations or proportions as on nothing else. There is no getting around this. A simple, unadorned box can succeed as art by virtue of these things; and when it fails as art it is not because it is merely a plain box, but because its proportions, or even its size, are uninspired, unfelt. The same applies to works in any other form of "novelty" art: kinetic, atmospheric, light,

environmental, "earth," "funky," etc., etc. No amount of phenomenal, describable newness avails when the internal relations of the work have not been felt, inspired, discovered. The superior work of art, whether it dances, radiates, explodes, or barely manages to be visible (or audible or decipherable), exhibits, in other words, rightness of "form."

To this extent art remains unchangeable. Its quality will always depend on inspiration, and it will never be able to take effect *as art* except through quality. The notion that the issue of quality could be evaded is one that never entered the mind of any academic artist or art person. It was left to what I call the "popular" avant-garde to be the first to conceive it. That kind of avant-garde began with Marcel Duchamp and with Dada. Dada did more than express a war-time despair of traditional art and culture; it also tried to repudiate the difference between high and less than high art; and here it was a question less of wartime despair than of a revulsion against the arduousness of high art as insisted upon by the "unpopular" avant-garde, which was the real and original one. Even before 1914 Duchamp had begun his counter-attack on what he called "physical" art, by which he meant what is today vulgarly termed "formalist" art.

Duchamp apparently realized that his enterprise might look like a retreat from "difficult" to "easy" art, and his intention seems to have been to undercut this difference by "transcending" the difference between good and bad in general. (I don't think I'm over-interpreting him here.) Most of the Surrealist painters joined the "popular" avant-garde, but they did not try to hide their own retreat from the difficult to the easy by claiming this transcendence; they apparently did not feel it was that necessary to be "advanced"; they believed that their kind of art was simply better than the difficult kind. And it was the same with the Neo-Romantic painters of the 30s. Yet Duchamp's dream of going "beyond" the issue of artistic quality continued to hover in the minds at least of art journalists. When Abstract Expressionism and *art informel* appeared they were widely taken to be a kind of art that had at last managed to make value discriminations irrelevant. And that seemed the most advanced, the furthest-out, the most avant-garde feat that art had yet been able to perform.

Not that Duchamp's ideas were particularly invoked at the

time. Nor did Abstract Expressionism or *art informel* belong properly with the "popular" avant-garde. Yet in their decline they did create a situation favorable to the return or revival of that kind of avant-gardism. And return and revive it did in New York, notably with Jasper Johns in the later 50s. Johns is—rather was—a gifted and original artist, but the best of his paintings and bas-reliefs remain "easy" and certainly minor compared with the best of Abstract Expressionism. Yet in the context of their period, and in idea, they looked equally "advanced." And under cover of Johns's idea Pop art was able to enter and give itself out as perhaps even more "advanced"— without, however, claiming to reach the same levels of quality that the best of Abstract Expressionism had. The art journalism of the 60s accepted the "easiness" of Pop art implicitly, as though it did not matter, and as though such questions had become old-fashioned and obsolete. Yet in the end Pop art has not succeeded in dodging qualitative comparisons, and it suffers from them increasingly, with every day that passes. Its vulnerability to qualitative comparisons—not its "easiness" or minor quality as such—is what is seen by many younger artists as constituting the real failure of Pop art. This failure is what, in effect, "novelty" art intends to remedy. (And this intention, along with other things, reveals how much "novelty" art derives from Pop art in spirit and outlook.) The retreat to the easy from the difficult is to be more knowingly, aggressively, extravagantly masked by the guises of the difficult. The idea of the difficult—but the mere idea, not the reality or substance—is to be used against itself. By dint of evoking that idea the look of the advanced is to be achieved and at the same time the difference between good and bad overcome. The idea of the difficult is evoked by a row of boxes, by a mere rod, by a pile of litter, by projects for Cyclopean landscape architecture, by the plan for a trench dug in a straight line for hundreds of miles, by a half-open door, by the cross-section of a mountain, by stating imaginary relations between real points in real places, by a blank wall, and so forth. As though the difficulty of getting a thing into focus as art, or of gaining physical access to it, or of visualizing it, were the same as the difficulty that belonged to the first experience of a successfully new and deeply original work of art. And as if

aesthetically extrinsic, merely phenomenal or conceptual difficulty could reduce the difference between good and bad in art to the point where it became irrelevant. In this context the Milky Way might be offered as a work of art too.

The trouble with the Milky Way, however, is that, as *art*, it is banal. Viewed strictly as art, the "sublime" usually does reverse itself and turn into the banal. The eighteenth century saw the "sublime" as transcending the difference between the aesthetically good and the aesthetically bad. But this is precisely why the "sublime" becomes aesthetically, artistically banal. And this is why the new versions of the "sublime" offered by "novelty" art in its latest phase, to the extent that they do "transcend" aesthetic valuation, remain banal and trivial instead of simply unsuccessful, or minor. (In any case "sublime" effects in art suffer from a genetic flaw: they can be *concocted*—produced, that is, without inspiration.)

Here again, the variety of nominally advanced art in the 60s shows itself to be largely superficial. Variety within the limits of the artistically insignificant, of the aesthetically banal and trivial, is itself artistically insignificant.

Power Institute of Fine Arts, University of Sydney, Australia, 1969; *Studio International*, April 1970 (unrevised); *Concerning Contemporary Art: The Power Lectures, 1968–1973*, ed. Bernard Smith, 1975.

61. Interview Conducted by Lily Leino

Q. Mr. Greenberg, you are known as one of the earliest champions of advanced American art. What were some of the factors that contributed to its breakthrough during and after World War II?

A. One thing I do know is that artists in New York during the latter 1930's tried harder, informed themselves more about what was going on elsewhere—especially in Paris—than artists in Paris itself did in those years. I was in Paris for the first time in the spring of 1939 and was somewhat startled by how unknowing the few younger artists I met there were by comparison with their counterparts in New York. In New York at that time the younger artists on 8th Street—especially those

who had some contact with Hans Hofmann, even if they weren't his students—were looking at everything and at the same time bearing down on themselves. They knew Matisse better than he was known in Europe and, as I think, valued him more. They knew Klee, they knew Miró, they knew Mondrian. In Paris—even though Miró and Mondrian were then living there—these artists seemed to have less status, less authority, as precedents than in New York. On top of that, for some mysterious reason, proficiency in painting—if you can call it that—prowess in painting, did seem to cross the ocean back in those years; I mean that the general level of ambitious painting became higher over here than in France. I realized that only in the 1950's and was as much surprised as any one, even though I was registering something that had already been true for some dozen years.[1]

Q. Do you suppose there was a sociological reason?

A. Oh, I'm sure of that—sociological and other extra-artistic reasons. New York is a big cosmopolitan city, also a rough one, rough in more senses than one, a place loaded with pressures, and during the latter 1930's and early 1940's the pressure in New York on painting was greater than in most other places, I suppose. I think the truth about art circulated downtown in New York more freely maybe than it did elsewhere.

Q. What was the truth about art?

A. That this was good and that was not good or less good. All this was no good and that little bit was good. And knowing where the good and the very good were.

Q. What spurred this development?

A. Because we Americans felt so much further behind the French, or behind Paris, that we tried that much harder to catch up—just catch up. Then what Marx called the law of combined development came into operation: the strenuous effort you make to catch up sends you ahead in the end; you don't just catch up, you overtake. A dozen or so American

1. This interview was conducted under the auspices of the United States Information Service, and circulated by it "for use by newspapers, magazines, or radio stations." The press circular described the purpose of the interview, which was one of a series, as "designed to present the views of prominent Americans on issues and situations of current significance." [Editor's note]

painters did make an extraordinary effort in the 1940's in order to come abreast of Paris—and then the next thing you knew, they were taking the lead away from Paris. This became evident in the early 1950's. I say this without any chauvinist feeling whatsoever.

In the years since then we've become more and more complacent here in New York. We've become parochial; now we don't notice enough what's going on elsewhere. I feel that there are four or five younger sculptors in England who are better than any we have working over here right now. I think anyhow that sculpture in Europe, in general, reaches a higher level than it does here, in spite of the fact that we did produce, I believe, the best sculptor of his generation in David Smith, who died just short of 60 in 1965, and in spite of the fact that we still do have such good sculptors as Seymour Lipton and Herbert Ferber—and also in spite of the fact that the first American artist of all who deserved to be termed major, in my opinion, was Gaston Lachaise, a sculptor who came here from France when he was 21 and died prematurely in the 1930's in New York. It remains, all the same, that prowess in sculpture hasn't migrated to these shores—not yet.

Q. Would you say that New York still is the center of art activity in the United States, or has the focal point shifted elsewhere?

A. Of course it still is, in spite of Los Angeles and San Francisco. San Francisco made its bid as a center of painting in the 1950's, then faded. Los Angeles really is no competitor, though it makes noises like that lately. If anything, American art is even more New York-centered today than it was 10 years ago.

Q. What about the regional effort?

A. It remains provincial, alas. I don't like it that way, but that's the way it's been with painting and sculpture these last 400 years: Florence, Venice, Rome, Bruges, Ghent, Paris, London—Paris was the unrivaled center of art in the 150 years before 1950. If you weren't in Paris or in touch with Paris you were condemned to be a more or less provincial or minor artist. Look back and notice who were the major painters during that time. Even Munch, the Norwegian, was Paris-oriented, and in any case he spent five years there in his young manhood. And Paul Klee, who stayed in Germany most of his life, in

Munich, broke through in his art only after he made contact with Cubism in Paris in 1912. There you are.

Q. You don't think, then, that art could be decentralized in any country?

A. I hope it could be. But I'm not talking about the future; I'm simply referring to the record. Painting and sculpture haven't been decentralized since the 15th century. I don't like the fact of centralization, or of one-city countries culturally, but there it is. Yet the past doesn't bind the future all that much, so let's hope something else will happen—I'd love to see Chicago, or Sydney in Australia, or Calcutta, take the lead in painting away from New York; that would liven things up. Anyhow you have to stay open about the future of art in general; you can't predict it or anything about it. People who try, make themselves look silly in the end.

Q. Where does American art stand on the international scene today?

A. American painting is well ahead. The credit of it is such that a lot of inferior American art is taken very seriously all over the world. It's a paradoxical situation when someone like Rauschenberg—who's nowhere nearly as good as Eakins, Homer, Ryder, or the early John Sloan, or Milton Avery, not to mention Marin—is viewed a major figure because of the credit American art in general now enjoys in the world. Andrew Wyeth is another such case. There are at least a hundred-odd people on earth today who paint as well as Wyeth, and many others who paint better. I happen to like his stuff (though its quality has fallen off in recent years), but it's still not that good. Wyeth is known all over the world right now because American painting is known all over the world. That's quite a change from 25 years ago when everybody was so sure that Americans couldn't produce art of any consequence—and that included Americans themselves.

I grew up into and lived through that feeling, and looking back now I feel amusement where I used to feel bitterness. In the latter 1940's and even in the early 1950's Englishmen coming over here would go to Cuba to find North America's significant painting, or to Mexico or French Canada. And right here in New York were people like Jackson Pollock and Barnett Newman, then producing their best work.

Q. Would you say that the experimentation now under way in the art world is a healthy sign?

A. It's not experimentation. Leonardo experimented—if you want to call it that—just as much as Picasso ever did, when Leonardo was doing the *Visit of the Magi*, which he didn't finish. An artist, when he's ambitious enough or charged enough, is always trying to insert his own experiment in art. That's not experiment. Picasso objected to that word, and he was absolutely right. There's no such thing in art. You try something and throw it away if it doesn't succeed—doesn't work as quality. Even an academic artist painting a bunch of flowers—if the picture fails in his terms he paints it out or throws it away. You're always experimenting when you try to make art above a certain level, so the word "experiment" becomes meaningless in this context. The word belongs to the journalism about modern art, and the journalism is always wrong.

Q. You do not agree, then, that Pop art, for example, is exciting because it reflects the multi-dimensionality of today's world?

A. No, I don't find it particularly exciting because it's all too familiar—second-hand—as illustration and at the same time trite in terms of "pure" painting. Not altogether, but rather. It asserts itself as newer and fresher than it is. Pop art's too agreeable, too readily pleasing; it doesn't challenge your taste enough. That's why it became so popular so quickly. And that's why it's wearing out—or already has worn out—even in the eyes of its devotees.

Q. Minimal art is a little more demanding, don't you agree?

A. Yes, it is. At the same time its spirit is a good deal like that of Pop. It's not too demanding on your eye. There is some good in Minimal art—whether better than anything in Pop art, I can't say yet—but it's still minor art, agreeable art, which is why it, too, has caught on so fast. Had it been big, challenging, taste-testing art it wouldn't have. It would have met the same more or less prolonged resistance that major art has almost always met in the last 150 years and more.

Q. Do you find that artists abroad are influenced by American practitioners of Pop and Minimal art?

A. In many, many cases. But let me explain myself more.

It isn't that I think that Pop and Minimal are worthless. It's just that neither has yet shown itself as capable of major art. And when I talk about Pollock, Newman, Rothko, Mother-well, or Hofmann—confining myself to Americans—or Sam Francis, Morris Louis, Noland, or Olitski—again confining myself to Americans—I'm talking about major art.

The difference between major and minor is very important. There was a lot of good minor art being produced elsewhere during all the years in which Paris was supreme, but it re-mained minor, and the art of the last 175 years that we are shown in museums and that we mostly read about is major art, and hardly anything else. And it came out of Paris or its "hinterland." When we talk about the Impressionists, or Co-rot, or Delacroix, or Ingres, or Braque, or Léger, or Matisse, or Picasso, or Rodin, or Maillol, or Brancusi, or Vuillard, we're talking about major art. The moment we move elsewhere in the latter two-thirds of the 19th century or the first third of the 20th century we run into minor art.

Q. Could you clarify the difference between major and mi-nor art?

A. No. There are criteria, but they can't be put into words—any more than the difference between good and bad in art can be put into words. Works of art move you to a greater or lesser extent, that's all. So far, words have been futile in the matter. . . . Nobody hands out prescriptions to art or artists. You just wait and see what happens—what the artist does.

Q. Is it not possible that one person can fail to be moved by something that moves another?

A. Ah, that's possible, but here we're getting into a funda-mental question of aesthetics that I don't think should clutter up this interview. It happens again and again: we're talking about art and—bang—we come up against questions that philosophers of aesthetics have broken their teeth on ever since the discipline of aesthetics was born, back in the middle of the 18th century. The answers, or lack of them, are there for any-one who's interested in finding out about them, in Kant's *Cri-tique of Aesthetic Judgment* and Croce's *Aesthetics as the Science of Expression*.

Q. In other words, art is not subjective.

A. One of the wonderful things about art is that everybody

has to discover the criteria of quality for himself. They can't be communicated by word or demonstration. Yet they are objective, only—as I've already said—not amenable to words. You have to find out for yourself by looking and experiencing. And the people who try hardest and look hardest end up, over the ages, by agreeing with one another in the main. That I call the consensus of taste.

Q. One can be guided by critics, can't one?

A. Critics can direct your attention; then you look for yourself. Critics are manipulators of attention, which is not the same thing as molders of taste. Once again, you make your own way through art, no matter what you read, no matter what you hear. Or rather, you ought to; if you don't you're missing most of the fun. That includes changing your mind as you go along. If you don't find yourself changing your mind from time to time, then you're not really looking for yourself—and there's no use looking at art if you don't look for yourself.

Q. Would you say that the American public's taste has matured over the years?

A. I would say that, which is not the same thing as saying that there's been progress in art itself as distinct from taste. There certainly hasn't. Art hasn't gotten better or more "mature" over the past 5,000, 10,000, or 20,000 years. On the other hand I do think that there has been a broadening of taste in our time, in the West, and it's owed in a certain large part to the effect of modernist art. Now we appreciate all sorts of exotic art that we didn't 100 years ago, whether ancient Egyptian, Persian, Far Eastern, barbaric, or primitive. Of course, Europeans became attracted to Chinese and other kinds of exotic art as far back as the 18th century, or even before, but they treated it as a curiosity, as decoration, rather than as art in its own right. That has changed since the Impressionists and their contemporaries fell in love with Japanese prints. Since then we in the West have acquired a catholicity of taste in art that is probably historically unique, without precedent; and this is a real gain. The Romans appreciated certain kinds of exotic art, and other peoples—the Indians, the Chinese and the Japanese—were quick to take to Greco-Roman art or to realistic Western painting, but we've opened ourselves to ex-

otic traditions in a complete way and also without condescension. And taste in art should be catholic; there's no question about that.

The rate at which the public assimilates advanced art does seem to be speeding up, but I don't know yet what to conclude from that.

Q. You have implied that the spectator's involvement in a representational work tends to hamper his understanding.

A. Because there's every temptation for the unpracticed eye to get involved in the illustrated subject, that's all. It's harder, I think, for a beginner to develop his taste with representational than with abstract art, all other things being equal. Abstract art is a wonderful way in which to learn to see art in general. You appreciate the Old Masters all the more once you can tell a good Mondrian or a good Pollock from a bad one.

Q. You were instrumental in bringing Pollock, whom you consider to be the best painter the United States ever produced, to the public eye. What caused you to believe in him when others did not?

A. His quality. His pictures "sent" me.

Q. Even though some maintained that a child could do as well?

A. I don't have to assert that children can't do as well; we've already seen that they can't. You can spot a child's abstract painting readily. I remember Helen Frankenthaler once showing Pollock a painting done by her three-year-old nephew without telling him who'd made it—it was a damned good child's painting too—and Jackson took one glance at it and said, "There's nothing in it." He took it for an adult's work, yes, but he also saw through it. There was the same sort of difference as that between a five-year-old prodigy's drawing and one by Raphael.

Q. Some experts claim that painting is finished, that we are entering an era in which sculpture is dominant?

A. They're not experts; they're merely people who sound off about art. Painting is not finished if only because the best art being produced in this country right now is still painting. A Minimal sculptor like Donald Judd is very small stuff compared with a painter like Jules Olitski. Judd is good, but small, quite small. And the other Minimal artists—well,

some of them have done good things now and then, but it's still small stuff. And now they seem already to be left with nothing more to say—that includes Judd too.

You know, the representative art figure of the 1960's is not the artist, critic, or collector, but the curator of modern art. He "swings," and he "swings" the most. The last sin of which he would want to be found guilty is that of not keeping up, of not being "with it."

Q. What do you think of the invasion of art by technology—or do you consider it that?

A. No, I don't consider it an "invasion." I haven't yet seen much good art produced with the help of what's called technology, but that doesn't mean it can't or won't be. So far, however, all the kinetic effects and all the light effects and the whatever other effects haven't been able to cover up the fact that the artists involved were not inspired and had nothing much to say. There's nothing wrong with technology as such in art; anything you use as a means is okay if it produces results, results that have artistic value. But the present noise about technology appears to be more a matter of fashion and desperation than anything else. I say desperation because artists in despair will clutch at fashions. (And most artists are in despair, whether they know it or not.) What did Goethe say? One of his epigrams was to the effect that when a lot of people got on to something in a short time, or at the same time, you could be sure it wasn't much good.

Q. Why have so many artists turned to technology at this particular time?

A. Because fashions now follow one another in art faster than they used to—not styles, but fashions—and the fashion now is "medium-exploding"—that's part of the painting-is-finished cry. Technology is explosive in this sense all right, and it also has its own connotations of modernity, or "far-outness." But to repeat: so far the results are paltry, and in art you always look at the results; you never talk about art that's not yet been made.

Q. What, in your opinion, should be the role of the artist in society?

A. To make good art, that's all. If the artist is charged with social awareness, all right. If it works, fine. It doesn't seem to

have worked much in the last 100 years or so. At the same time all the aims that the artist pursues are artistic, in a sense. . . . Good art, great art has been produced under controls, but there are controls and controls. I've seen some contemporary Soviet art, and as far as I can tell, art in the Soviet Union is controlled by Philistines. The same appears to be true in China and in every other place where Bolsheviks are in power. I call them Bolsheviks instead of Communists because I feel that that's more accurate, more specific. "Socialism" in backward countries means Bolshevism—Stalinism, if you want—and that means something barbaric, because "socialism" in a backward environment becomes, among other things, an aggressive expression of backwardness. At least that's the way it's been up to now. Yugoslavia may be an exception; I can't tell. And I can't tell about Cuba either. I do know, all the same, that there's a great deal of cultural repression in Bolshevized countries.

About "protest" today—I think it means something serious in so far as people are protesting, whether they know it or not, against the quality of life under industrialism. But there's often a lot of hysteria involved in latter-day protest. You know, the clinical definition has it that when you're hysterical you carry on about something other than what's really bothering you—because you feel you can't do anything about what's really bothering you, or what in any case are the real problems. There are two real problems in this country: the first is to give Negroes their rightful place as human beings, the second to overcome the dirt and ugliness and the inequities in general of the environment. But it's been far easier to carry on about the war in Vietnam—that's far enough away from home.

Q. Have you any thoughts on the burgeoning of art museums throughout the United States?

A. I think that the boringness of life in this country no longer is being accepted by the generations that have grown up since the Depression. The Depression was a great watershed. More and more people are enjoying material comfort, and they or their offspring have begun to ask for more than that, more than material well-being. There's no question but that the businessman's outlook that used to run this country no longer prevails in the same way—thank God it doesn't—

and more people look to art and the "finer things" in general as an alternative.

Let me say that the Johnson Administration did more for culture and art than all previous administrations put together. What's paradoxical is how little capital the former President or his supporters made of this. Every other year, $5,000 has been handed out to each of 60 painters and sculptors—and well chosen ones at that. It happened two years ago; it just happened again. That the Federal Government should do something like that was previously unheard of in this country.

Q. How would you characterize the pictorial and sculptural sensibility of the 1960's?

A. As sort of hard-edged, flat-colored, high-colored, linear, in contrast with the smudgy, deep-colored, turbid painterliness of the 1940's and 50's. That covers everything new in this decade: what they call color-field painting, Minimal, technological, even "earth" art (though this latter also begins to react against the 60's). Drawing is geometrical or quasi-geometrical, everything is at right angles, or in right circles—linear in a clear-cut way. That speaks for the sensibility of the 60's, which I'd say is the sensibility of a period of *détente*.

This may seem paradoxical. Here in the latter 60's, all filled with protest and apparent turmoil, the art looks like that of a time of relaxation. There you are. Abstract Expressionism, in the 1940's and 50's, had the air of a time of unrest. Well, the 1950's were not really a time of unrest, were they? As one who grew up in the 1930's, I know what a time of unrest feels like, a time of crisis (granting that the word "crisis" is much abused through over-use). Well, the art that actually reflected the temper of the 1930's came along only in the latter 1940's and in the 1950's. There you are again. Art is not always in advance of the general mood. There's a cliché about the artist as prophet, as foreseeing what's to come. Maybe he does, sometimes, but he can also follow and lag—and I'm speaking about the great artist, not just the mediocre one.

Nobody should make predictions about the course of art. The record shows that you can't, and when you try you are inevitably shown up. Thank God you can't see into the future of art—art would be less fun if you could.

There are, of course, more important things than art: life

itself, what actually happens to you. This may sound silly, but I have to say it, given what I've heard art-silly people say all my life: I say that if you have to choose between life and happiness or art, remember always to choose life and happiness. Art solves nothing, either for the artist himself or for those who receive his art.

Art shouldn't be overrated. It started to be in the latter 18th century, and definitely was in the 19th. The Germans started the business of assessing the worth of a society by the quality of art it produced. But the quality of art in a society does not necessarily—or maybe seldom—reflect the degree of well-being enjoyed by most of its members. And well-being comes first. The weal and woe of human beings come first. I deplore the tendency to over-value art.

"USIS Feature," United States Information Service, April 1969

Bibliography

Works by Greenberg

UNCOLLECTED WRITINGS, 1939–1949

"An Interview with Ignacio Silone," *Partisan Review* 6 (Fall 1939): 22–30.

With Dwight Macdonald. "10 Propositions on the War." *Partisan Review* 8 (July–August 1941): 271–78.

With Dwight Macdonald. "Reply" (to Philip Rahv, "10 Propositions and 8 Errors," in the same issue). *Partisan Review* 8 (November–December 1941): 506–8.

"Walter Quirt." *The Nation* (7 March 1942): 294.

"L'art américain au XXe siècle." *Les Temps Modernes* 2 (August–September 1946): 340–52.

BOOKS

Joan Miró. New York: Quadrangle Press, 1948.

Matisse. New York: H. N. Abrams, 1953.

Art and Culture: Critical Essays. Boston: Beacon Press, 1961.

Hans Hofmann. Paris: Georges Fall, 1961.

The Collected Essays and Criticism: Perceptions and Judgments, 1939–1944. Vol. 1. Edited by John O'Brian. Chicago: University of Chicago Press, 1986.

The Collected Essays and Criticism: Arrogant Purpose, 1945–1949. Vol. 2. Edited by John O'Brian. Chicago: University of Chicago Press, 1986.

TRANSLATIONS FROM THE GERMAN

The Brown Network: The Activities of the Nazis in Foreign Countries. Introduced by William Francis Hare. New York: Knight Publications, 1936.

With Emma Ashton and Jay Dratler. Manfred Schneider, *Goya: A Portrait of the Artist as a Man.* New York: Knight Publications, 1936.

Franz Kafka. "Josephine, The Songstress: Or, the Mice Nation." *Partisan Review* 9 (May–June 1942): 213–28.

With Willa Muir and Edwin Muir. Franz Kafka, *Parables*. New York: Schocken Books, 1947.

With Willa Muir and Edwin Muir. Franz Kafka, *The Great Wall of China: Stories and Reflections*. New York: Schocken Books, 1948.

Paul Celan. *"Fugue." Commentary* 19 (March 1955): 242.

Works on Greenberg

Most of the literature on Greenberg dates from the appearance of *Art and Culture* in 1961. Before then Greenberg's criticism was not subjected to any sustained analysis, at least not in print, although it was referred to with increasing frequency in articles and books. The fullest attention it received was in several reviews that followed the publication of *Joan Miró* in 1948, in George L. K. Morris's article of the same year, and in Alfred H. Barr, Jr.'s book on Matisse in 1951.

Art and Culture thus marked a shift in the kind of critical attention paid to Greenberg's work. The book seems to have clarified the extent to which his writings were informed by a developed theory of modern art and the extent to which he understood the practice of art criticism to be marked by peculiar limits and constraints that reflected the peculiar limits and constraints of its subject. In short, it clarified what he meant by modernism. Since 1961 most of the extensive discourse on Greenberg's critical practice has dealt with the implications of his modernist stance. The following list of selected secondary sources reflects this interest.

Alloway, Lawrence. *Topics in American Art since 1945*. New York: W. W. Norton, 1975.

Auping, Michael. *Abstraction-Geometry-Painting: Selected Geometric Abstract Painting in America since 1945*. New York: Harry N. Abrams, 1989.

Barr, Alfred H., Jr. *Matisse: His Art and His Public*. New York: Museum of Modern Art, 1951.

Bois, Yve-Alain. "Dossier Pollock: Clement Greenberg; les textes sur Pollock." *Macula* 2 (1977): 36–39.

Brook, D. "Art Criticism: Authority and Argument." *Studio International* 180 (September 1970): 66–69.

Burgin, Victor. *The End of Art Theory: Criticism and Postmodernity*. Atlantic Highlands, N.J.: Humanities Press International, 1986.

Calas, Nicolas. "The Enterprise of Criticism." *Arts Magazine* 42 (September–October 1967): 9.

Carrier, David. "Greenberg, Fried, and Philosophy: American-Type

Formalism." In *Aesthetics: A Critical Anthology*. Edited by George Dickie and R. J. Sclafini. New York: St. Martin's Press, 1977.

———. *Artwriting*. Amherst: University of Massachusetts Press, 1987.

Cavaliere, Barbara, and Robert C. Hobbs. "Against a Newer Laocoon." *Arts Magazine* 51 (April 1977): 110–17.

Clark, T. J. "Greenberg's Theory of Art." *Critical Inquiry* 9 (September 1982): 139–56.

———. "Arguments about Modernism: A Reply to Michael Fried." In *The Politics of Interpretation*. Edited by W. J. T. Mitchell. Chicago: University of Chicago Press, 1982–1983.

Collins, Bradford R. "Clement Greenberg and the Search for Abstract Expressionism's Successor." *Arts Magazine* 61 (March 1987): 36–43.

Crow, Thomas. "Modernism and Mass Culture in the Visual Arts." In *Modernism and Modernity*. Edited by Benjamin H. D. Buchloh, Serge Guilbaut, and David Solkin. Halifax, N.S.: Press of the Nova Scotia College of Art and Design, 1983.

Crowther, Paul. "Greenberg's Kant and the Problem of Modernist Painting." *British Journal of Aesthetics* 25 (no. 4, 1985): 317–25.

Curtin, Deane W. "Varieties of Aesthetic Formalism." *Journal of Aesthetics and Art Criticism* 40 (Spring 1982): 315–26.

De Duve, Thierry. "The Monochrome and the Blank Canvas." In *Reconstructing Modernism*. Edited by Serge Guilbaut. Cambridge, Mass.: MIT Press, 1990.

———. "Clement Lessing." *Essai daté* 1. Paris: Editions de la Différence, 1987.

Dorfman, Geoffrey, and David Dorfman. "Reaffirming Painting: A Critique of Structuralist Criticism." *Artforum* 16 (October 1977): 59–65.

Fisher, Philip. "The Future's Past." *New Literary History* 6 (Spring 1975): 588–606.

Foster, Stephen C. *The Critics of Abstract Expressionism*. Ann Arbor, Mich.: UMI Research Press, 1980.

Frascina, Francis, ed. *Pollock and After: The Critical Debate*. New York: Harper & Row, 1985.

Fried, Michael. Introduction to *Three American Painters: Kenneth Noland, Jules Olitski, Frank Stella*. Exhibition catalogue. Cambridge, Mass.: Fogg Art Museum, 1965.

———. "Art and Objecthood." *Artforum* 5 (June 1967): 12–23.

———. "How Modernism Works: A Response to T. J. Clark." *Critical Inquiry* 9 (September 1982): 217–34.

Gagnon, François-Marc. "The Work and Its Grip: Essay on Clement

Greenberg's First Critical Approach to Pollock." In *Jackson Pollock: Questions*. Montreal: Musée d'art contemporain, 1979.

Goldwater, Robert. "The Painting of Miró." Review of *Joan Miró*, by Greenberg. *The Nation* 168 (26 February 1949): 250–51.

Guilbaut, Serge. "The New Adventures of the Avant-Garde in America." *October* 15 (Winter 1980): 61–78.

————. *How New York Stole the Idea of Modern Art: Abstract Expressionism, Freedom and the Cold War*. Chicago: University of Chicago Press, 1983.

Guilbaut, Serge, ed. *Reconstructing Modernism: Art in New York, Paris and Montreal 1945–1964*. Cambridge, Mass.: MIT Press, 1990.

Halasz, Piri. "Art Criticism (and Art History) in New York: The 1940s vs. the 1980s; Part Three: Clement Greenberg." *Arts Magazine* 57 (April 1983): 80–89.

Harrison, Charles. *Essays on Art and Language*. Oxford: Basil Blackwell, 1991.

Harrison, Charles, and Fred Orton. Introduction to *Modernism, Criticism, Realism: Alternative Contexts for Art*. New York: Harper & Row, 1984.

Heron, Patrick. "A Kind of Cultural Imperialism?" *Studio International* 175 (February 1968): 62–64.

Hess, Thomas B. "Catalan Grotesque." Review of *Joan Miró*, by Greenberg. *Art News* 47 (February 1949): 9.

Higgens, Andrew. "Clement Greenberg and the Idea of the Avant-Garde." *Studio International* 182 (October 1971): 144–47.

Hoesterey, Von Ingeborg. "Die Moderne am Ende? Zu den ästhetischen Positionen von Jürgen Habermas and Clement Greenberg." *Zeitschrift fur Ästhetik und allgemeine Kunstwissenschaft* 29 (1984): 19–32.

Howard, David. "From Emma Lake to Los Angeles: Modernism on the Margins." In *The Flat Side of the Landscape*. Edited by John O'Brian. Saskatoon: Mendel Art Gallery, 1989.

Kees, Weldon. "Miró and Modern Art." Review of *Joan Miró*, by Greenberg, *Partisan Review* 16 (March 1949): 295–97.

Kelly, Mary. "Re-viewing Modernist Criticism." *Screen* 22 (Autumn 1981): 41–62.

Kozloff, Max. "A Letter to the Editor." *Art International* 7 (June 1963): 89–92.

————. "The Critical Reception of Abstract-Expressionism." *Arts Magazine* 40 (December 1965): 27–33.

Kramer, Hilton. "A Critic on the Side of History: Notes on Clement Greenberg." Review of *Art and Culture*, by Greenberg. *Arts Magazine* 37 (October 1962): 60–63.

Krauss, Rosalind. "The Im-Pulse to See." In *Vision and Visuality*. Edited by Hal Foster. Seattle: Bay Press, 1988.

Kroll, Jack. "Some Greenberg Circles." Review of *Art and Culture* and *Hans Hofmann*, by Greenberg. *Art News* 61 (March 1962): 35, 48–49.

Krupnick, Mark. "Art and Politics Once More." *Bennington Review* (Winter 1981): 23–26.

Kuspit, Donald B. *Clement Greenberg: Art Critic*. Madison, Wis.: University of Wisconsin Press, 1979.

―――. "The Unhappy Consciousness of Modernism." *Artforum* 19 (January 1981): 53–57.

Leja, Michael. "The Formation of the Avant-Garde in New York." In *Abstract Expressionism: The Critical Developments*. Buffalo: Albright-Knox Gallery, 1988.

Mahsun, Carol Anne. *Pop Art and the Critics*. Ann Arbor, Mich.: UMI Research Press, 1987.

Mitchell, W. J. T. "*Ut Pictura Theoria*: Abstracting Painting and the Repression of Language." *Critical Inquiry* 15 (Winter 1989): 348–71.

Morris, George L. K. "On Critics and Greenberg: A Communication." *Partisan Review* 15 (June 1948): 681–85.

Natapoff, Flora. "The Abuse of Clemency: Clement Greenberg's Reductive Aesthetic." *Modern Occasions* 1 (Fall 1970): 113–17.

O'Brian, John, ed. *The Flat Side of the Landscape: The Emma Lake Artists' Workshops*. Saskatoon: Mendel Art Gallery, 1989.

―――. "Greenberg's Matisse and the Problem of Avant-Garde Hedonism." In *Reconstructing Modernism*. Edited by Serge Guilbaut. Cambridge, Mass.: MIT Press, 1990.

Orton, Fred. "Action, Revolution and Painting." *Oxford Art Journal* 14, no. 2 (1991): 3–17.

Orton, Fred, and Griselda Pollock. "*Avant-Gardes* and Partisans Reviewed." *Art History* 4 (September 1981): 305–27.

Platt, Susan Noyes. "Clement Greenberg in the 1930s: A New Perspective on His Criticism." *Art Criticism* 5 (Spring 1989): 47–64.

Ratcliff, Carter. "Art Criticism: Other Eyes, Other Minds; Clement Greenberg." *Art International* 18 (December 1974): 53–57.

Reise, Barbara M. "Greenberg and The Group: A Retrospective View." *Studio International* 175 (May–June 1968): 254–57, 314–16.

Sandler, Irving. *The Triumph of American Painting: A History of Abstract Expressionism*. New York: Praeger, 1970.

Shapiro, David and Cecile Shapiro. "Abstract Expressionism: The Politics of Apolitical Painting." *Prospects* 3 (1977): 175–214.

Stadler, Ingrid. "The Idea of Art and of Its Criticism: A Rational Reconstruction of a Kantian Doctrine." In *Essays in Kant's Aesthetics*. Edited by Ted Cohen and Paul Guyer. Chicago: University of Chicago Press, 1982.

Steinberg, Leo. *Other Criteria: Confrontations with Twentieth-Century Art*. New York: Oxford University Press, 1972.

Storr, Robert. "No Joy in Mudville: Greenberg's Modernism Then and Now." In *Modern Art and Popular Culture: Readings in High & Low*. Edited by Kirk Varnedoe and Adam Gopnik. New York: Museum of Modern Art, 1990.

Wald, Alan M. *The New York Intellectuals: The Rise and Decline of the Anti-Stalinist Left from the 1930s to the 1980s*. Chapel Hill: University of North Carolina Press, 1987.

Wallis, Brian, ed. *Art After Modernism: Rethinking Representation*. New York: New Museum of Contemporary Art, 1984.

Chronology, 1950–1969

Clement Greenberg continued as associate editor of *Commentary*, a position he had held since the periodical began to publish in 1945. His home address remained 90 Bank Street, New York.

April 25–May 15. With Meyer Schapiro, organized *Talent 1950* for the Kootz Gallery, New York. The exhibition featured "work by unknown or little known young artists of promise," including Elaine de Kooning, Robert De Niro, Friedel Dzubas, Robert Goodnough, Grace Hartigan, Franz Kline, Alfred Leslie, and Larry Rivers. It was the first exhibition Greenberg agreed to organize. During the 1950s and 1960s he would organize eight more exhibitions and contribute to twice that number of catalogues.

July 6–August 30. Taught in the summer session at Black Mountain College, North Carolina. His courses were "The Development of Modernist Painting and Sculpture from Their Origins to the Present Time" and a seminar on art criticism organized around Kant's *Critique of Aesthetic Judgment*. Leo Amino, Theodoros Stamos, and Paul Goodman were among the summer faculty, Kenneth Noland among the students.

December 5–30. A painting by Greenberg was included in *Fifteen Unknowns*, an exhibition at the Kootz Gallery chosen by gallery artists. Adolph Gottlieb selected *Lake Eden* by Greenberg, as well as work by Helen Frankenthaler and William Machado. During 1950, Greenberg began a relationship with Frankenthaler, who had graduated from Bennington College in 1949. The relationship lasted some years.

December 9. Published in *The Nation* for the last time: "T. S. Eliot: The Criticism, The Poetry."

December 14. Attended the first official meeting of the American Committee for Cultural Freedom, held at the New York University Faculty Club, at which Sidney Hook was elected chairman.

1951

February 7. Wrote to Freda Kirchwey, editor of *The Nation*, protesting the political point of view expressed in J. Alvarez del Vayo's weekly column. Greenberg charged that it paralleled "Soviet propa-

ganda." When Kirchwey refused to publish the letter, Greenberg sent it to *The New Leader* for publication. *The Nation* initiated a libel suit against both Greenberg and *The New Leader* that was eventually settled out of court. The protest and the suit generated a good deal of press coverage.

Began to lessen his association with *Partisan Review*. During the year the magazine lost the patronage of a major sponsor and scaled back its operations.

1952

October 1. Nominated to the executive committee of the American Committee for Cultural Freedom.

November 17–30. Organized *A Retrospective Show of the Paintings of Jackson Pollock* at Bennington College, Vermont, at the invitation of Paul Feeley, which afterwards travelled to the Lawrence Museum, Williams College, Massachusetts. Greenberg wrote in the accompanying pamphlet: "[The exhibition] does much to clarify what has been happening in American art since the war, and shows why the most adventurous painters of the latest generation in Paris have begun to look to this country with apprehensive rivalry."

During the 1950s, Greenberg would organize three more exhibitions—of the work of Adolph Gottlieb (1954), Hans Hofmann (1955), and Barnett Newman (1958)—at Bennington College. He would also be invited to present two series of "seminars" at the college, the first in 1962 and the second in 1971.

1953

January 11–February 7. Wrote the foreword to the *Second Annual Exhibition of Painting and Sculpture*, and had one of his own paintings included in this cooperative venture involving close to one hundred artists at the Stable Gallery, New York.

April 4. Arranged for Morris Louis and Kenneth Noland to visit Helen Frankenthaler's studio in New York, where they saw *Mountains and Sea* (1952); when they returned to Washington, D.C., they began painting together in a style informed by her work.

April 8. Resigned from the executive committee of the American Committee for Cultural Freedom.

Summer. Wrote the text for *Matisse* (New York: H. N. Abrams, 1953) at Nag's Head, North Carolina.

1954

January 11–30. Selected eleven artists for inclusion in *Emerging Talent*, an exhibition at the Kootz Gallery, New York; Morris Louis,

Kenneth Noland, and Philip Pearlstein were among those included by Greenberg.

April 23–May 5. Organized *A Retrospective Show of the Paintings of Adolph Gottlieb* at Bennington College, Vermont; the exhibition travelled to the Lawrence Museum, Williams College, Massachusetts.

May 12. Delivered the Ryerson lecture, "Abstract and Representational," at the School of Fine Arts, Yale University; the lecture was published by *Art Digest* in November.

Summer. Travelled to Europe for the first time since 1939; visited England, France, Italy, and Switzerland.

1955

Spring. Publication of "'American Type' Painting," one of Greenberg's most anthologized essays; the essay was the last Greenberg would publish in *Partisan Review*. Also organized *A Retrospective Exhibition of the Paintings of Hans Hofmann* at Bennington College, Vermont.

June–August. Engaged in a critical exchange with F. R. Leavis over Greenberg's essay "The Jewishness of Franz Kafka" (*Commentary*, April).

December 19. Contributed the foreword to *Ten Years*, an anniversary exhibition at the Betty Parsons Gallery, New York.

1956

May 4. Married Janice (Jenny) Elaine Van Horne; the marriage was Greenberg's second.

1957

April. Fired from *Commentary*, where he had been associate editor since 1945, by the periodical's publication committee.

June. Travelled to Toronto, Ontario, at the request of William Ronald. Greenberg's visit was sponsored by members of the Painters Eleven, a group of Toronto artists. Spent half a day with nine of the eleven artists, looking at work and offering comments; Jack Bush was among the artists Greenberg visited.

November–December. Contributed the introduction to *An Exhibition of Paintings of Adolph Gottlieb*, Jewish Museum, New York.

1957–1961

In the period from 1957 to 1961 Greenberg worked on three books. Two were published, one was abandoned. *Art and Culture* (Boston: Beacon Press), a collection of critical essays, and *Hans Hofmann* (Paris: Georges Fall) were published in 1961. The abandoned project was a critical biography of Jackson Pollock.

Also during these years, Greenberg began to write for larger and more varied audiences. He accepted commissions from *Art News Annual* (1957), *Saturday Evening Post* (1959), *The New York Times Magazine* (1961), and *Country Beautiful* (1961); and his much discussed essay, "Modernist Painting," was originally delivered as a Voice of America broadcast (1960).

1958

February. Contributed the foreword to *An Exhibition in Tribute to Sidney Janis* at the Hetzel Union Gallery, Pennsylvania State University.

May 4–28. Organized *Barnett Newman: First Retrospective Exhibition* for Bennington College, Vermont.

Fall. Conducted the Christian Gauss Seminar in Criticism at Princeton University. Michael Fried, then an undergraduate student at Princeton, was among those present.

1958–1960

From December 1958 until February 1960, Greenberg was an adviser to French and Co., Inc., New York, at a salary of $100 per week. In October, 1958, French and Co. had opened a gallery devoted to contemporary art. Greenberg did not see clients but did advise the gallery about which artists to exhibit. Among the artists shown during his tenure were Friedel Dzubas, Barnett Newman, Adolph Gottlieb, Morris Louis, Kenneth Noland, and Jules Olitski. In 1959, French and Co. sent Greenberg overseas to search out promising European artists.

1962

August 13–24. Invited to lead the Emma Lake Artists' Workshop, Saskatchewan, by Kenneth Lochhead, Director of the School of Art, Regina College. Twenty-four artists attended, including Lochhead, Roy Kiyooka, Dorothy Knowles, Arthur McKay, Guido Molinari, Robert Murray, and William Perehudoff.

Following the workshop, Greenberg visited studios and galleries in Saskatchewan, Alberta, and Manitoba to gather material for an article on prairie painting and sculpture commissioned by *Canadian Art* (March–April 1963).

September–October. Conducted a weekly "seminar" on art at Bennington College, Vermont.

Fall. Became an adviser to Morris Louis's estate following the artist's death, and continued in that capacity until 1971.

1963

January 11–February 15. Organized the exhibition *Three New American Painters: Louis, Noland, Olitski* for the Norman MacKenzie Art Gallery, Regina, Saskatchewan.

February–March. Considered accepting a fall teaching appointment at the University of Saskatchewan, Regina; rejected the invitation in March.

April 16. Birth of Sarah Dora Greenberg, his second child and only daughter.

1964

April 23–June 7. Organized the exhibition *Post Painterly Abstraction* for the Los Angeles County Museum of Art. The exhibition included work by thirty-one American and Canadian artists, and travelled to Minneapolis (Walker Art Center) and Toronto (Art Gallery of Toronto).

Fall. Invited to Buenos Aires to be juror of an international exhibition. Visited Uruguay, Brazil, Peru, Columbia, and Barbados on the return journey to the United States.

1965

Spring. Travelled in the Middle East and Europe, visiting Israel, Greece, and Italy.

Late May. Named an executor of David Smith's estate, following the artist's death in an automobile accident.

October. Invited to Liverpool, England, to act as jury chairman of the John Moores Biennial of Painting.

October–December. Invited to Regina to select work for the *Diamond Jubilee Exhibition of Saskatchewan Art.*

1966–1967

June 18–October 16, 1966. Contributed the introduction to Jules Olitski's exhibition of painting at the XXXIII Venice Biennale.

October–November 1966. Undertook a lecture tour of Japan under the auspices of the American State Department; the tour was timed to coincide with an exhibition of American painting organized and financed by the International Council of the Museum of Modern Art, New York.

Winter 1967. Repeated the lecture tour in India, under the same auspices and for the same reasons.

October 1967. Published "Complaints of an Art Critic" in *Artforum*, eliciting responses from Robert Goldwater and Max Kozloff.

December 1967. Invited to Ireland to review *Rosc*, a juried exhibition held in Dublin.

1968

January. Publication in *Studio International* of an interview conducted by Edward Lucie-Smith, the first of many subsequent interviews.

May 17. Delivered the inaugural John Power Lecture in Contemporary Art, University of Sydney, Australia. The lecture, "Avant-Garde Attitudes: New Art in the Sixties," was published the following year.

Following the visit to Australia, travelled to New Zealand at the invitation of that country's Arts Council.

1969

April. Interviewed by Lily Leino for the United States Information Service. A press circular described the purpose of the interview, which was one of a series, as "designed to present the views of prominent Americans on issues and situations of current significance."

Greenberg concluded the interview with a cautionary remark. "Art shouldn't be over-rated," he said. "The quality of art in a society does not necessarily—or maybe seldom—reflect the degree of well-being enjoyed by most of its members. And well-being comes first. The weal and woe of human beings come first. I deplore the tendency to over-value art."

<div style="text-align: right">John O'Brian</div>

Index

Duchamp, Marcel, 253, 293, 301
Dufy, Raoul, 42
Durand-Ruel, Paul, 3, 7
Dyce, William, 266
Dzubas, Friedel, 218

Eakins, Thomas, 94, 243, 306
Earle, Herbert, 168
Earth art, 301
Eckhardt, Ferdinand, 163–64
Edmonton: abstract painting,
 160–61; landscape painting,
 169–70; sculpture, 173
Effervescence (Hofmann), 70, 74
Egan, Charles, 53
El Greco, 92
Eliot, T. S., 261
Emilie Ambre in the Role of Carmen
 (Manet), 240
Emma Lake Artists' Workshop,
 154–55, 159–60, 162, 169,
 171, 174
Emmerich (André) Gallery, 255,
 289
Encounter (magazine), 139, 144,
 148, 176
Enfants, Les (Picasso), 237
Environment art, 252, 262, 294,
 301
Erotic art, 252, 262, 281
Estienne, Charles, 280
Etty, William, 266
Evans, Walker, 187
Evergreen Review (magazine), 46, 47
Execution of Emperor Maximilian
 (Manet), 244
Existentialism, 136, 144, 146
Expressionism: of Hofmann, 68
Expressionism, Abstract: *See* Ab-
 stract Expressionism
Eyre, Ivan, 167

Facchetti, Paul, 280
Fairy Tale (Hofmann), 70
Fantin-Latour, Henri, 220, 244
Faure, Elie, 143
Fautrier, Jean, 125, 158
Fauvism: and abstract painting,
 142; acceptance of, 260; as
 avant-garde, 296, 298; and
 Avery, 40–41; and Brancusi, 57;
 and Hofmann, 68–69, 128; and
 landscape painting, 167; of

Matisse, 219–20; and Monet,
 10; and New York painting, 25
Feeley, Paul, 211
Feininger, Andreas: *The World
 Through My Eyes,* 183–87
Femme (Appel), 286
Femme au bord de la mer (Picasso),
 238
Femme nue (Picasso), 238
Ferber, Herbert, 216, 305
Ferren, John, 122, 195
Fifer, The (Manet), 244
Flagg, James Montgomery, 134
Flemish Primitives, 101–6, 201
Flowering Desert (Hofmann), 71
Focus Gallery, 160, 168
Foedisch, Heinz, 168
Formalism, 268–72
Foster, Velma, 163
Fra Angelico, 142
Fragonard, Jean-Honoré, 89
Francis, Sam, 99–100, 133, 195,
 214, 286, 308
Frankenthaler, Helen, 95–97, 99,
 152, 195, 310; *Mountains and
 Sea,* 96
Freedberg, S. J.: on Andrea del
 Sarto, 197–202; *Painting of the
 High Renaissance in Rome and
 Florence,* 197
French and Co. (gallery), 212
Fried, Michael, 205, 207–8
Friedman, Arthur, 40, 167, 182
Friesen, Victor, 167
Frischolz, Louis, 160
Fruit Bowl (Braque), 63
Fry, Roger, 102–5
Funky art, 294, 301

Galerie Michel Tapié, 46
Gallery Naviglia, 47
Gamma (Louis), 151–52
Garrish, Jane, 173
Gauguin, Paul, 4, 10, 260, 295
Gea Panter, 286
Gérôme, Jean-Léon, 281
Giacometti, Alberto, 58, 208
Gift (Noland), 151
Gilotin, Le (Hofmann), 71
Ginsberg, Allen, 261
Giotto, 89, 92, 102, 269
Girl Before a Mirror (Picasso), 110
Girtin, Thomas, 279

Impressionism: and abstract painting, 142; acceptance of, 260; attacks on, 75; as avant-garde, 295, 298; Avery's reaction to, 42–43; and disinterestedness of the spectator, 78; emphasis on the visual, 98; Gombrich on, 258; and Hofmann, 69; as lacking structure, 179; and landscape painting, 167; and Manet, 241, 243; of Matisse, 219; and Modernism, 60, 86, 89–90; of Monet, 4–10; and Newman, 55; and Paris, 308; Picasso's output compared to, 29; and Still, 130; and Turner, 232, 234; Wolff on, 177–78
Indiana, Robert, 196, 286
Informel painting: and Abstract Expressionism, 193; as avant-garde, 262, 294, 296, 301–2; and crisis of abstract art, 176–78; at Dublin exhibition, 285; and Turner, 230
Ingres, Jean-Auguste-Dominique, 88–89, 247, 295, 308
Ireland, 282–88
Irwin, W. F., 168

Jackson, Harry, 100–101
Jackson (Martha) Gallery, 100, 212
Jacobsen, Robert, 277
Janis, Sidney, 52–54; *Abstract and Surrealist Art in America,* 52
Janis Gallery, 45–46, 53
Jenkins, Paul, 95
Jewish Museum, 38
J. M. W. Turner (Lindsay), 230
Johns, Jasper: and Abstract Expressionism, 125–27; as Avant-Garde, 302; and European artists, 281; Greenberg on, 95; and Neo-Dada, 133; and Pop art, 196, 214–15, 289; Proto-Pop, 252, 263
Johnson, Lester, 285
Jorn, Asger, 286
Joyce, James, 261
Judd, Donald, 256, 290, 310–11

Kafka, Franz: "The Great Wall of China," 48–52
Kahnweiler, Daniel-Henry, 34

Kaldis, 24
Kandinsky, Wassily: and Gorky, 158; and Hofmann, 68–70, 73; as Modernist, 87; and New York painting, 22, 53, 121–23, 212; painterliness of, 193
Kant, Immanuel, 85, 118, 201; *Critique of Aesthetic Judgment,* 308
Kaufman, C. R., 161
Keats, John, 249
Kelly, Ellsworth, 95, 215, 256, 297
Kerkam, Earl, 24
Kerr, Illingworth, 162
Key, Archibald, 161
Kinetic art, 252, 294, 300
King, Phillip, 277
Kirstein, Lincoln: *Photographs by Cartier-Bresson,* 183–87
Kitchen, The (Picasso), 33–34, 37
Kiyooka, Roy, 155–56
Klee, Felix: *The Diaries of Paul Klee, 1898–1918,* 202–4
Klee, Paul: automatic painting of, 149; and Cowley, 170; *The Diaries of Paul Klee, 1898–1918,* 202–4; and Hofmann, 68, 72; and New York painting, 21, 121–22, 212, 304; painterliness of, 193; and Paris, 305; and Pollock, 109, 112; and Taylor, 161
Klein, Yves, 251, 254
Kline, Franz: and Abstract Expressionism, 125, 128, 133, 195, 214; as "action" painter, 141; emphasis on the visual, 97; Goldwater on, 270, 275, 276; and Greenberg, 116–17; Hofmann compared to, 73; and Janis, 53; and New York painting, 24, 95; and *Talent 1950* show, 218
Knoedler's (gallery), 100, 287
Knowles, Dorothy, 171–72
Kolbe, Georg, 57
Kootz, Samuel, 53, 238
Kootz Gallery, 74, 100, 218
Korean Massacres (Picasso), 31
Kozloff, Max, 218, 272–74
Krasner, Lee (Leonore), 19, 24, 45, 113, 249

Lachaise, Gaston, 57, 216, 305
Lam, Wilfredo, 237, 287

Painting: abstract, 56, 75−84, 87, 97, 154−65, 176−81, 212−16, 266; action painting, 136−42, 146−49, 178, 193; American, 94, 212−16, 306; automatic, 149; and the avant-garde, 296; drip painting, 111, 246−48; Flemish Primitives, 101−6, 201; Informel painting, 176−78, 193, 230, 262, 285, 294, 296, 301−2; landscape, 165−72; limitations of the medium, xv; Modernist, 85−94, 131−32; New York painting, 20−26, 95, 109, 121−24, 128−29, 157, 212−13; Painterly Abstraction, 179−81, 192−97; Paleolithic, 92; photography compared to, 187; in Prairie Canada, 153−72; representational, 77−78, 82, 87−88, 118−19, 121, 124−27, 182; and sculpture, 60, 310; *tachisme*, 262, 294, 296

Painting of the High Renaissance in Rome and Florence (Freedberg), 197

Palmer, Frank, 163, 168

Palmer, Samuel, 25

Panofsky, Erwin, 275

Paris: abstract art crisis, 176−77; academy and avant-garde in, 299; and American art, 135, 139, 214, 280; as art center, 305, 308; Atget photographs of, 184; and New York painting, 20−22, 25−26, 303−5

Parker, Raymond, 95−96

Parris, Mary, 169

Parrish, Maxfield, 118, 134

Parsons (Betty) Gallery, 45, 53

Participatory art, 294

Partisan Review (magazine), 19, 116, 124, 145n

Pasmore, Victor, 286

Pastoral (Picasso), 34

Patton, Harold P., 163

Perehudoff, William, 159, 170−71

Peridot Gallery, 251

Perrott, Stanford, 163

Peters, Kenneth, 156−57

Peto, John Frederick, 126

Phenomenology, 144, 146

Philadelphia Museum of Art, 240

Photographs by Cartier-Bresson, 183−87

Photography, 183−87, 258, 271

Picabia, Francis, 21

Picasso, Pablo, 308; *An Anatomy*, 235; *Artist and His Model*, 238; attacks on, 75; and Bruce, 164; *Bullfight*, 29; and Chagall, 15−16; *Charnel House*, 235−37; *Chimneys of Vallauris*, 31; collages of, 58, 61−65; *Crucifixion*, 30; Cubism of, 26−27, 30−33, 236−37; as cultural hero, 261; at Dublin exhibition, 285−87; *Les Enfants*, 237; exhibition of, 26−35, 234−39; on experimentation, 307; *Femme au bord de la mer*, 238; *Femme nue*, 238; *Girl Before a Mirror*, 110; and Gottlieb, 33n, 37; *Guernica*, 31−32, 235−37; and Hofmann, 68, 70; and Johns, 126; *The Kitchen*, 33−34, 37; *Korean Massacres*, 31; and Manet, 243; Matisse compared to, 219, 222; Mondrian compared to, 13; and Monet, 4; and New York painting, 20−22, 53, 121, 124, 213; *Night Fishing at Antibes*, 31; old masters compared to, 82; *Pastoral*, 34; and Pollock, 109−10; *Serenade*, 34; and Smith, 228; *Still Life with Black Bull's Head*, 28; *The Studio*, 34; *Tête de femme assise No. 3*, 238; *Three Dancers*, 29−30; *Version L*, 237; *War and Peace*, 31; *Winter Landscape*, 31; *Woman by a Window*, 34; *Woman in Green*, 34; *Woman in Rocking Chair*, 34; "Women of Algiers" series, 237; *Women of Algiers, after Delacroix*, 34

Piero della Francesca, 90, 92, 102

Piet Mondrian (Seuphor), 11−14

Pink Nude (Matisse), 221

Pissarro, Camille, 4, 6, 9

Poetry Reading (Avery), 41

Poindexter Gallery, 23−25

Poliakoff, Serge, 286

Pollock, Charles, 45, 47, 113

Pollock, Jackson, 118, 254, 306, 308; and Abstract Expression-